VELÁZQUEZ'S *LAS MENINAS*

Velázquez's *Las Meninas* was sequestered in the Spanish royal collections from 1656, when it was painted, until the opening of the Museo del Prado in 1819. From that moment, it has been one of the most famous masterpieces of Western painting, inspiring many published studies of its remarkable perspectival construction and of its iconography, as well as challenging later generations of artists, from the nineteenth century, to Pablo Picasso, to the present. The essays in this volume do not propose new interpretations of *Las Meninas*; rather, they provide an introduction to the reception history and the critical fortunes of a painting that has received an avalanche of attention from art critics and art historians, geometricians, philosophers, photographers, and semioticians. Together, the six essays trace the discussion of *Las Meninas* through two centuries, providing the reader with a sense of the history of taste and the ever-fluctuating parameters of art appreciation, history, criticism, and theory.

Suzanne Stratton-Pruitt is a scholar of Spanish painting. She has curated many exhibitions of Spanish art, most recently *Bartolomé Esteban Murillo, 1617–1682: Paintings in American Collections*. Editor of *The Cambridge Companion to Velázquez*, Dr. Stratton-Pruitt is also the author of *The Immaculate Conception in Spanish Art*, which received an award for the best book on Spanish art from the American Society for Hispanic Art Historical Studies in 1994.

MASTERPIECES OF WESTERN PAINTING

This series serves as a forum for reassessment of several of the most important paintings created from the Renaissance to the twentieth century. Each volume focuses on a single work and includes an introduction outlining its general history, and a selection of essays that examine the work from a variety of methodological perspectives. Demonstrating how and why these paintings have had such enduring value, the volumes also offer new insights into their meaning for contemporaries and their subsequent reception.

VELÁZQUEZ'S
LAS MENINAS

Edited by
SUZANNE L. STRATTON-PRUITT

CAMBRIDGE
UNIVERSITY PRESS

PUBLISHED BY THE PRESS SYNDICATE OF THE UNIVERSITY OF CAMBRIDGE
The Pitt Building, Trumpington Street, Cambridge, United Kingdom

CAMBRIDGE UNIVERSITY PRESS
The Edinburgh Building, Cambridge CB2 2RU, UK
40 West 20th Street, New York, NY 10011-4211, USA
477 Williamstown Road, Port Melbourne, VIC 3207, Australia
Ruiz de Alarcón 13, 28014 Madrid, Spain
Dock House, The Waterfront, Cape Town 8001, South Africa

http://www.cambridge.org

First published 2003

Printed in the United Kingdom at the University Press, Cambridge

Typeface Bembo 11/13.5 pt. *System* LaTeX 2$_\varepsilon$ [TB]

A catalog record for this book is available from the British Library.

Library of Congress Cataloging in Publication Data
Velázquez, Diego, 1599–1660.
 Velázquez' Las Meninas / edited by Suzanne L. Stratton-Pruitt.
 p. cm. – (Masterpieces of Western painting)
 Includes bibliographical references and index.
 ISBN 0-521-80057-9 (hb.) – ISBN 0-521-80488-4 (pb.)
 1. Velázquez, Diego, 1599–1660. Maids of honor. 2. Painting – Spain – Madrid.
 3. Musco del Prado. I. Stratton, Suzanne L. II. Title. III. Series.
ND813.V4 A68 2002
759.6 – dc21 2002025738

ISBN 0 521 80057 9 hardback
ISBN 0 521 80488 4 paperback

CONTENTS

LIST OF ILLUSTRATIONS

LIST OF CONTRIBUTORS

M. ELIZABETH BOONE is Associate Professor of Art History at Humboldt State University in Arcata, California. In 1998, Dr. Boone curated and wrote the catalog for the exhibition *España: American Artists and the Spanish Experience* (New York, Hollis Taggart Galleries and Connecticut, New Britain Museum of American Art). She is currently working on an anthology of writers and artists who visited Toledo, Spain (forthcoming from Ediciones Antonio Pareja), and on a book about the vogue for Spain among American artists during the nineteenth century.

XANTHE BROOKE is Curator of European Fine Art at the National Museums and Galleries on Merseyside, Liverpool, England. Her publications include the essay, "British Artists Encounter Spain: 1820–1900" in the catalog of the exhibition *Spain, Espagne, Spanien* (1993); the exhibition catalog for *Face to Face: Three Centuries of Artists' Self-Portraiture* (1994); and a catalog of the Weld Blundell collection of old master drawings at the Walker Art Gallery, Liverpool (1998). Most recently, she was the coauthor, with Dr. Peter Cherry, of the catalog accompanying the exhibition *Murillo: Scenes of Childhood* (London, Dulwich Picture Gallery and Munich, Alte Pinakothek, 2001).

ESTRELLA DE DIEGO is Professor of Contemporary Art History at the Universidad Complutense, Madrid. She held the King Juan Carlos I of Spain Chair in Spanish Culture and Civilization at the King Juan Carlos I of Spain Center, New York University during 1998–1999. Among her many publications are *La mujer y la pintura en la España del siglo XIX*

(Madrid: Cátedra, 1987), *El andrógino sexuado. Eternos ideales, nuevas estrategias de género* (Madrid: Visor, 1992), *Arte contemporáneo* (Madrid: Historia 16, 1996), and *Tristísimo Warhol* (Madrid: Editorial Siruela, 1999). Dr. de Diego is currently working on a book about uncertainty as a representational strategy in Western visual culture.

ALISA LUXENBERG, Assistant Professor at the University of Georgia (Athens), has published on various aspects of the relationships between eighteenth- and nineteenth-century French and Spanish art, including essays in *Spain, Espagne, Spanien: Foreign Artists Discover Spain, 1800–1900* (1993), *Painting in Spain in the Age of Enlightenment: Goya and His Contemporaries* (1997), and *Mehr Licht: Europa um 1770: Die bildende Kunst der Aufklärung* (1999), as well as articles in *Burlington Magazine* (2001), *Boletín del Museo del Prado* (1989, 1999, 2001), and *The Art Bulletin* (1998).

SUZANNE L. STRATTON-PRUITT wrote *The Immaculate Conception in Spanish Art* (Cambridge University Press, 1994), which received an award for the best book on Spanish art published that year in English from the American Society for Hispanic Art Historical Studies. She has curated many exhibitions of Spanish art, including, most recently, *Bartolomé Esteban Murillo 1617–1682: Paintings in American Collections* organized by the Kimbell Art Museum in Fort Worth and also seen at the Los Angeles County Museum of Art in 2002 (New York: Harry N. Abrams, Inc., Publishers). Dr. Stratton-Pruitt recently served as guest editor for the *Cambridge Companion to Velázquez* (2002). For her contribution to the wider understanding of Spanish culture, she was awarded the "Lazo de Dama de la Orden de Isabel la Católica" by the government of Spain.

GERTJE R. UTLEY is an independent scholar in art history who has published and lectured widely on the art of the nineteenth and twentieth centuries. Among Dr. Utley's recent publications are *Picasso, the Communist Years* (London and New Haven: Yale University Press, 2000); "Picasso entre deux Charniers: From *Guernica* to the *Charnel House*, the Radicalization of Picasso" in the catalog of the exhibition *Picasso and the War: 1937–1945* (San Francisco, Fine Arts Museum of San Francisco, 1998, and New York, Solomon R. Guggenheim Museum, 1999); "Picasso and the French Post War 'Renaissance': A Questioning of National Identity," in Jonathan Brown, ed., *Picasso and the Spanish Tradition* (New Haven and London: Yale University Press, 1996).

INTRODUCTION

Κing Philip IV of Spain died in 1666, six years after the death of his court painter Diego de Velázquez y Silva. As required by the king's death, the painter Juan Bautista Martínez del Mazo, Velázquez's son-in-law, proceeded to inventory the royal collection of paintings. In this 1666 inventory, the first written record of a work created in 1656, Mazo described a large painting "portraying" the Infanta Margarita with "her ladies-in-waiting [*meninas*] and a female dwarf, by the hand of Velázquez."

The first substantive description of the painting is in a manuscript treatise on painting, dated 1696, by the Portuguese Felix da Costa:

> To Diego de Velázquez the painter, Philip IV, King of Castile, gave the order of Santiago, which is the chief honor of that realm, as well as the key of the [royal] chamber. His own wit perpetuated this honor in a picture which adorns a room of the palace at Madrid, showing the portrait of the Empress, the daughter of Philip IV, together with his own. Velázquez painted himself in a cape bearing the cross of Santiago, with the key [to the chamber] at his belt, and holding a palette of oils and brushes in the act of painting, with his glance upon the Empress, and putting his hand with the brush to the canvas. At his left, and on the other side of the picture, we see the little Princess standing among kneeling ladies-in-waiting who are amusing her. [Nearby] is a large dog belonging to the palace, lying down obediently among these ladies. The picture seems more like a portrait of Velázquez than of the Empress.[1]

Indeed, inventories of the royal palace, the Alcázar, give some prominence to the fact that Velázquez "portrayed himself painting." However, the work is described in later documents as representing *La familia de Felipe IV* and did not appear in print with its now highly recognizable title of *Las Meninas* until 1843.

Antonio Palomino, in his biography of Spanish painters published in 1724, described *Las Meninas* with more detailed information than provided by Felix da Costa. When Palomino arrived in Madrid in 1678, there were still individuals at the Spanish court who had known Velázquez and could provide the artist/theorist with the identification of all the figures in the painting. Palomino titled his description of the painting as the section of his biography of the painter "in which the most illustrious work of Velázquez is described." Because all subsequent studies of the painting have depended on Palomino, it is worthwhile to open this volume of essays on the history and "critical fortunes" of the painting by quoting him in full:

> Among the marvelous paintings made by Don Diego Velázquez was the large picture with the portrait of the Empress – then Infanta of Spain – Doña Margarita María of Austria when she was very young. There are no words to describe her great charm, liveliness, and beauty, but her portrait itself is the best panegyric. At her feet kneels Doña María Agustina – one of the Queen's Meninas and daughter of Don Diego Sarmiento – serving her water from a clay jug. At her other side is Doña Isabel de Velasco – daughter of Don Bernardino López de Ayala y Velasco, Count of Fuensalida and His Majesty's Gentleman of the Bedchamber, also a Menina and later Lady of Honor – In an attitude and with a movement precisely as if she were speaking. In the foreground is a dog lying down, and next to it is the midget Nicolasito Pertusato, who treads on it so as to show – together with the ferociousness of its appearance – its tameness and its gentleness when tried; for when it was being painted it remained motionless in whatever attitude it was placed. This figure is dark and prominent and gives great harmony to the composition. Behind it is Maribárbola, a dwarf of formidable aspect; farther back and in half-shadow is Doña Marcela de Ulloa – Lady of Honor – and a Guarda Damas, who give a marvelous effect to the figural composition.

On the other side is Don Diego Velázquez painting; he has a palette of colors in the left hand and the brush in his right, the double key of the Bedchamber and of Chamberlain of the Palace at his waist, and on his breast the badge of Santiago, which was painted in after his death by order of His Majesty; for when Velázquez painted this picture the King had not yet bestowed on him that honor. Some say that it was His Majesty himself who painted it for the encouragement that having such an exalted chronicler would give to the practitioners of this very noble art. I regard this portrait of Velázquez as no lesser in art than that of Phidias, famous sculptor and painter, who placed his portrait on the shield of the statue of the goddess Minerva that he had made, crafting it with such cunning that if it were to be removed from its place, the whole statue would also come apart. Titian made his name no less eternal by portraying himself holding in his hands another portrait with the effigy of King Philip II, and just as Phidias's name was never effaced while the statue of Minerva remained whole, and Titian's as long as that of King Philip II endured, so too that of Velázquez will endure from century to century, as long as that of the lofty and precious Margarita endures, in whose shadow he immortalizes his image under the benign influence of such a sovereign mistress.

The canvas on which he is painting is large and nothing of what is painted on it can be seen, for it is viewed from the back, the side that rests on the easel. Velázquez demonstrated his brilliant talent by revealing what he was painting through an ingenious device, making use of the crystalline brightness of a mirror painted at the back of the gallery and facing the picture, where the reflection, or repercussion, of our Catholic King and Queen, Philip and Mariana, is represented. On the walls of the gallery that is depicted here and where it was painted (which is in the Prince's Apartments), various pictures can be seen, even though dimly lit. They can be recognized as works by Rubens and as representing scenes from Ovid's *Metamorphoses*. This gallery has several windows seen in diminishing size, which make its depth seem great; the light enters through them from the left, but only from the first and last ones. The floor is plain and done with such good perspective that it looks as if one could walk on it; the same amount of ceiling can be seen. To the mirror's left there is an open door leading to a staircase, and there stands José Nieto,

the Queen's Chamberlain; the resemblance is great despite the distance and the diminution in size and light where Velázquez assumes him to be. There is atmosphere between the figures, the composition is superb, the idea new; in brief, there is no praise that can match the taste and skill of this work, for it is reality, and not painting.

Don Diego Velázquez finished it in the year 1656, leaving in it much to admire and nothing to surpass. If he had not been so modest, Velázquez could have said about this painting what Zeuxis said about his beautiful Penelope, a work of which he was greatly satisfied: In visurum aliquem, facilius, quam imitaturum, that it would be easier to envy it than to imitate it.

This painting was highly esteemed by His Majesty, and while it was being executed he went frequently to see it being painted. So did our lady Doña Mariana of Austria and the Infantas and ladies, who came down often, considering this a delightful treat and entertainment. It was placed in His Majesty's office in the lower Apartments, among other excellent works.

When Luca Giordano came – in our day – and got to see it, he was asked by King Charles II, who saw him looking thunderstruck, "What do you think of it?" And he said, "Sire, this is the Theology of Painting." By which he meant that just as Theology is the highest among the branches of knowledge, so was that picture the best there was in Painting.[2]

Las Meninas was installed in the private office of the king, the "Cuarto Bajo de Verano," a semisubterranean room in the Madrid Alcázar (royal palace). The painting's proximity to the king himself certainly indicates his partiality to the work, although it should be noted that his eclectic taste was reflected in the other twenty-five paintings listed in the 1666 inventory of the apartment, including *Pomona and Vertumnus* by Rubens and Van Dyck's *Selene and Endymion Surprised by a Satyr*, as well as marble bureaus inlaid with jasper and seven large mirrors with fretwork frames of bronze and ebony. Although these summer quarters of the king were on a rather intimate scale as compared to the royal palace in its entirety, it was decorated with an eye toward the exalted, although restricted, persons who were able to visit the king there: members of the royal family and family servants, cardinals and papal nuncios, viceroys, presidents of the Council of State, and

the king's minister (his *valido*, or "favorite").[3] After the death of Philip IV, *Las Meninas* remained in the Alcázar until its destruction in a fire in 1734. The painting was thereafter moved to the new royal palace, the Palacio de Oriente, where it was seen in the "Sala de Conversación" in 1776 and, somewhat later, in the king's "Sala de Cena" (dining room), a space now called the "Antecámara de Gasparini." All this to say that *Las Meninas* was seen by few and was thus little known until much of the royal art collection was moved into the new Museo del Prado, which opened to the public in 1819. Between Palomino's detailed description of the painting published in 1724 and critical responses to the painting in the nineteenth century, there is little to illuminate our understanding of the work. One eighteenth-century response to the painting, the comment of the Neoclassicist Anton Raphael Mengs, reveals more about Mengs' taste than about the painting: "as this work is already so well known on account of its excellence, I have nothing to add but that it stands as proof that the effects caused by the imitation of the Natural can satisfy all classes of people, particularly those who have not the highest appreciation of Beauty."[4]

In the nineteenth century, "the Natural" lost the negative connotation placed on it by Mengs, and *Las Meninas* became an icon of Baroque Naturalism (as opposed to the idealizing qualities of Italian Renaissance art, or the Baroque classicism of Guido Reni, or the neoclassicism of David, Ingres, – or Mengs). In the first three essays in this volume Alisa Luxenberg, Xanthe Brooke, and M. Elizabeth Boone discuss how *Las Meninas* was interpreted by critics and artists of the nineteenth century as an icon reflective of their own time and tastes, from Realism to Impressionism (especially in the book about Velázquez by R.A.M. Stevenson) to the American Aesthetic movement, with the most pervasive reading of the painting based on its supposed truth to nature, its depiction of an actual moment in time, its likeness to photography. In the finest monograph on Velázquez of the nineteenth century, published in the closing years of that century, Carl Justi simply described the subject of the painting as a *tableau vivant*, and animated the figures into an imaginary narrative:

> It happened that on one occasion, when the royal couple were giving a sitting to their Court painter in his studio, Princess Margaret was sent for to relieve their Majesties' weariness.

> The light, which, after the other shutters had been closed, had been let in from the window on the right from the sitters, now also streamed in upon their little visitor. At the same time Velazquez requested Nieto to open the door in the rear, in order to see whether a front light might also be available.[5]

During the twentieth century, art historians have approached the painting as an acknowledged masterpiece produced within the context of its own time. Justi had made a noble effort to do just that, but he was inevitably swayed by the his own nineteenth-century context, in which Velázquez was honored for the naturalism of his art, for its apparent artlessness. The fourth essay in this volume is intended to introduce to a general reader the at first bewildering number of approaches to and interpretations of *Las Meninas* taken by art historians during the twentieth century. These have invested the painting with a variety of allegorical and emblematic meanings certainly closer to the mind set of seventeenth-century Spanish culture of Spain than Justi's anecdotal reading of it. However, sometimes the best efforts of scholars have eventually proven unconvincing, and the more convincing interpretations do not always agree with each other. As well, since the early 1980s there have been a number of articles about *Las Meninas* published by philosophers and art historians pursuing theoretical approaches to the painting unimaginable to earlier generations of art critics and historians.

The latter have been largely impelled by the essay on *Las Meninas* by Michel Foucault that was published in 1964 in *Les Mots et les Choses*. The fifth essay in this anthology, by Estrella de Diego, analyzes this notoriously difficult (and therefore often misunderstood) essay in order to help the reader understand what Foucault intended – and what he did not intend.

Finally, Gertje Utley examines the reflections, reponses, and appropriations of *Las Meninas* in twentieth-century art, from Picasso to the electronic media of today. It is hoped that these essays will serve the reader as an introduction to the historiography and influence of *Las Meninas* to date and as a firm basis for further exploration. We can be reasonably sure, however, that Velázquez's masterpiece will continue to provoke thought, research, and perhaps even more ways of thinking and looking than are considered in this volume. There is no last word.

NOTES

1 The treatise has been published in facsimile and translated by George Kubler and others. *The Antiquity of the Art of Painting by Felix da Costa*, with introduction and notes by Kubler (Yale University Press, 1967), p. 458.

2 Palomino's theoretical treatise, the *Museo pictórico y escala óptica*, was published in two volumes in Madrid in 1715 and 1724. The biographies of the artists, called *El Parnaso español pintoresco laureado*, appeared in 1724 as a third volume bound with the second. This quotation is from Nina Ayala Mallory's translated and annotated edition of the *Lives of the Eminent Spanish Painters and Sculptors by Antonio Palomino* (Cambridge University Press, 1987), pp. 164–6.

3 For the early history of the painting, see Fernando Marías, "Las Meninas de Velázquez, del despacho de Felipe IV al cenador de Carlos III," in *Velázquez y Calderón: Dos genios de Europa (IV Centenario, 1500–1600, 1999–2000)*. Madrid, 2000.

4 Ibid., p. 161: "siendo ya tan conocida esta obra por su excelencia, no tengo que decir sino que con ella se pueda convencer, que el efecto que causa la imitación del Natural es el que suele contentar a toda clase de gentes, particularmente donde no se hace el principal aprecio de la Belleza." Mengs' comments on *Las Meninas* were published by Antonio Ponz in his *Viage de España* (Madrid, 1772–1794), Vol. 6, p. 200.

5 Carl Justi, *Diego Velazquez and His Times*, trans. by A. H. Keane and revised by the author (London 1889), p. 416. Justi's *Velázquez und sein Jahrhundert* was first published in Bonn in 1888.

THE AURA OF A MASTERPIECE

Responses to *Las Meninas* in Nineteenth-Century Spain and France

...this marvelous canvas, *The Theology of Painting*, as Luca Giordano called it, ... [is] a successful group of portraits in the most Castilian of settings and with a well-painted ambiance that recreates the spirit [of the time].

José Ramón Mélida, 1899

[*Las Meninas*] deserves to be regarded and protected as the most precious jewel of [Spanish] painting.

Narciso Sentenach, 1899

Today, *Las Meninas* [Fig. 1] is widely considered to be the apex of Velázquez's achievement as well as a canonical Western masterpiece, and it is the single work of art most closely associated with the Spanish "national gallery," the Museo del Prado in Madrid. The citations listed here indicate that its status as national masterpiece was firmly established by the late nineteenth century, when numerous monographs on Velázquez and the 1899 tercentenary of his birth, celebrated by reinstalling his paintings at the Prado, scripted and literally cemented *Las Meninas'* position as the Spanish *ur*-artwork.[1]

This canonization was not simply a matter of taste. More exactly, such taste was shaped by various cultural factors that must be examined when studying the sanctification and nationalization of Velázquez's canvas. Modern art histories explain this appreciation of Velázquez through chronologies of facts and works that reflect radical French aesthetic values from Romanticism to Realism to Impressionism.[2] Their perspective springs from two *idées reçues* created in nineteenth-century

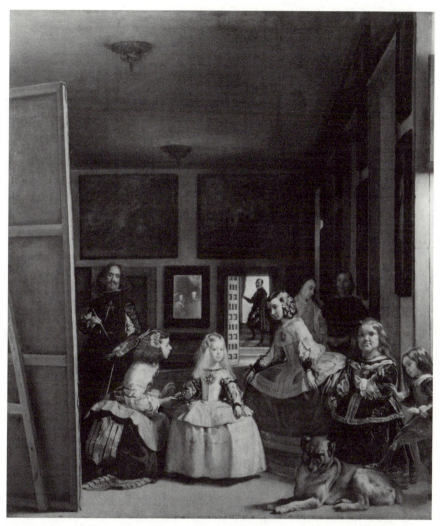

FIGURE 1. Diego Velázquez. *Las Meninas (The Ladies in Waiting)*. 1656. Oil on canvas. Madrid, Museo del Prado. © Museo del Prado, Madrid.

France: Spain neglected Velázquez's art, and French artists and critics discovered his painting and understood its progressive aesthetics better than native artists.[3] It is time to be critical of that narrative of discovery and artistic modernism and recognize that the status of national masterpiece is usually obtained only when both the center and the margins agree. In 1899, modernist writer Rubén Darío observed that artists as

dissimilar as Edward J. Poynter, Carolus-Duran, and Jean-Paul Laurens were united in "the same imperious admiration" for Velázquez's art, exemplified by *Las Meninas*.[4] This reception history not only amends and adds to the established body of mostly French responses to the painting, but also explores where those words and pictures came from, and what they meant in a broader visual, institutional, and cultural sense.

The Franco–Spanish discourse on *Las Meninas* is composed of more than intellectual debate and formal references. It includes institutional decisions on displaying the painting, and socioeconomic decisions concerning making and buying reproductions of it. The discourse appeared in high- and low-brow venues, such as art criticism and art history, travel writing, private letters and public articles, commissioned paintings, and commercial prints. Although I cannot claim to have exhausted this body of publications and representations, I found no linear development of taste for *Las Meninas*; rather, there are several recurrent themes and issues around which this essay is organized.

This reception history of *Las Meninas* first and foremost reintegrates the practices and opinions in Spain into the discourse.[5] Histories of nineteenth-century art tend to relegate Spain to the margins. However, Spain possessed the picture and, despite political and economic difficulties, sustained art institutions and criticism that addressed it. France exerted great influence on the discourse through its leading role in artistic institutions (e.g., museums, academies, exhibitions), opportunities (e.g., market, tourism), and interpretations (e.g., scholarship, publishing). In addition, France had a history of political intervention in Spain, including the Napoleonic occupation of 1808–1814 and the Bourbon invasion of 1823.[6] These nations' broader cultural dialog resonated in the reception of Velázquez's painting.

The various sources consulted here evidence relationships between "higher" and "lower" cultural practices that challenge twentieth-century divisions between art history and travelogs, or between travel by artists and tourism.[7] Significant themes and qualities raised in interpretations of *Las Meninas* match the values of the growing tourist economy. In *The Tourist*, Dean MacCannell argues that tourism's appeal derives from the human desire for authentic experience.[8] The meaning of *authenticity* varies, according to people's diverse expectations for it; like any cultural value, it is constructed and modified by authoritative

voices, as are the meanings assigned to the authentic object or experience. Thus, one sight/site may remain a significant monument for different peoples or during distinct periods, whereas natives and tourists may respond differently to another object or activity. In the trans-Pyrenean voices of this essay, a fetishized artifact (*Las Meninas*) in a museum context (Prado) often evoked pride or historical memory in the native Spaniard, and consumer desire or erotic leisure in the French tourist.

If the travel economy facilitated access to works of art in person, the desire for it first must be created. In nineteenth-century texts, viewing original works of art became an experience of authenticity *par excellence*.[9] With increased demand for first-hand looking came new print media such as lithography and photography that produced, with less "syntax,"[10] images that familiarized the original object and released it into capitalist circulation. Improved simulacra made the original even more desirable, and the journey to see it obligatory for those seeking to distinguish their aesthetic credentials from the crass majority satisfied with the facsimile at home.[11]

Armchair-travel books about "this very important artistic pilgrimage" to Spain were penned by art critic–novelists like Théophile Gautier (1843) and popular writers such as the countess de Gasparin (1875) and Fernand Petit (1877).[12] They frequently describe *Las Meninas* as a rare object, equivalent to a relic, with the power to enlighten or transform. It bespeaks a kind of cultural grafting of modern tourism and art-going in Madrid onto the earlier practice of pilgrimage to Santiago de Compostela. Like the weary, endangered pilgrim, the reader–tourist sacrificed (comfort, time, familiarity) to reach the shrine, where something akin to salvation or self-knowledge awaited.

International politics colored the reception of Velázquez and *Las Meninas* as well. The national crisis following Spain's defeat by the United States in 1898 weighed heavily on the Velázquez tercentenary the following year. Spanish critics lauded Velázquez's art as proof that the country could regenerate its glory; for them, his masterpieces in the Prado triumphed over his foreign rivals, achieving what Spain's military and navy had not.[13] In 1899, the Madrid newspaper *El Imparcial* urged the city to "take advantage of . . . [Velázquez's birthday] to show off its art and Spanishness."[14] The centerpiece of these nationalist celebrations was *Las Meninas*.

I do not want to suggest that a *zeitgeist* led to a single, unified inter-
pretation of *Las Meninas* by the end of the nineteenth century. Even
then, debates arose in and outside of Spain over who should and how
to interpret Velázquez's art. Because most writers and artists had read
the same books (at least those in their language), the discourse is often
self-reflexive, returning to internal themes. Occasionally, new pressures
or eyes created an interpretative leap, but this was not always followed.
This essay aims to explore both the dominant and novel ways in which
Spanish and French minds constructed meaning for *Las Meninas*.

WHAT BECOMES AN AURA: ACCESS
AND UNFAMILIARITY

Two competing qualities, accessibility and unfamiliarity, became es-
sential concepts in the nineteenth-century canonization of *Las Meni-
nas*. Like much art, famous or not, *Las Meninas* became increasingly
known during the nineteenth century as fine art audiences grew. The
opening of a royal art museum in Madrid in 1819 made the king's
collection more accessible, and there, *Las Meninas* remained not far
from its original location in the Alcázar and subsequent locations in
the new royal palace. Palace inventories note that the painting was
moved several times, from a bedroom in 1794,[15] to the queen's *salón del
servicio* in 1811,[16] then the dining room of Prince Francisco de Paula in
1812.[17] The museum first placed Velázquez's canvas in the main room
of Spanish paintings; by the mid-1870s, it hung in the grand gallery
with the best works of various schools.[18]

By the 1830s, professors at the royal art academy in Madrid encour-
aged or even required their pupils to study the art of Velázquez,[19] hailed
as the best of the "Spanish School."[20] French painter Léon Bonnat stud-
ied at that academy from 1847–1853, and later described his Spanish
comrades' enthusiasm: "Velázquez was our god. We knew his works by
heart, we knew how he had painted that hand, that head. The small-
est pentimento, so common to his works, did not escape us."[21] Such
Spanish practices and comments refute the numerous French claims
after 1830 to have discovered and rescued Velázquez's art from native
ignorance.

Rarity and national character were qualities easily associated with
Las Meninas. It is a unique, nonreproducible object found in one place,

a city largely omitted from pre-1800 itineraries of leisure travelers or art collectors. Much of Velázquez's limited oeuvre was painted for the king and remained in the royal collection, unlike the larger outputs of Zurbarán and Murillo, whose various patrons widely dispersed their works.[22] As Téodor de Wyzewa noted, Velázquez painted little in his late years, making *Las Meninas* more exceptional.[23] As typified by *Las Meninas*, the subjects, patronage, and location of most of Velázquez's works were standards of authentic Spanishness for critics and historians.

Still, the same argument could have been made for other pictures by Velázquez or Spanish artists in the Madrid museum. So why was this particular picture singled out for sacred status? First, *Las Meninas* was promptly given and never lost its standing in Spain as a highly original and beautiful work; such consistent admiration was exceptional, even for Velázquez. The legend of Philip IV painting the cross of the royal order of Santiago on Velázquez's figure served as proof for nineteenth-century critics of the picture's extraordinary value, recognized by a connoisseur, the king.[24] Moreover, the subject was considered highly original. Critics appreciated Velázquez's departure from the Spanish tradition of religious painting and the Old Master practice of reprised subjects.[25] *Las Meninas* was one of Velázquez's few contemporary genre paintings, and among those, his only portrayal of recognizable personages. Furthermore, for an era in which the biographical offered a principal avenue into interpreting art, Velázquez's self-portrait in the act of painting and in the presence of royalty elicited extensive speculation.

Most significantly, the optical impression conveyed by *Las Meninas* was believed to be enhanced by one's physical presence before the canvas: a demand for authenticity. Early writings attributed its extraordinary effect to Velázquez's subtle manipulation of linear and aerial perspective to suggest space, through which the viewer discovers that neither he nor the artist is the object of the figures' gazes. It clearly troubled the conservative Charles-Ernest Beulé, this "composition inverted in such a bizarre manner . . . the painter and his models are in the same plane and all look at the public: however, in principle, the public was the king and queen who were posing."[26] What an empowering experience it must have been after 1820 for ordinary viewers, without court connections, to see this painting and step into the royal shoes. First-hand analyses later in the century concentrated increasingly on Velázquez's optical impression of light and loose, individualized

brushwork. These visual effects qualified *Las Meninas* as a signature work and a successful tourist attraction, one that produced a "you are there" experience.[27]

As *Las Meninas* became better known, writers protected its status by constructing an aura of mystery around it. Nearly every Spanish and French critic maintained that one could see Velázquez's best works, including *Las Meninas*, only in Madrid, and French writers exaggerated the physical hardships of traveling to Madrid or the time spent studying the master's art.[28] In 1875, P.-L. Imbert implied that special vision was needed to divine its hidden import, "*Las Meninas*, which the whole world looks at and no one sees."[29] By mystifying the painting, echoing its depiction of a "hidden" canvas, these authors conferred authority on their own insights and elite status on their reader–travelers who now appreciated Velázquez's unique creation. Too much strangeness, however, risked alienating an audience; thus, French authors often drew parallels with French examples to orient their readers.[30] In 1859, the critic Henri Fouquier connected *Las Meninas* to France by proposing that the Louvre's portrait of the infanta Margarita was probably the study for her figure in *Las Meninas*.[31]

Several French authors decried the inaccessibility of Velázquez's art, which they ascribed to Spanish ignorance, greed, or jealousy. After visiting Spain in 1831, the novelist Prosper Mérimée opined that "the French were wrong to leave so many art treasures that often are not valued properly by their legal [Spanish] owners."[32] A few years later, King Louis-Philippe exploited the political instability and closing of religious institutions in Spain by sending Baron Isidore Taylor and two artists on a secret mission to acquire Spanish works of art. They amassed more than 400 pictures for the new Galerie Espagnole in the Louvre.[33] When the collection opened in early 1838, French critics lamented the lack of quality works by Velázquez, which triggered evaluations of his best painting. A student of David, Étienne-Jean Délécluze ranked *The Drinkers, The Surrender of Breda, The Forge of Vulcan*, and *Las Meninas* as masterpieces, but only the last picture aimed "to resolve ... all of the most difficult problems that the arts of drawing, modeling, and coloring present."[34]

Interestingly, the condition of *Las Meninas* was rarely addressed in the discourse until the 1890s. Lefort and Michel mentioned that the Alcázar fire in 1734 damaged the painting's upper section, which was later restored.[35] For Louis Gonse, these restorations destroyed the

picture's harmony (that he nonetheless perceived and considered a su-
perior example of Velázquez's late, great style).[36] Perhaps its condition
led Beulé to describe an "unpleasant appearance" and "gloomy color,"
yet, he, too, ranked it among Velázquez's four "brilliantly original"
masterpieces.[37] For all the study of the picture during the 1800s, its
material condition seemed unimportant. Like a crumbling relic, the
earthly state of the canvas may have enhanced its authenticity and ability
to evoke human response.

A SHRINE FOR THE RELIC: THE TRANSFORMATION OF THE PRADO

Historians have long credited the Peninsular War with introducing
Europeans to Spanish art and culture and Spaniards to European no-
tions of art institutions and practices. Recent scholarship has demon-
strated that such cross-cultural exchange was well underway during the
eighteenth century, but the depleted coffers of Carlos III and Carlos IV,
followed by the Napoleonic invasion, hindered the implementation of
several projects. The "intruder king" Joseph Bonaparte tried to estab-
lish a public art collection, finally realized by the restored Spanish heir
Fernando VII and his wife, Isabel de Braganza. In 1819, the first pictures
from the royal collections were transferred to Villanueva's building on
the Paseo del Prado. With the revolution of 1868, the royal art mu-
seum was given to the nation and named the Museo del Prado, after
the facing promenade known for its diverse public.

As the content of the museum changed over time, so did the context
for *Las Meninas*. Pictures from royal residences and private donations
enlarged the collections, which were sporadically reorganized and reat-
tributed. In 1819, forty-three paintings by Velázquez were cataloged in
the museum; in 1828, the total increased to sixty; the 1860s added four
more. However, in 1899, the scholarly commission appointed to define
Velázquez's oeuvre dramatically reduced it from sixty-four to thirty-
nine or forty-two, nearly the same number as cataloged in 1819.[38]
Equally significant, only thirty-one pictures outside of the Prado
were deemed authentic, which meant that the Prado alone owned
nearly sixty percent of Velázquez's oeuvre. The committee's findings
did not go unchallenged. The painter and Prado restorer Salvador
Martínez Cubells demanded that they explain and defend their deci-
sions to exclude eighteen works in the Prado. Scholarship radically

redefined Velázquez's oeuvre throughout the nineteenth century, but the authorship and supreme quality of Las Meninas were never doubted.

Museum visitors had more freedom than earlier palace guests did in how they looked at the royal pictures. Early on, the museum opened to the public two days per week, although foreigners could visit any day on presentation of their passports.[39] Still, writers described the museum as unknown, "the least known public collection in Europe . . . one of the most interesting, and surely one of the richest,"[40] again creating a sense of mystery. As the museum experience was recognized throughout Europe as a secular, spiritual enlightenment,[41] both guidebooks and art studies described the Madrid museum as a shrine, where one "entered with religious respect,"[42] and "for those who adore God as much in the works of men as in those of nature, [it] is a holy temple, a place of prayer."[43]

By 1862, well-known art historian Gregorio Cruzada Villaamil called for the museum to hang Las Meninas in conditions that would enhance its formal beauty.[44] His proposal was realized for the 1899 tercentennial. In 1896, a moderate Barcelona art critic invented a historical precedent for an isolated display of this canvas. Drawing on historical accounts of the public acclaim won by Velázquez after exhibiting his equestrian portrait of the king in San Felipe el Real, Balsa de la Vega claimed that Las Meninas was shown publicly in the same way.[45]

Political tensions and nationalist rhetoric inflected the Spanish discourse on Velázquez during the 1890s. This was never clearer than during the Velázquez tercentennial, when commentaries on the Prado's special exhibition, renovated gallery, and public monument, all devoted to Velázquez, used art and history as a rallying cry for the regeneration of Spain. Following Spain's humiliating defeat to the United States in 1898, the tercentennial represented "a matter of national decorum and a manifestation of pure patriotism and culture."[46] To that end, Las Meninas figured prominently. The Spanish novelist Emilia Pardo Bazán lauded Velázquez's "indisputable genius" as "universal and national at the same time; it expresses humanity (Los borrachos) and vigorously shows his race and people (Las meninas)."[47] For Balsa de la Vega, even the dog in Las Meninas had "racial character" (carácter de raza),[48] a phrase that referred to canine breeding and cultural roots. Amazingly, at this political nadir, Spaniards took control of the discourse on Velázquez and irrevocably claimed his national significance. Yet, France's impact

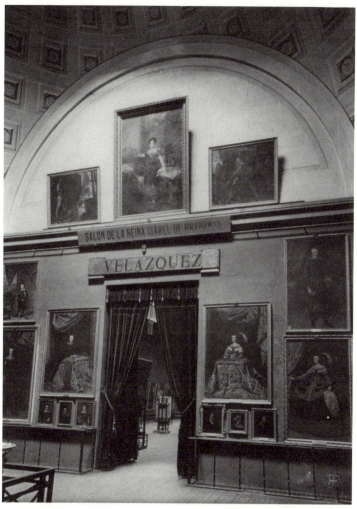

FIGURE 2. Entry to the Sala Velázquez, Museo del Prado, 1899. Photograph. © Museo del Prado, Madrid.

never disappeared completely. As I argue elsewhere, the Velázquez monument at the Prado's entrance was certainly catalyzed by a French precedent, Émmanuel Frémiet's *Vélasquez*, placed before the Louvre's east façade in late 1892.[49]

For the tercentenary, the Prado renovated a large oval room, the Sala Isabel de Braganza, that, like the Louvre's Salon Carré, exhibited the "best" paintings.[50] Renamed the Sala Velázquez, it now displayed all of Velázquez's works (Fig. 2); thus did the Spanish administration

honor "the prince of painters" by replacing a queen's name with his.[51] The renovation regulated and modernized the lighting and temperature conditions, and repainted the walls a silvery gray to harmonize with the admired tones of Velázquez's pictures. The new display was meant to enhance the visual experience of his paintings and was described as a soulful pilgrimage to another world.[52]

Within this space consecrated to Velázquez's art, *Las Meninas* was given special emphasis.[53] It was placed, alone, in a small, closed space carved out of the Sala de Velázquez and illuminated by an existing window. The intention, as curators and critics explained, was to replicate the real light conditions – soft, lateral, from the right – of the scene depicted. This isolated hanging replicated those created for Rembrandt's *Night Watch* in Amsterdam and for Raphael's *Madonna* in Dresden, both exceptional masterpieces in the nineteenth century.[54] Narciso Sentenach described the new installation of *Las Meninas* in hushed, sacred terms:

> You must go there to contemplate this prodigious [painting], and when you decide to leave, it will be with the conviction of having entered a sanctuary, of having admired a superhuman work, of having been lucky enough to penetrate into the Delphos of art.[55]

Other commentators discovered "unseen spaces and barely suspected beauties" in the new hanging.[56] The iconic status of *Las Meninas* seemed assured. When the iron window grate in its room fell down, *La Época* expressed thanks that the painting came to no harm, only afterwards expressing similar concern for humans.[57]

SOUVENIR FETISH

Copies, reproductions, and references to Velázquez's *Las Meninas* helped to cultivate an appetite for the picture, both as *apéritif* to future travelers and artists and as *digestif* to those who had seen it. Reproductions could serve as "authentic" substitutes for the actual painting when consumers knew to read in what was missing – color, dimension, surface qualities – and believed the designers to be disinterested copyists. They could also be cultural booty, as the Argentine

émigré Rodrigo Soriano remarked disapprovingly:

> A good crowd of copyists, like ambassadors from all over the
> world, gather round [Velázquez's] paintings fighting among
> themselves for the glory of reproducing them, in order to
> carry them off like trophies for [their] countries and like
> relics that believers in the cult of Velázquez need for worship.[58]

By the later 1700s, Spanish art administrators and artists understood
the importance of promoting and disseminating knowledge of Spanish
art and the special place occupied by Velázquez. Francisco de Goya
may have been the first to prepare an etching of *Las Meninas*, although
it seems never to have been printed or sold.[59] Many scholars discuss the
strong dialog between Goya's portraits and *Las Meninas*, especially *The
Family of Charles IV* (1800–1801). Both pictures ostensibly represent
the royal family in attitudes that were seen predominantly as casual,
spontaneous, and truthful. Both also include the self-portrait of the
artist in the process of painting a large canvas whose back faces the
viewer. Finally, both compositional orders literally draw in the viewer
in such a way that his position seems privileged.[60] Janis Tomlinson
proposes that Goya's reference to *Las Meninas* was an overt gesture to
Spanish artistic tradition in the face of growing internationalism.[61]

Between Goya's printed and painted references to *Las Meninas*,
French printmaker Pierre Audouin made a large etching of *Las Meni-
nas* that is dated 1799 (Fig. 3).[62] Audouin exaggerated the heads of
the dwarves, princess, ladies-in-waiting, and Velázquez, and by 1835,
French art critic and scholar Théophile Thoré judged Audouin's etch-
ing to be "detestable."[63] By then, one could compare Audouin's image
with a line engraving in Réveil's and Duchesne's *Musée de peinture
et de sculpture* that illustrated important works in European museums.
In the volume of the Spanish and English schools (both marginal to
French eyes), Réveil engraved *Las Meninas* (Fig. 4) and five other
works by Velázquez.[64] Its English title, *Velázquez Taking the Portrait of
an Infanta*, reflects the belief that the painter transcribed literally what
he saw.[65]

Lithography, invented in 1819, allowed printmakers to create more
painterly effects, and seemed suited to rendering the atmospheric
effects of *Las Meninas*. Only in 1855 did French lithographer Célestin
Nanteuil make a print after Velázquez's painting (Fig. 5), for a Spanish

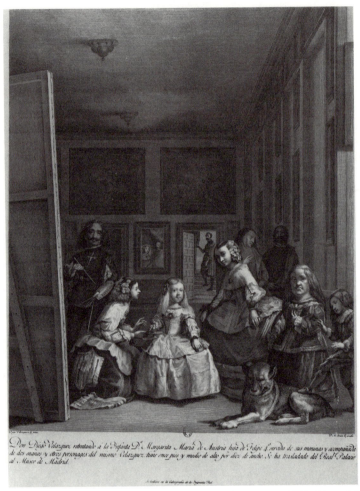

FIGURE 3. Pierre Audouin. *Las Meninas.* 1799. Etching. Paris, Bibliothèque Nationale.
© cliché Bibliothèque nationale de France.

publication, Pedro de Madrazo's *El Real Museo de Madrid, joyas de la pintura de España.*[66] Yet, even this author lamented print's inability to render surface texture, "forget the print and run to find the canvas in order to see that there is not the slightest exaggeration in what we say. The best drawn print cannot even give a distant notion of what the execution of ... *Las Meninas* is like."[67] Photography promised more authenticity through its apparently continuous tone, and its modest cost permitted wide dissemination. By 1863, Jean Laurent, a French

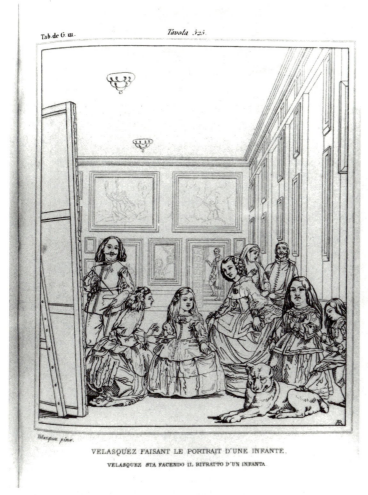

Tab.de G.III. Tavola 325.

VELASQUEZ FAISANT LE PORTRAIT D'UNE INFANTE.
VELASQUEZ STA FACENDO IL RITRATTO D'UN INFANTA

FIGURE 4. Réveil. *Las Meninas.* Ca. 1832. Engraving in Réveil et Duchesne, *Le Musée de Peinture et de Sculpture*, vol. 13 (Paris, 1832), no. 971. © cliché Bibliothèque d'art et d'archéologie Jacques Doucet–Paris.

photographer established in Madrid, mastered the difficulties in indoor exposure to reproduce master works in the royal museum. *Las Meninas* figures in his second catalog released in 1867, and the French text indicates that Laurent saw his biggest market as tourism and, possibly, scholarship.[68]

Copying in paints remained a popular practice among artists for studying techniques and gaining skills. Logically, young artists and

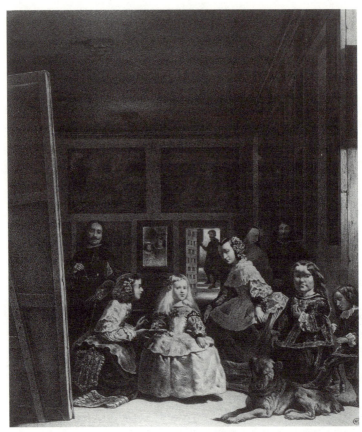

FIGURE 5. Célestin Nanteuil. *Las Meninas.* Ca. 1855–1859. Lithograph. Dijon, Musée des Beaux-Arts. © Musée des Beaux-Arts, Dijon, photograph François, JAY.

those with limited means shied away from large, multifigure composi-tions like *Las Meninas* and preferred Velázquez's single-figure portraits, philosophers, or dwarves. The amateur Mérimée made small watercol-ors after *Las Meninas* and other works by Velázquez, but these remained in a private album. Modern art histories emphasize the copies by rad-ical artists Edgar Degas and Édouard Manet after the Louvre's *Infanta Margarita,* the closest thing in France to *Las Meninas,* around 1859.[69] Yet, as early as 1841, the French state commissioned a painted copy of the Louvre's Velázquez,[70] as well as two painted copies of *Las Meninas* for the Musée des Copies (or Musée Européen) that opened briefly in 1873.[71] Copying the *Infanta Margarita* allowed artists to mimic what

many presumed that Velázquez depicted himself doing in *Las Meninas* –
portraying the princess – and perhaps to identify with the Spaniard's
social status and artistic freedom that they inferred from his great canvas.

The registers of copyists at the Prado that survive begin only in the
mid-1850s and are not complete, but they indicate the majority were
Spaniards until the later 1870s, when foreigners become more numer-
ous. One register from mid-1876 to mid-1878 shows most copyists
after Velázquez were Spaniards, but only two gave *Las Meninas* as their
subject.[72] This small number of painted copies after Velázquez's can-
vas was likely due to the special difficulties it presented. As Charles
Clément, no enemy of copying, declared in 1873, "Velázquez is the
most *uncopyable* (*incopiable*) of painters."[73]

Las Meninas was widely cited by artists in their depictions of
Velázquez, for this self-portrait came to be seen as his most authen-
tic image.[74] Although neither Degas nor Manet had seen the original
canvas, both referred to his self-portrait at work in their small, private
works: *Homage to Velázquez* (1857–1858, Munich) and *Spanish Stu-
dio Scene* (1859–1860, Paris Private Collection), respectively. Official
monuments to the artist in Spain from the 1890s reproduce the fa-
cial appearance and dress, and sometimes the pose, of the *Las Meninas*
self-portrayal,[75] so that publicly, the artist was linked to his masterpiece.

Typically, French painters whose art and words suggest a deep, abid-
ing interest in Velázquez's art visited the Prado – if they did at all –
as mature artists, often after having tried to incorporate the Spanish
artist's forms and technique into their own. Manet, for example, went
in 1865 after his *Olympia* was severely criticized; as Rosenthal noted,
he nearly abandoned Spanish subjects afterward and gradually ampli-
fied his limited, high-contrast palette.[76] Carolus-Duran went in 1866,
Courbet in 1868, and Degas in 1888, well after favorable reviewers and
modern scholars perceived references to Velázquez's palette and figural
poses in their works.[77] It may have been easier for a younger artist, or
one far from the "original," to imagine and reconfigure aspects of the
Spaniard's painting.

No artist, Spanish or French, seems to have created an indepen-
dent work that incorporates all of the visual problems and psycholog-
ical interplay – not to mention the stylistic and technical qualities –
of Velázquez's masterwork. A rare example of a French artist who
studied in the Spanish art academy, the young Léon Bonnat painted

a portrait of his own family[78] in 1853 that echoes several aspects of Velázquez's masterwork: semiobscure spaces, reduced palette, serious treatment of children, and hazy servant in the background. That same year, Bonnat's father died unexpectedly, and the absence of a patriarchal presence or mirror reflection may convey this loss. In Manet's *The Balcony* (1868–1869, Musée d'Orsay) and Degas' *The Bellelli Family* (1858–1867, Musée d'Orsay), the cramped spaces, conventional viewpoints, and disengaged figures convey very different impressions than does Velázquez's multifigure interior. Manet came closest to reimagining the compositional and psychological devices of *Las Meninas* in his *Bar at the Folies-Bergères* (1882–1883, Courtauld Institute), in which his busy palette and brushiness undermine naturalistic representation in a manner unthinkable for Velázquez's canvas.

The self-representation of the artist appearing to orchestrate the royal court in *Las Meninas* resonated among those who believed that artists occupied a privileged place in modern society. Such a place rested on Romantic myths of the modern artist as princely bohemian, misunderstood genius, or social visionary. Although some critics lavished attention on Velázquez's noble bearing, insignia, and mastery over the scene as an equal to royalty, others went to great lengths to separate him from the decadence of the court and make him marginal. The comparison between *Las Meninas* and Courbet's *The Artist's Studio* (1855, Musée d'Orsay)[79] seems tenuous in both formal and metaphorical terms; a stronger internal relationship can be found with his earlier *A Burial at Ornans* (1850–1851, Musée d'Orsay). Yet artists who devised original depictions of an artist in the studio more often borrowed secondary elements from *Las Meninas* rather than confront its major themes or devices.[80]

NAMING AND THE FEMININE

When José de Madrazo, director of the royal art museum and Royal Lithographic Establishment in Madrid, chose the pictures to be reproduced in the *Colección litográphica de cuadros del Rey de España* (1826–1832), *La Familia* was not included. This deluxe edition of lithographs announced its aim to disseminate knowledge and appreciation of the greatest pictures in the king's collection – that is, the art museum. Second only to Murillo among Spanish painters in the number of paintings

selected (eight to nine), Velázquez was represented by three male eques-
trian portraits, three male hunting portraits, *The Forge of Vulcan*, and
Saint Anthony and Saint Paul. This Spanish selection clearly presented
a royal, historical, and masculine view of his oeuvre that omitted *Las
Meninas*. In 1835, respected Spanish critic Eugenio de Ochoa judged the
Surrender of Breda, known as *Las Lanzas*, to be superior to *Las Meninas*,[81]
and French travelogs before 1850 often most admired *The Forge of Vul-
can* and *The Drinkers*.[82] Closer to midcentury, however, more liberal
writers and artists began to single out *Las Meninas* as Velázquez's chef-
d'oeuvre. Mostly conservative voices, like those trying to revive history
painting, considered *Las Lanzas* to be Velázquez's premier work.[83]

Velázquez's canvas had been cataloged prior to the nineteenth cen-
tury as *La Familia de Felipe IV* (*The Family of Philip IV*), or more
simply, *La Familia*. In 1843, *Las Meninas* became the official title when
it was printed in the revised catalog of the museum.[84] In this catalog,
Madrazo interpreted the scene as Velázquez painting the portrait of the
king and queen. Giordano's phrase "the theology of painting" was also
commonly used to refer to *Las Meninas* during the nineteenth century,
as were other monikers.[85] The new title's first French publication may
have been Mérimée's review of Stirling's book on Spanish painters in
1848.[86] More popular French writers and conservative critics, such as
Roger de Beauvoir and Edouard Laforge, continued to use *The Family
of Philip IV*.[87] For those unfamiliar with the Spanish language, Thoré
found an Old French masculine term *menins* that he claimed was an
equivalent for the feminine *meninas*.[88]

The change in titles is interesting because it shifts the focus from the
royal family and king to the women attendants. These female person-
ages were aristocrats, but not princesses, who attended to the needs
and desires of their royal charge. In the canvas, these female figures
are part of a larger group of court members of different ranks, and
they appear neither larger nor more active than the others near them.
Thus, their new attraction for the critics must have been based on other
criteria. Describing *Las Meninas* in 1864, A. Lavice thought that the in-
fanta appeared ugly, ridiculously dressed, and without interest, whereas
the figures of the maids of honor were lovely, simple, and graceful.[89]
One might see such titling and textual responses as part of the broader
European interest in images of contemporary women, or as a reflection
of shifting feminine ideals.

Indeed, even before Madrazo published the new title of *Las Meninas*, several publications, led by the French, interpreted the canvas as a depiction of the artist painting the portrait of Margarita rather than that of the royal couple.[90] Other French writers went further to feminize, domesticate, and even sexualize the image. In his anecdotal account, Roger de Beauvoir focused on the figure of the queen that he mistakenly believed represented French-born Isabelle de Bourbon; from there, he spun out stories about her amorous intrigues that are wholly irrevelant to the painted forms.[91] By locating a native and female subject, de Beauvoir familiarized and eroticized the picture for his French tourist–readers. In a passing mention of *Las Meninas*, Théophile Gautier expressed its convincing illusion in highly sexualized terms, "It is nature herself caught in the act (*en flagrant délit*) of realism."[92] Such erotic associations are rampant in Gautier's travel writing, in which he hunts for the elusive *manola*, or lower-class, flirtatious woman, as an example of authentic Spanish culture. Even a female writer like the countess de Gasparin first praised Velázquez's infanta for its pretty, fresh appearance, then described that of the kneeling *menina* as seductive, despite her irregular features.[93]

Some Spanish writers explicitly rejected sexuality in *Las Meninas* and Velázquez's art. In 1876, Francisco María Tubino praised Velázquez for having excluded all theatricality and academicism, including the "effeminate sensuality of neoclassicism,"[94] a style that Spaniards typically associated with France. Madrazo praised at length the beauty and freshness of the two *meninas*[95]; like the majority of Spanish critics, his descriptions remained more chaste than the French. In 1899, Pardo Bazán compared Velázquez's art to "the simplicity, sincerity, and majestic freshness" of that of the late Frenchwoman Rosa Bonheur, whose painting was praised as strong and virile.[96]

Conservative critics tended to present Velázquez's art as manly and heroic, focusing on works easily described as such: *The Surrender of Breda, The Forge of Vulcan, Los Borrachos*, and *The Equestrian Portrait of the Count–Duke of Olivares*. Their praise for *Las Meninas and Las Hilanderas*, still considered among the artist's masterpieces, generally revolved around qualities such as grace and class, as Juan Valera, who preferred *Los Borrachos* to *Las Meninas*, described the latter as a fine example of "aristocratic distinction, grace, and gallantry."[97] Efforts to make Velázquez and his art into examples of virility became even more

pointed in Spain after the 1898 debacle. The following year, a professor at the art academy of Valencia, Rafael Domenech distinguished
Velázquez's manly, energetic, and elitist art from Murillo's feminine,
popular one.[98]

However, can one limit a historical understanding of the feminization of Velázquez's canvas to aesthetics alone? Travel theorists studied
the ways in which travel has been associated with geographic as well
as sexual conquest.[99] To that end, a dominant culture feminizes the
"there" to suggest the other's weakness or desire to be dominated and
to justify whatever aggression was perpetrated. In *La Presse* of 1850,
the widely read Gautier created a feminized, sexualized metaphor for
Spanish art, that of a demure woman covering her naked body from a
penetrating gaze:

> Louis XIV's words, "The Pyrenees no longer exist" have never
> been true for Spain in terms of art. The Pyrenees, in spite of
> the Bourbon dynasty's installation beyond their crests, never
> lowered their snowy peaks, and raising an impenetrable cur
> tain, hid its peninsula from the eyes of Europe.[100]

Early in the century, both French and Spanish critics characterized
Spanish art, notably Velázquez's, by its virility and chivalry, but after the
French invasions and the Galerie Espagnole, only liberal French critics
began associating highly feminized or erotic qualities with Velázquez's
art and *Las Meninas* in particular. It may be that in resisting the feminization of Velázquez's painting, the later conservative Spanish critics
were trying to parry the influence of French opinion and claim the
Spanish character of Velázquez's masterpiece.

THE EXCEPTIONAL WORK: I. NATURALISM

Around 1789, Spanish author Jovellanos foresaw a new avenue for
interpretations of *Las Meninas*. He pointed out that no one had yet
analyzed the picture and its formal qualities, as writers had previously
concentrated on its subject matter. Judging *La Familia* "the best of
his works, or at least, the most distinguished," Jovellanos lauded the
painter's genius for representing spatial planes and combining colors
with great harmony. Then he stated, "it is said that he came to paint

what cannot be seen, what is seen better by the soul than with the eyes."[101] With those words, Jovellanos complicated the rational belief in seeing as knowing, and infused mystery and emotion into the visual experience of *Las Meninas*. More than a half century later, Charles Blanc, a widely read author on artistic practice, examined Velázquez's technique and several commonly held beliefs about it.[102] This discourse bore witness to the conflicted sight of Velázquez's picture: It looked perfectly real, but remained a mystery to most viewers, and its technical bravura appeared simple and modern, but proved nearly impossible to describe or reproduce.

The reputation and reception of *Las Meninas* profited especially from the dominant modes of naturalism in nineteenth-century art and literature. Naturalism and realism – words used interchangeably in the aesthetic discourse of the 1800s – were already closely associated with Spanish painting. For artists and writers striving to discover and manifest in their own works, greater fidelity and sincerity to reality (authenticity) and more consciousness of the viewer (through formal devices or presentation), Velázquez's picture was a paradigm of illusionism. Critics defined his naturalism in various ways and sometimes used other terms to describe its references to real life, yet all seemed to agree that the result was an unmediated and authentic vision of the Spanish past and painting. The artist's self-portrait bolstered the other signs of authenticity for nineteenth-century viewers, despite the suspiciously youthful image of the fifty-seven-year-old painter.

From the earliest texts of the 1800s, the quality of *Las Meninas* most widely recognized as extraordinary was its naturalism. Yet this naturalism retained a powerful mystery that tantalized Gautier:

> This artist is a fairy who instantaneously evokes every phantom's appearance, but with mysterious spells whose secret no one knows.... Velázquez...produces, one knows not how, an intangible and prodigious gradation of light...obtaining the most perfect modeling and most realistic relief.... Oh, the incomprehensibility![103]

After singling out Velázquez's best works as five profane pictures with a historical dimension – *The Drinkers, The Forge of Vulcan, The Surrender of Breda, Las Meninas,* and *Las Hilanderas* – French critic Louis Viardot

found *Las Meninas* to be the most realistic through its optical and sensual qualities:

> All these objects are palpable, all these creatures are living; the air plays between them, envelopes and penetrates them. Here is the true distancing of planes, space, and depth; here are light and all the optical phenomena in the gradation of tones. One can figure out the scale of the gallery; one lowers one's eyelids before the glowing light of the opened door; one sees these persons breathe and hears them speak.[104]

These critics related the picture's illusionism to contemporary artistic concerns so that it predicted modern art and consequently qualified as a work of genius. The protomodern aspects that they identified in Velázquez's canvas were unidealized study from nature; objective recording; optical phenomena such as light, differential focus, and atmospheric envelope; and untheatrical depiction of the past. What distinguished the illusionism in *Las Meninas* from that of other Spanish painting was its blurring of the boundaries between the subject and the object, the interpenetration of the vision of the painter with that of the spectator. Théophile Gautier succinctly expressed this quality in a question, "Where, then, is the picture?"[105] The French critic proposed that Velázquez had achieved a perfect illusionism, a legible transparency that cannot be fathomed:

> [Velázquez] seems to have invented painting and at the same time to have carried it to perfection. No veil, no intermediary between him and nature; the instrument itself is invisible, and his figures seem fixed in their frame by a magic operation.[106]

Gautier even reinterpreted Giordano's "theology," translated as "truth, dogma, orthodoxy," to mean that anyone who turned away from *Las Meninas*'s naturalism and atmospheric impression "was . . . a heretic of art."[107] In contrast, a conservative like Balsa de la Vega questioned whether naturalism could be a goal of great art; for him, the sense of life and the expression of moral character made *Las Meninas* a masterpiece.[108]

One common literary device for elucidating *Las Meninas*'s naturalism was comparison with mechanical reproduction and technology, such as drawing machines and photography. Opening the century, Ceán Bermúdez claimed that Velázquez used the camera obscura to

observe nature and create his "magic art of deceiving and surprising the spectator."[109] Quilliet followed Ceán in linking Velázquez's illusionism to the perceived objectivity of the camera obscura,[110] and Thoré did so specifically with *Las Meninas* in 1835.[111] After photography appeared publicly in 1839, analogies were made between Velázquez's painting and the new process, making the seventeenth-century artist seem all the more modern.[112] Just after discussing *Las Meninas*, the mid-century Spanish critic Agustín Bonnat discerned a difference between Velázquez's art and the new medium "copying the natural exactly as it is seen by the eyes of one's soul is to create [art] . . . there will always be the same distance between that and a servile copy, as between a picture by Velázquez and a photograph."[113] A late-century publication attributed to Ceferino Araujo Sánchez more aggressively denied such comparisons: "Those who believe that the aim of art is not the reproduction of nature, and they are right, will see the *ideal* in Velázquez's works the day that color photography is perfected."[114] Beulé, who was disappointed by *Las Meninas*, praised its perspective and naturalism but ultimately berated the painting for having

> all the merits and faults of photography; nature is traced there, but without charm. . . . Giordano . . . exclaimed, "Sire, this is the theology of painting." The moderns could say more simply, "This is the photography of painting."[115]

The metaphor of magic or sacred aura easily applied to such comparisons with new technology, as Balsa de la Vega wondered, "*Las Meninas* is, among other things, the miracle of a retina which challenges the most perfect camera lens that exists."[116] The tension between claims for the picture's optical, scientific truth and its emotional, magical opacity emerges in a passage by the novelist and art critic Jacinto Octavio Picón:

> In his time, it was customary to use black mirrors, reduction [mirrors], the camera obscura . . . , and other optical apparatuses, . . . accustoming himself to seeing as a whole, in totality, as . . . [in] *Las Meninas*. This is the indisputable superiority of Velázquez over all other painters. We don't know how he defined planes, how he figured distances, how he calculated gradations of tones according to the places they occupy; in a word, how he reasoned and explained with a brush the

distinguishing [effects] that are left on people and things by this invisible something that we breathe.[117]

THE EXCEPTIONAL WORK: II. NARRATIVE AND SILENCE

Another feature, or its lack, that made *Las Meninas* appear convincingly real was its subject. The unfavorable Beulé linked the picture's realism and resulting unattractiveness to its subject, whereas the Velázquez champion José Ramón Mélida found that the subject's very triviality showcased the painter's genius for "reproducing the truth, with all the intense power and expression with which [he] saw it, felt it, and knew how to represent it."[118] The perceived lack of a narrative in *Las Meninas* made for differing interpretations that basically divided into two camps. One reading was established in 1800 by art historian Ceán Bermúdez, who stated that Velázquez represented himself painting the portrait of the infanta. This meaning was given official support by being published in the first cataloges of the royal museum,[119] the widely read books by Viardot, and the progressive writings of Thoré.[120] In 1835, the other interpretation appeared in an article in the art journal *L'Artiste*, in which the author implies that the artist is depicted painting the portrait of the royal couple.[121] The revised Madrid museum catalog of 1843 and all later editions agreed with this second reading, and Gautier concurred in his travel article of 1847. As though compensating for this lack of a clear storyline, the postpainting *topos* regularly featured in descriptions and accompanying illustrations of *Las Meninas*, as seen in the engraving by Ortega (Fig. 6) from *Museo de las familias* of 1847, which borrows liberally from *Las Meninas* itself.

By the 1890s, Spanish and French art critics of all camps recognized that the contemporary art world had shifted its primary interest from the *What* to the *How*. Also, as Jovellanos predicted, the discourse on *Las Meninas* gradually focused on technical and aesthetic problems. For Mérimée, Velázquez meant to do something very different than relate a story, "[he] proposed to render all the effects of light that are possible in painting."[122] The writer then introduced each figure by its light effects, starting with Margarita, "of a dazzling whiteness," as though the depiction of light were the true subject of *Las Meninas*. More invested in academic hierarchies, Charles Blanc expected more from great art

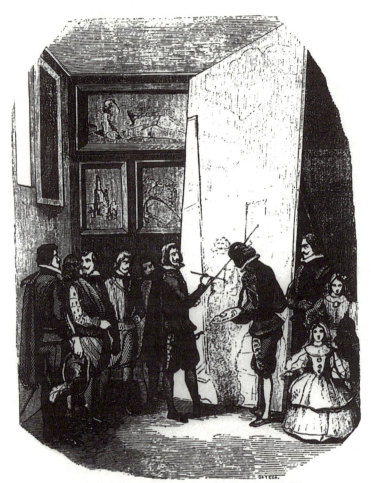

PINTA FELIPE IV LA CRUZ DE SANTIAGO EN EL RETRATO DE VELAZQUEZ.

FIGURE 6. Ortega. *King Philip IV Painting the Cross of Santiago on Las Meninas.* 1847. Engraving in *Museo de las familias* (1847).

than the reproduction of nature, "what Velázquez reproduces marvelously is the... external aspect of things that the eye sees and the hand touches. His work rarely speaks to the soul, never to the heart; it does not awaken feelings, but provokes sensations."[123] Also conservative, Mélida worried about all the praise lavished on the realistic exteriors, surface effects, and manual bravura of *Las Meninas*, and pointedly praised Velázquez's sensitive portrayal of the historic personages and especially their inner life.[124] However, such neutral, sensuous surfaces

developed from new artistic modes of Realism and Impressionism and appealed to less-informed viewers.

Even more conservative art critics, who otherwise complained about the contemporary emphasis on technique over content, realized that it was Velázquez's rejection of narrative or text that made *Las Meninas* so forward looking and unconventional. The greater visual emphasis on the dwarves and dog, rather than royalty, allowed those critics who championed genre painting and Realism to applaud the painter for his fidelity to nature and leveling of subject matter. Even an academic like Beruete came to champion art for art's sake in Velázquez's group portrait:

> *Las Meninas* moves us in a way absolutely independent of the subject that it represents. And as the different elements of this painting – lines, color, light, proportions, chiaroscuro, etc. – have no other purpose than art for art's sake, it follows that the attraction that it exercises over us has lost none of its intensity.[125]

One notable consequence of *Las Meninas'* powerful naturalism was the perceived futility of words to describe and interpret the picture. *L'Artiste* may have been the first to refer to speechlessness: "What one can't describe are the air, the shadows, the light, the depth, the relief."[126] Blanc believed that Velázquez's special "optic" left nothing for the critic to explain, "Close up, his painting is rough; at several feet, it is finished and perfect . . . He sketches, and everything is said."[127] This wordlessness before the picture obviously related to the perceived lack of narrative: the painting did not "speak," so neither could the critic. Of *Las Meninas*, Sentenach bluntly wrote, "All description and phrases are pointless."[128]

Nevertheless, it is difficult to argue that the picture's realism stifled voices, given the amount of ink spilled over it. Claims of muteness seem almost disingenuous. One might consider another meaning of silence, "to correct or confute," to understand how these critics were rendered (momentarily) speechless: The actual experience of the picture overturned their preconceptions of it. For the self-professed "simple tourist" Countess de Gasparin, this lack of words could be equated with the artist's pure vision. "For [Velázquez], to see was to express."[129]

LAS MENINAS AND MODERNITY

By the time of the modernization of the Prado and the creation of the Sala de Velázquez in 1899, most critics writing on his art considered it modern *avant la lettre*. This was especially true for his last style, which was exemplified by *Las Meninas*. In nineteenth-century publications, writers generally describe the artist's career as evolving through three different styles: an early linear mode seen in *Los Borrachos*; a second, more painterly style, as in *The Surrender of Breda*; and the last, highly painterly technique of *Las Meninas*.[130] This last style came to be called his "impressionism," a word that signified, to different degrees in Spain and France, contemporary and radical art.

Prior to the 1880s, most critics did not discuss Velázquez's influence on contemporary painting. Two instances were Fouquier's suggestion that Delacroix tried to emulate the magical light effects in *Las Meninas* and *Las Hilanderas* in his *Entry of the Crusaders into Constantinople* and his ceiling of Apollo,[131] and Blanc specifically compared Géricault's *Capitaine des guides* to Velázquez's equestrian Olivares, a painting that Blanc admired tremendously.[132] By the end of the century, Velázquez was being compared to some of the best-known radicals.

What made this shift possible was the way in which critics responded to the canvas's "ugly" aspects. No longer did the "unpleasant deformities" of the dwarves that Fernand Petit observed in 1877 disqualify *Las Meninas* as a masterpiece.[133] Avant-garde critic Ramón Casellas compared Velázquez's art to that of Degas and Whistler:

> The lovely and the ugly possess identical beauty when they are transformed in art by a painter like Velázquez. For this, the legacy of this great artist is today claimed with equal right, on the one hand by Degas, the cruel painter of modern deformities and miseries, and on the other by Whistler, the exquisite portraitist of contemporary aristocracy.[134]

Embracing a similar view held by sculptor Auguste Rodin, Casellas proclaimed that true art could transform an ugly or banal subject into beauty. Moreover, he implied that this was a more difficult accomplishment than treating a beautiful subject; thus, the mark of genius. It also supported the argument of art for art's sake by critics like Gautier, who declared by the mid-1830s that subject matter was inconsequential to art. Such views overthrew the hierarchy of genres maintained

by official art academies and conservative critics, but corresponded to the current art market trends.

The first writer to apply the term *impressionism* to Velázquez's painting was moderate French critic Paul Lefort, who wrote extensively on Spanish art. In 1888, he explained that Velázquez's late, summary mode (*manera abreviada*) resulted from the artist's recently increased workload, after being named the king's chamberlain. This loose technique that Lefort suggests allowed Velázquez to finish pictures more quickly "we call, for lack of a more precise term, *impressionism* . . . [of which] *Las Hilanderas, Las Meninas, the infanta Maria Teresa* . . . [are] the most perfect examples of impressionism that one can find, even in modern painting." However, if Lefort was "tempted to write that [Velázquez] already spoke the language of the painters of tomorrow," he judged the young French Impressionists to lag far behind the Spaniard. Lefort's appropriation of a rebellious term to modernize the old master soon impacted other writers. In 1895, cautious French critic Émile Michel agreed that Velázquez innovated, but "without posing as a revolutionary,"[135] but four years later, the Catalan Casellas, who disliked the handling of the Velázquez tercentenary in Madrid, adopted the term for an article, "El Impresionismo de Velázquez."[136] Casellas pronounced Velázquez's atmospheric illusionism "visionary, a prophecy," elevating the painter and *Las Meninas* into the sainthood of modern art.

Important critics agreed that Velázquez's treatment of light was the key to his modernity. Mélida considered the "motif of light" and the "so correct and admirable harmony of values" made *Las Meninas* the most modern painting in Velázquez's oeuvre.[137] This association of modern painting with an interest in and study of light made the renovation of the Velázquez Room and the special rehanging of *Las Meninas* so important. In his 1898 monograph, Spanish painter and critic Beruete recognized the modernity of *Las Meninas'* light effects, "The lighting in the picture was the real light that bathed the scene. . . . This innovation in the art of painting . . . is one of the motifs that today makes us consider Velázquez to be one of the greatest innovators."[138] Certainly, such attention to the artistic depiction of light, this time with a modern emphasis on optical, naturalistic effects, reflects the significant impact of French Impressionism. However, in returning to the analogy between *Las Meninas'* reputation with tourism and pilgrimage, one can hardly ignore the time-honored

symbolism of light as internal enlightenment and a subjective kind of vision.

It is evident that the Franco–Spanish discourse functioned as a means to control *Las Meninas* through knowledge and interpretation. Representatives of each culture aligned themselves with the "foreign" side when it served their interests, as in Beruete's case, publishing his monograph in Paris, in French, with a dedication to and frontispiece by his French friend Bonnat. As the stakes of speaking for Velázquez's painting rose, built on decades of study and mystification, the discourse in word and form accelerated to a kind of fever pitch in 1899. Those who study the numerous nineteenth-century texts and images concerning *Las Meninas* will appreciate the marvel of a defeated and disenfranchised Spain that prevailed in claiming Velázquez's canvas as its past and future.

NOTES

In my research for this essay, I owe many thanks to the capable staffs of the Biblioteca Nacional, Archivos del Museo del Prado, Instituto Diego Velázquez, and Biblioteca de la Real Academia de Bellas Artes de San Fernando, all in Madrid, as well as in the Bibliothèque Nationale, Archives Nationales, Archives des Musées Nationaux, Archives du Ministère des Affaires Étrangères, Documentation du Louvre et du Musée d'Orsay, all in Paris. I am especially grateful for the generosity of Jesusa Vega and Alexander Vergara in Madrid, and Christophe Léribault in Paris. A Junior Faculty Research Fellowship and teaching release from the University of Georgia supported my research. All translations are mine unless otherwise noted.

1 Various publications associated the artist and his fame with the group portrait, describing him as "the immortal" or "inimitable author of *Las Meninas*." For example, Comte L. Clément de Ris, *Le Musée Royal de Madrid* (Paris, 1859), p. 13, and Aureliano de Beruete, *Velazquez* (Paris, 1898), p. 362.

2 The most recent publications devoted to this subject are: *Varia Velazqueña*, 2 vols. (Madrid, Ministerio de Educación Nacional, 1960); *Velázquez, son temps, son influence* (Casa de Velázquez, Actes du Colloque, 1960; Paris, 1963); Ilse Hempel Lipschutz, *Spanish Painting and the French Romantics* (Cambridge, 1972); Arcadio Pardo, *La visión del arte español en los viajeros franceses del siglo XIX* (Valladolid, 1989); María de los Santos García Felguera, *Viajeros, eruditos y artistas: Los europeos ante la pintura española del Siglo de Oro* (Madrid, 1991); Suzanne L. Stratton, ed. *Spain, Espagne, Spanien: Foreign Artists Discover Spain 1800–1900*, exh. cat., New York, The Spanish Institute and the Equitable Gallery, 1993; Caroline Kesser, *Las Meninas von Velázquez: Eine Wirkungs- und Rezeptionsgeschichte* (Berlin, 1994); *Les peintres français et l'Espagne: de Delacroix à Manet*, exh. cat., Musée Goya, Castres, 1997; *Velázquez et la France: La découverte de Velázquez par les peintres français*, exh.

cat., Musée Goya, Castres, 1999. I am grateful to Jonathan Brown for informing me of the publication of Kesser's dissertation.

3 I first addressed these tropes in the scholarship in "Over the Pyrenees and Through the Looking-Glass: French Culture Reflected in Its Imagery of Spain," in Stratton, ed., 1993, pp. 10–31.

4 Rubén Darío, "La Fiesta de Velázquez," in *España Contemporánea* (Paris, 1901), pp. 172–3.

5 Any reception history of Velázquez's painting relies on José Ramón Mélida, "Bibliografía de Velázquez," *Revista de Archivos, Bibliotecas y Museos* 3; 5 (May 1899): 278–90, 3; 6 (June 1899): 335–50, 3; 8/ 9 (August–September 1899): 489–508, and, 3; 11/12 (November–December 1899): 679–83; Mélida, "Notas bibliográficas" *RABM* 3; 1 (January 1899): 50–3; and, Juan Antonio Gaya Nuño, *Bibliografía crítica y antológica de Velázquez* (Madrid, 1963). Kesser gives few Spanish examples.

6 Another intervention can be seen in the French government's rejection of the Hohenzollern candidate for constitutional Spanish monarch in 1870, which provoked Bismarck to send an offensive reply to Napoléon III and led to the Franco–Prussian War.

7 Théophile Gautier, "De Paris à Madrid," *Le Moniteur Universel* 268 (24 September 1864), wrote, "He who has not seen Madrid does not know [Velázquez] . . . [he] alone is worth the trip," blending references to low and high culture, a popular Spanish adage and Old Master art. In converting the Spanish proverb, *Quien no ha visto a Sevilla no ha visto a maravilla* ("He who has not seen Seville has not seen a wonder"), Gautier intimates that the Madrid museum and Velázquez were also wonders, thus magical destinations, and that witnessing them conferred special knowledge. Champfleury, *Grandes figures d'hier et d'aujourd'hui* (Paris, 1861; reprinted Geneva, 1968), p. 251, used similar syntax, "Qui n'a pas l'intelligence de Vélasquez ne saurait comprendre Courbet."

8 Dean MacCannell, *The Tourist: A New Theory of the Leisure Class* (Berkeley, 1999).

9 Daniel Sherman, *Worthy Monuments: Art Museums and the Politics of Culture in Nineteenth-Century France* (Cambridge, MA, 1989), pp. 140–3 and 190–1, comments briefly on how nineteenth-century French museums embodied the demand for and supply of authenticity. Studying fine art in person could satisfy both the positivist's belief in seeing as "knowing," as well as allowing for greater personal response in those who embraced the new "subjective" vision, as theorized by Jonathan Crary, *Techniques of the Observer: On Vision and Modernity in the Nineteenth Century* (Cambridge, MA, 1990). Numerous publications of first-hand accounts of works of art appeared, such as Eugène Fromentin's *Les Maîtres d'autrefois*, a study of Dutch and Flemish masters written in 1875.

10 See William M. Ivins, Jr., *Prints and Visual Communication* (Cambridge, MA, 1953), for his groundbreaking examination of print language. He was mistaken in believing that photography lacked syntax, especially in view of the various photographic processes and materials used during the 1800s.

11 Walter Benjamin, "The Work of Art in the Age of Mechanical Reproduction," in *Illuminations*, ed. Hannah Arendt and trans. Harry Zohn (New York, 1969),

pp. 217–51. For one discussion of the relationship between the concepts of "original" and "copy," see Rosalind Krauss, *The Originality of the Avant-Garde and Other Modernist Myths* (Cambridge, MA, 1985), pp. 151–94.
During the same period, the railroads emerged to make possible such experiences. French and British financial and technical teams helped to fabricate the Spanish railroad system, and it is no coincidence that these magnates often collected Old Master art and targeted their countrymen as potential customers.

12 Fernand Petit, *Notes sur l'Espagne artistique* (Lyon, 1877), p. 5. La condesa de Gasparin, *Paseo por España* (Valencia, 1875). P.L. Imbert, *L'Espagne: Splendeurs et misères, voyage artistique et pittoresque* (Paris, 1875).

13 Narciso Sentenach, "La nueva sala de Velázquez en el museo del Prado," *La Ilustración Española y Americana* 43; 28 (30 July 1899): 59: "en nuestro Museo del Prado . . . [à] las más deslumbradoras escuelas, la obra de Velázquez se imponga sobre todas ellas y obtenga más sin esfuerzos la victoria."

14 7 June 1899, n.p.

15 *Inventario del Real Palacio Nuevo de Madrid, 1794*, No. 14087, dormitorio; photocopy in the library of the Museo del Prado. The bedroom's occupant is unspecified, but may have been the Infanta María Luisa, and this might account for her interest in acquiring the sketch for the picture owned by Jovellanos, who mentions it on 28 October 1791. Jovellanos, *Obras de Gaspar Melchor de Jovellanos: Diarios (Memorias íntimas) 1790–1801* (Madrid, 1915), p. 55.

16 In the inventory of 1811, reprinted in Juan J. Luna, *Las pinturas y esculturas del Palacio Real de Madrid en 1811* (Madrid, 1993), p. 110, as *La Familia de Felipe 4o*.

17 Nicolás de la Cruz y Bahamonde, *Viage de España, Francia é Italia*, Vol. 11 (Cadiz, 1812), p. 25.

18 As noted by Louis Gonse, "Vélasquez," *Le Monde Moderne* 3; 55 (June 1896): 867.

19 Letters by José de Madrazo, first director of the art museum in Madrid, and his son and future director Federico de Madrazo indicate their study and admiration of Velázquez's art. José de Madrazo, *Epistolario* (Santander, 1998) and Federico de Madrazo, *Epistolario*, 2 vols. (Madrid, 1994).

20 F. Fernández Villabrille, "Glorias de España: Don Diego Velázquez de Silva," *Museo de las Familias* 5 (1847): 222: "above all, for those features characteristic of the country, for that truly Spanish arrogance of [its] figures, [the art of Velázquez] is the one that can best represent the term, national school."

21 Léon Bonnat, preface to Beruete, iii.

22 In the opinion of French art official Baron Taylor, these two artists had no masterpieces in the Madrid museum. Baron Isidore Taylor, *Voyage pittoresque en Espagne, en Portugal et sur la côte d'Afrique*, vol. 1 text (Paris, 1826 [sic, 1856], p. 111.

23 Téodor de Wyzewa and X. Perreau, *Les Grands peintres de l'Allemagne, de la France, de l'Espagne et de l'Angleterre*, vol. 6 (Paris, 1891), p. 62.

24 In his version, Charles Guellette, *Les Peintres espagnols* (Paris, 1863), p. 115, makes the painted cross express the king's delight with the picture. Several writers tried to correct this legend. Francisco R. de Uhagón compiled documentation to disprove it; "Diego Velázquez en la orden de Santiago," *Revista de Archivos, Bibliotecas y Museos* 3; 5 (May 1899): 257–71. In a modern parallel during the tercentennial

of 1899, the French painters Carolus-Duran and J.-P. Laurens, who paid homage to Velázquez in attending the ceremonies in Madrid, received the grand cross of the order of Isabel la Católica. The awards were noted in *Chronique des arts et de la curiosité* 24 (1 July 1899): 218.

25 William Stirling, *Velazquez et ses oeuvres*, trans. Gustave Brunet and annotated by William Bürger [alias Théophile Thoré] (Paris, 1865), p. 22.

26 [Charles-]E[rnest] Beulé, "Velázquez au musée de Madrid," *Revue des Deux Mondes* 31; 34 (1 July 1861): 178. The mirror reflection of the king and queen, or, more obliquely, of their painted portraits, implies that the viewer occupies the same spot that the royal couple did.

27 Beruete, p. 162: "Il n'y a point d'oeuvre de lui où la matière ait aussi bien porté l'artiste. Velazquez, peintre réaliste par tempérament et par éducation, se surpassa lui-même dans [*Las Meninas*], à tel point que celui qui considère avec attention ce tableau dans des conditions favorables d'éclairage et d'éloignement, croit assister à la scène qui y est représentée."

28 Clément de Ris, pp. v–vi, claimed having spent five to six hours daily in front of Velázquez's painting.

29 Imbert, p. 213. Around 1873 in Spain, he met the painter Alexandre Prevost, who illustrated this book.

30 For example, Frédéric Quilliet, *Dictionnaire des peintres espagnols* (Paris, 1816), p. 368, invented the term *gallo–espagnole* (Gallic–Spanish) to describe the school of Madrid in which he placed Velázquez, and compared the Spaniard to Charles Lebrun.

31 Henri Fouquier, *Études artistiques* (Marseille, 1859), p. 103. This was an extract of his "Vélasquez au Musée de Madrid," *Tribune Artistique et Littéraire du Midi* 3 (1859). Paul Lefort, "Le Musée du Prado: l'École Espagnole: 2ᵉ article," *Gazette des Beaux-Arts* 1 November 1894: 420, compared the same two portrayals of Margarita.

32 Prosper Mérimée, "Beaux-Arts: Musée de Madrid," *L'Artiste* 1;6 (March 1831): 73–4. Before Mérimée praised the qualities of Velázquez's art, he signaled some of his pictures, among them "the portraits of Charles IV and his family." Either he confused Goya's family portrait(s) with that/those by Velázquez, or Charles IV with Phillip IV. He may have been referring to *Las Meninas*.

33 Jeannine Baticle and Cristina Marinas, *La Galerie espagnole de Louis-Philippe au Louvre, 1838–1848* (Paris, 1981). See also the literary essay by José Cabanis, *Le Musée espagnol de Louis-Philippe: Goya* (Paris, 1985).

34 Étienne-Jean Delécluze, "Galerie Espagnole du Louvre," *Journal des Débats* 24 February 1838: n.p.

35 Lefort, 1894, p. 421, and Émile Michel, *Études sur l'histoire de l'art* (Paris, 1894), p. 122.

36 Gonse, p. 880.

37 Beulé, pp. 172 and 175.

38 This number depended on whether one included the three royal equestrian portraits mostly painted by Velázquez's assistants but with evidence of the master's retouching. This Spanish committee on Velázquez's oeuvre was a clear response to the increasing monographs and attributions by foreigners.

39 Mérimée, 1831, p. 73. Mérimée approved of this policy, because it made *his* visit more satisfactory and less disturbed by difference (lower classes and unserious viewers).

40 Clément de Ris, p. v. E. Beulé, *Causeries sur l'art*, 2ᵉ ed. (Paris, 1867), p. 258, confirmed Velázquez's stature as one of the greatest masters, "but this glory, the public can neither discuss nor confirm, because the material for judgment is not before their eyes."

41 Confirmed by the Spanish artist and historian Ceferino Araujo Sánchez, *Los museos de España* (Madrid, 1875), p. 13: "it's known that a museum is an establishment of as much learning and instruction as a cathedral or a library."

42 Gautier, "Voyage en Espagne," *Musée des Familles* 14 (January 1847), p. 104.

43 Fouquier, p. 1.

44 G.[regorio]C.[ruzada]V.[illaamil], "Variedades," *El Arte en España, Boletín* 3 (20 April 1862): 9. J.[osé] M.[aría] A.[sensio], "Velazquez y Murillo: Un monumento en proyecto," *La Ilustración Española y Americana* 16; 42 (8 November 1872): 663, reported that a monument to Velázquez and Murillo was discussed as early as 1851. Interest revived only in 1872, when conservative nationalism reappeared in the aftermath of the Republic, but even this did not lead to the monument's realization.

45 Ramón Balsa de la Vega, "Velázquez: Las Meninas," *La Ilustración Artística* 15; 757 (29 June 1896): 451.

46 R.B.[Ramón Balsa?], "Tercer Centenario de Velázquez," *La Correspondencia de España* 50 (7 June 1899).

47 Emilia Pardo Bazán, "La vida contemporánea: Velázquez," *La Ilustración Artística* 18; 912 (19 June 1899): 394.

48 R. Balsa de la Vega, "Velázquez *animalista*," *La Vida Literaria* 22 (8 June 1899): 364.

49 Alisa Luxenberg, "Regenerating Velázquez in Spain and France in the 1890s," *Boletín del Museo del Prado* 17; 35 (1999): 125–149.

50 It is interesting that, during the 1890s, the Louvre hung Velázquez's *Infanta Margarita* in its Salon Carré, according to Wyzewa and Perreau, p. 60.

51 This room had already undergone several transformations. See Pedro Moleón Gavilanes, *Proyectos y obras para el Museo del Prado: Fuentes documentales para su historia* (Madrid, 1996), p. 85. Moleón states that a connecting room was constructed in 1902 for the exhibition of *Las Meninas*, but many critics describe such a room in 1899. In Pedro de Madrazo, "Velázquez y sus obras," *El Siglo Pintoresco* 1 (May 1845): 27, an illustration depicts *Las Meninas* in a room with Spanish paintings. Madrazo's catalogues of the Prado were organized by school, not gallery.

52 "How satisfying will it be to sit before the picture of *Las Hilanderas, Las Lanzas*, or *Las Meninas*, your soul expanding in the presence of a sea of such peaceful and profound artistic emotions. Your soul feels well here; you will pass from a world full of conventions, affectations, and false impressions, to a whole other truth...." D. Rafael Domenech, *Velázquez, discurso leído en el Círculo de Bellas Artes de Valencia* 6 June 1899, published in *Revista Contemporánea* 115 (30 June 1899): 199.

53 Anonymous, "En el Museo del Prado: La sala de Velázquez," *El Liberal* 21; 7186 (6 June 1899): n.p.: "a summary and compendium of Velázquez's last and definitive style, [it] ought to be appreciated as an exceptional work and be exhibited in those natural conditions in which one can study it properly."

54 The pairing of Velázquez and Rembrandt in post-1840 criticism is not uncommon. Mérimée, "Annals of the Artists in Spain," *Revue des Deux Mondes* 15 November 1848: 643, opined that only Rembrandt's paintings could equal the skillful aerial perspective and the magical distribution of light of *Las Meninas*.

55 Sentenach, p. 61.

56 Anonymous, "El Centenario de Velázquez: La sala del museo," *El Imparcial* 6 June 1899. For J.R. Mélida, "El cuadro de Las Meninas," *Hispania* 9 (30 June 1899): 90, the new installation allowed even those familiar with the painting to appreciate more fully what Velázquez achieved, "what can't be seen." It is thoroughly in keeping with the desired effects of this visual–emotional experience that this room does not seem to have been photographed or illustrated, partly due to the difficulty of rendering such semiobscurity.

57 Anonymous, "Noticias Generales," *La Época* 27 December 1899.

58 Rodrigo Soriano, "El Centenario: Esperando Sentado (carta refundida de Velázquez)," *Los Lunes del Imparcial* 5 June 1899.

59 The Spanish prime minister Floridablanca did not realize his project to have engravings made of the principal works in the royal art collection, but some artists independently made some. See Jesusa Vega, "Goya's Etchings after Velázquez," *Print Quarterly* 12; 2 (1995): 145–63. For a larger study of reproductions of Velázquez's works in the 1800s, see *Velázquez en blanco y negro* (Madrid, 2000). I thank Jesusa Vega for alerting me to this recent publication. Juan Augustín Ceán Bermúdez, *Diccionario histórico de los más ilustres profesores de las bellas artes en España*, vol. 5 (Madrid, 1800), p. 172, noted that Goya made eighteen preliminary drawings after Velázquez's works, and he especially admired the one for *Las Meninas* (c. 1778–1779, now unlocated). In his 1848 monograph, the British scholar Stirling listed the prints that reproduced Velázquez's works, including more examples of Goya's etching after *Las Meninas* than were previously known.

60 Fred Licht, *Goya: The Origins of the Modern Temper in Art* (New York, 1979), pp. 7–82.

61 Janis Tomlinson, "Painters and Patrons at the Court of Madrid, 1701–1828," in *Painting in Spain in the Age of Enlightenment: Goya and his Contemporaries*, exh. cat., Indianapolis Museum of Art and The Spanish Institute, New York, 1997, p. 16.

62 The print was sold without the date and with a Spanish caption. The Cabinet des Estampes, Bibliothèque Nationale, Paris, possesses different states of the print. It seems that Audouin was hired by the *Compañía de estampas*, a privately funded enterprise that used the royal press in Madrid and engaged some foreign printmakers. In the 1700s, the Royal Academy of Fine Arts of San Fernando sent its most promising printmaking students to Paris to study, and José de Madrazo hired French printmakers to design pictures in the new medium of lithography for the royal lithographic establishment in Madrid.

63 Théophile Thoré, "Études sur la peinture espagnole: Deuxième partie," *Revue de Paris* 21 (October 1835): 57.

64 Achille Réveil and Jean Duchesne, *Musée de peinture et de sculpture*, vol. 13 (Paris, 1832), no. 971.

65 The verb "taking" predicts its application to photography and the notion that the image is "captured" and stabilized, with little or no human intervention or interpretation.

66 Although some sources give the publication date as c. 1855, I could only locate a later one, *El Real Museo de Madrid: Las joyas de la pintura en España* (Madrid, 1859). The publication may have been conceived for sale during the run of the Exposition Universelle in Paris in 1855.

67 Pedro de Madrazo, *Joyas del arte en España: Cuadros antiguas del museo de Madrid* (Madrid, 1878), p. 45. This was a deluxe folio edition with an added preface.

68 J. Laurent, *Catalogue des principaux tableaux des musées d'Espagne* (Madrid, 1867), p. 3, no. 30. The rationale behind Laurent's ordering and numbering of pictures is unclear; it is not chronological or based on subject, size, or significance.

69 Fouquier, p. 103. Twentieth-century scholars' statements that Velázquez's portrait of Margarita in the Louvre became very popular during the 1850s seem exaggerated; see *Registre de Copistes: Écoles Italienne et Espagnole, 1851–1859*, Archives des Musées Nationaux, *LL 26.

70 Commission for a life-size copy to Amédée Faure, 9 August 1841, paid 350 francs for the Standish Family, probably in thanks for their donation of Spanish paintings to the Galerie Espagnole; Livre de commandes: Peinture: 1833–1848, Archives des Musées Nationaux, *2DD5, f. 120. Leleux received a State commission for a copy after Velázquez on 20 January 1846; ANP F/21/42/A. José de Madrazo explained that Leleux instead chose a Murillo, because Velázquez's "history" pictures were "more complicated" and would take longer to copy. Madrazo, Letter to his son Federico, 10 August 1846, Madrid, in J. de Madrazo, p. 510.

71 Alexandre Prévost was commissioned on 14 November 1871 for a life-sized copy of *La famille de Philippe IV* at 8,000 francs. See Prévost's dossier, Archives Nationales, Paris, F/21/248. Prior to this, Prévost had made a smaller picture (1.41 × 1.20 cm) that Duro notes as having been acquired by the State and exhibited at the Musée des copies. Paul Duro, "Le Musée des copies de Charles Blanc à l'aube de la IIIᵉ République," *Société de l'Histoire de l'Art Français* (1985): 305, no. 144.

72 Pablo Pardo registered for "a figure (Meninas)" (28 × 29 cm) on 4 July 1876; Manuel Arrozo, Las Meninas (80 × 60 cm) on 2 August 1876, and signed out on 16 December. Libro de registro de los senores copiantes, 1873–1880; Archivo del Prado, L-34. The most copied works by Velázquez were: *The Drinkers, Forge of Vulcan*, the portraits of Phillip IV, prince Balthasar Carlos, and the dwarfs, *Menippus* and, to a lesser extent, *Aesop, The Crucifixion*, and, as one moves further in time, *Las Hilanderas*.

73 Charles Clément, "Variétés: Le Musée européen," *Journal des Débats* 25 April 1873.

74 Stated by Stirling, cited in Gerard W. Smith, *Painting Spanish and French* (London, 1884), p. 47 and repeated by Gregorio Cruzada Villaamil, *Velázquez: Anales de su vida y obras* (Madrid, 1885), p. 227. Bonnat etched the bust portion for the frontispiece to Aureliano de Beruete's monograph of 1898, in which Beruete,

p. 167, analyzed the self-portrait in *Las Meninas* as the most authentic. Numerous "citations" of the self-portrait from *Las Meninas* appear in illustrations to articles on the painter.

75 The full-length statues by Susillo (1891, Plaza del Duque, Sevilla), García (1893, Museo Arqueológico, Madrid), and even Marinas (1899, Museo del Prado). See illustrations and brief comments by Luis Bermejo, "Estatuas á Velázquez," *Blanco y Negro* (Madrid) 9; 423 (10 June 1899).

76 Léon Rosenthal, "Manet et l'Espagne," *Gazette des Beaux-Arts* September–October 1925: 203–14.

77 I am publishing evidence of Courbet's trip in an article to appear in *The Burlington Magazine*.

78 Reproduced in Luxenberg, "Léon Bonnat (1833–1922)," Ph.D. dissertation, Institute of Fine Arts, New York University, 1991, Fig. 16.

79 Most recently made by James Rubin, *Courbet* (London, 1997), pp. 41–2, 152.

80 Manet used the motifs of courtly dress and a backlit figure in his *Spanish Studio Scene* and *Spanish Cavaliers* (1859–1860, Lyon, Musée des Beaux-Arts), while Degas, in his *Homage to Velázquez*, focused on the act of painting rather than visual and psychological relationships between the depiction and the viewer.

81 E.[ugenio de] O.[choa], "Don Diego de Velázquez," *Semanario Pintoresco Española* 26 February 1837: 70, extract from *El Artista* 1 (1835).

82 For example, Manuel de Cuendias and V. de Féréal, *L'Espagne pittoresque, artistique et monumentale, Moeurs, usages et costumes* (Paris, 1848), pp. 187–8.

83 When the Calcografiá Nacional held a competition in 1870 for the best print after a work in the newly nationalized Prado museum, few artists entered. The winner, Bartolomé Maura, reproduced *Las Lanzas*.

84 Pedro de Madrazo, *Catálogo de los cuadros del real museo de pintura y escultura* (Madrid, 1843), p. 34, no. 155. In later additions, Madrazo added, "formerly known as *La Familia*."

85 Anonymous, "Galería de pinturas: Escuela española," *Semanario Pintoresco Español* 8 (18 June 1843): 193, called it *Estudio de Velázquez*. Eugène Poitou, *Voyage en Espagne* (Tours, 1869), p. 392, called it *Les Infantes*.

86 Mérimée, 1848. Occasionally, French writers offered translations other than *Les Ménines*. Fouquier, p. 103, came up with *Les Suivantes*; Guellette, p. 115, with *les Filles d'honneur*; and, Manet, Letter to Fantin-Latour, 3 September 1865, Madrid, cited in Juliet Wilson Bareau, *Édouard Manet: Voyage en Espagne* (Paris, 1988), p. 55, strayed farther with *les nains*, the dwarfs.

87 Edouard Laforge, *Des Arts et des artistes en Espagne jusqu'à la fin du dix-huitième siècle* (Lyon, 1859), p. 194. His book used the old typeface with an f-like shape for the letter "s," and he dedicated it to the Spanish queen. Roger de Beauvoir, *La Porte du Soleil* vol. 1 (Paris, 1844), pp. 246 fn. 1 and 256.

88 Stirling, trans. Brunet and ann. Bürger, p. 255.

89 A. Lavice, *Revue des Musées d'Espagne: catalogue raisonné* (Paris, 1864), pp. 191–2.

90 Louis Viardot, in *Galerie Aguado: choix des principaux tableaux* (Paris, 1839), p. 6. In his trilingual publication *Joyas de la pintura*, Madrazo gave a descriptive title, *Velázquez Painting the Portrait of the Princess*, perhaps to attract French readers through the connection to the Louvre's portrait of Margarita.

91 de Beauvoir, pp. 256–7. He was one of the rare travel writers to discuss contemporary art in Spain.

92 Théophile Gautier, "Une Esquisse de Velázquez," *Le Moniteur* 2 January 1862, reprinted in *Notice de Vélasquez première pensée du célèbre tableau la Rendition de Breda* (Paris, 1872), p. 14. It is interesting that this comment appears in an article devoted to a supposed sketch for the *Surrender of Breda*, a history painting of a military conflict and, therefore, considered a highly masculine subject.

93 Gasparin, pp. 206–7. The countess considered *Los Borrachos* to be Velázquez's master work.

94 Francisco María Tubino, "Luis Morales, llamado el divino y Diego Velázquez de Silva: el idealismo y el naturalismo en el arte pictórico español," *Museo Español de Antigüedades* 7 (1876): 100, 108.

95 P. de Madrazo, *Joyas*, 1878, p. 45.

96 E. Pardo Bazán, "De Europa," *La Ilustración Artística* 18; 914 (3 July 1899): 426.

97 Juan Valera, "Velázquez y su tercer Centenario," *La Ilustración Española y Americana* 43; 21 (6 June 1899): 350.

98 Domenech, p. 199.

99 For example, Cleo McNelly, "Nature, women and Claude Lévi-Strauss," *Massachusetts Review* 16 (1975): 7–29.

100 Gautier, "Musée Espagnol," *La Presse* 27 August 1850.

101 Gaspar Melchor de Jovellanos, "Reflexiones y conjeturas sobre el boceto original del cuadro llamado La Familia," 14 December 1789, in *Jovellanos: Obras en prosa*, ed. by José Caso González (Madrid, 1969), pp. 194–205.

102 Charles Blanc, "Vélasquez à Madrid," *Gazette des Beaux-Arts* 1 July 1863: 67. Blanc maintained that Velázquez did not use a loaded brush or a greatly varied palette; gray was the basis of his coloring; his blacks were never pure, mat, cold, or heavy, but instead light and transparent, while his whites were ecru.

103 William Bürger [Thoré], *Trésors d'art exposés à Manchester* (Paris, 1857), p. 116.

104 Louis Viardot, *Les Musées d'Espagne, d'Angleterre et de Belgique, guide et mémento de l'artiste et du voyageur* (Paris, 1843), p. 152.

105 Théophile Gautier, in W. Bürger et al., *Les Dieux et les demi-dieux de la peinture* (Paris, 1864), p. 279.

106 Gautier, "De Paris à Madrid." Gautier's second Spanish travel account (his first appeared in 1843 with great success) may have been stimulated by the exhibition of paintings attributed to and copied after Velázquez in the Parisian gallery of Louis Martinet during the late fall of 1863.

107 Gautier, in Bürger et al., p. 279. In 1819, J. A. Ceán Bermúdez, *Diálogo sobre el arte de la pintura* (Sevilla, 1819), p. 19, conflated remarks made by Nicolás de Azara and Anton Rafael Mengs in the later 1700s so that *Las Meninas* was described as one of Velázquez's pictures "painted not with brushes, but rather, by [his] will."

108 Balsa de la Vega, 1896, p. 451.

109 Ceán Bermúdez, 1800, vol. 5, p. 175.

110 Quilliet, p. 379.

111 Bürger, 1835, p. 57: "on dirait une scène réelle retracée par une chambre noire avec toute son illusion."

112 In his 1848 publication, William Stirling compared *Las Meninas* to Daguerre's invention, and Mérimée reiterated this comparison in his book review of the same year.

113 Agustín Bonnat, "Retrato de Doña Juana de Pacheco, mujer de Velázquez," *Semanario Pintoresco Español* 24 August 1856: 267.

114 Attributed to Ceferino Araujo Sánchez, *Biblioteca Popular de Arte: Los grandes artistas: Pintores españoles II* (Madrid, s.d. [c. 1897]), p. 19.

115 Beulé, 1861, p. 178.

116 Balsa de la Vega, *Ilustración Artística*, 1899, p. 371

117 Jacinto Octavio Picón, "Plutarco del Pueblo: Velázquez," *El Liberal* 16; 5329 (7 May 1894).

118 José Ramón Mélida, "El Arte de Velázquez," *Album-Sálon* 1899: 133.

119 Attributed to Luís Eusebi, *Catálogo de los cuadros de escuela española que existen en el real museo del Prado* (Madrid, 1819), p. 9, no. 114; *Catálogo de los cuadros que existen colocados en el real museo del Prado* (Madrid, 1821), p. 9, no. 106; *Catálogo de los cuadros que existen colocados en el real museo de pinturas del Prado* (Madrid, 1824), p. 13, no. 106; and, *Notice des tableaux exposés jusqu'à présent dans la galerie du Musée du Roi* (Madrid, 1828), pp. 26–7, no. 106.

120 Bürger, 1857, p. 117.

121 René, "Peintres espagnols: Don Diego Velazquez de Silva," *L'Artiste* 9; 20 (1835): 232: "[Velázquez] is facing a large canvas that the spectators cannot see but whose subject is repeated in the mirror placed at the back of the gallery."

122 Mérimée, 1848.

123 Blanc, pp. 70–1.

124 Mélida, *Album-Sálon*, p. 134.

125 Beruete, p. 162.

126 René, p. 232.

127 Blanc, p. 72.

128 Sentenach, p. 61.

129 Gasparin, p. 201. On page 4, she calls herself a simple tourist seeking agreeable sensations and attractive novelties.

130 An exception is Clément de Ris, p. 23, who attested, "The canvases [by Velázquez] of 1624 are absolutely the same as those of 1659." Such a statement is better understood in light of this author's great reluctance to call Velázquez a "realist" because the Louvre official did not want to associate the Spanish painter with the the vulgar connotations the term had acquired at the time.

131 Fouquier, pp. 103–4.

132 Charles Blanc et al., *Histoire des peintres de toutes les écoles: École espagnole* (Paris, 1869), p. 9.

133 Petit, p. 29.

134 Ramón Casellas, "El Impresionismo de Velázquez," *Hispania* 7 (30 May 1899): 54. Casellas' other article, "L'Espanya de Velázquez," *La Veu de Catalunya* 1; 161 (11 June 1899) exemplifies some of the tensions between Catalan and Castilian commentators in the discourse on Velázquez, an issue that I treated in my article in the *Boletín del Museo del Prado*, 1999. I am grateful to Annibale Biglieri of the University of Kentucky, Lexington, for his Spanish translation of the Catalan.

135 Michel, pp. 143 and 144.

136 Casellas, "El Impresionismo," pp. 51–4. The Barcelona illustrated periodical *La Ilustración Artística* also used the term *impresionista* to characterize the artist's late style.

137 Mélida, *Hispania*, p. 90.

138 Beruete, p. 157.

A MASTERPIECE IN WAITING

The Response to *Las Meninas* in Nineteenth-Century Britain[1]

It has long been acknowledged that it took the breaking up of Spanish collections and their dispersal across Europe during the Spanish War of Independence (1808–1813), and the opening in 1819 of the Prado Museum, with its display of some of the royal picture collection to make Velázquez's work more widely known. Yet even before the royal palace's treasures were transferred to the Prado, an English traveler in Spain at the height of the War, William Joseph Bankes (1786–1855), was negotiating for the purchase of the next best thing to *Las Meninas*, a copy possibly by Velázquez's son-in-law, Mazo (1612/15–67)[2] (Fig. 7).

Bankes had traveled to Spain in 1812 following in the footsteps of his friend the poet Byron, whom he had first met as a Cambridge undergraduate in 1804, both sharing a preference for the itinerant gypsy life. From Spain he continued his travels to the Middle East, finally returning to England (via Italy) in April 1820 to be lionized by London society as the great Middle Eastern explorer, one of the first to "discover" Petra. He devoted the next decades to remodeling the house of Kingston Lacy in Dorset, deep in England's West Country, which he inherited from his father in 1834. There he created a gilt-leather lined room to hang his Spanish art collection, devotional paintings by or attributed to Murillo, Ribalta, and Zurbarán, and Velázquez's portrait of *Cardinal Camillo Massimi* from Rome. For Bankes, believing his *Las Meninas* to be Velázquez's original sketch, it was "the glory" of his collection and "would be the finest in England tho not a finished picture." In a letter back to his father in October 1814 he had commented on

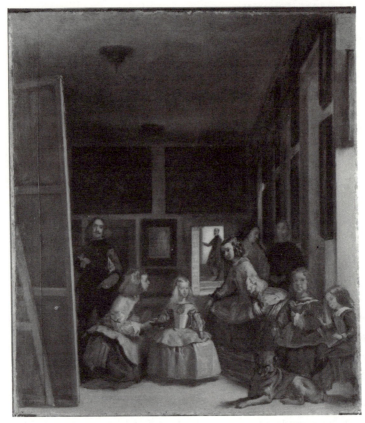

FIGURE 7. Juan Bautista Martínez del Mazo, *Copy after Velázquez's Las Meninas*. Kingston Lacy, The Bankes Collection (The National Trust). Photo. Photographic Survey of Private Collections, Courtauld Institute of Art, London.

how he had been "a long while in treaty for it and was obliged at last to give a high price."[3]

The copy seems originally to have belonged to the leading non-royal Spanish collector and patron of Velázquez, Don Gaspar de Haro, Marqués del Carpio, and first was mentioned in a *Memoria* of Carpio's collection drawn up in 1677 of the paintings remaining in Madrid when he left for Italy on 15 June 1677. As Enriqueta Harris has pointed out, the Carpio copy attributed to Velázquez's son-in-law and workshop assistant Mazo, who died in 1667, is the only copy of *Las Meninas* recorded in a seventeenth-century inventory.[4] The only such painted copy recorded in the eighteenth century belonged to the liberal lawyer

and statesman Gaspar Melchor de Jovellanos (1744–1811) who had
prized it as being from Velázquez's own hand and who had written
in praise of the oil sketch in 1789. His lack of discernment regarding
the copy is perhaps not surprising because despite being minister to
Charles IV, he stated that he had only seen the original a couple of
times and even then only in passing ("muy de paso").[5] Bankes almost
certainly did not know that the original was still, at the time, in the
Madrid Royal Palace, and accepted the belief of its previous owners,
the heirs of Jovellanos, that it was Velázquez's original oil sketch for
the finished painting. Its smaller size (140 × 123.8 cm) and slight differ-
ences in detail from the original, such as fewer colors on the painter's
palette and the slightly shorter stature of the Infanta, would have con-
firmed Bankes in this view. None of the copy's facial features are as
well defined as in the original; they are all more vague and sketchier,
the fuzzy, blurred handling closer to Mazo's brushwork as seen in his
portrait of *The Artist's Family* (1664–1665). However, the "copy's" main
and crucial omission is that the mirror on the back wall is blank, no
longer reflecting the images of Philip IV and his Queen.[6]

Although Bankes's copy had probably been sent back to England
in 1815, it spent most of the time thereafter in inaccessible Dorset,
well away from the London metropolis and other cosmopolitan West
Country centers.[7] Only once was it publicly exhibited in London dur-
ing Bankes's lifetime, at the British Institution in 1823. Furthermore,
from September 1841 Bankes' homosexual behavior forced him to lead
a life of exile in Italy, from where he masterminded the redecoration
of his house vicariously through his sister. In 1823, it was exhibited as
an "original sketch of Velásquez's great picture" of the Infanta and her
attendants with no mention of Velázquez's self-portrait and as the sole
representative of his work. On its own, it did not seem to have made
much of an impact, although it might have been seen by the Scottish
genre painter David Wilkie, who was a firm supporter of the British
Institution's exhibitions. Velázquez's public arrival on the cultural scene
in Britain had to wait until the 1828 British Institution summer exhibi-
tion with its display of the Duke of Wellington's *Waterseller*, along with
several other Spanish paintings, but not Kingston Lacy's.[8] By the time
of its later appearances in London, at the British Institution in 1864 and
at the Royal Academy in 1870 and 1902, its status as an original would
have been thrown into doubt by William Stirling's suggestion in 1855

that it might be a "small repetition," and his posthumous confirmation of it as a "fine repetition" in 1891.[9] As Sanchez Cantón commented, from then on it became a picture without a literature, and it was not until its recent technical analysis instigated by Enriqueta Harris that it was revealed and published in 1990 as a likely copy by Mazo.[10]

The early nineteenth-century was not a fertile seedbed for admiration of Velázquez to grow, despite the explicitly admiring comments about *Las Meninas* made by the liberal Irish diplomat Michael Quin in 1822–1823, who had found it, with the exception of Raphael's *La Perla* at the Escorial, "the finest production of the pencils which I have seen," preferring it to his earlier works. When *Las Meninas* was revealed to the artistic world with the opening of the Prado in 1819, the preeminent brush in British portraiture was that of Sir Thomas Lawrence. His assertive voice was dismissive of Velázquez's work. In 1810, he commented, in a letter of advice to a gentleman wishing to build up an art collection, on two newly imported paintings attributed to the artist. He had "liked neither, and am more and more convinced that Spanish art will disappoint us," believing that he had already seen the best that Spanish art could offer. He preferred the works of Rubens, Titian, Correggio, and Raphael.[11]

Unlike Lawrence, David Wilkie, the first British artist to visit the newly established Prado, was much more predisposed towards Velázquez's work, admiringly comparing his portraits and technique to those of Wilkie's Scottish compatriot Raeburn. He had traveled to Spain specifically in search of Velázquez's works for his friend and future prime minister Sir Robert Peel (1788–1850), and while there had enabled the banker/collector Samuel Rogers (1763–1855) to acquire the copy of *Baltasar Carlos in the Riding School* (Wallace Collection, London).[12] However, his own comments and the observations of others suggest that, despite being a court artist himself, his background as a genre painter influenced his own preference for Velázquez's more anecdotal genre-like paintings. According to Louis Viardot, Wilkie would spend three or four hours a day in front of the Prado's *Drunkards*.[13] Wilkie himself claimed to be most impressed by one of Velázquez's portraits of an Infanta in court dress (which he may have copied) and one of his dwarves and (according to William Stirling) by his *Sts. Anthony Abbot and Paul the Hermit*.[14] Wilkie's rare mention of *The Family of Philip IV*, as it was then officially called (although Wilkie's

alternative description of it was the "picture of children in grotesque dresses in his painting room"), was to recall the dazzling effect of its sparkling handling. Overall, it was "a surprising piece of handling... [which] would gain from glazes."[15] Although he was willing to praise Velázquez's originality, daring, and boldness, admitting in a letter to Lawrence, when comparing Velázquez and Murillo, that Velázquez "had more intellect... and more to captivate the artist," he criticized the painting's cool tonality and lack of glazed "finish."[16] He preferred Murillo's soft, warm colors, which were closer to his favorite artist Correggio. All of which suggests that although Wilkie had the chance to look at the picture more closely than anyone of his artistic generation, he probably did not study *Las Meninas* that intently. It is significant that the faint reminiscence of *Las Meninas* found in the trio of young girl and fussing helpers in Wilkie's *The First Ear-ring* of 1834–1835 (Tate, Britain) reflects only its foreground details and gestures.[17] Wilkie does not seem to have been interested in the painting's spatial complexity, nor of it as a self-portrait of an artist in action, let alone a court artist in action. Although Wilkie was appointed portrait painter to both King William IV and later Queen Victoria, he was never entirely happy with this role, which perhaps explains his preference for the characterization of the drunkards, dwarves, and hermits over the court group portrait.[18]

The decades after Wilkie's seven-month visit saw a compulsive curiosity about anything Spanish on both sides of the English Channel, an interest partly stimulated in Britain by the greater British involvement in Spanish politics after the War of Independence (1808–1813), during which some 40,000 British soldiers died on Spanish soil, and the subsequent influx of liberal political exiles fleeing Ferdinand VII's dictatorial rule. However, it had also been sparked off by a growing artistic curiosity about the country itself, aroused by the surge of imports of Spanish paintings released onto the market by war and the suppression of Spain's religious houses in the 1830s. All of this created a market for Spanish views, travel literature, and historiography that culminated in the publication in 1848 of William Stirling's *Annals of the Artists of Spain*. In 1832, both writer Richard Ford (1796–1858) and artist John Frederick Lewis (1805–1876) were touring Spain. The first was in the middle of his three-year stay in Spain gathering material for his future influential guidebook, *Handbook for Travelers in Spain* (1845); the second was painting watercolors to illustrate the increasingly popular

travel annuals with landscapes and scenes of popular life and customs. Lewis began his trip by copying sixty-four of the Old Masters from the Prado's collection and was particularly entranced by Velázquez.[19] The Royal Scottish Academy purchased the copies, including one of *Las Meninas*, from Lewis in 1853. Their collection of Old Master copies was heavily used as a teaching aid, and from the mid-1850s had a high profile among Scottish artists, including perhaps John Phillip, who painted his own copy in oils some five years later.[20]

Ford too was especially enthusiastic about Velázquez, as his publications and letters show. His *Handbook*, used as a guide to Spain's arts, antiquities, legends, literature, and gastronomy (to paraphrase its extended title), was especially important in spreading his appreciation. It went through many editions and remained the guide to Spain used by travelers, whether they were artists or collectors, diplomats or "tourists," throughout the second half of the nineteenth century. Lord Leighton was still citing it when, as President of the Royal Academy, he gave his discourse on Spanish art in 1889.[21] Although in his *Handbook* Ford admired the visual effect of *Las Meninas*, calling it "a masterpiece in local colour and in aerial and linear perspective," his description of the actual composition (in the fourth edition, 1869), was couched in rather dismissive, even pejorative terms, mocking the "dull Infanta... with her child-like uninteresting countenance." Instead, the work he recommended as "perhaps the finest picture by Velázquez" was the *Surrender at Breda*, "never were knights, soldiers, or national character better painted." Ford believed that the Spanish artist was emphatically a male portraitist, and like Wilkie before him, he considered that female beauty and infant grace was better depicted by Murillo.[22]

Ford initiated his advocacy of Velázquez with his anonymous entry on the artist in the *Penny Cyclopaedia* (1843), another reference work with an intended wide readership. His entry consisted of a succinct biography relying on Spanish authors such as Palomino and Ceán, followed by an appreciative, lively, and perceptive analysis of Velázquez's technique and style that anticipated various themes developed in later nineteenth-century literature. However, apart from the brief mention in the biographical section of the king's addition to Velázquez's self-portrait of his knighthood, there is no overt mention of *Las Meninas* at all in the entire three-page entry. One is left to infer from

his enthusiastic commentary that he had the painting in mind when he wrote of the mirror-like spaces of Velázquez's paintings.[23] It was a lively journalistic piece that stressed how one could understand Velázquez only by going to Madrid, a belief that may have spurred the visits of several later British artists and curators. The *Handbook* and its companion, *Gatherings from Spain* (1846), were the last major books Ford published, but he continued to write articles, reviews, and letters to the press commenting on Spanish art and culture until his death.

Ford only had to wait a few years for his potted biography to be expanded by his hispanophile young friend William Stirling (1818–1878). Stirling published his pioneering three-volume *Annals of the Artists of Spain* in 1848 at the age of thirty, to be followed in 1855 by a 265-page book devoted to *Velázquez and His Works*. His final words on the artist appearing in his *Catalogue of Prints after Velázquez and Murillo* (100 copies of which were published in 1873), and posthumously in the revised and extended version of the *Annals* in 1891. William Stirling (later, Sir William Stirling Maxwell on inheriting the Maxwell baronetcy and his maternal uncle's estates at Keir in Perthshire in 1865) was a prominent Scottish landowner and politician whose considerable wealth from farming and mining rights funded youthful tours abroad.[24] It was on the way to and from Egypt and the eastern Mediterranean, in the footsteps of the poet Byron, whom he greatly admired, that he first visited Spain in November 1841 and in 1842. During the two-month stay involved in the second of these visits, Stirling became seriously interested in Spanish history and culture. In 1845 he returned, Ford's *Handbook* in hand, for a further tour of ten weeks, already intent on writing the *Annals*, his comprehensive study of Spanish arts and crafts that was to cover embroiderers and silversmiths as well as architects and sculptors. This was to be arranged around the royal patronage of artists from the sixteenth century to the end of the eighteenth century and informed by contemporary documents and anecdotes. Stirling approached his task from the perspective of a historian and bibliophile. Above all, he favored a contextual approach studying the artists in relation to political events and their social, religious, and literary background. He treated Spanish art, and in particular Velázquez's portraits, as "real" historical documents, whose "unidealized" features he believed gave greater psychological insight and understanding. Although his descriptions were, in general, instructive and entertaining, he refrained

from any overly judgmental comments or from investigating the artist's technique, visual style, or iconography. Whereas Ford had been interested in savoring the "peculiar" Spanishness of Spanish art, sometimes viewing it with a jaundiced eye, seeing both its faults and merits, Stirling observed Velázquez's art more objectively via the context of Spanish history.

Stirling's monograph *Velázquez and His Works* was his reworking of the chapter on the artist in the *Annals*, written after a third visit to Spain in 1849.[25] He devoted several paragraphs to *Las Meniñas*, as he consistently referred to it, the mistake not being corrected until 1891 and influencing British commentaries well into the twentieth century. The anecdotal title, referring to the maids of honor or ladies-in-waiting who entertained and served the royal daughter, had been newly coined by José de Madrazo in the Prado's 1843 catalog. It had the effect of focusing attention on the foreground scene around the Infanta and away from the reflected portraits of the King and Queen, more prominent in the old eighteenth-century title of *The Family of Philip IV*. Stirling considered that the subject was that of "Velázquez at work on a large picture of the royal family."[26] He produced a full description of the painting making sure to identify the room and all those portrayed, repeating Palomino's story about the king painting in the Order of Santiago and Giordano's admiring comment, and mentioning the "fine repetition" at Kingston Lacy. Only once did he digress to introduce matter that was not backed up by documentation but related to his own observations, with the utmost acuteness of perception and understanding of Velázquez as an artist and an extraordinary willingness to see modern parallels in his art. Stirling summarized the importance and impact of *Las Meninas* with the phrase: "The perfection of art which conceals art was never better attained than in this picture," and continued by drawing an analogy with Daguerre's new photographic discoveries. To Stirling, the painting appeared to be "a real room with a real chance-grouped people fixed for all time on this canvas, as if by magic." Thus Stirling introduced for the first time the topos of *Las Meninas* as a "photographic snapshot" of verisimilitude, the artfully constructed replication of a casual incident, which was to so entrance writers and art historians from Stevenson and Justi through to Gombrich, Brown, Lord Clark, and Harris in the late twentieth century. It also formed part of the discourse around painting and photography that arose

immediately after the discovery of photography, in which Stirling took a pioneering interest by making a collection of photographs of Spanish art works. Above all, he saw *Las Meninas* from a historian's perspective, as an unrivalled witness to life at the court of Philip IV. His contemporaries reflected Stirling's attitude. When Charles Eastlake, the director of London's National Gallery, visited Madrid in 1859, he commented favorably on Velázquez's *Christ Contemplated by the Christian Soul* (now National Gallery), saying the only Prado painting he would prefer to it was "the one called *Las Meniñas* [sic] and that on account of its historical value" as it included portraits of the king, his daughter, and the artist.[27]

Stirling's *Velázquez and His Works* was quickly translated into German (1856), Spanish (in a serialized form in the 1856 *Gaceta de Madrid*), and French (1865). Moreover, soon after Stirling's works were published, information from them was being cited in other, more popular and populist publications, such as the guide published to accompany the Manchester Art Treasures Exhibition of 1857, the earliest art "blockbuster," accessible not only to the metropolitan elites in London but to the vast working populations of northern England as well. The specially built exhibition hall was sited alongside the railway route from London to the northern mill city of Manchester, in the suburb of Old Trafford. The exhibition attracted huge numbers (some 1,300,000 in four months) of the public, artists, art critics, commentators, and essayists, from Dickens to Engels and Ruskin to Whistler, and exhibited both Old Master European and contemporary British art from British collections. Its *Peep at the Pictures* guide was meant to explain the exhibits to the lay public, and particularly the working classes.[28] Although in the 1857 exhibition Murillo was still considered the greatest Spanish painter, some twenty-five paintings by or purporting to be Velázquez were exhibited and some, such as the *Toilet of Venus*, even received their nicknames (the *Rokeby Venus*) in Manchester. Neither the Kingston Lacy nor any other copy of *Las Meninas* was shown, but the story of how Velázquez gained his knighthood as a result of painting it had already entered artistic mythography, as demonstrated by the rather garbled comment accompanying a painting by modern British artist A.J. Herbert's *Philip II* [sic] *Conferring Knighthood on Velázquez*.[29] Stirling's scholarship was superseded in the 1880s only by more comprehensive works on Velázquez, by Cruzada Villaamil in Spain, Carl Justi in

Germany, and in the 1890s by R.A.M. Stevenson's new "Impressionist" interpretation in Britain. However, modern scholars still admire Stirling, partly because he discussed Velázquez's role and status as both artist and courtier, and that, in essence, is the primary concern of *Las Meninas*. Even if one does not accept in its entirety the view that *Las Meninas* was part of a successful to campaign petition the king to make Velázquez the first Spanish-born artist to gain a knighthood, one cannot ignore the fact that the group portrait is, in effect, a reflection of life in the royal household, holding up a mirror to the king and courtiers portrayed.

Stirling's *Annals* also pioneered the use of early photography. A separate appendix was published (1847) by Fox Talbot's assistant Nicolaas Henneman to illustrate some of the Spanish artworks discussed in the text volumes, thus producing the first art history publication illustrated photographically. As Hilary Macartney suggested, Stirling's comparison of *Las Meninas* to Daguerre's images, although ostensibly about realism, also may reflect his own knowledge of the tonal and textural qualities of Daguerrotypes.[30] Although the illustrated volume was limited to fifty copies, as Macartney shows, it was distributed deliberately at the author's request to public libraries, thus bringing it to a wider public. All but three of the sixty-six Talbotypes were made from copy drawings (by Ford, among others) and prints after paintings in Stirling's own collection, rather than of originals. However, although Stirling was later to own an example of Goya's etched copy of *Las Meninas* (Fig. 8), he did not acquire it until after the death of General Meade (Consul General in Madrid 1816–1832) in 1849.[31] Significantly, for future artists searching for visual sources the only Velázquez portrait of the Infanta Margarita illustrated showed her slightly older (Prado no. 1192), as engraved by Pierre Audouin (1768–1822), and standing alone with only a swathe of drapery breaking the tonally unified background.[32] Furthermore, *Velázquez and His Works*, unlike the *Annals*, was not illustrated, apart from a supposed self-portrait as its frontispiece. Stirling was Britain's first major collector of Goya prints and paintings, and he realized that Goya's print after *Las Meninas* (etched in 1778) was not his most successful homage to his seventeenth-century predecessor.[33] Indeed, Goya was so disenchanted with his attempt to capture the atmospheric effects of Velázquez's group portrait that he spoiled the plate after only a few proofs had been pulled from it. Goya's lack of success in his copy was commented on by Ambassador Lord Grantham's brother,

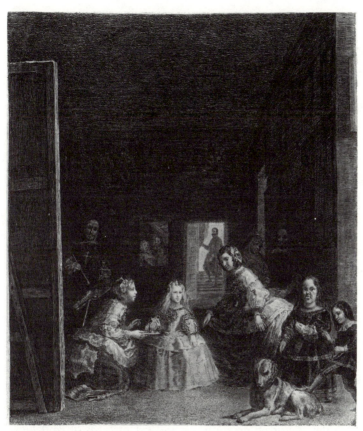

FIGURE 8. Francisco de Goya, *Etching after Velázquez's Las Meninas.* London, British Museum. © British Museum Photographs.

Frederick, who knew the original, that "much indeed of the merit of the originals is lost." Even Reynolds, who was happier with the over-all quality of Goya's etched copies and had himself copied Velázquez's *Pope Innocent X* in Rome, admitted that it was "impossible to judge of the extraordinary union of truth and freedom peculiar to the works of Velázquez from these imperfect copys[sic]."[34]

Stirling's importance as a promoter of Spanish art and culture in Britain lay not only in his historical pursuits, but also in his activities as a collector and connoisseur. He assembled the largest collection of Spanish art and literature in Britain in his time, and became trustee of the British Museum and National Gallery, often called on to adjudicate on matters of Spanish art. Although much of his painting collection

reflected his interest in royal patronage and the status of artists in Spain, it had no firmly attributed works by Velázquez. However, as well as Goya's etched copy, it may have had a small watercolor copy of *Las Meninas*, perhaps commissioned by Stirling in the 1840s or 1850s from Joseph West, as a copy of *The Artist's Studio with Numerous Figures* after Murillo [sic] hung in Stirling's bedroom in London, along with paintings by El Greco and Zurbarán.[35] Stirling was by all accounts a genial and clubbable man, whose vast library of Spanish books and historical documents was made available not only to other friends, writers, and collectors who shared his interest in Iberian topics, such as Richard Ford, but also to artist friends, some of whom had no hispanophile affiliations at all. In the mid- to late 1850s the Pre-Raphaelite artist Millais made several visits to Stirling to consult his publications and library at Keir. Another Pre-Raphaelite, William Bell Scott, consulted him before writing his study of Murillo's work in the 1870s. Also in the 1850s, J.F. Lewis wrote to thank him for a visit to Keir and asking for a copy of the *Annals* for the Royal Scottish Academy's library. Another painter who had already traveled to Spain for artistic inspiration, John "Spanish" Phillip (1817–1867), was also to find source material for his *Early Career of Murillo* (1865, Forbes Collection) in a paragraph from Stirling's *Annals*.

Phillip visited Spain twice in the 1850s (1851 and 1856) in search of fresh subject matter for his Wilkie-inspired genre scenes. Originally, he found it in the everyday life, customs, and celebrations of Andalucia. His interest in genre painting meant that if he showed an affinity with any Spanish artist, it was not the courtier Velázquez, but the "people's painter," Murillo. It was not until 1860 that he turned his attention to Madrid and the Prado. By then he may well have seen Lewis's watercolor copy of *Las Meninas* on display at the Royal Scottish Academy in Edinburgh. Perhaps Phillip's election to the Royal Academy (London), also in 1860, may have stimulated him to study more closely the work of Velázquez. Phillip may also have wished at this stage in his career to model himself on an Old Master portrait painter than the lower-status modern-day genre painting of his Scottish compatriot Wilkie. In the summer of 1860, he had exhibited at the Royal Academy in London his *Marriage of the Princess Royal with Prince Frederic William of Prussia, 1858*, so royal group portraits were very much in his mind during his third trip to Spain. Certainly by 1864 he had made copy studies in

FIGURE 9. John Ballantyne. 1864. *John Phillip in his Studio.* Scottish National Portrait Gallery.

oil of both the *Surrender of Breda* (Royal Scottish Academy) and *Las Meninas* (Royal Academy, London).

Significantly, Phillip's copy was only a partial one, omitting the dog and all the royal household seen to its right and the shadowy light shafts filtering through the window that forms the right edge of the canvas. It concentrated instead on the artist and the Infanta lit by the open door behind her.[36] Phillip was fascinated by the Spanish painter's conception of the roles played by the Infanta and the artist and the spatial relationship between them. This is implied by the role Phillip's own copy played in a portrait of *John Phillip in his Studio* (Scottish National Portrait Gallery) (Fig. 9), painted in 1864 by Phillip's fellow Scot, John Ballantyne.[37] The portrait was part of a series showing artists in their studios. However, there is evidence that his portrait of Phillip was more than just a standard production, and that there was close collaboration between the two artists. Phillip himself literally had a hand in the painting's construction. He is said to have painted in the large unfinished oil sketch for his *Dying Contrabandista* (1858, Royal

Collection) that sits on the easel awaiting the artist's touch, just as the canvas in *Las Meninas* awaits Velázquez's decision. Indeed, the whole composition acts as a homage to Phillip's conception of *Las Meninas* as perceived in his own partial copy, which dominates Ballantyne's portrait from its gloomy position on the end wall of the studio. The drawn curtain focuses the viewer's attention even further on the copy, which forms the tip of a compositional triangle that links Velázquez's portrait with Phillip's unfinished oil sketch and in the foreground the artist himself, scraping his palette clean, an inversion of the triangle created by Velázquez, his canvas, and the Infanta in Phillip's partial copy. That Ballantyne's entire painting is conceived as a homage to *Las Meninas* is highlighted by the profile bust portrait of Velázquez that hangs above an open doorway through to another side-lit room, a spatial relationship that suggests the view through to the backlit room in the Spanish canvas. The framed pictures provide further echoes of the paintings and mirror in *Las Meninas*.

This series of echoes and reflections suggests that Phillip, and through him, Ballantyne, understood part of the complexity of Velázquez's composition. For Phillip, *Las Meninas* was above all a seminal, but anecdotal, image of a master artist at work in his studio. Whom Velázquez was portraying, and the fact that he was a court artist to the King of Spain, was of much less importance; indeed, this may explain why most of the courtiers have been deleted from Phillip's copy and the reflected images of the king and queen are barely visible. Nor was he particularly interested in its exploration of reality and illusion and only partially in replicating its spatial effects. Phillip's success with Queen Victoria was dependant not on court portraiture, but on his genre scenes of Andalucian life, several of which, including the *Dying Contrabandista*, he sold to the Queen and her consort Prince Albert. Although he remained one of her favorite artists until his death in 1867, he could not be considered a court artist. He depended for his living on selling to the gallery-going patrons and public rather than on royal patronage. Ballantyne's portrait of Phillip is instead an attempt to reconstruct the pictorial space of *Las Meninas* by adapting the image of the artist at work for a mid–nineteenth-century world. Yet the theme of the artist as creator is only one of the strands of *Las Meninas*. It was not until early in the twentieth century, almost fifty years later, that a court portrait painter, Sir John Lavery, would attempt to work out the

key elements in Velázquez's painting – the optical illusion and creation of space, the artist's studio, and the group royal portrait – through a whole series of paintings.

At the beginning of the 1860s, Phillip, like his counterparts Manet and Whistler across the Channel, was leading the way in shifting artistic taste toward an appreciation of Velázquez's work. Indeed, Phillip's discriminating purchase of Whistler's *At the Piano* (Taft, Cincinnati) in 1860 shows that in many ways he spanned the gap between the early Victorian taste shown in his first Spanish paintings and the new currents in the late nineteenth century, which developed from Manet's and Whistler's interpretations of Velázquez's style. The second half of the 1860s saw the beginning of the dramatic rise in prestige among British artists of Velázquez as the painter's painter, the master whose brushwork and technique were most to be admired. Phillip's own partial copy of *Las Meninas*, acquired by the Royal Academy in London in 1867 and exhibited at the Leeds Art Exhibition in 1868 (no. 331), the second art "blockbuster" show in Britain's provinces, may have helped spur this rise to celebrity. Unusually, the Academy had bought the copy rather than received it by donation or bequest on Phillip's death. The Academy's purchases were usually for use in its schools, and so Phillip's oil copy may have been intended for teaching purposes, just as J.F. Lewis' watercolor copy, bought more than a decade earlier by the Academy's Scottish counterpart in Edinburgh, had been.[38] Ballantyne's portrait of *John Phillip in His Studio*, with Phillip's copy prominently displayed, was also exhibited at the Royal Academy in 1867. The following year, however, a more overt tribute was paid to Velázquez, although not directly to *Las Meninas*, when John Everett Millais (1829–1896) displayed his Diploma picture *A Souvenir of Velázquez* (Fig. 10) at the Royal Academy, the heart of the British artistic establishment.

Paradoxically, Millais, a founder member of the Pre-Raphaelite Brotherhood, never visited Spain. So what had influenced him to paint a child portrait whose free brushwork of hands, dress, and orange branch deliberately reflect Velázquez's, and why had he decided to honor the Spanish master in the Diploma picture he presented to the Royal Academy? The Diploma work was the example of the artist's work that the Royal Academy required each artist to give to its collection on or soon after his election to the Academy.[39] It was regarded not only as a supreme example of the artist's skill and abilities, but also as a

FIGURE 10. Sir John Everett Millais. *A Souvenir of Velázquez.* 1868. London, Royal
Academy of Arts. © Royal Academy of Arts, London.

demonstration of the achievements of a thriving British School of Art.
Millais presumably hoped to provide both by showing that his skills
were equivalent to those of an Old Master admired by the Academy's
founding president, Sir Joshua Reynolds.

Millais knew of Velázquez's work only at second or even third
hand. He had, for example, admired Whistler's transcription of the

Spaniard's style in his *At the Piano* when it was shown at the Royal Academy in 1860. He may also have seen the Kingston Lacy copy of *Las Meninas* when it was exhibited at the British Institution in 1864. We also know that from the early 1850s Millais visited his friend Stirling several times at his Scottish house at Keir, Perthshire, when he was holidaying nearby. In July 1853, he rode over to look at Stirling's collection of prints, books, and documents detailing the history of the Spanish Inquisition. An incident from which he used to compose his *Escape of a Heretic 1559* (Museo de Arte de Ponce, Puerto Rico) exhibited at the Royal Academy in 1857. The *Heretic* was intended as a pendant to his *A Huguenot (on St Bartholomew's Day Refusing to Shield Himself from Danger by Wearing the Roman Catholic Badge)*, exhibited at the Academy in 1852, and was his only subject painting with a Spanish topic. The 1857, the Academy catalog described the painting along with a lengthy quotation that purported to come from a manuscript of 1559, presumably in Stirling's collection.[40] From 1862, Millais continued to spend part of each year in Scotland with his new wife Effie (formerly Mrs. Ruskin), who had helped transcribe Stirling's archives.[41] During his visits, Millais may also have been shown Stirling's photographic collection, which included the Talbotype of an engraved print after Velázquez's supposed portrait of the *Infanta Margarita in Pink* (c.1660) in the Prado.[42] The *Infanta* is shown standing with her hands draped to either side of the bell-shaped silhouette of her dress, rather than seated, as is Millais' daughter. However, they both share the wavy golden tresses hugging the shoulderline, the same solemn facial expression, and the pose turned to her right and angled diagonally toward the spectator. Although the sepia-toned photo would not have brought to Millais' attention the salmony-pink stripes of the Infanta's dress, which are shared in a deeper redder form by the *Souvenir*, it is partially successful in transmitting the bravura effect of Velázquez's brushwork, which is what attracted Millais primarily. The other reason that Millais may have been drawn to Velázquez was the subject matter – a portrait of an under-ten-year-old girl.

Millais' paintings had fallen out of favor, attacked for their broader-brush style at the 1857 Academy. In his *Souvenir*, Millais may well have sought support for his criticized move by associating his new style with an Old Master admired even by Ruskin. Although Ruskin never wrote at length about Velázquez, he held his work in high regard, quoting

approvingly Reynolds's dictum: "What we are all attempting to do with great labour, Velázquez does at once." Typical of Ruskin's "truth to nature" philosophy, he considered him "the most accurate portrait painter of Spain."[43] Millais, newly married and with a growing family (three daughters within four years), had to find popular subjects that would sell. In the 1860s he began to move away from the morally instructive narratives, painted in the typical minutely detailed Pre-Raphaelite manner, to portraiture and portrait subjects painted in a broader style, using his daughters as models. In 1863, he painted *My First Sermon*, which showed his daughter Effie (born 1858), the first of many pictures of single children that struck a new successful seam, and on the strength of which he was elected an Academician. Followed in 1864 by its companion, *My Second Sermon*, also with Effie. Three further genre portraits of his daughters appeared in 1867.[44] Although there were no set rules as to the appropriate subject matter for Diploma pictures, Millais may well have thought that the somewhat trivial subject matter of his *Sermon* theme was not of itself appropriate. However, by dressing up this popular genre in borrowed Old Master clothes and adopting a new "Velázquez" brushstroke, he could both bolster his reputation as an Academician and further protect his decision to change his style from criticism. When, in 1867, he showed at the Royal Academy a portrait of *Hugh Cayley* (private collection), the young son of George Cayley, a hispanophile friend of his and Stirling's, whose pose and style may have been intended to recall Velázquez, the critics likened it to Van Dyck, Gainsborough, and Reynolds. In 1867, they were still not predisposed to think of Millais as a Velázquez follower. Once they had been, with the appearance in the following year of Millais' Diploma Picture, the perceived link to the increasingly fashionable Spanish artist became a cliché of the critic's discourse. By the early 1870s, it was commonly being applied to some of Millais's society portraits that in fact bore very little in common with Velázquez.[45] The Spanish artist's name was being used to enhance Millais's reputation. By entitling his genre portrait of his daughter *Souvenir of Velázquez*, Millais may have been paying homage to the Spaniard, but he was also adding value to his own work by association.

Millais's admiration for Velázquez's art was at its height in the late 1860s and early 1870s. Although the ghost of Velázquez's portraiture of royal children hovers over some of his child portraits, he was more

attuned to Velázquez as a male portraitist. *Souvenir of Velázquez* was to all effects a one-off, perhaps targeted at the Royal Academicians. Its implications for Millais' child portraiture were never to be returned to or developed further. Indeed, by the late 1870s he was to be heard dismissing Velázquez as a suitable role model for aspiring art students. He supposedly told one artist going to Spain, "Look well at Velázquez – study him, but don't copy him, he won't knock you down," which suggests that he was at best ambivalent toward the Spaniard's work and at worst afraid of his influence. Later he reportedly proclaimed, "It is worse than folly for young men to say ... as many do, that Velázquez is the only Old Master worth looking at."[46]

By the time Millais' *Souvenir* had been presented as his Diploma picture, another pillar of the British art establishment had already visited Spain in 1866 and made sketches from Velázquez's work. Frederic Leighton, later knighted and elected president of the Royal Academy (1878–1896), was a much-traveled man with a wide knowledge of foreign works of art. He encouraged appreciation of European art at the Academy by extending the range of the previously small and brief winter exhibitions of Old Masters established since 1870 (borrowed only, however, from British collections until 1920) and by dedicating his Presidential Addresses to single European Schools of Art. In December 1889, he devoted his sixth lecture to Spanish art, having made a research visit in the same year. The criteria of all his addresses was that national schools should be indigenously based and reflect the temperament and character of the artist's own country.[47]

By the 1880s a visit to Spain was not uncommon for a young British artist in training, even women artists, who generally had less opportunity to travel. Ethel Walker (1861–1951), having visited the Prado in the early 1880s, was attracted to Velázquez's work and went on to study Manet's work in Paris. For any artist studying in France in the 1880s, Velázquez was the artist to follow. Australian artists John Russell and Tom Roberts and British sculptor George Frampton all admired him while working in Paris, despite none of them giving any evidence in their subsequent work of a fascination with Velázquez. Frampton, who later went on to become a leading light of the British New Sculpture movement, kept a photograph of a Velázquez portrait of the Infanta Margarita in his Parisian studio in the mid-1880s.[48] Ironically, despite the fact that Spain had been on British artists' trail

since the early nineteenth century, they first felt the impact of *Las Meninas* second hand, through the paeans of praise for Velázquez in word and brush from English-based Americans Whistler and Sargeant. Velázquez's rise to celebrity status was especially swift after Whistler's famous Ten O'Clock Lecture of 1885, whose encomium to the artist could best be summed up in the axiom that a Great Master only occurred every 300–400 years – the last one being Velázquez.

Compared to British artists' rather laggardly "take" on *Las Meninas*, British, and especially Scottish, writers led the field. Although Stirling's biography had been superseded in 1889 with the publication in English of Justi's classic monograph, in 1895 another "biography" was published that had a much more dramatic affect on British artist's receptivity to Velázquez's work. What R.A.M. Stevenson's book *The Art of Velazquez* lacked in biographical detail, it made up for in an artist's spirited and aesthetic appreciation, if not adulation, of the character of Velázquez's technique, his brushwork, paint handling, and conjuring with light. As he himself admitted, it originally contained only one paragraph of biography, although this was expanded to a whole chapter in the 1899 edition. Stevenson (1847–1900), painter and critic (and cousin to author Robert Louis Stevenson), was a member of the New English Art Club founded in 1886 to champion French plein-air painting. His sensitive appreciation of Velázquez was matched by his admiration and understanding of Impressionism. Stevenson recalled what he learned in the studio of the French painter Carolus-Duran: that they were to study Velázquez constantly for his technique. For Stevenson, Velázquez was the grandfather of late nineteenth century Impressionism, and his influence on British and Continental nineteenth-century artists is one of the principal themes of the book.[49] Above all, he admired Velázquez's "modern" aesthetic. He was not interested in art as an art historian, but as an artist in technique – methods of composition, brushwork, modeling, and color were all reflected in the titles of the book's chapters. In particular, he was interested in Velázquez's tonal approach, his "mystery of light" and his masterly brushstroke. For Stevenson, himself a gregarious artist turned vocal art critic, Velázquez's "swaggering dexterity with a paintbrush" made him a role model for the swaggering modern portrait artist – a painter's painter and the precursor of modern art.

Stevenson, following Ford and Stirling, divided Velázquez's work up into three periods, the third, in which *Las Meninas* fell, being his

most impressionistic phase. He also acknowledged, as Ford had, that to know Velázquez's work in all its variety, one had to stay in Madrid, but commented significantly that whereas if you entered the Uffizi, you were surrounded by a crowd of tourists, in the Prado there were "few students ... and you may wander half a morning and see no other Englishman." He featured *Las Meninas* in a list of those works that one missed out on if one only knew Velázquez's work from the National Gallery, the Louvre, and English private collections: "Trusting to report, and to the evidence of reproductions, I expected to find *The Surrender of Breda* the finest Velázquez in the Prado. So I might have thought if ... he had never lived to paint *Las Meninas*, The Spinners, Aesop and Mennipus and the Infanta Margarita (inv. 1192)."[50] Although *Las Meninas* was featured, it was still as part of a list. The reference to past reports presumably referred to Richard Ford's highlighting *The Surrender* as Velázquez's masterpiece. However, on the following page, Stevenson signaled the change of priorities from those established by Ford in the mid-nineteenth century. He commented, "*The Surrender of Breda* you may admire according to your nature; you may even consider it the better picture, but by no means, as is *Las Meninas* an absolutely unique thing in the history of art." In his book Stevenson devoted most attention and the greatest praise to *Las Meninas*. He analyzed its qualities from the point of view of a practicing artist, and culminated by comparing favorably Velázquez's "truth to nature" to that championed by Victorian art critic and arbiter of taste John Ruskin in his promotion of the Pre-Raphaelites. Later, he made the significant point that as a composition it often reproduced poorly, whether by print or photograph, because so much of the canvas was seemingly empty space above a row of heads in the lower third of the picture,[51] confirming his view that Velázquez's mastery could only be understood by prolonged visits to the Prado. As if in acknowledgment of Goya's difficulties in copying *Las Meninas*, Stevenson commented how easy it was for an engraver to stumble over the painting's nuances or tighten a facial or costume detail to the detriment of the finished reproduction.

In his description of the Kingston Lacy copy, Stevenson for the first time introduced in print the discussion that was later to become a focus of so much speculative controversy: what *Las Meninas* was meant to depict and, more especially, whom was Velázquez portraying. He began by expanding on the version that ultimately derived from Palomino's

description: "It is generally said that Velázquez was painting the king, who sat in the spot from which the spectator is supposed to see the picture.... During a moment's rest the Infanta came in with her attendants... the canvas shown in the picture would naturally be the one on which Velazquez was painting the king's portrait." Yet he then introduced an alternative theory: "Some, however, will have it to be the very canvas of *Las Meninas*, which Velazquez was painting from a reflection in a mirror placed near to where the king had been sitting. The perspective of the picture hardly seems to agree with this view, but rather makes Velazquez to have been working on the king's right hand.... It is just possible that Velazquez was painting... a portrait of the Infanta only, when the idea of the large picture suddenly occurred to him or to the king."[52] However, from Stevenson's perspective as an artist–author the subject that was being painted was of no consequence – it was *how* that fascinated him, and he declined to discuss the matter further. As a result, he says little about the court society that Velázquez was painting for and totally fails to mention the radical element of the artist inserting his self-portrait into a royal portrait. The unusualness of the latter had first been mentioned in 1676, when Portuguese artist–author Felix da Costa remarked that the picture seemed more like a portrait of Velázquez than the princess.[53] Nor did Stevenson discuss the status of the painting. Whether Velázquez's near contemporaries might have considered it to transcend mere portraiture and become an image analogous to an imaginatively constructed "history painting" was left to late twentieth-century art historians to discuss.[54] Stevenson's take on Velázquez, as the master technician, was ultimately a dead end when one attempts to analyze the unique mastery and mystery of *Las Meninas*. Instead, Stevenson expounded on the artist's purely pictorial vision as distinguished from the literary and historical appeal of Velázquez's art. However, Stevenson's book, whatever its merits or faults, had an extraordinary effect on British avant-garde artists. It became a "bible" for English-speaking art students in the late nineteenth and early twentieth centuries. For one of Stevenson's younger art-critic colleagues, D.S. MacColl (himself the Ruskin of the British Impressionists), it was "the most substantial contribution to the theory and defense of painting since John Ruskin's *Modern Painters*."

Stevenson also drew a direct comparison between Velázquez's art and Millais' work in a belated reflection on Millais' reputation after his

death, providing his own damning verdict on the difference between popular and aristocratic taste. He regarded Millais' career "as the great disappointment of British Art," a portrait painter of promise who had sold out to popular taste to gain fame and fortune.[55] For Stevenson, Millais had had to make his way with a "most inartistic public, whereas Velazquez had secured his life-long patron, the connoisseur king; so that afterwards he had only his art to consider." The latter comment seems ironic in the light of Palomino's complaint that the king's honoring Velázquez through ennobling the art of painting had prevented the artist from creating more for posterity. The implication of Stevenson's comparison was that in the late nineteenth century, avant-garde artist critics, such as he, had taken the place of Philip IV and his courtly patronage. Whereas the "modern art" vanguard would promote Velázquez's reputation, the middle-class masses, with their bourgeois values and "sentimental" tastes, were left to admire the work of Millais or Murillo. The growing critical appreciation of *Las Meninas* in the final decade of the nineteenth century can thus be seen as a small episode in a far broader cultural development in Britain, the belief that great art was the preserve of an elect few, and a contempt for the taste of the "masses," which became central to the creed of many Modernist critics in the first half of the twentieth century.[56] Velázquez's lack of strong links to devotional art (especially Catholic Mariolatory) helped build him a reputation as an intellectual artist whose portraiture could fit easily into a nonreligious Impressionist, rationalist, "modern" art world of the late nineteenth and early twentieth centuries.

Although Stevenson had finally christened *Las Meninas* in print "a unique masterpiece" by a protomodernist artist, it had to wait almost another decade into the twentieth century before any artist in Britain tried to work through its masterly implications in paint. By the end of the nineteenth century, many British artists, with Scots again predominating, were visiting Spain, no longer in search of folkloric "color" but of artistic "light" radiated by the brilliant sun for their landscapes and metaphorically by Velázquez in his portraits. The Scots–Irish artist John Lavery (1856–1941), a leading member of the *plein-air*, Whistler-inspired "Glasgow Boys," first visited the Prado in 1891 and had eyes for Velázquez alone, copying several paintings. Originally, in the 1880s the Scottish-based "Glasgow Boys" had looked to the realism and monochromatic tonal style of French and Dutch painting,

but they gradually looked away from the Hague School toward the work of Whistler, Manet, and, as their paternal great-great grandfather, Velázquez. He thus gave an "Old Master" imprimatur to what in Britain was seen as a dangerously avant-garde style. However, most of these artists knew Velázquez's work only through the eyes and admiration of Whistler, and especially via his portraits of single standing young girls, such as *Harmony in Grey and Green: Cicely Alexander* (1873, Tate Gallery), all distantly reminiscent of the pose of the Infanta Margarita in *Las Meninas*. Whistler would have seen the Kingston Lacy copy on his visit to the Royal Academy in 1870. However, his main *aide-mémoire* for Velázquez's work was a collection of nine photographs of the Spaniard's paintings in the Prado. However, the photograph he owned of *Las Meninas* showed only the central portion with the Infanta. It was this image of a standing, isolated young girl that seems to have influenced Whistler's child portraits.[57] Like Phillip before him, Whistler's assimilation of *Las Meninas* depended on a partial copy.

The crucial effect of Phillip's and Whistler's partial views was that they omitted one of the painting's most visually striking effects noticed by everyone who actually viewed the painting rather than a reproduction. So much of its impact is the result of the relationship of the painting's "space" with the physical space occupied by the viewer, and this can be understood only by viewing the whole composition at its actual size. Furthermore, its significance lay not only in its technically superb recreation of a room with correct aerial perspective, but, as Palomino had first suggested, in its combining a royal portrait with an artist's self-portrait. However, most British artists ignored the importance of this optical and thematic combination of images.

John Lavery was one of the few artists of the British Isles who, in his own work, seems to have understood the spatial ramifications of *Las Meninas* and its importance, not just as a portrait of a royal child, but as a group portrait of a royal family as well. Stirling's comment that Velázquez's art concealed art was never really understood properly by British artists until perhaps Lavery's attempt in his several versions of *The Artist's Studio* to develop something from it. Lavery had first been befriended by Stevenson in 1884, when they met at the French artist's colony Grès-sur-Loing.[58] He eventually settled in London in 1896 to make his name as a portrayer of high-society ladies. Until then, he was a "Glasgow Boy" by adoption, and as such was heavily influenced by

Whistler, whose *Harmony in Grey and Green* inspired Lavery's portrait of his daughter Eileen at her *First Communion* (1902, private collection). Such a portrait was an example of Velázquez's Infanta seen through Whistlerian eyes and harmonies. However, Lavery had actually studied *Las Meninas* closely at first hand in visits to Madrid between 1892 and 1894. Stevenson noted how difficult Lavery found it to make copies of Velázquez's works that truly captured their spirit.[59] Shaw-Sparrow, Lavery's earliest biographer, described Lavery's disappointed reaction to his first view of Velázquez's work more emotionally and revealingly,[60] explaining that this was the familiar disappointment that faced those who confronted "the heroic great so modestly sure of themselves that we are not at first awed by them... we behold quite simple and unaffected gentlemen who do noble things with so much more ease and grace and power... their art conceals art." It was only lesser painters, he added wryly, who, being like minor philanthropists, "like their charities to advertise themselves."

When Lavery attempted almost two decades later to revise *Las Meninas* having thought he had long digested its lessons, he was to realize with how much art Velázquez had concealed his art and how difficult it was to develop his concept further. Lavery began his earliest homage to the challenge represented by *Las Meninas* in around 1910. In the completed *Lady Lavery with Daughter and Step-Daughter (The Artist's Studio)* (1913, National Gallery of Ireland) (Fig. 11), he succeeded in revisiting and reworking some of the problems posed by *Las Meninas*. He painted a tall studio, hung with dimly perceived favorite canvases, peopled with adults and animals – a solemnly staring young girl, a crouching dog, a maidservant, and a mirror that reflects the artist rather than the sitters. As originally conceived three years earlier, it had been even closer in composition to the Spanish masterpiece, showing Lavery standing on the left, brush in hand, in exactly the same position occupied by Velázquez in *Las Meninas*. After many reworkings, Lavery's self-portrait was transferred to a background mirror reflection, which, in a subtle reversal of the male–female couple facing us in *Las Meninas*, also revealed the back view of his wife.[61] The mirror set in a darkened corner reflects the light as it filters through from the curtained side windows and isolates Lavery's own "maids of honor" in the foreground. To the right, on an easel, balancing the mirror compositionally, is a portrait of Queen Mary, revealing that another important commission was in progress.

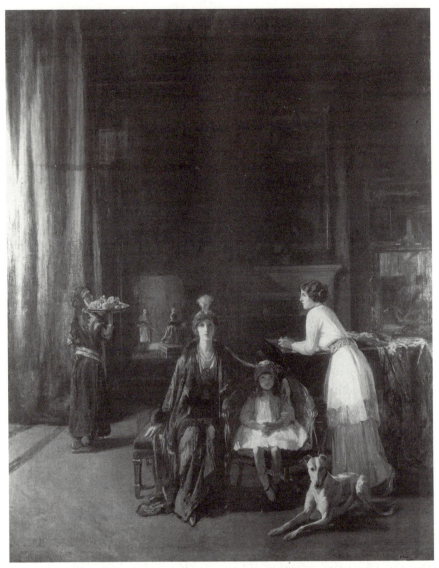

FIGURE 11. John Lavery. *Lady Lavery with Daughter and Step-Daughter.* Ca. 1910. Dublin, National Gallery of Ireland. © National Gallery of Ireland.

Lavery was approached to paint the British royal family in 1912. Although in the resulting portrait, *The Royal Family at Buckingham Palace, 1913* (London, National Portrait Gallery, inv. 1745), he refrained from inserting himself, or any dogs and servants, it was to become

Lavery's ultimate tribute to *Las Meninas* and to Velázquez as a court painter. The fact that he had *Las Meninas* (318 × 276 cm) in mind when he was painting his own royal group portrait is betrayed by an anecdote Lavery related in his autobiography. When the king and queen visited his studio to view the picture in creation, the royal couple was so pleased with it that the king asked whether he might be allowed a hand. Lavery continued in his autobiography: "[T]hinking that royal blue might be an appropriate colour, I mixed it on the palette and taking a brush he applied it to the Garter ribbon." He then recorded that when *Las Meninas* had been completed, King Philip painted the insignia of the Knights of Calatrava [sic] on Velázquez's breast.[62] In actuality, Velázquez had to wait three years after the royal visit, and Lavery five years, for a knighthood. Furthermore, at the time of the royal visit, the *Artist's Studio* (344 × 274 cm), Lavery's own *Las Meninas*, was leaning against the studio wall in the process of one of its many radical reworkings.

Both series of paintings with their related studies reveal the extent to which he had absorbed the lessons of *Las Meninas* at a deeper level. Ultimately, the dependence of both these Lavery paintings on *Las Meninas*, one readdressing it as a portrayal of artistic inspiration in the studio and the other as the creation of a royal image, was less evident in the final compositions. The complexity of developing such masterly concepts in one canvas defeated Lavery. He ended up developing the two strands separately, both of which, although conventional, in completion, have dim reminiscences of *Las Meninas* hovering over them.

The long gestation of critical approval of *Las Meninas* shows how awkward most nineteenth-century British painters felt about it. As British reaction illustrates sometimes masterpieces are not necessarily recognized immediately for what they are. In many ways, Velázquez's "ladies-in-waiting" remained in the nineteenth century, at least, a "masterpiece-in-waiting." Indeed, it could be said that it was not until after World War II, after Picasso's seminal deconstructive series of 1957 (which was shown at the Tate Gallery in 1960), Lord Clark's television popularization in 1969, and Enriqueta Harris' published research, that British artists, critics, and public were happy to proclaim *Las Meninas* as Velázquez's masterpiece, "original in conception and unequalled in execution."[63]

NOTES

1 I should particularly like to acknowledge the help and advice of Hilary Macartney of Glasgow University for the many useful comments and suggestions made during the research for this essay, and for allowing me to see the notes she made toward a lecture given at the Scottish National Portrait Gallery on Ballantyne's portrait of John Phillip.

2 Alistair Laing, *Kingston Lacy Guide*, London, 1988, p. 37, and 1994, *Guide*, pp. 39–43, 68–9.

3 Enriqueta Harris and Herbert Lank, "The Cleaning of Velázquez's Portrait of Camillo Massimi," *Burlington Magazine*, CXXV, 1983, p. 412; Enriqueta Harris, "Las Meninas at Kingston Lacy," *Burlington Magazine*, CXXXII, February 1990, p. 127.

4 Enriqueta Harris, as above, 1990, pp. 129–30.

5 *Varia Velazqueña*, vol. II, 1960, p. 156, citing *Reflexiones y conjeturas sobre el boceto original del cuadro llamado La Familia*, 1789, which remained unpublished during his lifetime; and Enriqueta Harris, p. 127.

6 In omitting significant details, it is similar to another supposed Mazo copy (Wallace Collection, London) after Velázquez's *Baltasar Carlos in the Riding School*.

7 Another copy by "R. Millan" was in the equally inaccessible Lyme Hall in Cheshire, having probably been acquired by the second Lord Newton between 1900 and 1904. The copy was probably made for the quintessentially English reason that the dozing mastiff was believed to be a descendant of the pair of Lyme Park–bred mastiffs presented to Philip III during diplomatic negotiations in 1604.

8 Nicholas Tromans, "Museum or market? The British Institution," in *Governing Cultures: Art Institutions in Victorian London*, eds. Paul Barlow and Colin Trodd, Aldershot, 2000, pp. 51–2. The summer of 1828 also saw the return of David Wilkie from his tour of Spain, having been able to visit the Prado.

9 William Stirling, *Velázquez and His Works*, Madrid, 1999, introduction. Enriqueta Harris, translation of 1855 original, p. 276; *Annals of the Artists of Spain*, London, 1891 ed., vol. II, pp. 773–4. However, Gustav Waagen, in his *Supplement of 1857*, did not believe it could be a copy, although he admitted that he had never seen the original in Madrid, and in 1864 it was still exhibited as an original sketch, with the reviewer in *The Athenaeum* suggesting it might have been painted to get the king's approval.

10 Francisco Javier Sánchez Cantón, *Las Meninas y sus personajes*, Barcelona, 1952, p. 33.

11 10 January 1810, published in *Letters Addressed to the Late Thomas Penrice, Esq; while Engaged in Forming His Collection of Pictures, 1808–1814*, Yarmouth, n.d., pp. 11–12.

12 Allan Cunningham, *Life of Wilkie*, London, 1843, vol. II, p. 417. The *Baltasar Carlos* copy hung prominently in Rogers' dining room, where he entertained leading members of the political, literary, and artistic world at his celebrated breakfasts. Frank Herrmann, *The English as Collectors: A Documentary Chrestomathy*, London, 1972, pp. 251, 249, 252. Wilkie himself is also thought to have brought back portrait[s] attributed to Velázquez.

13 Louis Viardot's *Musées de l'Espagne*, 1843, quoted by Edmund Head, *Handbook of the History of the Spanish and French Schools of Painting*, London, 1848, pp. 153–4.

14 Cunningham, II, p. 504; Stirling *Velázquez and His Works*, 1999 ed., p. 312, citing Cunningham, II, p. 486. An unattributed copy after a Velázquez Infanta was in Wilkie's posthumous studio sale.

15 Cunningham, II, p. 486, citing Wilkie's journal entry for 29 October 1827.

16 Cunningham, II, p. 471, citing letter of 12 November 1827.

17 My thanks to Hilary Macartney for first drawing my attention to this painting.

18 See the entry on Wilkie's portrait of *Queen Victoria in Robes of State* in Alex Kidson, *Earlier British Paintings in the Lady Lever Art Gallery*, Liverpool, 1999, pp. 171–5.

19 Thomas Bean, "Richard Ford as picture collector and patron in Spain," *Documents for the History of Collecting: 19 Burlington Magazine*, CXXXVII, February 1995, pp. 101, 105, records Ford as reporting in late August 1832 that Lewis was still in Madrid and "in love with Velázquez."

20 Royal Scottish Academy (RSA), Acc. no. 1992.498. According to the descriptive catalog of the RSA's collection produced at the time, Lewis' copy of *Las Meninas* is described as a "portion," but the description of the watercolor kindly provided for me by the RSA's curator Joanna Soden suggests that the copy was of the whole painting.

21 Frederic Leighton's *Discourse on Spanish Art*, London, 1889, p. 13. Frederic Leighton referred to it as a "book of unsurpassed charm and brilliancy" and probably used it on his visits to Spain in both 1866 and 1889. However, he preferred Justi's *Velazquez und sein Jahrhundert*, which he saw as a much-needed corrective to Ford and Stirling's work.

22 Ford's diplomat friend Sir Edmund Head also considered the *Surrender* to be Velázquez's chef d'oeuvre, *Handbook of the History of the Spanish and French Schools of Painting*, London, 1848, p. 152.

23 "His portraits . . . drew the minds of men; they live, breathe and seem ready to walk out of the frames. His power of painting circumambient air, his knowledge of lineal and aerial perspective, the gradation of tones in light, shadow and colour, give an absolute concavity to the flat surface of his canvas; we look into space, into a room, into the reflection of a mirror. . . . No painter was ever more *objective*. There is no showing off of the artist, no calling attention to the performer's dexterity," *Penny Cyclopaedia of the Society for the Diffusion of Useful Knowledge*, London, 1843, vol. XXV, pp. 189–91.

24 He owned estates in Scotland and sugar plantations in the West Indies. *Dictionary of National Biography*, Oxford, 1898, vol. 54, pp. 384–7.

25 I used the bilingual edition of *Velázquez and His Works*, Madrid, 1999, pp. 24, 34, 272, with an introduction by Enriqueta Harris, who, since 1964, has done so much to research Stirling's importance as a historian and collector of Spanish art; see also Enriqueta Harris, "Sir William Stirling Maxwell and the History of Spanish Art," *Apollo* LXXIX, 1964, pp. 73–7; Hilary Macartney, "Sir William Stirling Maxwell: Scholar of Spanish Art," in *Espacio, Tiempo y Forma*, Series VII, *Historia del Arte*, vol.12, 1999, pp. 287–316. I should also like to thank Hilary Macartney for allowing me to see the draft of her review of the 1999 edition of Stirling's *Velázquez* in *Bulletin of Hispanic Studies*, October 2001.

26 In 1780, Mengs described it as Velázquez painting the Infanta, as quoted in *Varia Velazqueña*, 1960, II, p. 136, "Letter from Mengs to Ponz 1780."

27 Nigel Glendinning, "Nineteenth-century British Envoys in Spain: Documents for the History of Collecting 7," *Burlington Magazine*, CXXXI, 1989, p. 125.

28 As the author wrote on the first page: "We do not offer this as a catalogue, for we have merely tried to indicate some works of the most celebrated painters ... to point out those pictures, which, from their subject, seem most likely to interest the working classes." See also the review of Francis Haskell, *The Ephemeral Museum*, 2000, in *The Art Newspaper*, February 2001, p. 52.

29 No. 600 in the *Guide*: "We told you that Velázquez went to the court of Spain. He was painting his own portrait and the king was interested in its progress. When it was nearly completed, Philip remarked that it wanted one thing more, and taking the brush, he made the sign of knighthood on his breast. You may see the portrait reflected in the mirror, with the red cross."

30 Letter 17/01/01 and personal communication from Hilary Macartney to the author.

31 Now in the Museum of Fine Arts, Boston. By the mid-nineteenth century, several of the rare prints after *Las Meninas* had made there way into British collections, such as that of Sir Henry Wellesley, the brother of Lord Wellington, ambassador to Spain (1811–22) and the friend to whom William Bankes entrusted his copy for safe return to England. Wellesley's print entered the British Museum (1860.7.14.44) and is the one illustrated.

32 A calotype photograph is illustrated in Susan Lambert, *The Image Multiplied: Five Centuries of Printed Reproductions of Paintings and Drawings*, London, 1987, pp. 110–11, Fig. 98A–C.

33 Nigel Glendinning, "Goya and England in the Nineteenth Century," *Burlington Magazine*, 1964, CVI, pp. 4–14; *Velázquez and His Works*, Madrid, 1999, ed. cat. no. 39, where Stirling states that Goya "very justly considered it a failure."

34 Nigel Glendinning, Enriqueta Harris, and Francis Russell, "Lord Grantham and the taste for Velázquez: 'The Electrical Eel of the day,'" *Burlington Magazine*, CXLI, October 1999, pp. 598–605, regarding the collecting activities of Thomas Robinson, second Baron Grantham, ambassador to Spain, 1771–1779.

35 Information from Hilary Macartney, who pointed out that the inventory of Stirling's Mayfair house appears to confuse West's copies after Velázquez and Murillo. Some of West's copies after Old Masters in the Prado were sold at Christie's sale of the "Property of Archibald Stirling of Keir," 22–24 May 1995, lots 435–446. A part of Stirling's picture collection including works by Goya, Cano, and Tristán is displayed at Pollok House, Glasgow.

36 Indeed, when it was acquired for £600 by the Royal Academy in June 1867 to commemorate the artist after his death, it was referred to as "Velázquez Painting of the Infanta." Many thanks to Mark Pomeroy, archivist at the Royal Academy, for this information.

37 My understanding of Ballantyne's portrait was helped greatly by discussion with Hilary Macartney, who allowed me to see the notes she made toward a lecture given at the Scottish National Portrait Gallery on Ballantyne's portrait of John Phillip. Ballantyne (1815–1897) moved to London in 1863 and devised a series of artists in their studios (from which he intended to sell reproduction rights) as a means both to exploit public interest in artists (others in the series included

Landseer) and associate his name with the established and fashionable art world. He exhibited the series in Pall Mall in 1865. See Kit Wedd, Lucy Peltz, and Cathy Ross, *Creative Quarters the Art World in London, 1700–2000*, Museum of London exhibition, 2001, p. 87.

38 *From Reynolds to Lawrence: The First Sixty Years of the Royal Academy of Arts and Its Collections*, Royal Academy exhibition catalog, 1991, p. 13.

39 As above, pp. 11, 14. Other than the Founding Members Angelica Kauffman and Mary Moser, no women artists were elected to the Royal Academy until the twentieth century.

40 For the quotation, see Christopher Forbes's entry on the reduced copy of the *Heretic* in *The Royal Academy Revisited: Victorian Paintings from the Forbes Collection*, New York, 1975, p. 149. Forbes, however, believed the quote to be a fake.

41 David Howarth, "Mr. Morritt's Venus: Richard Ford, Sir William Stirling Maxwell and the 'cosas de España,'" *Apollo*, CLXI, October 1999, p. 37, n. 3.

42 Inv. 1192 is thought to have been left unfinished on Velázquez's death and completed by Mazo according to López-Rey, *Velázquez Catalogue Raisonné*, 1999, vol. 1, p. 191. Millais may also have known of the 1655 portrait of Infanta Margarita attributed to Velázquez in the Louvre, which he definitely visited in 1870, in which she is shown three-quarter length in a white dress trimmed with stripes of black lace, and red bows in her long hair trailing over her shoulder.

43 *The Two Paths: Lectures in Art and Its Application to Decoration and Manufacture* delivered in Manchester, 1859, as published in Edward Tyas Cook and Alexander Wedderburn, *The Works of John Ruskin*, London, 1903–1912, vol. 16, p. 312; *Modern Painters* vol. V (1860), Cook and Wedderburn, vol. 7, p. 419. Although in a typically idiosyncratically English way Ruskin commended Velázquez for his painting of dogs (*Lectures on Art*, 1870, Cook and Wedderburn, IV, p. 334, n. 1), he never used *Las Meninas* as an example in any of his illustrated talks to Working Men's Colleges and preferred to encourage his students to copy details from the horse's harnesses of the Spanish artist's equestrian portraits.

44 For which, see Geoffroy Millais, *Sir John Everett Millais*, London, 1979, pp. 67–8, 72–4, 87. Although *The Minuet*, 1866–1867 shows none of Velázquez's tonality or style, the outline of Millais's daughter's pose with a floral ornament/bow in her hair and her arms stretched either side of her bell-shaped skirt of her dress, which she holds daintily at the sides, is reminiscent of the pose of Infanta Margarita's 1660 portrait in the Prado (1192), of which Stirling had a photo, and to a lesser extent, the Infanta as she is shown in *Las Meninas*.

45 Of the group portrait *Hearts Are Trumps* (1872–1873, Tate Britain) it was written: "There is a bravura in the execution, and a union of respect for the minutest vagaries of fashion with breadth of hand and unity of result, which has never been excelled since the days of Don Diego Velazquez," *Millais: Portraits*, London National Portrait Gallery, 1999, pp. 130, 203, cats. 35, 48; quotes from Walker Armstrong, "Sir John Millais, RA: His Life and Work," *Art Annual* (the Christmas number of the *Art Journal*), December 1885, p. 17. The triple portrait of the three daughters of Walter Armstrong was strongly inspired by Millais' wish to outdo Reynolds famous portrait of the *Ladies Waldegrave* (at Strawberry Hill Twickenham, which he knew well) and supposedly to "do" Reynolds over again from Velázquez. In

fact, however, apart from a liveliness of brushwork, little in the setting, dress, or colors is reminiscent of Velázquez.

46 Marion Harry Spielmann, *Millais and His Works*, Edinburgh, 1898, pp. 61, 66, as cited in Alan Braham, *El Greco to Goya: The Taste for Spanish Paintings in Britain and Ireland*, London National Gallery, 1981, pp. 36–7.

47 Sir Frederic Leighton, *Discourse on Spanish Art*, 1889, pp. 1–36. However, Leighton barely mentioned *Las Meninas* because he preferred Zurbarán as the true embodiment of Spanish art, and distrusted Velázquez's late atmospheric style and abhorred his "tendency to subordinate everything to the pursuit of royal favour" (pp. 31–4). The last complaint sounded particularly ironic coming from an already knighted painter (1878), who was to become the first an only British artist to be ennobled (in 1896).

48 Photograph in Frampton's artist's file in the Walker Art Gallery, Liverpool. I should like to thank Joseph Sharples, former curator of Sculpture at the Walker, for drawing my attention to this photograph.

49 "No preparation in colour or monochrome was allowed [by Duran], but the main planes of the face must be laid directly on the unprepared canvas with a broad brush. These few surfaces . . . stood side by side like pieces of a mosaic, without fusion of their adjacent edges." "When . . . truth of impression became the governing ideal of art, Velazquez became the prophet of the new schools"; "how often he forestalled the discoveries of recent schools of painting. . . . The names of Regnault, Manet, Carolus-Duran, Henner, Whistler and Sargent rise to one's lips at every turn in the Prado," Robert Alan Mowbray Stevenson, *Velazquez*, ed. Denys Sutton, London, 1962, pp. 146–7, 63. Significantly, not one of the artists mentioned by Stevenson is British.

50 As above, p. 65.

51 "The art of this thing – for it is full of art – is done for the first time and so neither formal nor traditional. . . . This is not the reality obtained by the Pre-Raphaelite exploration of nature, which builds up a scene bit by bit . . . [The Pre-Raphaelite painter] will not conceive of his picture as a big pattern which produces detail; he compiles a great many separate details, and accepts, though he has not designed, the ensemble which they happen to produce. Now the ensemble of *Las Meninas* has been perceived in some high mood of impressionability and has been imaginatively kept in view during the course of after-study." As above, pp. 70, 86.

52 As above, p. 98.

53 Quoted in Enriqueta Harris, *Velázquez*, Oxford, 1982, p. 170.

54 See José López-Rey, *Velázquez Catalogue Raisonné*, Cologne, 1999, p. 310.

55 *Art Journal*, January 1898, pp. 1–2. See also the similar opinions expressed by Joseph and Elizabeth Pennell, *Fortnightly Review*, vol. 66, September 1896, p. 445.

56 The development is traced much more fully in literature by John Carey in *The Intellectuals and the Masses: Pride and prejudice among the literary intelligentsia, 1880–1939*, London, 1992.

57 The importance of Whistler's collection of Velázquez photographs was discussed in Margaret Macdonald's lecture, "Why bring in Velázquez?" presented at the Art Historians Association Conference, Edinburgh, April 2000.

58 Walter Shaw-Sparrow, *John Lavery and His Work*, London, 1911, p. 21, who described him as "Irish by race and Scotch by education."

59 Even after more than six months of careful copying, on his return visit, Lavery found that "while the copy that in Scotland had been to him and to other painters . . . the very interpretation of Velázquez now seemed lacking the essential spirit of the master." Kenneth McConkey, *Sir John Lavery*, Edinburgh, 1993, p. 68.

60 "[B]ut when he entered the Prado, with eyes for Velázquez alone, he was taken aback, he was disappointed. That he should have given so much thought to this master that he should have gone to so much trouble to reach Velázquez in his own home! See how simple that art is, how frank and candid, how self-reliant and quiet; the compositions seemed to have nothing in them; there is no sensation no mystery; and Lavery himself so he could not help thinking might have done something very similar, long ago, if he had known earlier how Velázquez at his best appeared as a champion painter." Shaw-Sparrow, as above, p. 78.

61 McConkey, as above, pp. 120–2, 145–9, n. 60–8.

62 John Lavery, *Life of a Painter*, London, 1940, p. 159. Significantly, it is the only occasion that Lavery mentions Velázquez.

63 Enriqueta Harris, *Velázquez*, Oxford, 1982, p. 173.

WHY DRAG IN VELÁZQUEZ?

Realism, Aestheticism, and the
Nineteenth-Century American
Response to *Las Meninas*

James McNeill Whistler posed the rhetorical question, "Why drag in Velázquez?" to a fawning admirer who placed him second to Velázquez in the pantheon of great artists. It was a characteristically curt comment from an artist known for his dripping sarcasm and rapid wit.[1] However, when modern observers take up the challenge and consider the implications of Whistler's inquiry, they find that it is answered neither easily nor quickly. The significance of Velázquez's work, the reasons for its popularity, and the ways in which artists responded to it were intricately tied in the United States to the complicated social and cultural concerns of the late nineteenth century, a period marked by growing nationalism, increased cosmopolitanism, and the development of industrial manufacturing systems. Velázquez was the most popular Spanish painter among Americans during the second half of the nineteenth century. Critics praised his unaffected approach to his subject, his artistry, and his bravura handling of paint. They commended his independence and individuality, his freedom from academic rules and idealization. Americans, eager to define a set of national characteristics and temper the rapid changes in their young country, found these qualities admirable. They linked Velázquez's art to the development of American culture, as well as to the grand tradition of European art history.

Fine art in the United States, practically nonexistent in the seventeenth century and an afterthought in the eighteenth century, was still suffering an inferiority complex at the time of Whistler's caustic comment.[2] With the availability of quicker and less expensive modes

of transportation, Americans began flocking to Europe after the Civil War with the goal of assimilating the latest European styles and joining the international community. Art critics added their voices to the expanding literature about Velázquez and his work, and four of the most prominent painters created variations on *Las Meninas* (ca. 1656; Museo del Prado, Madrid). These American artists – Whistler with *The Artist in His Studio* (1865–1866; The Art Institute of Chicago), Thomas Eakins with *The Gross Clinic* (1875, Jefferson Medical College, Philadelphia), John Singer Sargent with *The Daughters of Edward Darley Boit* (1882, Museum of Fine Arts Boston), and William Merritt Chase with *Hall at Shinnecock* (1892, Terra Museum of American Art, Chicago) – reinvented this masterpiece of Western painting. They challenged the expectations of the art-viewing public with their creations and associated themselves with the most progressive movements of their time. Recasting Velázquez's painting at various points along the spectrum of realism and aestheticism, they transformed *Las Meninas* into a prototype for their own modern ideals.

Americans of the late nineteenth century often received their information about Spanish painting from British publications. In May 1855, the New York periodical *The Crayon* extracted several lengthy passages from William Stirling Maxwell's *Velázquez and His Works*, published in London that same year. This book introduced a pervasive bias into American criticism because Stirling Maxwell insisted that the Spanish painter relied wholly on nature for inspiration. After studying with Francisco Pacheco, Stirling Maxwell wrote, Velázquez discovered "that Nature herself is the artist's best teacher and industry his surest guide to perfection. He very early resolved neither to sketch nor to color any object without having the thing itself before him."[3] This decision was sympathetically received by Americans, who maintained a decided preference for images of life over the imagination, and more particularly, by the readers of *The Crayon*, a magazine founded to promote the writings of English artist and theorist John Ruskin in the United States. Edited by art critics William J. Stillman and John Durand, the magazine ran articles that encouraged American artists to avoid preconceived artistic formulae and instead meticulously follow God-given nature. Their approach was aligned with moral superiority, and the sections reprinted from Stirling Maxwell's work on Velázquez displayed a concern not just for the painter's art, but also for his character.

Along with Velázquez's industrious study of "nature," Stirling Maxwell also extolled Velázquez's dedication to everyday subjects, for it was through his democratic contemplation of all facets of Spanish life that he was able to rival "the painters of Holland in accurate studies of common life and manners."[4] Velázquez, readers were told, had extensive knowledge of the other masters, but still he "remained constant in his preference of the common and the actual to the elevated and ideal."[5] His refusal to idealize his subjects and his independence from classicism were marks of his strong and independent character. When given the opportunity, Velázquez diligently studied the Italian masters in Rome, but, Americans were informed, "the oak had shot up with too vigorous a growth to be trained in a new direction."[6] *The Crayon* concluded its introduction to the painter with a celebration of his portraits; Stirling Maxwell, quoting yet another English critic, claimed that these works "'baffle description and praise; [Velázquez] drew the minds of men; they live, breathe, and are ready to walk out of their frames.' Such pictures as these are real history."[7]

In his book, Stirling Maxwell extended these observations to *Las Meninas*, "a work which artists, struck by the difficulties encountered and overcome, have generally considered [Velázquez's] masterpiece."[8] He devoted four full pages to this painting, including an identification of the sitters, the infanta Margarita, the attending maids of honor María Agustina Sarmiento and Isabel de Velasco, the dwarfs Mari Bárbola and Nicolás Pertusato, behind them Doña Marcela de Ulloa in conversation with a male chaperon, and at the top of the stairs in the back the queen's *aposentador*, José Nieto. Stirling Maxwell also noted the reflected image of the king and queen as well as the presence of the artist at his easel. "It is said that Philip IV," explained the author, "who came every day with the queen to see the picture, remarked, when it was finished, that one thing was yet wanting; and taking up a brush, painted the knightly insignia with his own royal fingers, thus conferring the accolade with a weapon not recognised in chivalry."[9] Although *The Crayon*'s editors refrained from reprinting the *Las Meninas* portion of Stirling Maxwell's text, preferring to focus on his more general discussions of Velázquez and Spanish art, this information was readily available to readers in the late nineteenth century.[10]

The Crayon ran two more extracts from Stirling Maxwell's book over the next months, one titled "The Church and the Artist in Spain," the

other captioned "Philip IV of Spain." The editors had already approvingly differentiated Velázquez as "the only great Spanish painter who did not find habitual employment in the service of the Church,"[11] and neither of these excerpts dealt specifically with Velázquez or his work. Instead, they contributed to the development of the American view of Spain, one that emphasized the country's entrenched histories of Catholicism and monarchism, usually in negative contrast to the traditions of Protestantism and democracy in the United States. American society of the mid-nineteenth century was being dramatically transformed through the influx of Catholic immigrants, and these new citizens were causing unease in Protestant circles.[12] The foreignness of Catholic belief is clearly evident in the selection chosen by *The Crayon* editors for republication. Stirling Maxwell wrote,

> The true importance of [the Spanish painters'] functions is difficult, perhaps for a Protestant to appreciate. Here the character and ancient habits of our people have rendered it possible, even for the masses, to dispense with symbols, to attach themselves warmly to theological dogmas, and to feel enthusiasm about doctrinal abstractions. But to the simple Catholic of Spain these things were, as they still are, unintelligible.[13] The infrequency of religious subjects in Velázquez's oeuvre confirmed his exceptionalism, keeping him safely removed from the stigma of Catholic faith.

The influence of the monarchy was not so easily excised from Velázquez's life and art, however, and the king's conferral of nobility on to the artist, emblematized by the addition of the cross of Santiago to the self-portrait in *Las Meninas*, confirmed the powerful link between royalty and the fine arts. References to the Spanish monarchy and its centuries long involvement in the colonization of the Americas were certainly problematic to democratic and, increasingly after the Civil War, imperialistic American readers,[14] but the king's action also offered compelling support for the elevation of the artist in society. The third extract from Stirling Maxwell's *Velázquez and His Works*, devoted to Philip IV, focused almost exclusively on the Spanish monarch's collecting activities, with a brief report on his imperturbable nature. The editors of *The Crayon* decided not to reprint Stirling Maxwell's harsh portrayal of the king's reign, described as a "history of misrule at home, oppression, rapacity, and revolt in the distant provinces and

colonies, declining commerce, and bloody and disastrous wars,"[15] and picked up his text a bit further on with an appreciative discussion of his extraordinary patronage of literature and painting. Although the praise occasionally has the ring of a backhanded compliment ("To acquire works of Art was the chief pleasure of Philip, and it was the only business in which he displayed earnestness and constancy"; or, a bit later, "The gold of Mexico and Peru was freely bartered for the artistic treasures of Italy and Flanders"[16]), clearly, it was Philip's support of Velázquez that made possible such paintings as *Las Meninas*. Philip's patronage of a native son could be seen as a model for art patronage in the United States as American-born artists struggled for recognition in their own country. Despite the continuing presence of Spanish colonies on nearby Caribbean islands, Velázquez's associations with the royal family became a model for elevating art in the United States, a country still struggling to achieve cultural parity with Europe.

"WE HAVE NO OTHER WORD THAN THE IDEAL"

James McNeill Whistler (1834–1903), the first American to create a variation on *Las Meninas*, is an artist as tied to the history of art in Europe as the United States. Born in Lowell, Massachusetts, Whistler spent his childhood in Russia, where his father worked as an engineer on the tsar's railway, and in England with his half-sister Deborah, who married London surgeon and amateur etcher Seymour Haden. Whistler returned briefly to the United States after his father's death in 1849, but six years later the ambitious young man left again to study art in Paris. He never returned to the United States, although throughout his life he affected certain Americanisms, including a pronounced Southern drawl that came and went on command (Whistler's mother had relatives in South Carolina), a proclivity for American liquor, and a preference for American breakfasts. His exposure to Velázquez came through European sources, and in 1857 he took a break from his studies in France to see the collection of paintings attributed to the Spanish master at the Exhibition of Art Treasures in Manchester, England.[17]

From the first, critics connected Whistler's art to Velázquez. *At the Piano* (1858–1859; Taft Museum, Cincinnati), rejected from the Paris

Salon, appeared in 1860 at London's Royal Academy, where it received
a complimentary review:

> The name of Mr. Whistler is quite new to us. It is attached
> to a large sketch rather than a picture called *At the Piano*.
> This work is of the broadest and simplest character. A lady
> in black is playing at the piano, while a girl in white listens
> attentively. In colour and handling this picture reminds one
> irresistibly of Velázquez. There is the same powerful effect
> obtained by the simplest and sombrest colours – nothing but
> the dark wood of the piano, the black and white dresses, and
> under the instruments [*sic*] a green violin and violoncello case,
> relieved against a greenish wall, ornamented with two prints
> in plain frames. Simpler materials could not well be taken in
> hand; but the painter has known what to do with them.[18]

Along with the subdued color and heavy handling of the pigment,
the reduction of narrative and suggestion of arrested time in *At the
Piano* linked Whistler's work to that of Velázquez. Stirling Maxwell had
described *Las Meninas* as "a real room and real chance-grouped people,"
fixed "as it were, by magic, for all time on his canvas."[19] Whistler
achieved a similarly spontaneous effect in his image of a woman and
young girl who have come together to share a casual musical moment.[20]

Although delighted by the positive response to his work, Whistler
undoubtedly noted the warning embedded in the conclusion of the
review: "If this work be the fair result of Mr Whistler's own labour
from nature, and not the transcript of some Spanish picture the gentle-
man has a future before him, and his next performance will be eagerly
watched."[21] As the avant-garde began to expand the parameters of art,
innovation became one of the most effective means of attracting critical
notice. If Whistler were to develop his reputation as a modern painter,
he would have to avoid the taint of imitation. Between *At the Piano* and
The Artist in His Studio, Whistler's most direct response to *Las Meninas*,
the painter cemented his credentials with the avant-garde by painting
The White Girl, which, with Edouard Manet's *Déjeuner sur l'herbe* (1863;
Musée d'Orsay, Paris), became one of the most talked about paintings
at the 1863 Salon des Refusés. He may have been unhappy with the
critics' narrative explanations of this painting,[22] but at least they re-
frained from exploring its debt to Spanish or any other earlier sources.

Whistler's interest in the Spanish tradition reveals his relationship to
the realist movement in France at this early point in his career. Theories

of realism had undergone significant changes since Plato defined an elevated ideal against which all earthly reality stood as a mere reflection. In the hierarchical system of classical Greece, the ideal realm was eternal and unchanging, accessible only through philosophical inquiry, whereas the physical world, perceptible through the human senses, was constantly in flux. Artists might strive to attain the spiritual realm of the ideal, but their efforts were necessarily futile; their work, like the world through which they knew it, an imperfect copy. Realists in the nineteenth century, developing the Enlightenment ideas of such thinkers as Auguste Comte, argued in contrast that the real was manifested by the physical world of experience. They rejected the imaginative ideal in favor of empirical observation. As artists began depicting scenes of contemporary middle- and working-class life, painting their images in a straightforward, unidealized manner, nineteenth-century realism acquired democratic and moralistic associations.[23]

Whistler was associated with some of the most prominent French realists of the time. At the Louvre, he met and befriended Henri Fantin-Latour, who introduced him to Gustave Courbet. Courbet exhibited his manifesto of realism, *The Painter's Studio: A Real Allegory Summing Up Seven Years of My Artistic Life* (1855, Musée du Louvre, Paris), in his Pavilion of Realism at Louis-Napoléon's Universal Exposition of 1855. Like *Las Meninas*, Courbet's painting included the artist's self-portrait, a large canvas, a young child, and even a dog, along with a group of admiring onlookers gathered together in his studio.[24] The enigmatic subtitle of this painting, combining the physical and symbolic realms into the seeming contradiction of *A Real Allegory*, might profitably be related to the various theories of realism with which Courbet was contending.

Whistler may have conceived his ode to *Las Meninas*, *The Artist in His Studio* (Fig. 12), with Courbet's painting in mind, but his more immediate challenges were two large realist paintings by Fantin-Latour, *Hommage à Delacroix* (1864, Musée d'Orsay, Paris) and *Hommage à la Vérité: Le Toast* (1865, destroyed by the artist).[25] Fantin included in his first work, which caused a mild sensation at the Salon of 1864, portraits of himself and his friends, including Whistler, Manet, Alphonse Legros, and critics Champfleury and Baudelaire, posed in an egalitarian manner around the framed image of the recently deceased Eugène Delacroix. Fantin hoped in vain to build on the notoriety of this

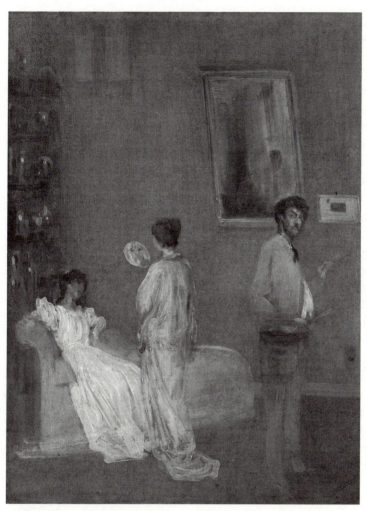

FIGURE 12. James McNeill Whistler. *The Artist in His Studio.* 1865–1866. Oil on paper mounted on panel. The Art Institute of Chicago: Friends of American Art Collection. Courtesy of The Art Institute of Chicago.

painting with his second painting, which at one point in its development included framed portraits of both Velázquez and Rembrandt surrounded by a group of contemporary artists and a female nude personifying Truth. The final painting retained only the artists and the nude, but critics disliked Fantin's awkward inclusion of an allegorical personage amid a gathering of real painters.

Whistler, avoiding such incongruity in *The Artist in His Studio*, explained in a letter to his friend that his painting would include a reunion in his studio of three artists, Fantin, Albert Moore, and himself, along with his model and mistress Joanna Hiffernan and another woman dressed *à la Japonaise*, in "an apotheosis of everything that will scandalize the Academicians; the chosen colors are charming. Me in pale gray – Jo in a white gown – la Japonaise (seen from behind) in the color of flesh – you and Moore in black – the back of the studio in gray – it is large, and will be close to ten feet high by six or seven wide."[26] Whistler had recently met Moore, who was making a name for himself with images of toga-draped women, and Whistler was beginning to move away from realism toward Moore's aestheticized arrangements of shape and color on canvas.

Developing at roughly the same time as nineteenth-century realism, aestheticism traced its roots to the writings of Immanuel Kant, who posited the autonomy of artistic standards and separated them from moral, political, or utilitarian functions. The rise of industrialism provided impetus to the movement as mass-produced goods flooded the market and producers became alienated from the fruits of their labor. Proponents of aestheticism strove to reinvest art with the properties lost through this process. Cultural critics promoted the handcrafted object, and artists acquired the responsibility for ensuring high quality. Art, eternal and absolute, became valued for its beauty alone, and painters strove to create art that moved away from the prosaic world of everyday life toward a transcendent ideal. Insistence on this other plane of reality brought aestheticism closer than realism to Plato's original conception.[27]

Whistler's several studies for *The Artist in His Studio* stand as introductory experiments with this mode, for although a watercolor and two oil studies for the painting exist, he never executed the final work.[28] The watercolor includes the two women in the foreground, with the artist in the background, framed by a door and barely indicated on the right. Whistler apparently derived the placement of this male figure from that of José Nieto in *Las Meninas*. Neither Fantin nor Moore appear in the watercolor, nor in the later two oils. These studies also include the artist and his two female companions, but the artist is in a more prominent position. He still appears on the right side of the canvas, but now he is in the foreground and, like Velázquez, Whistler stands before a canvas with palette and brushes in hand.

Although Whistler had planned a pilgrimage to Spain and the Prado in 1862, he had not actually completed the trip to see *Las Meninas* when he created *The Artist in His Studio*. He probably worked instead from a cropped photograph of the painting that is now in the Whistler archives in Scotland.[29] Avoiding the discomfort of a journey to Madrid, many aficionados knew Spanish art through photographs rather than personal experience, and at least one American periodical, citing the *Pall Mall Gazette*, claimed that Velázquez's work was particularly suited to black and white reproduction:

> Owing to the sober and subdued nature of his tones, [Velázquez's] pictures lose far less by being photographed than those, for instance, of his rival colorists, the Flemings and Venetians. It is even possible by means of photographs to guess, and that not too darkly, at that consummate mastery of handling, in which he was on a level with Teniers himself — a quality which makes him at once the model and the despair of all who seriously study painting in oil.[30]

As a scientific medium that ostensibly recorded the world with complete veracity, photography seemed the perfect mode of reproduction for the work of Velázquez, the painter who, as Stirling Maxwell wrote in his discussion of *Las Meninas*, "anticipated the discovery of Daguerre."[31] Photography and, more specifically, the prints produced by commercial establishments that specialized in reproductions of artworks in the galleries of Europe, made art more available to the people, and democratically minded Americans, concerned with promoting the fine arts in their own country, enthusiastically approved of its use for educational purposes. These imperfect reproductions lost the auratic power of the original artwork, but Whistler, relying on a photograph, reinvented the painting and endowed Velázquez's *Las Meninas* with new significance.[32]

In *The Artist in His Studio*, Joanna Hiffernan, who had posed earlier for *The White Girl*, wears a loose white dress and reclines on a couch. Standing next to and facing her is the unidentified model Whistler referred to as *la Japonaise*. Her hair piled loosely on her head, she wears a flowing kimono and holds a Japanese fan. Blue and white porcelain on a tall shelf and three Japanese scrolls adorn the wall behind the women.[33] Whistler's own figure dominates the right half of the composition, his prominence clearly asserted through his placement

highest on the canvas and closest to the picture plane. The work is painted with fluid brushstrokes in delicate gradations of grey, white, and peach, highlighted by gold accents. Like Velázquez, Whistler stands with his paint brush raised and pauses from his work to acknowledge the presence of the viewer. He holds his palette and extra brushes in the other hand, and behind him are a mirror and a small, framed print.

Both *Las Meninas* and *The Artist in His Studio* depict the working space of the artist. Velázquez's workroom, hung with paintings from the royal collection, was in the palace; aside from the paintings lining the back and side wall, the room held only the painter's easel and, of course, the various members of the court who came either to pose or visit. Whistler portrayed his studio at 7 Lindsey Row (now 101 Cheyne Walk) in London. Art Historian Sarah Burns refers to the studio in late nineteenth-century American life as a "nondomestic space, a private realm that had nothing to do with the family, mapping itself unambiguously in the territory of bohemia."[34] This characterization certainly holds true in Whistler's case. The women in his studio are neither wife nor daughters, and his relationship with Jo Hiffernan, the model in white, was decidedly unconventional. From dramatically different social classes, the couple never married. When Whistler's mother decided to move to London and run her son's affairs, Jo moved out of the home she shared with Whistler on Lindsey Row. Eventually, the two went their separate ways.

Although both Velázquez and Whistler depicted the studio, the importance of the painter in that space differs in Whistler's reinvention. Velázquez carefully maintained the proper relationship between painter and patron through the central placement of the princess and, reflected in the mirror on the back wall, the monarchs, but Whistler eliminated any sitters, most notably Fantin and Moore, who might challenge his dominant position. Velázquez's attire identified him as a courtier and, with the later addition of the red cross of Santiago, a member of the nobility; his status was established through his relationship to the royal family. Whistler is dressed in clothing that also marks his identity: The dandified light suit, white shirt, and thin black tie distance him from the rough dress of the realists and link him to the refined manners of the aesthetic movement. Neither the associations of monarchism found in *Las Meninas* nor the egalitarian politics of realism appear

in Whistler's depoliticized reinvention. Although Whistler metaphorically compared himself to Velázquez, an unsurprising act given his self-aggrandizing personality, he is subordinate neither to Velázquez nor anyone else.

Whistler may have known that Stirling Maxwell described *Las Meninas* as "the perfection of art which conceals art,"[35] and as in Velázquez's painting, the front of the canvas on which the artist is working is not visible. In fact, Whistler only suggests the location of his canvas, his raised brush proposing a position perpendicular to the right edge of the actual painting. On the back wall of the studio is a mirror. Whistler's head overlaps its bottom right corner, and the small matted print, hung horizontally at the same level as his head and perfectly parallel to the mirror's bottom edge, draws further attention to its place in the composition. In *Las Meninas*, the king and queen are clearly visible in the mirror's reflection, but Whistler's framed glass reveals only an impenetrable recession into space.

Elizabeth and Joseph Pennell, Whistler's friends and first biographers, noted that the artist must have employed a second mirror in order to paint *The Artist in His Studio*.[36] He lifts his brush in his left, rather than his right (painting) hand, so that his gaze at the viewer may also be understood as a gaze into a looking glass, placed parallel to the picture plane. Art historian Rhonda Reymond explored a multiplicity of readings for these two mirrors and convincingly interpreted Whistler's use of them as an act of obfuscation; the mirrors refuse to divulge the source of artistic creation, reserving that knowledge for the artist alone.[37] Whistler's painting, to recall Stirling Maxwell's description of *Las Meninas*, may depict "a real room and real chance-grouped people," but they are fixed "as it were, *by magic*, for all time on his canvas"[38] (emphasis mine).

Mirrors are also associated with fidelity to nature, and Whistler knew that Fantin-Latour, in *Hommage à la Vérité: Le Toast*, posed his personification of Truth with a small oval looking glass in one hand.[39] The Japanese fan held by *la Japonaise* in Whistler's painting has a similar shape, and the substitution of this unique object for one that, in reflecting the world suggests the possibility of endless replication, is significant. Realism, repetition, and industrial production in the nineteenth century served the masses; in contrast, the delicate hand-painted fan was available only to an individual with the means to acquire and the

sensibility to appreciate it.[40] Whistler used a mirror to create *The Artist in His Studio*, which is itself a sort of reflection of *Las Meninas*, yet at the same time the painting's readily visible brushwork declares that this is not a mass-produced copy. Peopling his studio with beautiful women and ornamenting his walls with carefully selected *objets d'art*, Whistler transformed Velázquez's painting into a declaration of art for art's sake, and cleverly crafted for himself an original self-portrait.

With *The Artist in His Studio*, Whistler explicitly asked the viewers of his work to compare him to the Spanish painter. He repeated the request on a number of occasions, basing *Harmony in Grey and Green: Miss Cicely Alexander* (1872–1873, Tate Gallery, London) on a Habsburg infanta, and even painting his late self-portrait, *Brown and Gold* (ca. 1895; Hunterian Museum and Art Gallery, University of Glasgow) in the guise of Velázquez's *Pablo de Valladolid* (ca. 1636–1637; Museo del Prado, Madrid). Critic William Crary Brownell, writing in 1879, became so tired of comparisons between Whistler and the Old Master that he objected in frustration: "He certainly is not Velázquez."[41] Brownell's observation came in the context of an extended consideration of Whistler's influences in which he asserted that "no one – certainly no one as sensitive and impressionable as Mr. Whistler – can be utterly free himself from the influences around him, from feeling them keenly, and from resenting them indignantly, if they displease him."[42] Whistler's sarcastic protest, "Why drag in Velázquez?" inspired more attention and future comparisons to the Spanish painter while simultaneously insisting on his independence from outside influence. Brownell tried to comply with Whistler's contradictory demands, framing the irascible painter as the embodiment of aestheticism in its highest form:

> But how delightful it is to reflect, that though he is not something other than he is – something which, with his traits, he could never become – nevertheless he is precisely what he is: perhaps the most typical *painter* and the most absolute artist of the time. That positive as is his delight in color, and great as is his success with it, . . . admirable as is his sense of form, . . . skilled as is his composition, it is after none of these things, nor the sum of them, that he especially seeks, but after something of which they are merely the phenomena and attributes, something for which we have no other word than the Ideal.[43]

"IT STANDS OUT LIKE NATURE ITSELF"

Although Whistler began promoting Velázquez as the quintessential artist of the aesthetic movement during the mid-1860s, others followed Stirling Maxwell and viewed the Spanish painter as a realist. The marking of Velázquez with the characteristics of realism prevailed in one of the more whimsical American publications on Velázquez, the fictional story of a chance encounter between the young painter and the creator of *Don Quijote*, Miguel Cervantes. Gabriel Harrison, the author of this story published in 1874, set a romantic stage for his narrative, placing Velázquez, a youth of nineteen, literally in a Sevillian garret, with everything "in a state of disorder; cobwebs, thickened with dust, hung in heavy festoons in the corners and from the rafters, while here and there could be seen standing around panels in preparation for paintings."[44] Velázquez was trying to paint, and seated on the floor is his subject, a lively beggar boy "with a face full of the most brilliant color, eyes sparkling with vivacity, and an expression of mirth so strongly developed as to make it almost impossible for the beholder to keep from laughing."[45] The artist had been at work for some time, and in his determination to capture the life of his subject on canvas, he moved backward and forward before the canvas, dipping his brush into color in a frantic attempt at reproducing on his canvas the flickering light reflected on the cheek of his model. In frustration, he finally throws his brushes at the canvas and collapses in exhaustion.

The encounter with Cervantes occurs the next morning, when Velázquez stumbles out of his studio and finds himself by chance before the doors of the Cathedral. Cervantes, dressed in a ragged camlet cloak, greets the dejected painter and, noting his young friend's despair, offers some philosophical advice. Ruefully gesturing toward his worn garment, the renowned author of *Don Quijote* admits, "I am poor; but, thank God, I am honest. Not only this, I have written not so much for others as for myself. There is an indescribable reward when we indulge the exercise of whatever genius God in his mercy may have graced us withal."[46] Then taking the painter in hand, the philosopher escorts Velázquez back to his attic studio, where the young artist poses the beggar boy with an aged water vendor as the picturesque pair in his early genre painting, *The Waterseller* (ca. 1620, Wellington Museum, London). When, after many hours of uninterrupted toil, Velázquez

once again begins to falter from fatigue, Cervantes stops him with a second piece of wise counsel: "Rest, my friend, your eyes require rest. Put your work aside for the day, and, to-morrow, you will see your picture as it is – admirable in color, composition and drawing."[47]

The morals to this story were easily appreciated by modern American readers, toiling in offices during long hours away from the home. Both Cervantes and his young protégé worked hard at their professions, and their strong work ethic paralleled a highly esteemed Protestant value. However, in an age when these urbanized businessmen feared fatigue from their fast-paced life, the reminder to rest offered a welcome excuse to take time from work to enjoy well-earned moments of restitution. Harrison's narrative struck other resonant chords as well: The author and the painter are "honest" men who rely on their own resources and independent initiative for success. The works of each ultimately achieved the recognition they deserve, able to stand, in the fictional painter's words, "as a peer with the lofty few."[48] In this story, Velázquez is a realist; he works exclusively from life, using his perceptive abilities to carefully duplicate the colors of nature in order to create his own original composition.

Given this emphasis on the realism of Spanish painting, it is not surprising to find Thomas Eakins (1844–1916) among the Americans who derived inspiration from Velázquez's art. Eakins supplemented his education at the Pennsylvania Academy of the Fine Arts with anatomy classes at Jefferson Medical College before departing for Paris in 1866 to enroll in the atelier of Jean-Léon Gérôme. A much more diligent student than Whistler, Eakins worked hard to master the academic style and expressed little interest in the modernist concerns of Courbet or Manet. After three years under Gérôme's precise tutelage, he changed studios to study briefly with Léon Bonnat, who was responsible for drawing his attention to Velázquez. Bonnat was trained at the Academy of San Fernando in Madrid, where Velázquez's paintings in the Prado had served as an important model. He published a tribute to the Spanish master thirty years later, in Aureliano de Beruete's monograph of 1898. There, Bonnat proclaimed Velázquez his "deity"; as a student, he recalled, he "knew his works by heart; how every hand, every head had been painted."[49]

Before returning to the United States, Eakins decided to follow Bonnat's example and travel to Madrid in order to see Velázquez's work

for himself. He journeyed with classmate Harry Humphrey Moore, ar-
riving in the capital city in early December 1869. The two men headed
immediately for the Prado, and Eakins' response to the paintings he
saw there is now quite famous. He wrote on 2 December to his father:

> [S]ince I am now here in Madrid I do not regret at all my
> coming. I have seen big painting here. When I had looked at
> all the paintings by all the masters I had known I could not
> help saying to myself all the time, its [sic] very pretty but its
> [sic] not all yet. It ought to be better, but now I have seen
> what I always thought ought to have been done & what did
> not seem to me impossible. O what satisfaction it gave me to
> see the good Spanish work so good so strong so reasonable so
> free from every affectation. It stands out like nature itself.[50]

Eakins spent considerable time studying Velázquez's technique, and
he took detailed notes on the technical points of *The Fable of Arachne
(The Spinners)* (ca. 1644–1648, Museo del Prado, Madrid) in his *Spanish
Notebook*:

> Here is how I think the woman tapestry-weaver was painted,
> the most beautiful piece of painting that I have seen in my
> life.
> He drew her without giving attention to the details. Only
> he put her head and arm well in place. Then he painted her
> very solidly without seeking or even marking any folds of the
> draperies, and perhaps he sought for his color harmonies in
> several repetitions painting over, for the color is excessively
> thick on the neck and all the delicate parts. Finally he glazed
> [or scumbled] over when everything was quite dry using
> tones already prepared and only then he finished his drawing
> indicating the details.[51]

Eakins incorporated these observations into his earliest composition, a
roughly worked image of gypsy musicians called *Street Scene in Seville*
(1870, private collection) that also owes debts to popular tourist pho-
tography and the illustrations of Gustave Doré.[52] He elaborated on
the spinning theme of Velázquez's painting several times later in his
career: *In Grandmother's Time* (1876, Smith College Museum of Art,
Northampton, Mass.), *The Courtship* (ca. 1878, Fine Arts Museums of
San Francisco), and *Homespun* (1881, Metropolitan Museum of Art,
New York) all depict the female figure hunched over an old-fashioned

spinning wheel. Recent scholars have linked these works to Eakins' personal interest in manual labor infused with mental concentration, as well as a national fascination with colonial American history prompted by the Philadelphia Centennial Exposition of 1876.[53]

Eakins did not explicitly mention *Las Meninas* in either his letters home or his notebooks, but five years after his return from Spain, he created one of his most dramatic and explicit statements of realism, *The Gross Clinic* (Fig. 13), a work in which Velázquez's painting became a vehicle for the representation of the American artist's ideals. The proportions of this canvas, like those of Whistler's painting, are similar to *Las Meninas*, but although Whistler's painting remained a small-scale study, Eakins' composition extends to a massive 96 × 78 inches. This is just one of the ways that Eakins evoked the "big painting" he had seen in the Prado. More obviously than his paintings of women spinning, *The Gross Clinic* intersects with traditionally defined masculine concerns: nationalism, professionalism, and an unflinchingly direct and unmediated relationship with nature.[54]

Elizabeth Johns and Michael Fried were the first to note connections between the work of Eakins and Velázquez. Johns developed a link between the pose of Dr. Samuel Gross, "with its emphasis on both dexterity and intelligence, action and thought," and that in Velázquez's portrait of the sculptor Martínez Montañés,[55] and Fried directly connected *The Gross Clinic* to *Las Meninas*, aptly suggesting that Eakins' work may function as a "metaphorical representation of the enterprise of painting."[56] Dr. Gross, bathed in heroic light, hand raised to display a scalpel dripping blood, functions as a variation on Velázquez's self-portrait. The esteemed surgeon wields his scalpel like a paintbrush, his surgical instruments in the foreground – multisized blades, retractors, and gauze bandages – standing in for the variety of paintbrushes, maulsticks, and rags with which the painter practices his art. Also, lest the reference to *Las Meninas* be missed, Eakins added a silhouetted figure in the doorway of Gross' amphitheater, posed in the position of Velázquez's José Nieto, who awaits the departure of the king and queen from the studio. Eakins did not include the doorway in preliminary studies for the paintings, and his addition suggests a desire to strengthen the visual connections with Velázquez's work.[57]

Although Velázquez works on a canvas, Dr. Gross works on a patient's body, a suitable substitution, given Eakins' devotion to anatomy

FIGURE 13. Thomas Eakins. *The Gross Clinic*. Ca. 1875. Oil on canvas. Jefferson Medical College, Philadelphia.

and science. Dr. Gross steps back from the operating table to speak with his audience, but unlike Velázquez in *Las Meninas*, he does not acknowledge the viewer in front of the canvas. Gross' audience is behind him, and among these young medical students sits the artist himself, diligently taking notes on the far right side of the canvas. Eakins acquired his painting knowledge from both the eminent surgeon and the illustrious painter. Elizabeth Johns argues that the surgeon, like

the painter, was striving to raise his status in late nineteenth-century society, and Eakins' desire to produce "big painting" is linked to his concerns about the professionalization of these two arenas of activity.[58] *Las Meninas* provided the American artist with a celebrated model for the elevation of art in his own time.

As professional activity was of considerable concern for late nineteenth-century men, the operating amphitheater depicted in *The Gross Clinic* is almost completely devoid of female actors. Whereas Velázquez constructed the narrative of *Las Meninas* and the arrangement of the people depicted in the canvas around the figure of the Spanish princess, Eakins positioned the sole woman in his painting on the far left. This darkly clad figure, often identified as the mother of the patient, covers her eyes and refuses to see or learn from the demonstration. She is subordinate to the men – attending doctors, clinic scribe, and medical students – who use their eyes to accomplish their respective tasks. Vision and visual observation play important roles in both surgery and art.

Equally important for both surgeon and painter are his hands, and almost all the people in Eakins' *Gross Clinic* hold either medical or writing instruments. Again, the lone woman provides the exception; her hands, spastically clenched in a uncontrolled gesture of horror, are empty. In a period of rapid industrialization, hand-made things were becoming less common, and painters, struggling to elevate their professional stature, found themselves in the ironic situation of working with their hands when such activity was becoming the exclusive domain of the laboring classes. The ubiquitous machines of modern society, repetitiously producing the same object, rendered the handiwork and the individuality of the artist both rarified and obsolete. *The Gross Clinic*, with its thick impasto and heavily worked surface, is clearly one of a kind, made by hand. Eakins' omission of the mirror in his reinvention of *Las Meninas* is also provocative, for the absence of this object so closely associated with reproduction reinforces the authenticity of the image. It was, in fact, the tendency for American audiences to read *The Gross Clinic* as a real medical procedure rather than as an artistic creation that led to its problematic reception.

Eakins submitted his painting to the Centennial Exposition of 1876, where the organizers made the controversial decision to hang the painting in the U.S. Army Post Hospital rather than with the art display in

Memorial Hall.[59] Because of its poor placement, the painting received few reviews, save the complimentary treatment offered by Eakins' good friend William Clark. Clark, who saw the painting at the Haseltine Galleries before the opening of the fair, acknowledged the unpleasant qualities of the painting's subject, but praised the artist's performance in patriotic terms. Clark wrote in the *Daily Telegraph*:

> Leaving out of consideration the subject, the command of all the resources of a thoroughly trained artist, . . . demand[s] for it the cordial admiration of all lovers of art, and of all who desire to see the standard of American art raised far above its present level of respectable mediocrity. This portrait of Dr. Gross is a great work – we know of nothing greater that has ever been executed in America.[60]

A similarly nationalist chord was sounded in the "Address to Artists of the United States," the Centennial's announcement to the art world:

> Patriotism demands that American Artists should use their utmost efforts to make the Art Department of the Exhibition fully equal in all respects to the other departments by the contribution of works which will show the advancement of art in the United States during the past hundred years, and display to the best advantage the peculiar characteristics of American art.

These works, the writers continued, would stand as a direct challenge to the European works on display at the fair:

> As contributions to the Exhibition will undoubtedly be made by the most celebrated foreign artists, . . . it is peculiarly important that American painters, sculptors, architects, engravers, and other art-workers should use every endeavor to fill the space to be assigned them with performances which will do honor to the country and to the occasion.[61]

What better way to challenge the European artists, Eakins may have decided, than to revise and Americanize a venerated Old Master? He replaced the Spanish monarchy, a discomforting subject in the democratic United States, with Dr. Samuel Gross, who, with the rise of the medical field, was one of the new urban professionals poised to become the royalty of the American nation. The infanta standing in splendor in

the center of *Las Meninas* performed no productive function. In Eakins' revision, the helpless woman is relegated to the edge (like Spain herself?), whereas the American man of action takes center stage.[62]

Although the response to *The Gross Clinic* at the Centennial was minimal, the public had several other opportunities to see Eakins' work during the late 1870s, most notably at the Second Annual Exhibition of the Society of American Artists in New York in 1879. Here, the painting's artistic precedents were introduced and discussed – critics pointed to David's *Death of Marat*, Géricault's *Wreck of the Medusa*, and of course, Rembrandt's *Anatomy Lesson of Dr. Tulp* – but Velázquez's *Las Meninas*, despite Eakins' several visual references to the Spanish painting, was inexplicably overlooked. The critic for the *New York Times* remarked on the dreadful subject matter, pointing specifically toward the "ugly, naked unreal thigh."[63] Although Whistler's interest in aestheticism had vastly outweighed realism in his earlier variation on Velázquez, Eakins' treatment of reality veered off in the opposite direction, dangerously careening beyond the limits of respectable art: "The violent and bloody scene shows that at the time it was painted," complained the *Times* critic, "the artist had no conception of where to stop in art, or how to hint a horrible thing if it must be said, or what the limits are between the beauty of the nude and the indecency of the naked. Power it has, but very little art."[64]

William Brownell, a critic who generally preferred the aesthetic to the real, included Eakins and his painting, which he called *An Operation in Practical Surgery*, in a discussion of "The Younger Painters of America." "Mr. Eakins," wrote Brownell in a consideration of the technical strength of the new art, "is another instance of a painter who knows how to paint." The reason for the work's controversy, he continued, "was its intense realism: the sense of actuality about it was more than impressive, it was oppressive. It was impossible to doubt that such an operation had in every one of its details taken place, that the faces were portraits, and that a photograph would have fallen far short of the intensity of reproduction which the picture possessed."[65] Brownell's comparison of *The Gross Clinic* to a photograph underlines his concern with differentiating the unique character of painting from a mechanical means of reproduction. In an age of black-and-white photography, it was undoubtedly Eakins' color – the brilliant red on Dr. Gross' thumb and forefinger, on the tip of his scalpel, and, of course, in and

around the wound on the patient's thigh – that sickened the jurors, moving them to relegate the work to the walls of a military hospital. Eakins, like the imaginary Velázquez painting a street urchin before the great Cervantes, had carefully compared the color of his pigment with nature. Eakins, however, providing no mediation between art and science, dissolved the distinction between pigment and body fluid. Red paint was actually transformed into blood, and the nausea it produced could only be cured in a medical display.

Although realism had its place in art, Brownell explained, the artist must introduce a modicum of beauty to temper its immediacy. "An exquisite and almost caressing art there is in the most intensely real Velázquez or the most superficially ugly Franz Hals," claimed Brownell in reference to the Old Masters of the realist tradition.[66] "Mr. Eakins's power almost makes up for the lack of poetry," he wrote of *The Gross Clinic*, and

> very little in American painting has been done to surpass the power of this drama. But if the essence of fine-art be poetic, an operation in practical surgery can hardly be said to be related to fine-art at all. Many persons thought this canvas, we remember, both horrible and disgusting; the truth is that it was simply unpoetic. The tragedy was as vivid as that of a battle-field, but it was, after all, a tragedy from which every element of ideality had been eliminated. . . . [Mr. Eakins] is distinctly not enamored of beauty, unless it be considered, as very likely he would contend, that whatever is is beautiful.[67]

Velázquez and Hals had added an aesthetic element to their realist art. Eakins, whose debt to the Spanish painter went unnoticed for more than a century, needed to model *The Gross Clinic* more closely on *Las Meninas* if he were to achieve similar success.

"MAY NOT THIS BREED AN IRRESPONSIBILITY...?"

Any artistry deemed lacking in Eakins' interpretation of *Las Meninas* was reintroduced six years later by John Singer Sargent (1856–1925), the nineteenth-century painter most frequently compared to the Spanish artist. William Brownell, ever present when the issue of modern art and Velázquez came together, began his 1883 discussion of *The Daughters of Edward Darley Boit* (Fig. 14) by acknowledging that Sargent, more than

FIGURE 14. John Singer Sargent. *The Daughters of Edward Darley Boit.* 1882. Oil on canvas. Boston, Museum of Fine Art. Gift of Mary Louisa Boit, Julia Overing Boit, Jane Hubbard Boit and Florence D. Boit in memory of their father, Edward Darley Boit. Courtesy Museum of Fine Art, Boston.

any other painter, "is Velázquez come to life again."[68] Like Whistler twenty years earlier, Sargent was compared to the Spanish painter by critics, friends, and other artists early in his career. The comparison was made so frequently, in fact, that critic Clarence Cooke, a vocal proponent of American art, finally demanded a halt in 1891 with an angry reiteration of Whistler's question, "Why drag in Velázquez?"[69] To repeatedly connect the painter with the Old Master served only to reopen the thorny issue of originality, imitation, and authenticity, considerable concerns in this period of modern American history.

Even more so than with Whistler, defining Sargent's nationality is difficult. Born in Florence to expatriated American parents, Sargent did not step foot in the United States until the age of twenty. He spent his childhood traveling through Europe, visiting the cultural sites and

restorative spas of Switzerland, Germany, Italy, and Spain. He first visited the Prado as a twelve year old when the family made a grand loop through the Iberian peninsula, visiting Barcelona, Tarragona, Valencia, Cordoba, Seville, Cadiz, Gibraltar, Malaga, and Madrid in the spring of 1868. The Sargents finally settled in Paris in 1874 to enable the ambitious youngster to begin his professional training in the atelier of Carolus-Duran. Sargent's teacher, a highly successful portrait painter, had studied Velázquez's work at the Prado from 1866 to 1868. He constantly commanded his students: "Velázquez, Velázquez, Velázquez, ceaselessly study Velázquez."[70] By this time, the vogue for Spain and Spanish painting was firmly entrenched in French art circles. Like Eakins ten years before Sargent, many American painters studying in Paris concluded their educations with a trip to Madrid.

Sargent traveled to Spain in the fall of 1879, accompanied by Charles-Edmond Daux and Armand-Eugène Bach, French art students whom he had met two summers earlier in Capri. By 14 October, he was studying Velázquez's work in the Prado.[71] Sargent painted at least thirteen copies after Velázquez, among them a detail from *The Fable of Arachne* (1879, the Alfred Beit Collection, Russborough, Ireland) and a smaller than life size version of *Las Meninas* (1879, private collection). Hamilton Minchin, a colleague from Carolus-Duran's studio, noted the summary brushwork of the copies and reported that in one, he "could count the brushstrokes." Questioning Sargent at the time, Minchin inquired with concern: "I suppose you hadn't time to finish it?" "On the contrary," the painter replied, "it is to the best of my ability just what I saw in the original."[72] Like Whistler, Sargent also collected photographs of Velázquez's paintings, which he kept in a personal scrapbook along with drawings and clippings that documented his career.[73]

Critics discerned the influence of Spain and Velázquez on Sargent's work almost immediately. At the Paris Salon of 1882, Sargent received considerable attention for his submission of *El Jaleo – Danse des Gitanes* (1882, Isabella Stewart Gardner Museum, Boston), the dramatic depiction of a Spanish dancer in a dark tavern, and *Portrait of Mlle ✳✳✳*, also known as *Lady with the Rose (Charlotte Louise Burckhardt)* (1882, Metropolitan Museum of Art, New York). The formal connections between Sargent's likeness of Charlotte Burckhardt and Velázquez's portraits, especially those of the young infantas and the court jesters,

are particularly intriguing. Katherine Nahum argues provocatively that Sargent's portrait of Charlotte, a young woman who may have hoped to win the artist's affection, combines the air of a marriageable princess on display at the royal courts of Europe with the futile attempts of a court jester for serious consideration.[74]

The Daughters of Edward Darley Boit, Sargent's most explicit variation on *Las Meninas*, was exhibited at the Galeries Georges Petit in Paris in December 1882 and again the following May at the Salon of 1883. The painting depicts the four daughters of a Boston lawyer and artist, a friend of the painter, artfully arranged in the hall of the family's rented Paris apartment.[75] The four girls, ranging in age from four to fourteen, are dressed in a similar fashion, with small alterations in clothing and stance to differentiate them from one another. All wear white dresses and black stockings, except the youngest, who has on a starched white frock rather than the neat pinafores of her older siblings. The younger girls face forward to acknowledge the presence of the viewer, but Florence, the oldest, turns away and leans against a tall Japanese vase.

Both *Las Meninas* and *The Daughters of Edward Darley Boit* represent the protected world of childhood. Like Velázquez, Sargent emphasizes the artificial nature of life at the Spanish court – suggested by the self-possession of the tiny princess amidst her attentive ladies-in-waiting – to create an aestheticized space where young girls and Japanese vases exist interchangeably. Critics pounced on the unusual juxtaposition (and semblance) suggested by the Boit daughters and these rarified objects. Arthur Baignères, for example, jokingly criticized the rendering of the girls' anatomy in an 1883 review for the *Gazette des Beaux-Arts* by praising the irreproachably painted Japanese porcelain, objects, he noted, that lack both lower extremities and ankles.[76] More recently, scholars explored the archetypal relationship between women and vessels, associating the physical and psychological development of the four daughters to their relative distance from infancy and motherhood.[77] Sargent literalized this theme by placing a doll between the open legs of the youngest child and by posing the oldest girl next to a vase, conforming her body to the vessel's pregnant swell.

Along with a shared depiction of childhood, *The Daughters of Edward Darley Boit* and *Las Meninas* are also similar in their unusual rendering of space. Both canvases depict rather boxy rooms, which contain their

inhabitants like *objets d'art*. A large doorway separates the Boit family's front hall from a dimly lit back room, in which two patches of light wittily suggest José Nieto's open door. Little is discernible in this dark interior, save the dim outline of three small Japanese vases, several frames on the wall, and a mirror. No image is visible in its reflective surface. Sargent's canvas is large, although it does not quite measure up in scale to its Spanish prototype. Its format also differs, the square proportions of the Boit painting creating a tension between the two dimensionality of the canvas and the three dimensionality of its fictive space.[78] Early critics professed confusion over Sargent's unusual composition; one critic called the painting "four corners and a void," and a second claimed the painting had been composed according to the new rules of a "four-corners game."[79]

A particularly significant deviation from *Las Meninas* is the absence of the artist's self-portrait. Neither of Sargent's predecessors omitted the element of self-portraiture from their reinterpretations of the Spanish canvas: Whistler accentuated his position in *The Artist in His Studio*, and Eakins had incorporated both his own self-portrait and his alter-ego, Dr. Samuel Gross, in *The Gross Clinic*. All three painters were responding to *Las Meninas* early in their careers, and the self-portrait made this painting particularly useful for young artists intent on placing their work in the professional arena of American art.[80] Yet Sargent's work is difficult to place. Is *The Daughters of Edward Darley Boit*, a canvas inspired by Spain and executed in France, an American painting? Does it engage academic or avant-garde, aesthetic or realist, stylistic concerns? Sargent's art straddles traditional definitions, destablizing these markers of national and artistic identity and making categorization difficult, if not impossible.

Although Velázquez included a mirror in *Las Meninas* to clearly indicate his connection to the Spanish monarchs, neither Whistler nor Sargent used the reflected image to provide an explanation of their work. They used rich brushwork and a luscious facture to emphasize their personal involvement in the creation of their paintings, but they confounded critics who strove to differentiate the originality of their work from their debts to Velázquez. William Brownell, reviewing the Salon of 1883, began his review of *The Daughters of Edward Darley Boit* by noting that many viewers claim Sargent, more than any

other artist, "is Velázquez come to life again." Yet he quickly moved beyond this observation to examine the ways in which Sargent did and did not compare to the Spanish Old Master. There is in Sargent's work, Brownell conceded, a "general truth and general point of view" that identifies his work with that of Velázquez, but the Boit painting lacks the necessary "effort for technical perfection." Distinguishing between ability and effort, Brownell argued that there is a great difference "between what may be called adequate expression, fairly enough, and realisation."

> [T]o be thoroughly satisfactory, a work of art must not merely satisfy the mind, it must please the sense as well; and if the foreground of a picture is as vacant and loose and the background as obscure as those of Mr. Sargent's "Children's Portraits," . . . the very basis on which the sense reposes and in which it delights is lacking, despite the palpable fact that what is positively necessary for a correct induction is provided in abundance. In other words, the painter's ideal is merely conveyed to the beholder without being perfectly realised, and there is not that fulfilment of one of the oldest and least adequate definitions of a work of art, viz., the interpenetration of an object with its ideal.[81]

Brownell's ideas apparently derive from a desire to reconcile the Platonic definition of realism, with its clear-cut distinction between the ideal form and its inferior reflection with late nineteenth-century empiricism. Artists can mediate between these two poles, and some – Brownell cites Velázquez as an example – are able to unite visible form with an abstract concept, bringing together the lines, colors, and brushstrokes of a painting with its archetype. The aim, to put the problem in different terms, was to unify the physical with the intellectual. Whistler, Brownell continued later in the review, was a modern painter who realized this goal,[82] but Sargent had left his foreground too "vacant and loose" and his background too "obscure" to merit such praise. Sargent had not provided enough evidence of hard work to make his accomplishment look convincing.

The issues of effort and labor come out more explicitly in the writings of Henry James, who penned an extended analysis of Sargent's art for *Harper's New Monthly Magazine* in 1887. Moral concerns were particularly important in James' discussion of the Boit

portrait. *The Hall with the Four Children*, as he called it, is a painting that prompts difficult questions about Sargent's ease and facility with paint:

> [T]his is the sort of work which, when produced in youth, leads the attentive spectator to ask unanswerable questions. He finds himself murmuring, "Ay, but what is left?" and even wondering whether it is an advantage to an artist to obtain early in life such possession of his means that the struggle with them, the discipline of *tâtonnement*, ceases to exist for him. May not this breed an irresponsibility of cleverness, a wantonness, an irreverence – that is vulgarly termed a "larkiness" – on the part of the youthful genius who has, as it were, all his fortune in his pocket?[83]

The economic metaphor for Sargent's talent is apt. In achieving so much, so early, and with so little apparent exertion, Sargent might fall into laziness, clearly a concern for Americans struggling to maintain a Protestant work ethic in a rapidly industrializing society. Gabriel Harrison's story about Velázquez and Cervantes, published only eight years earlier, had emphasized the long, arduous hours spent by the Spanish artist in his quest for success. Edward Boit's young daughters had the demeanor and bearing of four little princesses, a potentially unpopular air during the economic depression of the late 1870s and 1880s. The heavily worked impasto of *The Daughters of Edward Darley Boit* might assure viewers that labor, rather than legerdemain, went into his art, but Sargent needed to beware lest his brushwork appear sloppy, unfinished, wanton, or irreverent.

Observers throughout the nineteenth century continued to connect Sargent to Velázquez, as if such a comparison confirmed the American painter's constancy and worth. However, questions lingered for those concerned about the implications of such unconsidered parallels. When Sargent exhibited his portrait of Beatrice Goelet at New York's Society of American Artists in 1891, *Harper's Weekly* published a series of five interviews with the painter's contemporaries: William Merritt Chase, Julian Alden Weir, Kenyon Cox, John White Alexander, and Frank Millet.[84] Four of these five Americans evoked Velázquez in their discussion of Sargent's work, prompting critic Clarence Cook to respond in anger. "But must it not have occurred

to every reader of these remarkable interviews," Cook complained,

> that when four out of five persons interviewed insist on com-
> paring Mr. Sargent with Velázquez, there must be implied
> at least, a charge of imitation, that, if sustained, would make
> short work of any claim on his part to originality or even to
> style! This perpetual dragging-in of the name of Velázquez
> whenever Mr. Sargent's work is discussed, is most damaging
> to his reputation as an artist of the first rank.[85]

For Sargent to distinguish himself from Velázquez, and, by extension,
for American artists to differentiate themselves from their European
forebears, the daunting issue of imitation and originality needed to be
addressed.

"ABSOLUTE ORIGINALITY IN ART ... "

William Merritt Chase, one of the four guilty of linking Sargent
with Velázquez, was himself frequently compared to the great Spanish
painter, and a discussion of his *Hall at Shinnecock* (Fig. 15) takes the
problematic response to *Las Meninas* into the last decade of the nine-
teenth century. Chase made his first trip to Spain after complet-
ing his training at the Royal Academy in Munich. The teachers at
the Academy – Karl von Piloty, Wilhelm von Diez, and Wilhelm
Leibl – encouraged their students to paint unassuming models with
rapid brushstrokes and a deep Old Master's palette. Chase excelled
at this style, and his early painting *Keying Up – The Court Jester* (1875,
Pennsylvania Academy of the Fine Arts, Philadelphia) displays his mas-
tery of painterly technique as well as his affinity for the unidealized
subjects of Frans Hals and Diego Velázquez. Chase spent several weeks
during the summer of 1881 in the Prado copying the paintings of
Velázquez. He wrote about this experience to his friend Dora Wheeler:

> The Old Gallery of pictures is simply *magnificent*. Velázquez
> is the greatest painter that ever lived. How you would enjoy
> the pictures by him here. I am sure you would be inspired and
> encouraged; . . . I am copying at the Gallery, have finished one
> large full length figure by Velázquez and have begun another.
> I will not undertake to describe them as you will soon see
> them. I have been highly complimented on my first copy.

FIGURE 15. William Merritt Chase. *Hall at Shinnecock*. Ca. 1892. Pastel on canvas. Chicago, Terra Museum of American Art. Photograph courtesy the Terra Museum of American Art, Chicago.

> I understand that my way of going to work has created considerable talk here among the painters. It seems they are not accustomed to see a brush and paint used as freely as I find it necessary in order to get the character Velázquez got in his work.[86]

Returning to Madrid the following summer, Chase began to compose his own subject paintings. *A Spanish Bric-a-Brac Shop* (ca. 1882, private collection) depicts a traditionally attired merchant smoking a cigarette in front of a stall crowded with plates, jugs, tiles, and curios. Behind the lounging vendor, up a flight of steps and within the shop's interior, a woman working at a tapestry loom is clearly visible. In his organization of space and the inclusion of a textile worker, Chase inventively referred to Velázquez's *Spinners*. He further referenced the art of the Spanish master by including a miniature copy of *Calabazas* (ca. 1635, Museo del Prado, Madrid), high on the wall of the bric-a-brac shop.

Like Sargent, Chase visited the Prado multiple times during his career; on his early trips he copied Velázquez's *Menippus, Aesop,* a *Head of Philip IV,* and, not surprisingly, *The Spinners.*[87] Later, in the 1890s, he hung reproductions of Velázquez's supposed self-portrait from *The Surrender of Breda* (1636, Museo del Prado, Madrid) and a detail of *Las Meninas* on the walls of his Shinnecock studio.[88] When Chase took a class of students to Madrid in 1896, he again studied Velázquez, working at this time on copies of a *Portrait of María Teresa* and *Las Meninas.*[89] The time spent in front of this last painting provided an opportunity for what had become, by now, a familiar means of praising a contemporary American artist:

> One day while Chase was working at his copy of *Las Meninas* in the museum two Spaniards, picturesquely enveloped in dark cloaks, stopped to watch him. Mrs. Chase, who was with the artist, noticed that one was decorated with the Cross of Santiago. When the Spanish gentlemen saw the copy they removed their hats, and one made a remark in Spanish. When they walked away another watcher translated the Spanish nobleman's tribute to the masterly copy: "Velázquez lives again," he had said.[90]

Comparisons between Chase and the Spanish master were made so often that the organizers of a satirical exhibition held in Boston in 1906 included a painting by the fictitious William Emm, titled *A Chase, After Velázquez,* with the improbable dimensions of "50 long and 20 high."[91] Chase encouraged viewers to make this very connection by referencing *Las Meninas* in numerous works, including *Hide and Seek* (1888, The Phillips Collection, Washington, D.C.), *A Friendly Call* (1894–1895, National Gallery of Art, Washington, D.C.), *Ring Toss* (ca. 1896, private collection), and *An Infanta: Souvenir of Velázquez* (1899, private collection). This last depicts Chase's daughter, Helen Velázquez Chase, named in homage of the Spanish painter and amusingly dressed as a little princess.

Hall at Shinnecock depicts Chase's wife and two of his daughters in the splendidly ornamented central room of their eastern Long Island home.[92] This is a family with highly refined, even regal, taste: Mrs. Chase reclines in a plush easy chair while her daughters peruse an accordion-bound book of Japanese prints. A large oriental vase, not as

large as the vessels in Sargent's painting, yet comparable in size to the young girls, is displayed prominently at the right, effectively balancing the figure of their mother. Antique furniture, paintings and prints, bric-a-brac, textiles, and floral arrangements fill the room to profusion. As had Whistler for his carefully composed *Artist in His Studio*, Chase furnished this room and his adjoining studio with beautiful objects, imposing his artistic demands on the surroundings and the people who exist within it.

The format of *Hall at Shinnecock*, like the format of Sargent's *Daughters of Edward Darley Boit*, deviates from the verticality of *Las Meninas*, but the boxy space unquestionably refers to Chase's Spanish model. The recession into space is emphasized by the floor and ceiling boards of the room, reinforced by the parallel marks of pigment applied by the artist. The orthogonals forcefully direct the viewer's eye toward a vanishing point in the distant back. There, reflected in the mirrored door of a dark wood chest, is the artist himself. Chase offered with this painting yet another variation on Velázquez's self-portrait and mirror, one that conflates these two elements into one. The sequence of gazes in Chase's reinvention is important. The painter, in reflection, looks from the back of the room at his family. Mrs. Chase turns toward her children. One daughter gazes at the Japanese prints, while the other looks up to acknowledge a viewer outside the canvas. Completing this self-sufficient circle, Chase, implicitly present as both artist and father, brackets the family from the front in order to paint the scene. The painting domesticates Whistler's bohemian space, turns the studio into a home, and places the artist both in front of and behind his family.

The colors of *Hall at Shinnecock*, unlike *Las Meninas*, are light. Although Mrs. Chase wears an enveloping black day dress, the children are dressed in white, the vase closest to the viewer is marked by blue, and flickers of russet and gold permeate the interior. Chase worked on this canvas in pastel, rather than oil, creating a sumptuous surface texture that emphasizes the materiality of the pigment and the luxuriousness of the scene. The individual brush strokes are easily visible, and the artist's hand is clearly in evidence. Pastel allowed the artist to exaggerate the painterly qualities of his work, and his choice of color and medium evoke the paintings of the Impressionists Edgar Degas and Mary Cassatt, who by the early 1890s were having a profound influence on American art.

In a revealing parallel, Velázquez was also being compared to the Impressionists at this point in history. Kenyon Cox, American artist and critic, brought their similarities to the public's attention in his 1889 review of Carl Justi's *Diego Velázquez and His Times*, which had just been translated into English. Cox had little use for Justi's exhaustive research on the painter's sitters or his detailed discussion of the historical development of Spanish art, but he approved of Justi's comments about the modernity of the seventeenth-century artist. "With the Dutchmen and with Velázquez modern painting begins, but Velázquez is more essentially modern than the Dutchmen," explained Cox enthusiastically. The depiction of light and air, key ingredients for Impressionist painting, signaled the modernity of Velázquez's art:

> Assuredly Velázquez had an idealizing power of his own, but it lay in his intense perception of truth and beauty of light. Here he was the innovator and the unapproachable master. He was the first to see and to paint light and air, the first painter of aspects, the great and true *impressionist*. In his greatest works, "The Maids of Honor" [Las Meninas] and "The Spinners," the figures seem merely incidents, while the true subject is the light that plays upon them, and the air in front of them and around them.[93]

Cox disagreed with Justi's assertion that Velázquez was actually a modern *plein-airist*, but he did believe that what made the Spanish painter's work important was its relationship to contemporary art. The aristocratic subjects of Velázquez's famous paintings, Cox claimed, were less interesting than the artistic manner in which they were rendered. *Las Meninas*, by the end of the late nineteenth century, stood as a compelling model for a bewildering assortment of artistic and cultural choices.[94] Impressionism is typically described as a furthering of the realist impulse, yet in reducing *Las Meninas* to an "intense perception of truth and beauty of light," Cox blurred the distinction between realism and aestheticism. Such concepts had become interchangeable, conditioned by the needs of the critic rather than any stable meaning they may have possessed.

Both Cox and Colin Campbell Cooper, another American artist who weighed in on Velázquez's art during the early 1890s, were quick to reiterate many of the earlier justifications for the Spanish painter's acceptance in the United States. He was not, both writers explained, a

painter of religious subjects, thus exempting him from the Catholicism that marred the reputations (in American eyes) of other Golden Age Spanish painters. Cooper, a painter and the author of the breezy exegesis "A Spanish Painter," published in *Lippincott's Magazine*, also reaffirmed Velázquez's independence from outside influence and placed his art firmly in the context of empirical realism.[95]

No one, Cooper claimed, sounding a familiar note, "seems to have been able 'to hold the mirror up to nature' as did Velázquez."[96] The Spanish painter was, he continued, "the true father of realism."[97] Like other American commentators, Cooper carefully distinguished realism from reality by extending his definition of the former to include an element of artifice and illusion:

> After all, a picture is but the representation of a thing, not an actuality: as one of our greatest modern painters has put it, "not an imitation of reality, but a parallelism of Nature:" we do not want to see the figure breathe, but to fancy that it might breathe. And the artist is an important factor in our admiration of the work: we must look at Nature through his eyes and learn to appreciate her by his methods. The picture, therefore, which is a transcript or attempts to be a transcript of Nature loses its character as a work of art, because it becomes mere imitation.[98]

The adaptability of nineteenth-century definitions of realism is suggested by recalling Stirling Maxwell's discussion of Velázquez almost forty years earlier. The Spanish painter's portraits, the influential critic had intoned, literally "live, breathe, and are ready to walk out of their frames."[99]

Chase addressed the issue of imitation (and originality) in several contexts during the 1890s, referring both to his own art and that of Velázquez. His comments, drawing on almost thirty years of debate over the negotiation of these contradictory demands, suggest a clever reconciliation of the problem. In an interview, he explained the importance of earlier models for his artistic development:

> Absolute originality in art can only be found in a man who has been locked in a dark room from babyhood. He knows nothing of distance. He reaches out his hand to take an apple that is fifty feet away and he jumps three feet, stepping over a crack in the floor. Since we are dependent on others, let us frankly and openly take in all that we can. We are entitled to

it. The man who does that with judgment will produce an original picture that will have value.[100]

However, although offering judicious imitation as the means of assuring originality, Chase simultaneously held up Velázquez as a perfect specimen of "independence and individuality." Velázquez, erroneously claimed his American admirer in a short essay devoted to the Spanish painter, "had little or no school training. Like Shakespeare he seems, without the intermediate assistance of teacher and text-book, to have stepped into the proud position of foremost artist of his day." Later in the text Chase elaborated:

> Velázquez, with the independence of true genius, struck out for himself, and casting aside the dogmas and formulae of the schools of his day, painted after his own good fashion, and with such results that we to-day are lost in amazement that one particular genius should so far have excelled and advanced before his age.[101]

Chase concluded his essay on a contemporary note, decrying the poor state of art patronage in the United States and declaring his conviction that were Velázquez to arrive in New York in the 1890s, no person with the daring of Philip IV would step forward to patronize his art. American artists at the top of their profession were still forced to supplement their incomes with ancillary work. Chase taught throughout his career at the Art Students League and later the New York School of Art, Sargent chafed at his need to paint portraits of the wealthy, and Eakins, after his suspension from teaching at the Pennsylvania Academy of the Fine Arts, lived in remarkably humble circumstances. In his essay on Velázquez, Chase seemed to be harking back to an earlier complaint about the value of art in American society. He used the Spanish painter's association with the monarchy to elevate the art of painting, but reassured his readers that in following Velázquez modern artists will not develop aristocratic qualities inappropriate to the democratic tradition. This, Chase explained, was "a man of *extreme modesty*.... Velázquez, enjoying as he did the king's favor, and conscious of his own superior artistic power, had too sensible a mind to be vain and assuming."[102]

Chase brought many of these ideas together in *Hall at Shinnecock*. The interior space reminds viewers of Velázquez's famous painting, with its attendant anecdote about Philip IV painting the cross of

Santiago on the breast of the artist. However, the nobility of the modern American painter is modified by Chase's representation of his home, for he, like the ideal American, is a man of solid family values. Chase assured his American audience, in a time when the United States was reaching for international influence, that he had honorably earned his home, his castle. He supported his family with his art, and he painted the room and its inhabitants with rich Impressionist brush strokes that proudly testify to his personal involvement with the painting's production. *The Hall at Shinnecock* is both imitative and original, realistic and aestheticized. Ten years earlier, William Brownell had criticized Sargent for making his work look too easy. The painter to whom he had directed readers desirous of more honestly labored art was none other than William Merritt Chase.[103]

"WHY DRAG IN VELÁZQUEZ?"

James McNeill Whistler had not expected an answer when he asked his infamous question, as his biting queries were usually designed to silence his audience rather than foster discussion. Yet dragging in Velázquez, and, more particularly, his painting of *Las Meninas*, was a popular move by American artists in the late nineteenth century, and the question demands this extended consideration. Portraiture was the most well-established genre of art in the United States, and Velázquez was primarily a painter of portraits. Nineteenth-century viewers perceived *Las Meninas* as a transparent work of art, a straightforward record of a moment in time, a painting unencumbered by interpretations that limited its possibilities. It could mean any number of things to any number of people, and the mutability of its significance provides a key to its popularity. Painters and critics associated Velázquez's art with seemingly contradictory traits: It was simple yet elegant, part of, yet separate from a grand artistic (and aristocratic) tradition, frankly labored yet magically unrehearsed. American artists used *Las Meninas* to define the relationship between art and life. Their results varied dramatically, from realism to aestheticism, and from Whistler to Eakins and Sargent and Chase.

Originality was a particularly troublesome issue for these painters, and frustration over the repeated comparison of modern American artists to Velázquez led in 1900 to an essay by Philip Leslie Hale titled, "Velázquez and All the Little Velázquez's."[104] Hale devoted most

of his essay to an analysis of Whistler and Sargent, in a circular and perhaps futile attempt at pinpointing their differences from the Spanish painter. Whistler paints work that is too elusive, he claimed, and Sargent too concrete, to warrant such monikers as "a modern Velázquez." However, Hale's explanations, in the end, leave the reader confused. The problem ultimately derives from changes occurring in nineteenth-century art theory as demands for innovation began to clash with the traditional studio practice of learning from and responding to the past. Patricia Mainardi, in an essay on "Copies, Variations, and Replicas," astutely connected this conundrum to "the contradictory modernist fetish for both originality, in the cultural realm, and exact reproduction in the industrial realm."[105]

Mainardi is interested in how this dilemma was resolved by such high European modernists as Delacroix, Manet, and Monet, but the problem was also of acute concern to artists in the postbellum United States. Big business, mass production, internationalization, and a young art community resulted in a complicated mix of needs: a preference for fine and hand-crafted material goods, a means of integrating art into a democratic society, and a way to compete with Europe. In fact, American worries about the originality of its artists, especially those deriving inspiration from Velázquez, are undoubtedly connected to a desire to distinguish them from their European predecessors. Velázquez was an eminent model for modern American artists, but association with a seventeenth-century Spanish court painter muddied the quest for a definable national style. *Las Meninas* became a work through which Americans explored their concerns about appropriate artistic styles and their implications, the relative importance of imitation and authenticity, and the distinctions between national and international identity. Velázquez was transformed into the most modern of Old Masters, and America's modern Velázquezes – Whistler, Eakins, Sargent, and Chase – offered the late nineteenth-century art public masterly American art.

NOTES

This essay was completed thanks to a grant from the Humboldt State University Faculty Development Program. Thanks also to the following individuals for reading and commenting on my work during its various stages of completion: Marco Katz, Susan Larkin, Sally Mills, Anne Paulet, and Wendy Robertson.

1 Whistler's question first appears in "Two Whistler Stories," *Suffolk Chronicle*, 26 July 1884. See Sarah Burns, *Inventing the Modern Artist: Art and Culture in Gilded Age America* (New Haven and London: Yale University Press, 1996), p. 367, n. 2.

2 For a comprehensive overview of the status of art in the United States, see Neil Harris, *The Artist in American Society; The Formative Years, 1790–1860* (New York: [1966]).

3 "Reviews: Velázquez and His Works. By William Stirling," *The Crayon* 1 (2 May 1855), p. 279.

4 Ibid.

5 Ibid., p. 280.

6 Ibid.

7 Ibid.

8 William Stirling [Maxwell], *Velázquez and His Works* (London: 1855), p. 171.

9 Ibid., p. 174.

10 Stirling Maxwell's *Velázquez and His Work* was easily acquired by readers in the United States during the period under consideration. Charles Boyd Curtis, author of the the first American book on Velázquez, also included this information in *Velázquez and Murillo: A Descriptive and Historical Catalogue* (London and New York: 1883). This book is, by the author's account, the "materials for a catalogue," or a catalogue raisonné, rather than a critical analysis of the work of these two Spanish painters. Curtis became interested in Spanish painting during an extended visit to the peninsula, and indulging his passion for collecting, he compiled one of the best collections of reproductive prints and photographs of the time. His method was orderly, even mathematical, and his goal was to catalog the entire corpus of each of the artists under consideration.

11 "Reviews: Velázquez and His Works," p. 279.

12 Sidney Ahlstrom discusses the influx of Catholic immigration in the United States in *A Religious History of the American People* (New Haven: Yale University Press, 1972).

13 Stirling Maxwell, quoted in "The Church and the Artist in Spain," *The Crayon* 1 (21 June 1855), p. 392.

14 The impact on nineteenth-century American artists of political relations between the United States and Spain is discussed in my essay, "Sol y Sombra: American Artists Explore the Sunlight and Shadows of Spain," in *España: American Artists and the Spanish Experience* (Exh. cat., New York: Hollis Taggart Galleries and New Britain Museum of American Art, 1998).

15 Stirling [Maxwell], *Velázquez and His Works*, p. 46.

16 Stirling Maxwell, quoted in "Philip IV of Spain," *The Crayon* 2 (11 July 1855), p. 21.

17 Whistler's connections to the United States are discussed by Nicolai Cikovsky, Jr. with Charles Brock in "Whistler and America," *James McNeill Whistler* (Exh. cat., London: The Tate Gallery, 1994), pp. 29–37.

18 [Tom Taylor], *The [London] Times*, 17 May 1860; reprinted in Roland Anderson and Anne Koval, *James McNeill Whistler: Beyond the Myth* (New York: 1994), p. 89.

19 Stirling [Maxwell], *Velázquez and His Works*, p. 173.

20 Identification of the models, Whistler's half-sister Deborah and her daughter, furthers the atmosphere of casual domesticity evident in *At the Piano*.

21 [Tom Taylor], *The [London] Times*, 17 May 1860; reprinted in Anderson and Koval, *James McNeill Whistler*, p. 89.

22 Whistler was particularly unhappy when critics linked *The White Girl* to a popular story by Wilkie Collins called "The Woman in White." See Anderson and Koval, *James McNeill Whistler*, p. 106.

23 This summary of realism is based on a lecture by English Professor Mary Ann Creadon, Humboldt State University, November 2000.

24 Sally Mills first made this astute observation after reading an earlier version of this essay.

25 Both Rhonda Laseman Reymond and Eric Denker have written important considerations of this work, to which I am indebted. See Reymond's "James McNeill Whistler's 'The Artist in His Studio': A Study in the Concealment and Revelation of an Artist" (M.A. Thesis, University of Georgia, 1997) and Denker's *In Pursuit of the Butterfly: Portraits of James McNeill Whistler* (Exh. cat., Washington, D.C.: National Portrait Gallery, 1995).

26 "J'ai pour le salon une réunion de nous autres à mon tour – j'en ai fait une esquisse qui est bigrement bien – ça représente l'intérieur de mon atelier – porcelaine et tout! Il y a toi et Moore, la fille blanche assise sur un canapé et la Japonaise qui se promène! En fin un apothéose de tout ce qui peut scandaliser les Académiciens, les couleurs choisies son charmantes. Moi en gris clair – la robe blanche de Jo – la robe couleur de chair de la Japonaise (vue de dos) toi et Moore en noir – le fond de l'atelier gris – c'est en hauteur, et aura à peu près dix pieds de haut, sur six ou sept de large – ." My translation, Whistler to Fantin-Latour, 16 August 1865, Library of Congress; reprinted in Andrew McLaren Young, et al., *The Paintings of James McNeill Whistler* (New Haven and London: Yale University Press, 1980), p. 37.

27 Gene H. Bell-Villada, *Art for Art's Sake & Literary Life* (Lincoln and London: University of Nebraska Press, 1996), pp. 1–12 and Alison Byerly, *Realism, Representation, and the Arts in Nineteenth-Century Literature* (Cambridge: Cambridge University Press, 1997), pp. 184–95.

28 The watercolor, called *In the Studio* and dated 1865, is in the Detroit Institute of Arts. See Margaret F. MacDonald, *James McNeill Whistler: Drawings, Pastels and Watercolours* (New Haven and London: Yale University Press, 1995), p. 105. The two oil studies, also dated 1864, are *The Artist's Studio*, in the Municipal Gallery of Modern Art, Dublin, and *Whistler in His Studio*, in the Art Institute of Chicago. The features of the figures are slightly more finished in the Chicago painting.

29 Nigel Thorp, "Studies in Black and White: Whistler's Photographs in Glasgow University Library," in Ruth E. Fine, ed., *James McNeill Whistler: A Reexamination: Studies in the History of Art* 19 (Washington, D.C.: National Gallery of Art, 1987), pp. 88–9. Whistler wrote to Fantin on 10 November 1862, shortly before his aborted Spanish trip, that he hoped to bring photographs of Spanish works back from Madrid. See Anderson and Koval, *James McNeill Whistler*, p. 122.

30 "Art Items," *Philadelphia Evening Bulletin*, 20 September 1870, p. 2.

31 Stirling [Maxwell], *Velázquez and His Works*, p. 173.

32 Walter Benjamin discussed both the egalitarian possibilities of photography and the original's loss of aura in "The Work of Art in the Age of Mechanical Reproduction," [1936] in *Illuminations*, ed. Hannah Arendt (New York: 1968), pp. 217–51.

33 The juxtaposition of Spanish painting with the arts of Asia is curious and needs additional consideration. Of the four artists currently under consideration, three of them (Whistler, Sargent, and Chase) explicitly insert motifs drawn from Asian art into their variations on *Las Meninas*.

34 Sarah Burns, *Inventing the Modern Artist*, p. 254.

35 Stirling [Maxwell], *Velázquez and His Works*, p. 173.

36 Elizabeth Robins and Joseph Pennell, *The Life of James McNeill Whistler* (new and rev. ed., Philadelphia: 1920), p. 130.

37 Reymond, "James McNeill Whistler's 'The Artist in His Studio,'" pp. 96–102.

38 Stirling [Maxwell], *Velázquez and His Works*, p. 173.

39 Mirrors were also traditionally associated with vanity, and this emblem of sinfulness could have conceivably been employed by critics antagonistic to aestheticism to condemn its lack of moral engagement.

40 The issues of imitation and authenticity receive extensive treatment by Miles Orvell, in *The Real Thing: Imitation and Authenticity in American Culture, 1880–1940* (Chapel Hill and London: The University of North Carolina Press, 1989). My ideas have also been influenced by T.J. Jackson Lears, *No Place of Grace: Antimodernism and the Transformation of American Culture, 1880–1920* (Chicago and London: University of Chicago Press, 1981).

41 William Crary Brownell, "Whistler in Painting and Etching," *Scribner's Monthly Magazine* 18 (August 1879), p. 495.

42 Ibid., p. 494.

43 Ibid., p. 495. Sarah Burns identifies a similarly dualistic understanding of Whistler's persona in "Old Maverick to Old Master: Whistler in the Public Eye in Turn-of-the-Century America," *American Art Journal* 22 (1990), pp. 29–49.

44 Gabriel Harrison, "The Two Artists," *The Aldine* 7 (March 1874), p. 52.

45 Ibid.

46 Ibid., p. 53.

47 Ibid.

48 Ibid.

49 Léon Bonnat, "Preface," in Aureliano de Beruete, *Velázquez* (London: 1906), p. xvii.

50 Thomas Eakins to Benjamin Eakins, Madrid, 2 December 1869, Charles Bregler's Thomas Eakins Collection, Pennsylvania Academy of the Fine Arts, Philadelphia, quoted in Kathleen A. Foster and Cheryl Leibold, *Writing About Eakins: The Manuscripts in Charles Bregler's Thomas Eakins Collection* (Philadelphia: University of Pennsylvania Press, 1989), p. 211. Eakins contrasted his appreciation for Velázquez with his opinion of Rubens, "the nastiest most vulgar noisy painter that ever lived."

51 Translation in Goodrich, *Thomas Eakins* (Cambridge, MA: Harvard University Press, 1982), vol. 2, p. 62, "Spanish Notebook," Charles Bregler's Thomas Eakins Collection, Pennsylvania Academy of the Fine Arts, Philadelphia: "Voici comme

quoi [overstrike] je pense être peinte la femme filandière de tapis: le plus beau morceau de peintre que j'ai vu de ma vie. Il l'a dessinée sans faire attention aux traits. Seulement il a mis sa tête et bras bien en place. Alors il l'a peinte très solidement sans chercher ou même marquer aucun plis des draperies, et peut être a-t-il cherché les harmonies de couleur à plusieurs reprises peignant là-dessus car la couleur est excessivement épaissse sur la cou et toutes les parties delicates. Enfin il a frotté là-dessus quand tout était bien sec se servant de tons déjà preparé et alors seulement a-t-il fini son dessin indiquant les traits."

52 Gerald Ackerman connected Eakins's *A Street Scene in Seville* to Gérôme's *The Pifferari* (1859; private collection) in "Thomas Eakins and His Parisian Masters," *Gazette des Beaux-Arts*, ser. 6, 73 (April 1969), pp. 235–56. There are also compositional similarities between Eakins's painting and photographs of Spain by Jean Laurent and José Sierra Payba, bought by Eakins in either France or Spain and now in the Seymour Adelman Collection, Bryn Mawr College Library, as well as Doré's *Musiciens ambulants*, published in "Voyage en Espagne," *Le Tour du monde* 8 (2nd sem., 1863), p. 356.

53 Sally Mills explored developed the links between the spinning theme and the colonial revival in her catalog entry for Eakins's *The Spinner* (ca. 1878, Worcester Art Museum) in John Wilmerding, ed., *Thomas Eakins* (Exh. cat., London: National Portrait Gallery, 1993), pp. 95–6.

54 For an extensive exploration of masculinity in the late nineteenth century, see Martin A. Berger, *Man Made: Thomas Eakins and the Construction of Gilded Age Manhood* (Berkeley: University of California Press, 2000). Berger mentions only briefly *The Gross Clinic* in his study of Eakins' art.

55 Elizabeth Johns, *Thomas Eakins: The Heroism of Modern Life* (Princeton: Princeton University Press, 1983), p. 75. Turning later in her book to Eakins' *William Rush Carving His Allegorical Figure of the Schuylkill River*, a work contemporary to *The Gross Clinic*, Johns again connected the two painters by comparing the "gentlemanly dress and graceful bearing" of William Rush to "the aristocratic tradition of Velázquez in his studio paintings at the Prado." Johns, *Thomas Eakins*, p. 100.

56 Michael Fried, *Realism, Writing, and Disfiguration in Thomas Eakins and Stephen Crane* (Chicago: University of Chicago Press, 1987), p. 16. David Lubin identifies *Las Meninas* as one of the sources behind *The Agnew Clinic*, Eakins' later surgical painting of 1889, in *Act of Portrayal: Eakins, Sargent, James* (New Haven: Yale University Press, 1985), pp. 56–7.

57 The figure in the pose of José Nieto has been identified as the orderly, Hughey O'Donnell. The other man is Dr. Samuel W. Gross, son of the surgeon. See Julie S. Berkowitz, *"Adorn the Halls": History of the Art Collection at Thomas Jefferson University* (Philadelphia: Thomas Jefferson University, 1999), p. 169.

58 Johns, *Thomas Eakins*, p. 46–81.

59 A complete summary of the literature is found in Berkowitz, *"Adorn the Halls,"* pp. 162–83; 199–211.

60 Quoted in Berkowitz, *"Adorn the Halls,"* p. 201. Berkowitz points out that although the art press virtually ignored Eakins' painting, several medical journals made a point of discussing it. See Berkowitz, pp. 204–6.

61 Quoted in Berkowitz, *"Adorn the Halls,"* p. 164.

62 Anne Paulet made this point after reading an early draft of this essay.

63 Quoted in Berkowitz, *"Adorn the Halls,"* p. 207.

64 Quoted in Berkowitz, *"Adorn the Halls,"* p. 207.

65 William Crary Brownell, "The Younger Painters of America," *Scribner's Monthly* 20 (May 1880), p. 4.

66 Ibid., p. 14.

67 Ibid., pp. 12–13.

68 William Crary Brownell, "American Pictures at the Salon," *The Magazine of Art* 6 (1883), p. 498. Brownell's comment was recently incorporated into Marc Simpson's excellent summary of criticism, "Sargent, Velázquez, and the Critics: 'Velázquez come to life again,'" *Apollo* 148 (September 1998), pp. 3–12. Simpson finds that many of Sargent's allusions to Velázquez are elusive rather than direct, and the critics generally restrained themselves to formal comparisons between the two painters.

69 [Clarence Cook], "Why Drag in Velázquez?" *The Studio*, n.s. 6 (16 May 1891), pp. 233–4.

70 "Velázquez, Velázquez, Velázquez, étudiez sans relache [*sic.*] Velázquez." My translation, Evan Charteris, *John Sargent* (New York: 1927), p. 28.

71 Sargent signed for permit #630 on 14 October 1879, giving his address as Salud 13. The subjects that he intended to copy and the duration of his stay are not stated. *Libro de registro de los señores copiantes*, 27 October 1873–30 April 1881, Box L-34, Archives of the Museo del Prado, Madrid. See also Juan J. Luna, "John Singer Sargent y el Museo del Prado," *Historia 16* 13 (June 1988), pp. 100–07.

72 Hamilton Minchin, "Some Early Recollections of Sargent," *The Contemporary Review* 127 (June 1925), pp. 737–8.

73 The scrapbook was part of the Ormond gift to the Metropolitan Museum of Art, New York.

74 Katherine Coburn Harding Nahum, "The Importance of Velázquez to Goya, Manet and Sargent" (Ph.D. Dissertation, Boston University, 1993), pp. 211–17. Sargent's refusal to form a wedded partnership during the course of his life has led some recent critics to speculate on his sexual preferences. The most extended considerations of Sargent's sexuality are by Trevor Fairbrother. See especially "A Private Album: John Singer Sargent's Drawings of Nude Male Models," *Arts Magazine* 56 (December 1981), pp. 70–80 and "Sargent's Paintings and the Issues of Suppression and Privacy," in *American Art around 1900: Lectures in Memory of Daniel Fraad; Studies in the History of Art* 37 (Washington, D.C.: National Gallery of Art, 1990), pp. 28–49.

75 The issue of professionalism, so important for Eakins' *Gross Clinic*, might also be applied to a consideration of the regal young girls in *The Daughters of Edward Darley Boit*. Boit was a lawyer, another of the new urban professionals who performed a job with their minds not their hands, and reaped economic rewards for their difficult-to-quantify work. See also Burton J. Bledstein, *The Culture of Professionalism: The Middle Class and the Development of Higher Education in America* (New York: 1978). Thanks to Anne Paulet for directing me to this source.

76 "A ce morceau capital, où M. Sargent a mis ses tons les plus brillants, je préfère la fillete du coin avec son tablier blanc et se bas noirs. Hélas! Ils ne sont pas assez noirs pour dissimuler la défecteuse anatomie des chevilles. Les potiches, elles,

n'ont ni bas ni chevilles, aussi sont-elles enlevées avec un brio irréprochable." [Of all this capital painting, on which Mr. Sargent has applied his most brilliant tones, I prefer the young girl in the corner with her white apron and dark lower extremities. Alas! They are not dark enough to hide the defective anatomy of her ankles. The pots, having neither lower extremities nor ankles, are painted with an irreproachable brio.] My translation, Arthur Baignères, "Première Exposition de la Société Internationale de Peintres et Sculpteurs," *Gazette des Beaux-Arts* 27 (February 1883), p. 190.

77 Elizabeth Broun explored some of these ideas in the context of Whistler's art in "Thoughts that Began with the Gods: The Content of Whistler's Art," *Arts Magazine* 62 (October 1987), pp. 36–43. Authors applying similar ideas to Sargent's *Daughters of Edward Darley Boit* include David M. Lubin in *Act of Portrayal*, pp. 83–122 and Susan Sidlauskas in *Body, Place, and Self in Nineteenth-Century Painting* (Cambridge: Cambridge University Press, 2000), pp. 61–90.

78 William H. Gerdts pointed to the square format of Sargent's painting in "The Square Format and Proto-Modernism in American Painting," *Arts Magazine* 50 (June 1976), pp. 70–75.

79 As quoted in Gerdts, "The Square Format," p. 73.

80 Sally Mills, commenting on an earlier version of this essay, encouraged me to consider the relationship between the self-portrait in *Las Meninas* and its use by these three artists so early in their careers.

81 All quotes in the previous paragraph are from Brownell, "American Pictures at the Salon," p. 498.

82 "But one need not go so far back as Velázquez for an illustration which may be found in this same Salon," continued Brownell. "If in modern times there has been painted a picture thoroughly imbued with the tradition of the golden age of art, it is Mr. Whistler's portrait of his mother." Brownell, "American Pictures at the Salon," p. 498.

83 James' use of the word *tâtonnement*, meaning to feel one's way, suggests that artistic achievement is only valid when uncertainty and struggle are part of the process. Henry James, "John S. Sargent," *Harper's New Monthly Magazine* 75 (October 1887), p. 689.

84 "What the Artists Think of Sargent's 'Beatrice,'" *Harper's Weekly* 35 (9 May 1891), pp. 346–47.

85 [Cook], "Why Drag in Velázquez?" p. 234.

86 William Merritt Chase to Dora Wheeler, Madrid, 24 July 1881, Archives, Cincinnati Art Museum, Gift of Candace Stimson.

87 These copies, among others, were included in a sale to raise funds for Chase's 1896 trip to Spain. See "Catalogue of Paintings, Studio Appointments, Curios, Bric-a-Brac,... Belonging to William Merritt Chase, N.A.," (Exh. cat., New York: American Art Association, 7–11 January 1896).

88 They are visible in photographs of Chase's studio illustrated in Nicolai Cikovsky, Jr., "Interiors and Interiority," in D. Scott Atkinson and Nicolai Cikovsky, Jr., *William Merritt Chase: Summers at Shinnecock* (Exh. cat., Washington, D.C.: National Gallery of Art, 1987), figs. 10 and 22, pp. 27 and 52.

89 According to the Prado copyist registers, Chase began these copies on 25 and 29 February 1896 and removed them from the museum two years later, on a return

trip of 22 September 1898. Chase's copyist permit for *Las Meninas* was #132. *Libro de registro de los señores copiantes*, 2 January 1896–31 December 1897, Box L-2, Archives of the Museo del Prado, Madrid.

90 Katharine Metcalf Roof, *The Art and Life of William Merritt Chase* (New York: 1917), pp. 168–9.

91 *Illustrated Catalogue: A Lone [sic.] Exhibition of the Masters of Modern Caricature and Others* (Exh. cat., Boston: The Copley Society, 1906).

92 The central hall, in which *Hall at Shinnecock* was painted, provided direct access by means of a short flight of stairs to the room that was more officially designated Chase's "studio." Chase used both rooms as the setting for his Shinnecock interiors. See Cikovsky, "Interiors and Interiority," pp. 46–7.

93 [Kenyon Cox], "Justi's Velázquez," *The Nation* 49 (18 July 1889), p. 58.

94 Nicolai Cikovsky has connected the reflective surfaces in paintings like Chase's *Hall at Shinnecock* to both "the standard of perfect and complete artistic illusion" and "the symbol and the instrument of self-reflection and psychological insight." Just as realism, aestheticism, and impressionism functioned as lenses through which Velázquez's *Las Meninas* was viewed in the United States, it is not surprising to find the introduction of symbolist concerns at the very end of the nineteenth century. See Cikovsky, "Interiors and Interiority," p. 61.

95 Colin Campbell Cooper, "A Spanish Painter," *Lippincott's Magazine* 51 (January 1893), p. 77.

96 Ibid., p. 78.

97 Ibid., p. 80.

98 Ibid., pp. 81–2.

99 "Reviews: Velázquez and His Works," p. 280.

100 "From a Talk by William M. Chase with Benjamin Northrup, of the Mail and Express," *The Art Amateur* (February 1894), p. 77. Shortly before his death, Chase expanded on these thoughts, informing his audience, "I have been a thief; I have stolen all my life – I have never been so foolish and foolhardy as to refrain from stealing for fear I should be considered as not 'original.'" William Merritt Chase, "Address Given at the Metropolitan Museum of Art, New York," 15 January 1916, quoted in Mary Kay Hastings, "The Impact of Velázquez on Nineteenth Century American Artists: Thomas Eakins and William Merritt Chase" (M. A. Thesis, George Washington University, 1986), p. 69.

101 William M. Chase, "Velázquez: Extract from an address made by Mr. Chase before the American Art Association of Paris," *Quartier Latin* 1 (July 1896), p. 4.

102 Ibid., p. 5.

103 Brownell, "American Pictures at the Salon, p. 498. Brownell was particularly enthusiastic about Chase's *Portrait of Miss Dora Wheeler* (1883, Cleveland Museum of Art).

104 Philip L. Hale, "Velázquez and All the Little Velázquez's," *Criterion* 1 (November 1900), pp. 15–16.

105 Patricia Mainardi, "Copies, Variations, Replicas: Nineteenth-Century Studio Practice," *Visual Resources* 16 (1999), p. 135.

SUZANNE L. STRATTON-PRUITT

VELÁZQUEZ'S *LAS MENINAS*

An Interpretive Primer[1]

The first three essays in this anthology trace the "reception history" of *Las Meninas* in Europe from the eighteenth to the end of the nineteenth century, a long period during which artists, critics, art theorists, and art historians admired Velázquez as a natural genius who responded to what he saw with astonishing technical brilliance. Many were taken with the apparent realism of this "backstage" scene at the Habsburg court in Madrid – informal, unposed, "captured" by the painter as the then new photograph could capture, without evident artifice, a moment in time.[2]

Twentieth-century art historians, however, have been held accountable for identifying the subject of a painting within a validly reconstructed historical context. Also, since the turn of the nineteenth century, our understanding of Velázquez's art has been enriched by study of his training and education as a painter, and the learned company and artistic stimuli available to him in his native Seville (the nineteenth century had not been particularly interested in Velázquez before he arrived in Madrid), as well as the cultural and intellectual ambience at the court of Philip IV.[3]

With this more informed view of Velázquez, both the subject of *Las Meninas* and its composition and structure received new attention, and all the tools of art historical research as well as more recent theoretical methods have been called into play. The resulting literature on *Las Meninas* is vast. This focused "primer" can only touch on the various approaches to and interpretations of *Las Meninas* – enough, it is hoped, to encourage further reading.[4]

A NEW GENRE?

The changes in the title given the painting from the seventeenth cen-
tury into the nineteenth contributed to the perplexity of those seeking
to define the genre of painting into which *Las Meninas* might fit best.
Is it, as the early writers suggested, a portrait of the infanta that seems
more like a portrait of the painter? Is it, as Antonio Ponz wrote in the
late eighteenth century, a "historiated picture" – one that tells a story?[5]
A century later, German scholar Carl Justi, in his monograph *Velázquez
und sein Jahrhundert* (Bonn, 1888), described *Las Meninas* as "strictly
speaking a portrait of Princess Margaret as the central figure in one of
the daily recurring scenes of her palace life."[6] Justi read the painting as
a *tableau vivant*, and animated the figures into an imaginary anecdote:

> It happened that on one occasion, when the royal couple were
> giving a sitting to their Court painter in his studio, Princess
> Margaret was sent for to relieve their Majesties' weariness.
> The light, which, after the other shutters had been closed,
> had been let in from the window on the right from the sitters,
> now also streamed in upon their little visitor. At the same time
> Velázquez requested Nieto to open the door in the rear, in
> order to see whether a front light might also be available.[7]

Today, a (generally) agreed on, similarly abbreviated description of
the painting might be:

> The Infanta and her entourage have been visiting the painter's
> studio, watching him at work. Palomino reported that *Las
> Meninas* was created under the watchful eye of the royal fam-
> ily, and indeed, the king and queen are here too, stopping by
> to check on progress. At the moment, they are on their way
> out. In the background, the *aposentador*, the queen's "door-
> man," holds the portal open for their departure, and the dwarf
> Nicolás Pertusato stirs the mastiff to accompany its master, the
> king, out of the room.[8]

For Fernando Marías, the painting is neither a portrait of the princess
nor a portrait of the artist, but a *capricho nuevo*, as Palomino had called
it, a brand new concept, an image of the "family" of the king in the
Latin sense of the word – the extended family of the king, including
the members of his household: his greatly beloved younger daughter,
dwarves, ladies in waiting, and admired court painter.[9] If we accept

Las Meninas as a new, unique kind of composition, we may ask: What impelled Velázquez to invent a new genre?

EMBLEMATIC READINGS OF *LAS MENINAS*

A turning point in Velázquez studies came in 1925 with the publication of the inventory of his library made after his death in 1666.[10] Velázquez's 154 books, a substantial collection for a seventeenth-century painter, suggested ways of reading *Las Meninas* beyond Antonio Ponz's vague designation of it as a *quadro historiado*. Velázquez's books on mathematics, geometry, and architecture reveal the level of sophistication the artist brought to his creation of the compelling, if ambiguous, perspectival space of *Las Meninas*. His emblem books and compilations of mythology suggest Velázquez's comfort with allegory and other complex ways of thought so characteristic of the cultural milieu of Baroque Spain.

Velázquez's collection of emblem books included the very popular ones by Cesare Ripa and Andrea Alciati. Those compilations of texts expressing abstract concepts and related simple images – no more, usually, than hieroglyphics –, were often used by Spanish artists as sources of inspiration for ephemeral decorations or for engraved frontispieces to books. However, emblem books were little used by seventeenth-century Spanish painters for their images and ideas.

J.A. Emmens initiated emblematic readings of *Las Meninas* with a 1961 article in which he interpreted the painting as representing the education of the princess, the Infanta Margarita.[11] For Emmens, the reflected image of the king and queen in the background of *Las Meninas* serves as the "Mirror of Princes," as developed by Diego Saavedra Fajardo in his *Idea de un príncipe cristiano* first published in 1640. Saavedra Fajardo had dedicated his book to Baltasar Carlos, the firstborn son of King Philip IV, in whose former apartments *Las Meninas* is set. However, the Infanta Margarita did not succeed Baltasar Carlos as heir apparent to the Spanish monarchy, so Emmens' hypothesis that the little princess is being educated to rule lacks historical foundation.[12] This flaw in Emmens' argument is magnified by his insistence on reading all the figures in the painting as emblems, and we are reminded how carefully art historians must avoid the seductive attraction of using

emblem books as keys to the interpretation of paintings when the con-
nection between emblem and painted image is not unequivocally clear.
Emmens's idea that the mirror in *Las Meninas* symbolizes Prudence –
a lesson for the Infanta – is in accord with his overall interpretation of
the painting. However, when he suggests that Maribárbola personifies
Invidia and little Nicolás Pertusato *Odium*, the hypothesis begins to
unravel.

In an article entitled *"Las Meninas* and the Mirror of the Prince,"
published in 1985, Joel Snyder independently interpreted the paint-
ing in conjunction with Saavedra Fajardo's emblem book.[13] Snyder
concludes that:

> In a sense, *Las Meninas* is the painted equivalent of a manual for
> the education of the princess – a mirror of the princess. . . . The
> painting is a speculation about and around an idea thoroughly
> familiar to the painter and his audience, and one that was,
> finally, like a second nature to the king–the mirror of the
> prince. And as this examplar/model/ideal emerges through
> the course of viewing and re-viewing the painting, it should
> become clear that *Las Meninas* is a speculation about specula-
> tion, a reflection by an exemplary artist of an ideal image that
> engenders images.[14]

Emmens's ideas have recently found a sympathetic response in
the writings of Santiago Sebastián (who was unaware that Snyder
had also linked the painting to Saavedra Fajardo's emblem book).[15]
Sebastián describes *Las Meninas* as "un retrato pedagógico con trans-
fondo político,"[16] even suggesting that the painting might have been
intended for the older of the infantas, María Teresa, to take with her
to Vienna as a memento of her family in Madrid when she married
her Austrian cousin Leopold Ignatius. "Sadly," Sebastián notes, "the
program of political prudence erected around the *Familia de Felipe IV*
or *Las meninas* crumbled like many things in the Spain of the second
half of the seventeenth century."[17] Sadly as well, the emblematic read-
ing of *Las Meninas* that led Emmens, Snyder and Sebastián to arrive
at a didactic purpose for it, with a pedagogical intention similar to
that of Saavedra Fajardo's book on the education of a prince, is finally
unconvincing on historical grounds.

LAS MENINAS IN DEFENSE OF PAINTING AS A LIBERAL ART

In 1949, Charles de Tolnay offered a penetrating description of the self-portrait of Velázquez in *Las Meninas*:

> He seems to be seized by an inspiration: he is bending his head slightly as if in dreamy thought, and is holding the brush – as a poet would hold a pen – with a soft touch in his wonderfully spirited hand. This is a moment of suspense – a concentration on that inner image which the theoreticians of the period called the "*disegno interno.*" This is the painter as sovereign creator who is capable, thanks to a divine gift, of recreating within himself the visible world.[18]

De Tolnay distinguished this self-portrait of the artist from those of the Middle Ages and the early Renaissance, in which painters and sculptors depicted their craft by illustrating the manual process of creating the work of art – the artist at work. Velázquez does not reject the earlier tradition, for he shows himself at work before a canvas, "But he is in this moment of inspiration, concentrating upon his inner emotions and thoughts. It is one of the earliest self-portraits of an artist where the subjective spiritual process of creation is emphasized rather than the objective material execution."[19] In this way, de Tolnay thus introduced what has slowly come to be a generally accepted art historical interpretation of *Las Meninas*, that it was Velázquez's aim to create a work that would symbolize the nobility of the art of painting. However, the justifications for this reading of *Las Meninas* have varied. For de Tolnay, Velázquez's depiction of himself as "sovereign creator" is underlined by the subject of the paintings on the rear wall of the room:

> It was a tradition since the late Middle Ages to comment upon the main idea of a work of art by the insertion of paintings within the painting whose subject brought the main theme into sharper light through typological relation. In the background of the *Meninas* there are two large paintings. The one at the left represents *Pallas and Arachne* (after a composition of Rubens) and that at the right *Apollo and Marsyas* (after a composition of Jordaens). Both are myths which symbolize the victory of divine art over human craftsmanship, or the victory of true art over unskillfulness.[20]

[The painting at the right has since been correctly identified as the *Contest of Pan and Apollo*, also after a painting by Rubens designed for the Torre de la Parada.[21]]

In 1966, George Kubler bolstered de Tolnay's reading of the painting by noting that "another message of the *Meninas* concerns the nobility of painting as proclaimed by Romano Alberti and other theorists until Felix da Costa in 1696; a nobility proved by the familiar association of painters with kings, and by the taste of kings for paintings; a taste documented by many prior generations."[22]

The most fully fleshed out argument favoring the interpretation of *Las Meninas* as a defense of the nobility of the art of painting is found in the essay first published by Jonathan Brown in 1978 and reconsidered in his 1986 monograph on the artist.[23] Brown described the contemporary status of the painter in seventeenth-century Spain, specifically at the court in Madrid, where artists chafed under government rules that taxed their works like craft goods.[24] Turning to *Las Meninas*, he explained the nearly unprecedented presence in that painting of the painter with members of the royal family with reference to book 35 of Pliny's *Natural History* (of which Velázquez owned two different editions). In that anecdote, well known to Renaissance and later artists, Pliny describes the relationship between Apelles and Alexander the Great, who visited his painter's studio to watch him at work and to whom he granted the sole right to paint his portrait. Velázquez had similarly been granted the sole right of portraying Philip IV, and we know from Palomino that the king often visited the painter at work. According to Brown, "*Las Meninas* would appear fundamentally to be the record of a unique relationship between Velázquez and Philip IV, a relationship that guaranteed the noble status of the painter's art."[25]

Spanish philosopher José Ortega y Gasset, in a 1945 essay, was really the first to recognize the importance for Velázquez's of his personal stature at the court of Philip IV. For Ortega, Velázquez's ambitions had primal psychological and social roots:

> Velázquez came of a noble family which had emigrated and become impoverished, and in which moreover the preoccupation with their lineage must have been obsessive.... In the initial and deepest layer of his soul, Velazquez found this commandment: "You must be a nobleman." But for the time being this incentive was schematic, remote and impracticable.

Nearer to hand, more concrete, his discovered at the very threshold of his life a magnificent possibility: his incredible talent for painting.[26]

Ortega recognized that "Velázquez's vocation was made up of two factors – the artistic aspiration and the aspiration to nobility."[27] Taking up Ortega y Gasset's provocative but general suggestion, Brown brought Velázquez's personal ambitions to bear on the creation of *Las Meninas*, it being the establishment of the credentials to become a member of the aristocratic Order of Santiago, a process officially initiated two years after the painting was created. Brown notes that, for Palomino:

> *Las Meninas* was Velázquez's claim to immortality, a claim based not only on the fact that it was the greatest of paintings, but also, and perhaps principally, on the fact that it showed the artist in the company of the royal princess. As such, the picture epitomized the immutable credence of courtiers that access to the royal family could guarantee nothing less than eternal fame.[28]

This argument is enhanced by the fact that Velázquez chose to site his composition in a room of the royal palace hung with forty paintings by the hand of Velázquez's son-in-law, Juan Bautista Martínez del Mazo, in the great majority copies after paintings by Peter Paul Rubens.[29] Rubens, who had been knighted by Philip IV in 1631, was inevitably for Velázquez the model of the modern artist–courtier, and the pictures within the picture in *Las Meninas* provided another bit of ammunition in his own struggle for social as well as artistic recognition. Steven N. Orso confirmed Palomino's identification of the room in which *Las Meninas* takes place as a particular room in the old royal palace of Madrid – the *pieza principal* in what had been the apartments of deceased Prince Baltasar Carlos (the *Cuarto bajo del Príncipe*).[30] A 1686 inventory of the room enabled Orso to identify enough of the paintings installed there to confirm that Velázquez painted the room exactly as it was (with the notable exception of the mirror, which he invented). Accordingly, Velázquez pictured the scene in a room (not his actual working studio) hung with paintings after Rubens (*Minerva and Arachne* and *Contest of Pan and Apollo*) that represent the status of painting as a liberal art.

John F. Moffitt provided a precisely measured reconstruction of the painter's field of vision to underline the scientific manner in which Velázquez must have composed the painting, using, Moffitt argues, a camera obscura or other device. Moffitt concludes that, "the camera obscura would only have been a tool employed to a larger, even philosophical, end, that is, the demonstration that painting – because of its use of scientific perspective – is a liberal art, an idea early championed by Leon Battista Alberti."[31] Thus, as *Las Meninas* was based on mathematical principles, it was as scientifically valid as the liberal arts.

In 1994, Juan Miguel Serrera pointed to another precedent for the painter's special relationship with the king, a more immediate one than Pliny. Serrera proposed that *Las Meninas* might be inspired by Francisco Pacheco's narrative report on the close relationship between the sixteenth-century court painter Alonso Sánchez Coello with his sovereign Philip II, one that also drew comparison to Apelles and Alexander the Great.[32]

STRUCTURE OF THE PAINTING

Efforts to analyze the perspectival construction of *Las Meninas* have been various, often ingenious, and sometimes dispiriting, for using yardsticks and algebraic equations to plumb the mysteries of a painting, any painting, would reduce an artist's achievement to his command of geometry.[33] Among the earliest of these approaches to *Las Meninas* was the effort of Spanish architect Ramiro de Moya to establish the perspective of the room in order to understand the precise placement of the figures.[34] This insistence on the realistic nature of the painting, which unintentionally continues the nineteenth-century understanding of Velázquez's art, was followed by other readings of the space in the painting that complicated Ramiro de Moya's original intention to clarify.[35] In fact, there is some question about the degree to which Velázquez was interested in Renaissance perspective systems, although no doubt he was familiar with them. Avigdor Arikha has noted that:

> Velázquez seems not to have bothered much with perspective ... but he is not the only painter of the seventeenth century to have replaced the perspective pyramid by a bifocal or multifocal perspective, which transforms depth into rhythm,

bringing all perspective lines back to the flat plane. The understanding of the flat plane, the *piano*, was not a discovery of modernism.[36]

The literature on *Las Meninas* was characterized by Jonathan Brown as having three currents of interpretation: the realist, the historical–empirical, and the philosophical. The last, with the notable exception of Ortega y Gasset, was largely impelled by Michel Foucault's 1966 essay on the painting, a preface to his book entitled, in English, *The Order of Things: An Archaeology of the Human Sciences*. Foucault's intention was characterized briefly by Avigdor W. Posèq as follows:

> Foucault holds that the conceptual apprehension of reality always depends on the fundamental codes of culture, especially those which govern the use of languages. The peculiarities of the verbal idiom establish moral hierarchies and are directly applied to the practices and techniques which are the very essence of our existence. It is only natural that the structure of the language is also reflected in the theories of artistic representation. Foucault introduces his theory of the codes by an extremely detailed verbal description of Velázquez's *Las Meninas*. He says that Velázquez transformed the conventional concept of painting as an art of representation into an unprecedented "representation of the representation," which allows the viewer to become more keenly aware of the interpretative aspect of painting. Foucault argues that although Velázquez chose a very obvious subject matter the subject has been elided; the pictorial representation undertakes to represent itself, and freed from the relation to reality that was impending, it offers itself in its pure form. Foucault's theory of the dependence of the apprehension of reality on the verbal codes may also be exemplified in his own study of the *Las Meninas*.[37]

Foucault's essay does not seem to be about the vexing issues of Velázquez's perspectival construction of the painting or, more specifically, the supposed location of the viewer. Nevertheless, much of the published discussion of the painting following Foucault has in fact focused on just those issues. (For a different reading of Foucault, see the essay in this volume by Estrella de Diego.)

Foucault described *Las Meninas* with an impressively probing eye as a majesterial example of what he considered classical representation

(i.e., from about 1650 to 1900) "the representation, as it were, of classical representation."[38] His essay, now quite famous, did not intially elicit much of a response. Then, in 1980, University of California, Berkeley professor of philosophy John R. Searle took issue with Foucault's use of *Las Meninas* as an ideal of seventeenth-century representation, instead finding the work incompatible with the "way that classical pictorial representation combines resemblance, aspect, and point of view."[39] For Searle, *Las Meninas* "has all the eyemarks of classical illusionist painting but it cannot be made consistent with those axioms," and, for Searle, the result is paradoxical: The point of view of the painting cannot be occupied by the artist, who inhabits the picture area, and the painting is made from the subject's rather than the artist's point of view, so that the spectator "becomes" the king and queen of Spain. There was a quick response to Searle's assertions from Joel Snyder, a photographer and professor of humanities and art and design, and Ted Cohen, professor of philosophy, both members of the faculty of the University of Chicago.[40] Following their detailed dissent with Searle's reading of the painting, Snyder and Cohen summarized the ineffable aspect of the relationship between a painting and its viewer:

> Some pictures are very delicately balanced on a viewpoint and look distorted when seen from a position even slightly away from the geometrically sanctioned point. But most pictures do not behave in this way, and we are free to wander in front of them without missing their significance. We do not approach paintings in the way that we approach problems in surveying, and our perceptual capacities are not, by themselves, typically equipped to inform us when we are at the right point of view. The error made by Searle and Foucault in seeing *Las Meninas* is an acute illustration.[41]

Three years later, in 1983, Svetlana Alpers weighed in on this running argument, suggesting that in *Las Meninas* Velázquez "embraced two conflicting modes of representation, each of which constitutes the relationship between the viewer and the picturing of the world differently." Alpers defined these two modes as generated by "the glance" and "the gaze." The glance simply takes in a world that is already there. The gaze is exemplified by Titian's *Venus of Urbino*, in which "the artist is a viewer who is actively looking out at objects – preferably human figures – in space, figures whose appearance, considered as a matter

of size, is a function of their distance from the viewer."[42] In sum: "In Velázquez's *Las Meninas* we find the two as it were compounded in a dazzling, but fundamentally unresolvable way."[43]

Philosophers Foucault, Searle, and Snyder; photographer Cohen; and art historian Alpers share a fascination with the way in which Velázquez seems to be breaking the rules that had governed pictorial representation since the Early Renaissance. They are not so interested in what the painting might have meant to a seventeenth-century viewer, or who the individuals in the painting are; Foucault never mentions them by name. Alice Sedgwick Wohl summarized the difference between the traditional interests of the art historian with the different attraction to *Las Meninas* provoked by Foucault:

> Like Ortega y Gasset a generation earlier, Foucault approaches Velázquez not as an art historian but as a philosopher. While Foucault considers pictorial representation in relation to specific structures of knowledge, these are not to be equated with the local ideological and social codes that are the focus of the contextual approach. His concern . . . is the epistemological rupture between the classical period and the modern age, and in *Las Meninas* he finds the paradoxes and ambiguities that signify a shift in the structure of knowledge governing pictorial representation. The impact of Foucault's reading has been methodological.[44]

Opinions have been weighed in from all corners.[45] For Leo Steinberg, who published a revised version of a 1965 lecture in 1981, "the literature on *Las Meninas* is an epitome of recent thinking about illusionism and the status of art . . . a cherished crux for modern investigators, for geometricians, metaphysicians, artist–photographers, semioticians, political and social historians, and even rare lovers of painting."[46]

"INTERPRETATION AS EXEMPLIFICATION"

This ca.1980 round of critical and theoretical thinking about *Las Meninas* was reconsidered by Denis Donoghue in 1985.[47] Donoghue describes the approaches taken by Foucault and Alpers as "Interpretation as Exemplification; where someone analyses a work of art not for its own sake but to offer it as an example, proof, or illustration of some

argument he wants to make,"[48] an observation to which he concludes: "One of the limiting consequences of an interest in theory is that one's recourse to works of art can only be opportunistic or illustrative. We are forced to comment on works of art which exemplify whatever theoretic argument we want to make; and, in the nature of the case, our interest in the work of art begins and ends with its exemplary usefulness."[49] In a response to Donoghue, Charles Karelis observed:

> John Stuart Mill claimed that the solving of mathematics problems could proceed perfectly well without an adequate philosophy of mathematics. The controversy over *Las Meninas* suggests that the interpretation and criticism of paintings, by contrast, is quite vulnerable to bad theory. It seems to me, specifically, that most of the recent interpreters of *Las Meninas* have misconstrued it in an important way, and this this is due to a widespread misconception about the nature of pictures.
>
> The basic interpretive mistake common to most of these writers is accepting the real-life spectator's imaginary presence in the depicted space.[50]

Karelis argues that all of these discussants, with the exception of Snyder and Cohen, assume that "Velázquez is inviting us to imagine, as we view his canvas, that we're present in the depicted room, whether as the king and queen, or as ourselves in their place, or as ourselves standing at their side."[51] He adds that, "Only Jonathan Brown, to whom Professor Donoghue accords but a passing reference, recognizes this: 'The viewer is not meant to inhabit the same areas as the king and queen, which would have been a breach of court protocol. Instead,' says Brown, 'he occupies a space outside the illusion.'"[52] In thus indicating how "bad theory has led to bad criticism," Karelis' critique also points to the reality that the philosophers (the speculators) and the art historians (the interpretors of what the picture meant to Velázquez and his contemporaries) have been working, with equal enthusiasm, in parallel universes.

Jonathan Brown summarized succinctly the interests of the empirically inclined historians, such as himself, as distinct from those of the philosopher/theorists:

> [Foucault] and his followers are concerned not with the content of *Las Meninas* but with its structure. For these writers, the

painting is not the representation of a historical or quasihis-
torical event but a historical event in itself. It is a landmark in
the history of representation, which poses searching, original
questions about how the visible world is presented and contin-
ually re-presented in a complex, unending dialogue between
painting and viewer. Rather than being an object fixed in a
confluence of historical and biographical circumstances, *Las
Meninas* is a philosophical disquisition into the inherent insta-
bility of all representational activity. Where historians seek to
establish boundaries using sources and documents, the philo-
sophical interpreters seek to demolish them by unmasking the
constantly shifting relationships between object and audience
which, for them, lie at the very core of this profoundly sug-
gestive work.[53]

Art historian and philosopher Hubert Damisch would not encour-
age us, however, to think the distinctions can be so elegantly and tidily
drawn. In his observation of the reactions to Foucault of Steinberg,
Searle, and Alpers, Damisch notes that Alpers found the "standard in-
terpretative methods of art history *structurally* inadequate to deal with
such a painting."[54] Damisch adds:

And if there is one thing to be learned from all the preceding,
it is that painting is a distinct object of historical study and must
be dealt with as such: which means paradoxically that one must
adopt a deliberately structuralist point of view, which only
throws the historical dimension of phenomena into greater
relief.[55]

For Richard Brilliant, the focus on *Las Meninas* by scholars and thinkers
outside of the "Spanish art history establishment" has been salutory:

Extravagant epithets have been thrown at the painting, ranging
from "masterpiece" and "paradigm" to "meta-metapicture,"
thereby acknowledging the painting's authority and the cen-
trality of its critical position in the modern discourse about
the nature of pictorial representation, while progressively
distancing the art object from the strings of interpretation
that have woven a screen around the work partially obscuring
it from view.[56]

THE PORTRAIT OF PHILIP IV AND QUEEN MARIANA

The art historians whose area of expertise is Spanish art have, despite what has been called "the intrusion of Michel Foucault into the critical fortunes of *Las Meninas*,"[57] continued to pursue their traditional concerns about the meaning of the painting, its relationship to Velázquez's career at court, and how it was read by Philip IV, for whom, after all, it was painted. Donoghue describes this approach to the interpretation of the painting as proceeding "under the auspices of causation: that is, it proposes to find the meaning of a work in the circumstances of its origin or otherwise in a motive imputed to it."[58]

Jan Baptist Bedaux, in an article about Velázquez's *Fable of Arachne* published in 1992, wrote:

> I am convinced that Brown's interpretation . . . will not readily be contested. Why, one wonders, does it appear so much more convincing than all the other theories about *Las Meninas?* Its elegance lies above all in the fact that it is neither forced nor unduly complex, but on the contrary stands out because it is self-evident and simple, and yet clarifies so much.[59]

Of course, an interpretation "not readily contested" inevitably invites further discussion and contest. Several writers have recently offered differing readings, specifically, of the portrait of the king and queen that is it now (generally) agreed is the canvas upon which Velázquez is at work and that is seen reflected in the mirror. Palomino undoubtedly thought he was perfectly clear about what was represented on the canvas, of which we can only see the back, when he wrote:

> Velázquez demonstrated his brilliant talent by revealing what he was painting through an ingenious device, making use of the crystalline brightness of a mirror painted at the back of the gallery and facing the picture, where the reflection, or repercussion, of our Catholic King and Queen, Philip and Mariana, is represented.[60]

Nevertheless, later writers offer different interpretations of what Velázquez is painting: for example, that the canvas represents *Las Meninas* itself [61] or a portrait of the princess.[62] In these scenarios, the actual presence of the king and the queen watching the painter at work is reflected in the mirror image. Recent scholarship, however, generally

accepts the premise that the mirror reflects a double portrait of the king and queen on which Velázquez is at work, and some have extrapolated further on the meaning of this royal portrait.[63]

For Emily Umberger, in an essay published in 1995, the fictive double portrait "depicts Philip as a faithful husband with his queen," and the overall composition, with the luminous presence of Philip and Mariana's only living child, Margarita, is intended to offset the supposed rise to power of Don Juan, the illegitimate son recognized by the king in 1642.[64]

In 1996, Amy M. Schmitter returned to the Searles–Snyder–Cohen discussion of the structure of *Las Meninas* stimulated by Foucault as a springboard for her hypothesis that the painting would only be complete when the king himself stood before it:

> [W]hen the king contemplates the painting that analyzes his presence, the representation at work in it achieves completion. It represents to the king *that which makes him the King*: his natural body, his representation, and the incorporation of the two in sovereignty. And as such, the encounter between the king and the painting of the relations established in representation both constitutes and embodies the Kingship.[65]

For Schmitter, "Velázquez's construction . . . makes the circle of representation complete only when the king stands in the viewing position. So, through the shifting readings it generates, *Las Meninas* displays the king's need for his representation, and analyzes the interdependence of king and representation."[66] Similarly, the presence of the king is crucial to the analysis of the practice of portrait painting as depicted in *Las Meninas* by George and Linda Bauer:

> Velázquez does not picture the king as a sitter painted by the artist, but as an image reflected in a mirror. Moreover, the specular image is not seen by the painter, who has his back to it, but by the king and queen. Thus, the mirror's function is not to reveal what the artist paints on his canvas – though it does that, too – but specifically to bring the portrait of the king and queen directly under the gaze of the king . . . it is the king who contemplates himself in his image.[67]

For Victor Stoichita, the royal portrait in *Las Meninas* is of two types, both traditional – the full-length version on which the painter is at

work (in the manner of Spanish royal portraits since Titian), and a half-length version, that seen reflected in the mirror, like the ones intended, from the mid-sixteenth century, for private purposes.[68]

The interpretations of the royal double portrait sketched out here are, for the most part, speculative in nature.[69] Fernando Marías has instead taken an historian's approach to placing the work within the context of Philip IV's life and Velázquez's career in 1656 – precisely when *Las Meninas* was created. Marías quotes from Philip IV's letter of July 1653 to Sor Luisa Magdalena de Jesús, in which the king indicated that he was sending her portraits of members of his family, but not one of himself: "No fue mi retrato porque ha nueve años que no se ha hecho ninguno, y no me inclino a pasar por la flema de Velázquez, así por ella como por no verme ir envejeciendo."[70] Marías emphasizes the fact that:

> Velázquez had not painted a portrait of the king since at least 1644, the date of the portrait of Philip IV at Fraga [New York, Frick Collection], painted during the military campaign in Cataluña. Just afterward, the deaths of his wife Isabel of Bourbon and of his son would have ushered in a long period of mourning. With the passing of the years, the king's fear of having himself shown as an old man (even though he was not yet fifty years old) increased, as did his reluctance to pose for the brush or pencil of his phlegmatic and parsimonious portraitist. Thus, for more than ten years [to the date of *Las Meninas*] Velázquez had been prevented from fulfilling his principal task as *pintor de cámara*: portraying the king.[71]

Marías diverges from those who interpret the painting as an allegorical representation of painting as a liberal art: for him, the first known installation of the painting in the king's apartments is alien to such a grandiose concept. However, Marías agrees that *Las Meninas* was intended to emphasize that the art of painting *solo al servicio del monarca* (only in the service of the king) freed Velázquez's work from the social stigma borne by the mere mechanics of art, and that *Las Meninas* was indeed intended to eventually support Velázquez's quest for knighthood. If the king was in no mood to have his portrait painted, how was Velázquez to portray himself as the only painter permitted to portray the king? How, Marías asks, to paint the "impossible portrait" of the king? This is how Marías explains it: We do not see the painting that

Velázquez is working on, only its fuzzy reflection in the mirror; but we do see Velázquez as painter to the king. "Theoretically and conceptually, Velázquez would not have infringed the royal prohibition. The impossible and prohibited royal portrait did not exist in reality, as it had never really been painted; It only existed in the imagination and intentions of the painter, and in the fiction of *Las Meninas*."[72] As Orso had earlier discovered, the mirror was the only architectural or decorative element in the room that did not actually exist: "The 1686 inventory lists no *adornos of* any kind in the Main Room, which means that there were no mirrors in it. Velázquez invented the looking glass in *Las Meninas* in order to introduce the king and queen discreetly into his composition. It is the one inaccuracy in his portrayal of the chamber."[73] Fictive mirror, fictive royal portrait – all far from the nineteenth-century reading of *Las Meninas* as a magnificent exemplar of realism.

MAKING *LAS MENINAS*: VELÁZQUEZ'S TECHNIQUES AND MATERIALS

Around the close of the nineteenth century, artists, art historians, and critics were much taken with the apparently effortless techniques of Velázquez, the "Prince of Painters," who seemed to many a harbinger of Impressionism, and so his works in the Prado were studied with an eye to his use of color and brushwork, and almost total disregard of iconography or social context. Conversely, writings about Velázquez during most of the twentieth century nearly abandoned the formal analysis of his work in favor of the exploration of his erudition, and some of the theoretical approaches to *Las Meninas* noted in the preceding pages might as well have been undertaken without the author ever having laid eyes on the painting in the Prado.

In the early 1980s, art historians and conservators began to study *Las Meninas* seriously as a material object, and interest in the supports, grounds, pigments, and techniques used by Velázquez in the creation of his masterpiece intensified when the painting was restored by John Brealey in May 1984.[74] With the aid of radiography, infrared reflectography, photography, photography with ultraviolet fluorescence, and the technical analysis of materials, conservators and art historians probed *Las Meninas* in yet another route to understanding its timeless allure.[75]

These approaches focus on the "how" of the painting. However, scientific methods do not always yield definitive answers; the radiographs of *Las Meninas* have been read quite differently by different eyes.

Like the analyses of Velázquez's perspectival construction of *Las Meninas*, the minute study of materials and brushwork might reduce a lesser work of art to a few dry facts about the making of a painting. Velázquez's genius defies such a reductive assessment, for his technique and materials are so tightly harnessed in the service of a greater goal. Following a description of the materials used in the creation of *Las Meninas* (e.g., lapis lazuli, calcite, smalt) and technique (e.g., "dragging the brush back and forth," "daubs of thick impasto," "highly diluted pigments"), art historian Jonathan Brown and paintings conservator Carmen Garrido conclude: "Behind this display of pictorial technique is a desire to create a great painting, a veritable masterpiece of art."[76]

At the beginning of the twenty-first century, despite all the analyses of it, *Las Meninas* somehow still eludes us. "*Las Meninas* is no doubt Velázquez's most remarkable and most haunting masterpiece. It hits one's senses like nothing else, and we don't grasp why."[77] The painting has been considered the visual equivalent of *Life Is a Dream*, a play by Velázquez's contemporary, the dramatist Pedro Calderón de la Barca. That work is summarized in a single famous line: "What is life? – an illusion, a shadow, a fiction." Francisco Calvo Serraller, in his monographic study of *Las Meninas*, invokes the ineffable connection of the painting to the cultural ambience of the era: "Velázquez then invents a reality, and he does so within a culture and historical moment in which it was incessantly repeated that life is an illusion."[78] John Berger has also observed the tendency in Spanish painting "that derives from the conviction that truth is found *behind* appearances. And what is behind appearances is a great darkness. And it is in that darkness that one will have to search for the truth."[79]

Perhaps that is the direction in which *Las Meninas* studies will take us in the twenty-first century.

NOTES

1 I am very grateful to my friends and colleagues Gridley McKim-Smith and Steven N. Orso for their good advice.

2 During the 1970s the art of painting seemed to some artists and critics to be doomed by the unprecedented popularity of photography among other artists

and critics. Painter Richard Hennessy defended his métier by invoking *Las Meninas* as a supreme example of "Paintings's quasi-miraculous mode of existence . . . produced . . . by its mode of facture. . . . *Through the hand*: this is the crucial point." ["What's All This about Photography?" *Artforum* 17 (May 1979), p. 23.] Douglas Crimp later criticized Hennessy's hyperbole; however, as we will see, Hennessy was not wide of the mark in describing *Las Meninas* as "a gift we will never finish unwrapping (ibid., p. 25)." See Douglas Crimp, "The End of Painting," *October* 16 (Spring 1981), pp. 69–86.

3 See, for example, the essays by Margaret R. Greer, "Calderón de la Barca, Playwright at Court"; Lía Schwartz, "Velázquez and Two Poets of the Baroque: Luis de Góngora and Francisco de Quevedo"; and Louise K. Stein, "Three Paintings, a Double Lyre, Opera, and Eliche's Venus: Velázquez and Music in the Royal Court in Madrid" in the *Cambridge Companion to Velázquez,* Suzanne L. Stratton-Pruitt, ed. (Cambridge, 2002).

4 This essay is intended as a guide for the novice in *"Las Meninas* studies," but is not the first ever historiography of the painting, and the references in these notes, while numerous, do not include absolutely everything published about the painting. For additional references, see also: Alice Sedgwick Wohl, "Velázquez: Las Meninas," *News from RILA (International Repertory of the Literature of Art, The Getty Art History Information Program)* no. 5 (February 1987), pp. 5–10, which explores "the development of a variety of approaches – optical, iconographic, formalist, psychoanalytic, contextual, and philosophical – in the field of art history over the past hundred years." The goal is ambitious for the several pages dedicated to it, but the entries are usefully annotated. The "Bibliografía básica sobre Las Meninas" in Francisco Calvo Serraller's *Las Meninas de Velázquez* (Madrid, 1995) lists many of the publications dedicated at least in part to the painting from Felix da Costa in 1696 to 1994, although without comment. Similarly, the bibliography in Caroline Kesser's published Ph.D. Dissertation, *Las Meninas von Velázquez: Eine Wirking-und Rezeptionsgeschihte* (Berlin, 1994), is extensive but simply arranged alphabetically. An anthology of *Las Meninas* essays edited by Fernando Marías, *Otras Meninas* (Madrid, 1995), offers a selection of previously published essays translated into Spanish, thus making some modern approaches to the painting accessible to Velázquez's countrymen; it includes a useful bibliography. Another anthological volume of previously published essays has been published with an introduction by Thierry Greub, ed.: *Las Meninas im Spiegel der Deutungen. Ein Einfürung in die Methoden der Kunstgeschichte* (Berlin, 2001). See also Javier Portús Pérez, *Entre dos centenarios: Bibliografía crítica y antológica de Velázquez (1962–1999)* (Seville, 2000), *passim*.

5 Antonio Ponz, *Viage de España* 5 (1782), p. 29.

6 Carl Justi, *Diego Velazquez and His Times*, trans. by A.H. Keane and rev. by the author (London, 1889), p. 414. Bo Vahlne, a century later, describes the painting as "first and foremost a portrait of the Infanta Margarita" . . . "made by royal command, most likely the Queen's." See his article, "Velázquez' *Las Meninas*: Remarks on the Staging of a Royal Portrait," *Konsthistorisk Tidskrift* 51 (1982), pp. 25–6.

7 Justi, *Diego Velazquez*, p. 416.

8 Thomas L. Glen's understanding of the role of these hunting dogs at the Habsburg court led to his observation that the royal couple is leaving the room, rather than

entering it, as had been thought. See "Should Sleeping Dogs Lie? Once Again, *Las Meninas* and the Mise-en-Scène," *Source* 12, no. 3 (1993), pp. 30–6.

9 See Fernando Marías's essay, "El género de *Las Meninas*: Los servicios de la familia," in: *Otras Meninas*, ed. by Fernando Marías (Madrid, 1995), pp. 247–78. Marías refers to similar thinking on the part of Norbert Elias in his discussion of the painting in *Involvement and Detachment*, trans. by Edmund Jephcott (London, 1987), in which Elias notes: "Not the least significant aspect of his self-portrait is that he represented himself not as an isolated individual but as one person within a small group of people holding similar rank within the innermost circle of the royal family's private life." (p. lvi). Marías's argument is also published in his monograph *Velázquez: Pintor y criado del rey* (Madrid, 1999), pp. 212–22.

10 Francisco J. Sánchez Cantón, "La librería de Velázquez," in *Homenaje a Menéndez Pidal*, vol. 3 (Madrid, 1924), recently reprinted in Francisco J. Sánchez Cantón, *Escritos sobre Velázquez* (Pontevedra, 2000), pp. 25–51. The complete inventory of all the goods that Velázquez and his wife Juana Pacheco owned is included in the *Corpus Velazqueño: Documentos y textos*, ed. by José Manuel Pita Andrade and Angel Aterido Fernández (Madrid, 2000), vol. 1, pp. 469–83, no. 436. The first to recognize the significance of Velázquez's library for the interpetation of *Las Meninas* was Michail W. Alpatow, "Menn'i Velaskera," *Iskusstvo*, no. 1 (1935), pp. 123–36; Spanish translation as "*Las Meninas* de Velázquez," *Revista de Occidente* (April 1953), pp. 35–68; in German as "'*Las Meninas*' vom Velázquez," in *Studien zur Geschichte der westeuropäischen Kunst*, ed. by Werner Hofmann (Cologne, 1974), pp. 204–28. Alpatow's early contribution to *Las Meninas* studies was brought to light by Kesser, *Las Meninas von Velázquez*, p. 109.

11 J.A. Emmens, "*Les Ménines* de Vélasquez: Miroir des Princes pour Philippe IV," *Nederlands Kunsthistorisch Jaarboek* 12 (1961), pp. 51–79.

12 More recently, Manuela Mena Marqués similarly argued for a political reading of the painting in "El encaje de la manga de la enana Maribárbola en *Las Meninas* de Velázquez," in *El Museo del Prado. Fragmentos y detalles* (Madrid, 1997), pp.135–61. Mena's interpretation is based in part on the notion that Philip IV had decided to marry his older daughter María Teresa to the French King Louis IV and to name his younger daughter, Margarita, as his heir. *Las Meninas* would thus be read as a painted presentation of the Infanta Margarita as heir to the Habsburg throne. This argument does not hold water, as demonstrated by Jonathan Brown, assisted by historian John Elliott and Carmen Garrido, Head of Technical Services at the Museo del Prado, in the essay "'*Las Meninas*' como obra maestra," in: *Velázquez* (Barcelona, 1999), pp. 85–109. See also Fernando Marías, "*Las Meninas* de Velázquez, del despacho de Felipe IV al cenador de Carlos III," in *Velázquez y Calderón: Dos genios de Europa (IV Centenario, 1599–1600, 1999–2000* (Madrid, 2000), pp. 157–77.

13 Joel Snyder, "*Las Meninas* and the Mirror of the Prince," *Critical Inquiry* 11 (June 1985), pp. 539–72. In a footnote (note 30, p. 571–2), Snyders reports that Emmens' article escaped his attention until just before his 1981 publication. He writes, "Some of the symbolic identifications Emmens provides seem plausible and others less so. I am of the opinion that once the mirror is shown to have a figurative dimension, it is opened to just this sort of analysis. But because of his preoccupation with the iconographic values of the painting, Emmens fails to address the dialectical relation

between the realistic and the figurative aspects of the painting and fails, therefore, to address the painting as a whole."

14 Ibid, p. 564.

15 One of the outstanding problems in interdisciplinary studies is the likelihood that the visitor to a given discipline will not be sufficiently aware of all the prior literature on a given subject. Such "visitors," and *Las Meninas* has invited a number of them to its fascinating space, cannot, even with the best will in the world, help but overlook some publication or another. The emblematic interpreters of the painting have been remarkably incognizant of each other's work. Emmens (1961) was unknown to Snyder until his study was completed, and Snyder (1985) was evidently unknown to Sebastián (1995).

16 Santiago Sebastián, *Emblemática e Historia del Arte* (Madrid, 1995), p. 248. I am grateful to Sagrario López Poza for providing me with a copy of Sebastián's essay published in that volume.

17 Ibid., 248–9. "Tristemente, el programa de prudencia política montado en torno de la *Familia de Felipe IV* o *Las Meninas* fracasó como tantas cosas en la España de la segunda mitad del siglo XVII."

18 Charles de Tolnay, "Velázquez's *Las Hilanderas* and *Las Meninas* (An Interpretation)," *Gazette des Beaux-Arts*, 6th series, vol. 35 (1949), p. 36.

19 Ibid, p. 37.

20 Ibid, p. 36.

21 For example, Svetlana Alpers, *The Decoration of the Torre de la Parada*, Corpus Rubenianum Ludwig Burchard, pt. 9 (London, 1971), pp. 237–9, and Steven N. Orso, *Philip IV and the Decoration of the Alcázar in Madrid*, (Princeton, 1986), p. 165.

22 George Kubler, "Three Remarks on the *Meninas*," *Art Bulletin* 48 (1966), p. 213. Kubler's short article draws attention to the similarity of the composition of *Las Meninas* with a ca. 1570 miniature painting by Hans Mielich of Munich portraying a performance by the court musicians of Albrecht V of Bavaria in his presence. Velázquez's familiarity with the image is unlikely. Part of the fascination of *Las Meninas* is, indeed, the lack of any obvious prototype. Velázquez certainly knew Jan van Eyck's *Arnolfini Portrait* (London, National Gallery), then in the Spanish royal collection, with its mirror, though the reflective surface in *Las Meninas* functions quite differently. Paul Barolsky has suggested that the composition may be based in part on Tintoretto's *Christ Washing the Feet of the Apostles* (Madrid, Museo del Prado). See his article "A Source for *Las Meninas*," *Source: Notes in the History of Art* 10 (Winter 1991), 22–4.

23 Jonathan Brown, "On the Meaning of *Las Meninas*," in *Images and Ideas in Seventeenth-Century Spanish Painting* (Princeton, 1978); *Velázquez, Painter and Courtier* (New Haven and London, 1986).

24 See Brown, "On the Meaning of *Las Meninas*," p. 102. For further discussion, see Julián Gállego, *El pintor, de artesano a artista* (Granada, 1976) and Mary Crawford Volk, "On Velázquez and the Liberal Arts," *Art Bulletin* 58 (March 1978), pp. 69–86.

25 Brown, "On the Meaning of *Las Meninas*," p. 94.

26 José Ortega y Gasset, *Velázquez, Goya and the Dehumanization of Art*, trans. by Alexis Brown, with an introduction by Philip Troutman (New York, 1972), p. 92.

27 Ibid, p. 95.

28 Brown, *Velázquez: Painter and Courtier*, p. 259. Madlyn Millner Kahr reached a similar conclusion, stating that "In creating the picture ... he ... was responding to the demands of life as well as art, and he sought a more concrete reward: the status of nobility." See her *Velázquez: The Art of Painting* (New York, Hagerstown, San Francisco, London, 1976), p. 202, as well as her article published the year prior: "Velázquez and *Las Meninas*," *Art Bulletin* 57 (June 1975), pp. 225–46. Kahr's arguments for her conclusion are far less convincing than Brown's. It is worth noting that the theorists who have since written about *Las Meninas* refer to the essays by Brown and Kahr in one breath, evidently unaware of their quite different levels of success.

29 For details of the decoration of the room, see Orso, *Philip IV and the Decoration of the Alcázar*, for his Chapter V on "The Role of the Setting in *Las Meninas*," pp. 165–82.

30 Because it is now clear that Velázquez sited the scene in a real room of the royal palace, the idea that the composition is related to Flemish gallery pictures (on account of the paintings on the wall) is unlikely. That connection was first suggested by Matthias Winner, "Gemälte Kunsttheorie. Zu Gustave Courbet's 'Alégorie réelle' und der Tradition," *Jahrbuch der Berliner Museen* N.F. 4 (1962), pp. 151–85 and was later pursued by Madlyn Kahr, "Velázquez and *Las Meninas*."

31 John F. Moffitt, "Velázquez in the Alcázar Palace in 1656: The Meaning of the *Mise-en-scène* of *Las Meninas*," *Art History* 6 (September 1983), p. 286.

32 Juan Miguel Serrera, "El palacio como taller y el taller como palacio. Una reflexión más sobre *Las Meninas*," in: *Madrid en el contexto de lo hispánico desde la época de los descubrimientos* (Madrid, 1994), vol. 1, pp. 585–601. Also published in *Otras Meninas*, ed. Fernando Marías (Madrid, 1995), pp. 231–46.

33 Examples of this approach are found in the work of Angel del Campo y Francés, *La magía de Las Meninas: Una iconología velazqueña*, with a prolog by José María de Azcárate (Madrid, 1978, 4th edition 1989), in which the author's expressed intention is a guide to the "creative process" of *Las Meninas*. It is worth noting that the author is an engineer and artist: his book was published by the Colegio de Ingenieros de Caminos, Canales y Puertos. In a similar vein, see Campo y Francés' "La invención de '*Las Meninas*'," in *V Jornadas de Arte: Velázquez y el arte de su tiempo* (Madrid, 1991), pp. 151–60, and more recently, his essay "Especularia geométrica en '*Las Meninas*,'" in: *Reflexiones sobre Velázquez* (Madrid, 1992), pp. 133–50, in which the author hypothesizes Velázquez's use of a half dozen mirrors in the creation of the scene. Angel del Campo was one of the first scholars to correctly identify the precise room in the Alcázar in which *Las Meninas* is set, in his "El Alcázar de *Las Meninas*," *Villa de Madrid* 12 (1974), pp. 55–61. Of *La magía de Las Meninas*, Santiago Sebastián has written: "Campo Francés ... ha querido ver la escena palaciega como soporte de la idea imperial de la monarquía española como centro del cosmos político del siglo XVII; los Reyes están rodeados de personajes reales y alegóricos, portadores de un complejo sentido astrológico, presentado en forma ingeniosa, pero dificilmente convincente." See Santiago Sebastián, *Emblemática ...*, p. 241.

34 Ramiro de Moya, "El trazado regulador y la perspectiva en *Las Meninas*," *Arquitectura* 3 (January 1961), pp. 3–12.

35 This architectural parlor game was continued by, among others, Carlos de Inza, "Prosiguen las pesquisas (sobre Las Meninas), *Arquitectura* 3 (April 1961), pp. 44–8, and Luis I. de Arana, "*Las Meninas*. Punto final," *Arquitectura* 3 (May 1961), p. 27. For a clear explication of perspective techniques in art, see Martin Kemp, *The Science of Art: Optical Themes in Western Art from Brunelleschi to Seurat* (New Haven and London, 1990). Kemp emphasizes the degree to which Velázquez uses "complex interlays of tone, colour, definition and scale"… "to give a wider sense of the subtle processes of vision and how they can be magically evoked or paralleled in the medium of paint than was possible with the drier mechanisms of linear perspective and geometrical shadow projection." Kemp's response to *Las Meninas* offers a corrective to the limitations of the geometrical analysis of the painting: "No painting was ever more concerned with 'looking' – on the part of the painter, the figures in the painting and the spectator. Velázquez's art is a special kind of window on the world – or a perceptual mirror of nature – or perhaps even more literally in this instance his personal door to the subtle delights of natural vision and painted illusion" (p. 108).

36 Avigdor Arikha, *On Depiction: Selected Writings on Art, 1965–1994* (London, 1995), p. 56.

37 Avigdor W. Posèq, "On Creative Interpretation: Igael Tumarkin's Homage to Velázquez's *Las Meninas*," *Konsthistorisk Tidskrift* 69, no. 1 (2000), pp. 33–4. Posèq adds that, following Foucault's ekphrasis of the painting, "The rest of the book, discussing the philosophical implications of the conceptual codes goes far beyond anything Velázquez may have meant to convey in the painting." Ibid.

38 See Ellen Harlizius-Klück, *Der Platz des Königs: Las Meniñas als Tableau des klassischen Wissens bei Michel Foucault* (Vienna, 1995).

39 John H. Searle, "*Las Meninas* and the Paradoxes of Pictorial Representation," *Critical Inquiry* 6 (Spring 1980), p. 481.

40 Joel Snyder and Ted Cohen, "Reflexions on *Las Meninas*: Paradox Lost," *Critical Inquiry* 7 (Winter 1980), pp. 429–47.

41 Ibid., p. 446. Snyder returned to study of the perspective construction of the painting in the first part of his 1985 article "*Las Meninas* and the Mirror of the Prince." See especially pp. 541–57, with perspective drawings.

42 Svetlana Alpers, "Interpretation without Representation, or the Viewing of *Las Meninas*," *Representations* 1 (February 1983), p. 37.

43 Ibidem.

44 Wohl, "Velázquez: *Las Meninas*," pp. 6–7.

45 In 1991, Mieke Bal wrote about *Las Meninas* in a chapter she described as "self-reflexivity as a mode of reading." See *Reading "Rembrandt": Beyond the Word–Image Opposition. The Northrup Frye Lectures in Literary Theory* (Cambridge, 1991), p. 255.

46 Leo Steinberg, "Velázquez' *Las Meninas*," *October* 19 (Winter 1981), pp. 45–6.

47 Denis Donoghue, "A Form of Attention," in *Creation and Interpretation*, eds. Raphael Stern, Philip Rodman, and Joseph Cobitz (New York, 1985), pp. 77–100.

48 Ibid., p. 85.

49 Ibid., 87–8.

50 Charles Karelis, "The *Las Meninas* Literature – and Its Lesson": in *Creation and Interpretation*, as in note 25, pp. 103–14. Quotation from p. 103.

51 Ibid., p. 105.

52 Ibid., quotation from Jonathan Brown, *Images and Ideas in Seventeeenth-Century Spanish Painting* (Princeton, 1978), p. 101, note 42.

53 Jonathan Brown and Carmen Garrido, *Velázquez: The Technique of Genius* (New Haven and London, 1998), pp. 184–6.

54 Hubert Damisch, *The Origins of Perspective*, trans. John Goodman (Cambridge, MA, 1994), p. 430. First published as *L'Origine de la perspective* (Paris, 1987).

55 Ibid., p. 444.

56 Richard Brilliant, *My Laocoön: Alternative Claims in the Interpretation of Artworks*. Berkeley, CA, 2000, p. 81. The first to describe *Las Meninas* as a "metametapicture" was W.J.T. Mitchell, *Picture Theory* (Chicago and London, 1994). See his discussion on pp. 58–82.

57 See Nicole Dubreuil-Blondin, "Le Philosophe chez Vélasquez: L'intrusion de Michel Foucault dans la fortune critique des *Ménines*," *Revue d'Art Canadienne/Canadian Art Review* 22 (1993), pp. 116–29. The article usefully examines the "diverging strategies of the 'theoreticians' and the 'scholars.' . . . One important point of divergence between the two groups is the result of Foucault's interest in the 'apparatus' of the painting as opposed to a concern for its narrative and symbolic content. This implies a passage from the 'what' to the 'how' of representation, from reference to self-reference and a privileging of structural functions over or before considerations of social status" (p. 116).

58 Donoghue, "A Form of Attention," p. 88. Steinberg's essay is called "Interpretation as Elucidation: what it elucidates is the manner in which the painting forces us to be more intently and more specifically conscious." (p. 89)

59 Jan Baptist Bedaux, "Velázquez's *Fable of Arachne (Las Hilanderas)*: A continuing story," *Simiolus* 21 (1992), p. 298.

60 Antonio Palomino, *Lives of the Eminent Painters and Sculptors by Antonio Palomino*, trans. and ed. by Nina Ayala Mallory (Cambridge, 1987), p. 165.

61 Kurt Gerstenberg, *Diego Velázquez* (Munich, 1957), p. 191 and Gustav Künstler, "Uber '*Las Meninas*' und Velázquez," in *Festschrift Karl M. Swoboda zum* 28 January 1959 (Vienna-Wiesbaden, 1959), pp. 141–58. The image in the mirror has been similarly subjected to various readings. George Kubler first thought that the mirror reflects the king and the queen posing for the portrait Velázquez is painting. (Kubler, "Three Remarks on the *Meninas*," pp. 212–4. Years later, he proposed a much more complicated reading, that the mirror is not a mirror at all, but a "painted image of the King and Queen, painted on a small canvas as if seen in a mirror." Other ideas he found "inconsistent with the idea of exact or photographic perspective diminution." See George Kubler, "The 'Mirror' in *Las Meninas*," *Art Bulletin* 67 (June 1985), p. 316.

62 For example, Elizabeth du Gué Trapier, *Velázquez* (New York, 1948), p. 339. Bo Vahlne reads the painting as "first and foremost a portrait of the Infanta Margarita." See "Velázquez' *Las Meninas*: Remark on the Staging of a Royal Portrait," *Konsthistorisk Tidskrift* 51 (1982), p. 25.

63 Moffitt's hypothesis that the painting is an actual, but now lost, double portrait of Philip and Mariana, has not gained a following. See John F. Moffitt, "Velázquez in the Alcázar Palace in 1656," p. 286. The identification of the canvas as a double portrait of the monarchs had earlier been suggested by another mathematical investigation undertaken by Bartolomé Mestre Fiol and made accessible to more readers in José Gudiol's monograph on the artist. See discussion and illustration of Mestre Fiol's drawing in José Gudiol, *Velázquez: Historia de su vida, catálogo de su obra, estudio de la evolución de su técnica* (Barcelona, 1973), p. 289, or in the English translation by Kenneth Lyons (New York, 1974).

64 Emily Umberger, "Velázquez and Naturalism II: Interpreting *Las Meninas*," *Res* 28 (Autumn, 1995), p. 112. Umberger argues that *Las Meninas* "contains a traditional iconography that alludes to verbally articulated ideas through allegory" (p. 95), emphatically rejecting the most widely accepted interpretation of the painting: "The issue of liberal arts status, however, is not referred to in the composition's allegorical allusions; nor is Velázquez's specific ambition for knighthood. Addressed instead are the problem of naturalistic representation and the role of the learned artist" (p. 115).

65 Amy M. Schmitter, "Picturing Power: Representation and *Las Meninas*," *Journal of Aesthetics and Art Criticism* 54 (Summer 1996), p. 264.

66 Ibid., p. 265.

67 George and Linda Bauer, "Portrait Practice in *Las Meninas*," *Source: Notes in the History of Art* 19 (Spring 2000), p. 41.

68 Victor I. Stoichita, "Imago Regis: Kunsttheorie und königliches Porträt in den Meninas von Velázquez," *Zeitschrift für Kunstgeschichte* 49 (1986), 165–89, and in Spanish as *"Imago Regis: Teoría del arte y retrato real en Las Meninas* de Velázquez," in *Otras Meninas*, ed. Fernando Marías, pp. 181–204. In that article, Stoichita also reflects the "Mirror of Princes" ideas first put forward by Emmens. Stoichita returned to *Las Meninas* in his book *The Self-Aware Image: An Insight into Early Modern Meta-Painting* (Cambridge, 1997), where he describes the painting as a "scenario of production in the first person" (p. 247).

69 Some of these positions would be strengthened by a deeper understanding of the role of portraiture at the Spanish Habsburg court, as examined, for example, in the essay by Antonio Feros, "Sacred and Terrifying Gazes: Languages and Images of Power in Early Modern Spain" in the *Cambridge Companion to Velázquez*, as in note 2.

70 Fernando Marías, *"Las Meninas* de Velázquez," p. 176. The essay is also published as a small book, *Las Meninas* (Madrid, 1999), subtitled: "Del cuadro historiado de la Infanta Margarita a *Las Meninas.*" See also Fernando Marías, "El género de *Las Meninas*: Los servicios de la familia," in: Fernando Marías, ed., *Otras Meninas* (Madrid, 1995), pp. 247–78.

71 Marías, *"Las Meninas* de Velázquez," ibid.

72 Ibid., p. 177.

73 Orso, *Philip IV and the Decoration of the Alcázar*, p. 170.

74 See Manuela Mena Marqués, "La restauración de *Las Meninas* de Velázquez," *Boletín del Museo del Prado* 5 (May–August 1984), pp. 87–107.

75 See Gridley McKim-Smith, Greta Andersen-Bergdoll, and Richard Newman, *Examining Velázquez* (New Haven, 1988); Gridley McKim-Smith and Richard Newman, *Ciencia e historia del arte. Velázquez en el Prado* (Madrid, 1992); Carmen Garrido Pérez, *Velázquez. Técnica y evolución* (Madrid, 1992); and Jonathan Brown and Carmen Garrido, *Velázquez: The Technique of Genius* (New Haven and London, 1998).

76 Ibid, p. 280.

77 Arikha, *On Depiction*, p. 54.

78 Calvo Serraller, *Las Meninas de Velázquez*, p. 51. [My translation.]

79 Ibid. Quoted from John Berger, "Los enanos cambian de sitio," in: *El retrato en el Museo del Prado* (Madrid, 1994), pp. 376–7. [My translation.]

REPRESENTING REPRESENTATION

Reading *Las Meninas*, Again

WHAT YOU GET IS (OFTEN) NOT WHAT YOU SEE: SOME IDEAS ABOUT UNCERTAINTY

> The painter is standing *a little* back from his canvas. He is glancing at his model; *perhaps* he is considering whether to add some finishing touch, *though* it is also *possible* that the first stroke has not yet been made. The skilled hand is *suspended* in mid-air, *arrested* in rapt attention on the painter's gaze; and the gaze, *in return*, waits upon the arrested gesture[1] (emphasis added).

These were the opening remarks in Michel Foucault's 1966 ground-breaking essay about *Las Meninas*. He was using Velázquez's painting as a starting point to discuss "words and things" – or, as the title was translated into English, "the order of things."

In this book, the French philosopher was attempting to conform what he called an *archaeology of knowledge*, a discontinuous space, "a history which is not that of its growing perfection, but rather that of its condition of possibility."[2] He was practicing an approach to knowledge differing from "history," as understood in the traditional Hegelian teological model, in which a mode of production emerges dialectically from another.[3] Foucault appeared, therefore, to be interested in discontinuity as opposed to progression, in the articulation of the Same – Order – and the Other – Disorder – and in the manner in which both terms are defined and redefined in language. Foucault was, witthout a doubt, exploring linguistic relationships: The world is perceived by the way it is named.

Why, then, use *Las Meninas* to introduce such a topic if the painting had always been considered an ultimate monument of Western visuality with the most complex and elaborate perspective, as many art historians would agree? Why focus attention on *Las Meninas* to explore "the order of things" when the narration in the painting – the story told – had often been interpreted as a sort of an excuse for the previously mentioned visuality? Why select a masterpiece of Western civilization – even a privileged icon in our cultural display – to approach "the named"?

Moreover, what did Foucault *see* in this painting that no one had seen before him? What new element did he *perceive* in a profusely discussed, widely written about canvas? What exquisite rupture could Foucault have discovered in such a "popular" painting, an image produced and reproduced on candy boxes, calendars, posters, stamps, postcards, ashtrays, other painters' works, and so on.

In fact, *Las Meninas* is more than a work of art: It is a cultural symbol. For some obscure reason, "we"– as part of Western culture – belong there, in the surface of the painting. One could almost say it is a means to materialize our cultural "selves."[4] Indeed, *Las Meninas* condenses many of our collective longings and aspirations: It represents "us." We are *Las Meninas* because *Las Meninas* is a powerful icon in our cultural and visual tradition. Yet could that be an irrefutable explanation for our intense fascination with the painting?

In any case, at the Prado Museum in Madrid day after day, month after month, year after year, visitors stand in front of the huge canvas and stare attentively. They have to: Before their amazed eyes appears a "masterpiece" painted by a "genius."

Truly enough, the author of *Las Meninas*, Diego Velázquez, represents a category very dear to the Western cultural construction: He is a "genius," a "positive exception" in art history. So, *Las Meninas* is a "masterpiece" because it was painted by a "genius." Neeedless to say, this reductive discourse – one quite well established in classical art history – has been questioned since the early 1980s by gender studies: In Western tradition, only men have the capacity of being geniuses – and that is why the term *positive exception* is used here.[5] Yet not only here: Masterpieces, like religious dogmas, are accepted as such without further discussion. The elusive quality of *Las Meninas*, the unsolved and unsolvable mystery in the painting, could perhaps derive from this

quite simple definition: A "masterpiece" is such because it was painted by a "genius" or, in other words, "geniuses" produce "masterpieces," which *must* be admired.

Maybe visitors stand in front of the painting and take that equation for granted. Do they really "see" the work, or are they merely trapped by the legend and the fame of the painting? Do we really "like" that work of art, or are we simply seduced by it? And if so, in what way? Moreover, how could such an elusive painting have become a cultural icon for a discourse such as the Western one that seeks certainty, that adopts and reinforces a binary logical system, that rarely takes the "in-betweens" seriously, that tends to exclude all unclear or slippery territories? In fact, for the Western logical system, things are either the Same – Order – or the Other – Disorder. Perhaps both terms can even cohabit, but always in clearly separated territories. What Foucault is trying to achieve in his text is the unveiling – or, we might say, the *naming* – of that space in which the two terms can comfortably relate.

So, Foucault is not interested in the genius of the painter. In fact, he mentions the artist's name *en passant*. The reader has the impression that Foucault gives the painter a name only to avoid unnecessary repetions when telling the story: *The artist* equals Velázquez, but that name could almost be modified to any name. Acording to Foucault's strategy, Velázquez seems to be no more than the painter in the painting – in the narration – he becomes almost any painter. The only thing required from Velázquez is his remaining faithful to his function in the sophisticated representational system that *Las Meninas* stages. Therefore, Velázquez's uniqueness is not attached to his genius, but to the way he contributes to materializing the conflict on the very surface of the painting, a conflict that surpasses the visual one – traditionally so intriguing for art historians – and slaps the viewer like a menacing weapon, unbalancing the traditionally privileged and secure position ouside the painting.

Indeed, Foucault is not searching for uniqueness – or, at least, not in the way it is understood in most art history contexts, as the quality of being a "genius." One could say that Foucault seeks something more. In his own fashion, he is, of course, tracing exceptionality, even if an exceptionality referring only to difference and split – and in this respect, *Las Meninas* serves his purpose perfectly well. The philosopher is trapped in the vulnerability of the painting, in its fragility, in that

elusive contradiction that goes further beyond the "Baroque tautology," as Severo Sarduy calls it.[6]

In this respect, the contribution of the French philosopher is essential. Although he poses a number of problems that are reread by gender studies and feminist theory – some of his theoretical positions, like Lacan's, exclude or leave unclear the female self or the idea of power related to women [7]– it is obvious that in disregarding the genius qualities – maybe as part of the Same (Order, positive exceptions) – he leaves a wide open territory for further dismantling of the classical art history approach, a narrative of exclusions that places women artists in an undiscussed inferiority position.

Therefore, let us return to the remarks Foucault uses to introduce his essay. The philosopher is simply seeing and describing what seems to be obvious to anyone: The painter is in front of his canvas, glancing at his model. Nevertheless, the very language he chooses to describe an apparently matter-of-fact image – a painter in the midst of the act of painting – reveals the intense, impossible to grasp atmosphere that pervades Velázquez's work. There are too many ambiguities in Foucault's language, too many doubtful expressions, too many "yes but no": a little, perhaps, although, possible, suspended, arrested, in return. Through the careful selection of his words to approach a visual reality which might have seemed obvious at first glance – a painter in the act of painting – Foucault is naming uncertainties, or to use his own words, discontinuities. In that way, *Las Meninas* becomes a strategy for revisiting Western culture itself, a device used to locate the split between two systems, two orders, two fractures – the visual and the linguistic. Foucault does not aim to constitute a system, although his works do have a strong internal coherence. He wants to work by and through difference, or, in other words, he decides to face the conflict so amazingly offered by *Las Meninas*

Let us return, then to the painting; let us observe the painting, as Foucault does. *Almost* in the middle of the canvas a little girl faces the viewer; she *seems* to be the most glittering focus of the scene. Next to her, two young ladies are offering something that she *is at the point* of taking. On the right side, a group of people *could* be speaking; on the left side, the "painter," as Foucault observes in his text, shows his hand *suspended* in mid-air. In the far rear of the room, where the real luminous spot *appears* to be, a man – José Nieto, as he has been

identified – is *either entering or leaving* the room: "He may be about to enter the room; or he may be merely observing what is going on inside it, content to surprise those within without being seen himself."[8] Finally, a closer look reveals a *blurred* framed image that could *perhaps* be a mirror.

Everything in the painting is slippery, every action is suspended: it is *about* to happen or it has *just* happened. *Las Meninas* possesses this peculiar photographic quality that Ortega y Gasset pointed out in his essay on the painter: "This man portrays the man and the pitcher, he portrays the form, he portrays the attitude, he portrays the instant. And there, ultimately, is *Las Meninas*, where a portraitist is portraying the portrayal."[9]

In *Las Meninas* time seems to be frozen, as if it had been stopped in a precious moment that gives the event a rare quality: The event takes place inside the picture and, at the same time, it happens ouside of it. As in a photograph, one has the feeling that the essential information has been excluded from the visual field: It is invisible. Also as in a photograph, the "real" event is missing, impossible to grasp. There is only some kind of intense, so hard to define emptiness, some "lack": in front of a photograph, all classifications remain incomplete. As Roland Barthes says: "Photography evades us."[10] That is maybe why, as Rosalind Krauss notes, most people try to explain the "what" in front of a photograph – "It is x or y" –[11] as if by revealing the action that takes place in the picture, describing it, the ultimate lack could be solved.

Regardless, the strategy simply fails. As Barthes suggests, all photographs establish a kind of vaguely sentimental relationship with the viewer; all photographs are, at least to a certain extent, "our" photographs because they make some certain lack evident: "The *noeme* of Photography is simple, banal; no depth: 'that has been.' I know our critics: What! a whole book (even a short one) to discover something I know at first glance? Yes, but such evidence can be a sibling of madness. The Photograph is an extended, loaded evidence – as if it caricatured not the figure of what it represents (quite the converse) but its very essence. The image, says phenomenology, is an object-as-nothing. Now, in the Photograph, what I posit is not only the absence of an object; it is also, by one and the same movement, on equal terms, the fact that this object has indeed existed and that it has been there where I see it."[12]

Now, if all photographs are "our" photographs, if we tend to de-
scribe their contents – "It is... " – because the relevant issue – their
implied lack – is impossible to put into words, as it embodies the "un-
said," could we assume, even for a moment, that *Las Meninas* is "us"
not only for its cultural significance, but also for its photographic qual-
ity, this quality that in Barthes' term blurs the distinction between the
photograph (or painting) from "its referent (from what is represented),
or at least not *immediately* or *generally* distinguished from its referent"?[13]

If *Las Meninas* has this ambiguous photographic quality, that would
explain why art historians have devoted most of their efforts to desig-
nating who is who in the painting, to clarify what is taking place in the
scene – Krauss' "It is...." Yet, maybe even after so many attempts, the
essential issues remain unsaid or, to use pictorial terms, invisible. This
is precisely what Foucault faces in his essay. He is actually looking for
a space in which the Same and the Other can comfortably meet; he is
trying to pin down that territory. That space is, no doubt, a linguistic
space or, as he puts it, the "non-place of language."[14]

THE SAME AND THE OTHER: SOMEBODY
IS WATCHING YOU

In the preface to *The Order of Things*, Foucault quotes Jorge Luis Borges
and his "Chinese Encyclopedia," in which a universe of heteroclite
animals are arranged in a curious taxonomy. When reading that list,
Foucault feels "all the familiar landmarks of [his] thought... breaking
up all the ordered surfaces and all the planes with which we are accus-
tomed to tame the wild profusion of existing things, and continuing
long afterwards to threaten with collapse our age-old distinction be-
tween the Same and the Other."[15]

Facing this strange mixture of creatures, the philosopher tries to
find a common territory, a new taxonomy in which these antagonistic
categories can meet. They do, in fact, meet, at least in Borges' proposi-
tion, on the very page. To be more precise, they meet – or at least they
interact – in language: "Where else could they be juxtaposed except in
the non-place of language?"[16] Language, even the very page where the
list appears printed, becomes a kind of *space*, even if a non-place space.

This is not the first time a similar proposition has been put for-
ward. In a way, Gustave Flaubert seems to work within this conceptual

framework in some of his writings, although he does not, of course, verbalize the tactics theoretically as Foucault does. In some of his novels, Flaubert uses the text as space. It becomes a textual space in which the characters circulate.

Let us take *Bouvard and Pécuchet* as an example, and consider how Flaubert organizes the plot. Two men, coming from opposite directions – the Bastille and Le Jardin des Plantes – meet one summer afternoon and realize they have much in common: They both work as clerks at some gloomy office, and they both agree life in the suburbs is not very exciting. From that afternoon on, by pure chance, the two men become friends and suddenly, another hot afternoon, when fortune strikes one of them in the form of an unexpected sum of money, they decide to move together to the country.

Away from Paris, they start a new life together, and try to fulfil their existence with some controlled passions; they fight boredom collecting objets, knowledge, and so on. They build a museum; they impress their provincial neighbors with their apparent Parisian sophistication. They even experience jealousy. They attempt, as Crimp has very astutely noted,[17] a new taxonomy, or, at least, they represent a criticism of "modern" order – Sameness – the order established by the Enlightenment – "history" as progress and progression – the order Foucault hopes to question and dismantle through his "archeological" approach.

Then, gradually, an intense tedium invades the two men's lives. What to do next? The story goes on, lingering with that paradoxical feeling the two characters are taken by, boredom and excitement, until at some point it ends abruptly. After that, only a few notes are left, as in a rush, as if the men's tedium, the two men's impossibility, had entered the mood of the author himself.

The notes for this unfinished story are pervaded by the two characters' gradual lack of interest in life. Then, all of a sudden, they simultaneously express an idea: They should go back into copying like in the old days, they should sit down and copy, with no precise aim at all, like they did at the office before attempting to set themselves free. This ending of *Bouvard and Pécuchet* leaves the reader astonished, restless, even angry. Why end a story in such a rush, why leave the story unfinished?

Flaubert knows encounters are not forever, but he is unable to face the inevitable separation of his characters, so he decides to leave the

book incomplete. He cannot face their parting. The revolutionary po-
sition of Flaubert is that he takes the very written text as space, as
physical space. In fact, Flaubert's textual space[18] allows the reader to
circulate within the written text itself, to circulate like Lacan's concep-
tion of desire. Bouvard and Pécuchet do not meet in Paris; they meet
in the textual space. Flaubert does not want them to part, he cannot
allow them to abandon that space: therefore, the text remains open,
indefinite; in a way, suspended.

Perhaps Foucault operates similarly. For him, the visual space be-
comes a kind of textual, linguistic space, the place where the conflict
manifests itself. This conflict is not painterly at all, not even narrative,
but linguistic, as it implies subjectivity, the very formation of the Self
and the Other; two antithetical, paradoxical, condemned-to-separation
concepts that bump into one another in Velázquez's painting.

Who are the characters in *Las Meninas*? What is taking place in the
scene? What is painted on the canvas within the canvas? Classical art
history had been asking these questions ever since the very appearance
of the work, as if determining who was who in the painting and there-
fore establishing their precise function in the scene could somehow
clarify the enigma, as if it could explain what was represented in the
painting. Foucault's question implies a flagrant change of paradigm.
As Nicole Dubreuil-Blondin explains, "At that level, Foucault can ask
the painting not anymore what it represents, but how it is becomes a
model for representation."[19]

In fact, for him, it is not important to assign a name to all the actors
on stage. Identifying them does not solve the basic problem, nor does
it answer the key question: "And the proper name, in this particular
context, is merely an artifice: It gives us a finger to point with, in other
words, to pass surreptitiously from the space where one speaks to the
space where one looks, in other words, to fold one over the other as
though they were equivalent."[20]

Indeed, they are not equivalent; quite the opposite. For Foucault,
the visible – what we see – cannot be explained through language –
what we say – and, at the same time, language cannot be equivalent to
visuality: "and in vain we say what we see; what we see never resides
in what we say."[21] Those are the two systems, the two orders, the two
fractures we were referring to before: the Seen and the Said.

This remark is, of course, crucial for his very theoretical *mise-en-
scène*, for the philosopher is questioning the tradition of art history:

Can a painting be explained, can it be put into words, does identifiying the characters give an even approximate idea of what is taking place in the painting, on the canvas as textual space? The answer to these questions is undoubtedly "no." However, naturally, Foucault is not interested in what *Las Meninas* represents; he wants to explain how it becomes a model for representation. In other words, he once again questions *history* – understood in the traditional manner –, because history tries to identify the visible, whereas *archeology* – his chosen method of knowledge – aims to name the invisible – the discontinuity, or, even better, seeks to explore it. *History* tells a story, although because the Seen and the Said belong to two different orders, to two different taxonomies, *history* will not explain the painting. *History* is, therefore, a narrative that approaches what is represented in the painting, not what the painting represents.

At this point, we could perhaps finally ask what the painting is about, what it represents. We could try to *name* the conflict. So, let us return to the spatial problems for a minute. In this respect, Foucault and art history coincide, at least to a certain extent. They both think the composition of the work is essential to the very painting. Yet, a relevant difference is implied in both positions. Traditional art history understands composition as an auxiliary mode for representation, and therefore tends to exclude the spectator from its plans. On the contrary, Foucault gives us the impression that the elaborate representational system of *Las Meninas* depends on the spectator, that it must take the spectator into consideration, even if he/she is definitely excluded from the visible space of the painting. Why and how is the spectator an invisible and yet integrated part of the work?

As Foucault explains in the opening remarks of his essay, Velázquez is glancing at his model. As a result of the actual position assigned to the spectator – us – in the painter's gaze, the spectator – we – are that model. We occupy the space Velázquez's gaze is directed to. This way we constitute a vital part of the painting that, paradoxically, lives outside the painting itself.

If we accept this hypothesis as true, *Las Meninas* can in a way be considered a somehow incomplete painting, a painting riddled with holes: It needs the spectator to be complete as much as the spectator needs the painting to achieve such a status. This quality of confrontation and incompleteness is one of the starting points for Lacan's approach.

Herein lies the paradox described by the painting, probably one of the most revolutionary points in Foucault's essay. The spectator is looking at the painting, but at the same time he/she is being looked at by the painting and, as has been explained, his/her traditionally secure position is suddenly assaulted. Model and painter indefinitely exchange their positions. They are alternately object and subject of the gaze in the painting: he/she who sees, he/she who is seen. In this way, the spatial game becomes linguistic in so far as it is related to the formation of subjectivity.

In any case, there are obviously other invisibilities apart from the invisible spectator. The matter on canvas remains a mystery to all those outside the painterly space – an anomaly for most classical pictorial representarions, where the canvas becomes a window from which the spectator virtually "enters" and controls the whole world open to his/her gaze. Yet that is not all: There is also, in Foucault's account, yet another invisible element – invisible at least to the figures in the painting – that could be the key to the reading of *Las Meninas*. On the rear wall, as has been pointed out, a blurred framed image is vaguely perceived. That could perhaps be the final clue for Foucault's interpretation: The king and queen are reflected on that fading framed surface – in fact, a mirror that challenges most typical art history uses and representations. This mirror does not duplicate the information in the painting – a common use in Flemish art. It shows the image of the king and queen who, simultaneously outside and inside *Las Meninas* – to continue with the game of the visible and the invisble, occupy the identical external space where the spectator ideally stands. The mirror should, then, reflect the spectator – us – but instead, the image we are confronted with is not our image, but the image of Otherness.

Therefore, at least two conflicts can be singled out in this textual, linguistic space: The first is about the very formation of the self as gaze, a conflict returned to when discussing Lacan; the second is at the core of Foucault's theory and is connected to his epistemologic method itself. If Foucault is interested in a discontinuous approach that implies both difference and split, *Las Meninas* serves his purpose perfectly. As Douglas Crimp points out: "[T]his is indeed a painting in which the artist, on the one hand, and the spectator on the other, have usurped the position of the subject, who is displaced to the vague reflection in the mirror on the rear wall of Velázquez's studio."[22]

The very absence of the "tangible" king on the surface of the painting – the conscious absence because Velázquez is an artist of strategies – the lack that absence proclaims, the "essential" absence, that of the "subject" as understood by classical etiquette – makes of *Las Meninas* a "representation of Classical representation, and the definition of the space it opens up to us."[23] As Crimp explains it:

> What Foucault sees when he looks at this painting, then, is the way representation functioned in the Classical period that came to an end, in Foucault's archeological analysis of history, at the beginning of the nineteenth century, when our own age, the age of modernism, began. And, of course, if this era of history came to an end, so too did its understanding of the world, of which *Las Meninas* is a particularly fine example.[24]

This is, then, the rupture, the discontinuity Foucault is seeking. The missing king, only vaguely reflected in the mirror, returns a reflection to the world – of the world – that implies those radical changes, that split. Even more, it returns a reflection to the spectator that also names a split – the one related to the desiring self. The mirror of *Las Meninas*, as a basic Lacanian element of analysis, would also trap the psychoanalist in his obsession to define desire.

ENCORE: MIRROR, MIRROR...

In one of his last and maybe more obscure seminars, *Encore*,[25] Jacques Lacan speaks about love. He himself seems to be surprised about the chosen subject. How can anyone speak about love? Little by little, the reader discovers Lacan is still – *encore* – only speaking about desire, because desire is, no doubt, at the core of Lacanian psychoanalytic theory.

Lacanian desire, so difficult to grasp and define because it varies along with the writer's thoughts, could perhaps be called a *lack*, a *split*, and – why not? – a kind of *discontinuity*. In Lacanian terms, *desire* is crucial in the formation of subjectivity, it intrudes on our perception of the world and into our relationships with others. In fact, desire is the clue to understanding the relationship between the Self and the Other: the Self knows who he/she is when the Other says "No." The Other does, of course, say "No" quite often, or, at least, he/she frequently

says "Maybe," because the Other is nothing but another Self, who, in return, sees the Self as Other. The encounter of the Self/Other and Other/Self is essentially the encounter of two impossibilities, of two desires.

Desire, that lack we all suffer from as linguistic beings, could therefore be defined as "giving something we do not really have to somebody who does not really need it – or, at least, to somebody who needs something completely different from what is given." Desire, then, makes these two roles – Self and Other – indefinitely interchangeable.

As is well known, in the long process of the definition of desire in Lacanian theory, the mirror plays a basic role. We, as linguistic beings, are condemned to lack – and therefore to desire – simply because we are condemned to becoming linguistic beings. In other words, we must be fully aware of the existence of the Other in order to achieve our status as Self, in order to become linguistic beings, but, at the same time, separating from the Other gives place to the incompleteness that originates desire. This tautology is clearly expressed in the approach Lacan takes to the articulation of the Self, the "I."

The often referred to *mirror stage* – the means to acquire the Self – is based on reflection.[26] The child (sometime between the ages of six months to eight months) stands in front of the mirror with an adult and is unable to distinguish between the two reflections (this would be the first stage). In a second moment, the child realizes that they are not real beings but reflections (second stage) and finally understands that he/she is not the other and that the other is not him/her (third phase). From that moment on, the moment that generally represents the ultimate separation from the mother, the child suffers from a split, some lack that creates desire, a hole, a discontinuity, impossible to fill no matter what. In fact, *desires* can be fullfilled; *desire* cannot.

Therefore, in Lacan's formation of the Self and in his definition of desire, the scopic field is extremely important – the child learns about the existence of the Other (the second presence in the mirror) through gaze. Desire is indeed, among other definitions, an impossible encounter with the Other. It is, always and hopelessly, a sort of "promise." This is perhaps what draws Lacan's interest to painting and painters, two subjects he approaches in some of his writings and seminars quite often. Painting has that elusive quality – what is seen and

what is not quite seen – that lures Lacan's curiosity. Painting represents, somehow, a necessity for completeness that, from the Lacanian point of view, is never achieved.

Taking into consideration the essence of *Las Meninas*, its elusive quality, its game of visibility and invisibility and the fading and yet strong presence in the mirror, it does not seem strange at all that Jacques Lacan decided to discuss the work both in his XI and XII seminars.[27]

In Lacan, as in Foucault, the actual content of the invisible canvas does not matter so much as it does for traditional art history. For him, it seems to be nothing but an excuse for other fundamental issues. In fact, the essential thing for Lacan, as for Foucault, is the function of the canvas in the whole representational system. The canvas acquires the function of a veil, the ultimate representation of desire, what is never fully seen or fully achieved and, of course, never said. The right question would be then what the canvas represents, and not what is represented on the canvas.

To try to pin this question down, Lacan, like Foucault,[28] faces the complicated formal construction of the painting, its multiple focal points. In Lacan's discussion, they are used as a manifestation of the conflict in the formation of subjectivity. This multiplicity of perspectives makes the spectator – the seeing Self created by the seen space – a multiplied gaze that can no longer refer to the classic unitary focal point.

This issue is somehow related to Marxist theory in art history, which tries to explain Renaissance perspective from an ideological angle. In fact, the rise of the new bourgeois class during that time did not manifest itself only through the use of a more "realistic" and secular subject matter, but by the "invention" of perspective. That system, based on a convergence toward a vanishing point in the picture, indicated that there was only one irrefutable point in space to identify with, therefore establishing a unitary system, one the new class aimed to impose on the rest. Or, as it could be explained in Lacanian terms, there is only one possible Self, the one that the Enlightenment would perfect and impose on the whole world with its sophisticated colonial behavior. That was precisely the subjectivity both Lacan and Foucault would question from their post-structuralist position. For the first, the Self and the Other would inevitably interchange their positions; for the second, the Same and the Other could share a common territory, the nonlanguage space.

So, the multiple and multifocal space in *Las Meninas* relates to the multiplicity of the subject. It belongs to the subject's unsteady position in the world and implies the forever exchanged roles the Self and the Other play. What does the spectator – us – see when looking at the mirror? What does he/she find in the place where his/her image should be? He/she finds the king or, in other words, the Other, that necessary Other that the Self needs to be completed, the indispensable Other that the Self needs in order to acquire the consciousness of his/her own existence: "My mother is reflected in the mirror, I am not my mother, therefore, I am 'I,'" the child would think. Once again, and as it was in Foucault, the reflected king is the basic clue for Lacan: His very presence as Other guarantees the completeness of the painting.

In his brilliant interpretation of *Las Meninas* following Lacan, Severo Sarduy compares José Nieto – the one who leaves – to Velázquez – the one who stays: "Only he who goes," says Lacan, "is the one who is seen and the one who has been seen; the one who stays – Velázquez – [is] the other focal point: he is the gaze that would paint in our place, the vision's place, but only since it does not contain gaze; the master leaves it on the canvas."[29]

Velázquez is, then, staying, but he stays only as gaze. That is why the slippery *Las Meninas* can never be explained by "history": It can never be put into words. Foucault had caught that impossibility: The "seen" could never be the "said." Lacan went a step further in expressing the necessity of that conflict in the formation of the Self.

NO PARADOXES, PLEASE: WE ARE ART HISTORIANS

Needless to say, the early response to Foucault from the artistic world was not wholly enthusiatic although in recent years, and as a result of the changes that have taken place in the field of art history, Foucault's and Lacan's theories have been adopted by a fair number of art historians routinely. When Foucault's essay appeared in the mid-1960s, it was often contested and rarely truly understood by the great majority of scholars who took it as a starting point for their discussions.

In fact, most of the articles commenting on Foucault's work that were published after *The Order of Things* expressed their disagreement with the philosopher. The authors believed his hypothesis was incorrect. He was not an art historian, and therefore was missing some basic

point when examining *Las Meninas*. He missed one of the fundamental problems both in the painting and for art history: the formation and development of perspective. That was the "lack" in the philosopher's training. Probably, the masked question in Foucault's critique was as simply as this: Why is a philosopher intruding into what seemed to be purely a matter of visuality?

Perhaps that is why some of the articles "post Foucault" approached the philosopher's opinions from a quite restrictive classical art history position: They focused their discussion on how perspective worked in the painting and insisted on answering the question that was precisely irrelevant in Foucault's account, and later in Lacan's as well. What is the subject painted on the invisible canvas?

That was, for instance, the formalist approach taken by John Searle, a philosophy professor at the University of California at Berkeley, whose article "*Las Meninas* and the Paradoxes of Pictorial Representation" appeared in *Critical Inquiry* in 1980.[30] His discussion was based on classical painterly representation and, through a detailed reconstruction of the "point of view" in *Las Meninas*, he formulated an answer to the enigma on the invisible canvas: the painted subject is nothing more than the very painting of *Las Meninas*. "I think that the painter is painting the painting we are seeing: that is, he is painting *Las Meninas* by Velázquez. Although this interpretation seems to me defensible on internal grounds alone [Searle is referring here to the perspectival issues], there are certain bits of external evidence: as far as we know, the only portrait Velázquez ever painted of the royal couple is the one we are looking at – *Las Meninas*. Velázquez is plainly painting us, the royal couple, but there is no other picture in which he did that; and indeed he seldom used such large canvases for interiors."[31] The invisible canvas was simply too large to be a portrait of the royal couple, he argued.

The answer to his article was not long in coming. The authors, Joel Snyder (a photographer and professor of Art and Design at the University of Chicago) and Ted Cohen (a philosophy professor at the same university), wrote their article, "Critical Response. Reflexions on *Las Meninas*: Paradox Lost," published a few months later in the same magazine.[32]

Once again, using a detailed perspective study that questioned Searle's approach, they assumed the image on the invisible painting

was the reflection of the one on the mirror at the rear wall. That mirror was not, then, reflecting the "real" king and queen, but the painted king and queen on the invisible canvas. That way, Velázquez was challenging and even surpassing nature.

> A gifted painter rivals nature; a great painter forces nature to rival art. Velázquez wants, and he wants the viewer to understand that he wants, the mirror to depend upon the unseeable painted canvas for his image. Why should he want that? The luminous image in the mirror appears to reflect the king and queen themselves, but it does more than just this: the mirror outdoes nature. The mirror image is only a reflection. A reflection of what? Of the real thing – the art of Velázquez.[33]

Regardless, and as has been said, what Velázquez was really painting is perhaps not the most relevant issue, and not even in Foucault's critical context. The most important and indicative phenomenon in these two articles is the choice of a formalist approach that can probably give us an idea about the somewhat "distorted" reading of Foucault by his contemporaries. It seems that something was missing in their answer to Foucault, something crucial that only since about 1985 has given him the place in art history that he no doubt merits. Maybe some of those first scholars "after Foucault" did not quite understand the philosopher's contribution to art history, although thirty years later it seems clear enough.

In fact, from today's perspective, one could probably say that Foucault was not interested in art historical practice – the construction of visuality or visual space – but in art historical narrative – the construction of a privileged discourse that establishes its realm of domination hiding behind facts and names. In his hoping to overthrow "history," Foucault aimed to make that hegemonic discourse fragile, open, and based on uncertainties as opposed to the certainties "history" seeks. Foucault longed for the rupture or, in other words, he wanted to unmask the fictitious "history" and place it in a sort of vulnerable territory. That was also, no doubt, a kind of hidden paradox his contemporaries did not understand or would not accept.

Perhaps that is why in their articles "post Foucault," Svetlana Alpers[34] and Leo Steinberg[35] were closer to the philosopher's basic

concerns, even if the first said explicitly that he was not right: "He argues that the absence of a subject–viewer is essential to classical representation. This seems to me wrong"[36] – and the second jokingly mentioned "a philosopher loving paradoxes."[37] They seemed to understand Foucault better since they saw the painting as conflict; one could even say they read it as a conflict in art history practice itself. In a way, both attempted to revisit the discipline and both tried to find some sort of discontinuity or, even better, the necessity for discontinuity in classical art history as would be proved by the rest of their scholarly contributions.

In the case of Svetlana Alpers, *Las Meninas* becomes a means to prove one of the more recurrent points in her writings. Professor Alpers has always shown her concern about general terms such as *Renaissance* or *Baroque*, terms that, as Ernst Gombrich would say, exclude, never include. Indeed, those great categories never take on the same appearance or even the same strategies in different regions of Europe, as Alpers often points out.

This preoccupation that Alpers manifests in many of her works (can we speak about Early Renaissance art, or should we refer to it as Dutch art in the fifteenth century?) finds in *Las Meninas* an ideal territory for discussion. Taking as a departure point Foucault's notion of the spectator, she clarifies how not all classical traditions imply the presence/absence of the spectator the same way:

> Imagine two different kinds of pictures – the first is conceived to be like a window on the perceived world. The artist positions himself on the viewer's side of the picture surface and looks through the frame to the world, which he then reconstructs on the surface of the picture by means of the geometric convention of linear perpective. . . . The second mode is not a window but rather a surface onto which an image of the world can casts itself, just as light focussed through a lens forms a picture on the retina of the eye.[38]

These two modes of representation that are central to Western art were synthesized in Velázquez's painting, being one of the last in what she calls the "northern or descriptive mode."[39] Velázquez was not then, as Foucualt explained, confronting the classical notion of representation: for Alpers, he combined two antagonistic modes that created the very ambiguity of *Las Meninas*.

Leo Steinberg also took the idea of the spectator as a starting point to refer to an "encounter." Velázquez needed the complicity of the spectator for the painting to function the way it did. The spectator was the essential part of the work and in his *mise-en-scène*. Steinberg almost described a poetical encounter, and therefore he constructed a vulnerable discourse opposing the strict tradition of art history. Moreover, he gave voice to the painting, he "gave gaze" to the painting:

> Rather, the picture conducts itself the way a vital presence behaves. It creates an encounter. And, as in any living encounter, any vital exchange, the work of art becomes the alternate pole in a situation of reciprocal self-recognition. If the picture were speaking instead of flashing, it would be saying: I see you seeing me – I in you see myself seen – see you seeing yourself being seen – and so on beyond the reaches of grammar.[40]

If the painting could speak. . . . but it cannot, as Foucault quite clearly explained, because the "said" is never the "seen," and vice versa. The silent, impossible to fully verbalize painting, like desire, is still watching us from its mysterious territory, the territory of the Other.

So, what happens after Foucault and after "after Foucault"? The future of *Las Meninas* seems exceptionally open. In the continuous search for "Otherness" – even physical "Otherness" – the recently appeared Freak Theory – an approach to the "anomalous" body from a "normality" angle, simply a different body, even if it does not fit into the so-called average[41] – could take *Las Meninas* as a representative picture of the pre-Enlightenment world, a world that will probably come to life again in the present day, after the collapse of the hegemonic Enlightenment Self.[42]

Yet how can the critical fortunes of a painting be so rich if *Las Meninas* represents a merely banal scene? As Jonathan Brown accurately points out: "And yet the subject could not be less prepossessing – an informal group portrait in an artist's studio."[43] Maybe Lacan was right after all when suspecting, no doubt after Freud, the intense hidden signification of everyday expressions – slang, jokes, proverbs, slogans. Perhaps desire manifests itself with greatest struggle precisely there. That territory of the "unsaid," the impossible to say, to verbalize, is the privileged place that *Las Meninas* so amazingly exemplifies under the appearance of a simple, everyday, informal, "frozen" family portrait.

NOTES

1 Michel Foucault, *The Order of Things: An Archaeology of Human Sciences* (London, 1970), p.3.
2 Ibid., p. xxii.
3 For Foucault's ideas of history related to the genealogical Nietzschean approach, see the useful study by Madan Sarup, *An Introductory Guide to Post-Structuralism and Post-Modernism* (Athens, GA, 1989), pp. 63–4.
4 In this respect, for the construction of cultural "selves" and its relation to "master-pieces," see James Clifford, "On Collecting Art and Culture," *The Predicament of Culture: Twentieth-Century Ethnography, Literature, and Art* (Cambridge, MA, 1988), pp. 215–51.
5 For this specific problem, Christine Battersby's *Gender and Genius: Towards a Feminist Aesthetics* (London, 1989) is enlightening.
6 Severo Sarduy, *Barroco* (Buenos Aires, 1974), p. 78.
7 Many gender studies scholars have questioned Foucault. Basic considerations about the problem are addressed in Rosi Braidotti, "Un-Cartesian Routes," in *Patterns of Dissonance* (Cambridge, 1991), pp. 51–5; *Up Against Foucault: Explorations of Some Tensions between Foucault and Feminism*, ed. C. Ramazanoglu (New York, 1993).
8 Foucault, *The Order of Things*, p. 10.
9 Quoted from *Velázquez, Goya, and the Dehumanization of Art*, trans. by Alexis Brown with introduction by Philip Troutman (New York, 1972), p. 106. This hypothesis is brilliantly elucidated by Jonathan Brown in his essay, "On the Meaning of *Las Meninas*" in *Images and Ideas in Seventeenth-Century Spanish Painting* (Princeton, 1978).
10 Roland Barthes, *Camera Lucida: Reflections on Photography* (New York, 1981), p. 4.
11 Rosalind Krauss, "A Note on Photography and the Simulacral," in *The Critical Image: Essays on Contemporary Photography*, ed. Carol Squires (Seattle, 1990), pp. 15–20.
12 Barthes, *Camera Lucida*, p. 115.
13 Ibid., p. 5.
14 Foucault, *The Order of Things*, p. xvii.
15 Ibid., p. xv.
16 Ibid., p. xvii.
17 Douglas Crimp, "On the Museum Ruins," in *On the Museum Ruins* (Cambridge, MA, 1993), pp. 44–65.
18 Some of these problems related to Flaubert are discussed wonderfully in Roger Célestin, "Flaubert: The Cannibal Stylist," in *From Cannibals to Radicals: Figures and Limits of Exoticism* (Minneapolis, 1996), pp. 93–133.
19 Nicole Dubreuil-Blondin, "Le Philosophe chez Vélasquez: L'intrusion de Michel Foucault dans le fortune critique des *Ménines*," *Revue d'Art Canadienne/Canadian Art Review*, 22:1–2 (1993), p. 121.
20 Foucault, *The Order of Things*, p. 9.
21 Ibid.
22 Crimp, "The End of Painting," pp. 95–6.
23 Foucault, *The Order of Things*, p. 16.
24 Crimp, "The End of Painting," p. 96.

25 Jacques Lacan, *Encore, Le Séminaire*, vol. 20 (París, 1975).

26 Jacques Lacan, "The mirror stage as formative of the function of the I as revealed in psychoanalytic experience," in *Ecrits*, translated by Alan Sheridan, pp. 1–7 (Paris, 1966).

27 Jacques Lacan, *Les quatre concepts fondamentaux de la psychanalise*, vol. 11 (Paris, 1973), and *L'objet de la psychanalise* (unpublished).

28 Athough Lacan crticises Foucault for saying *Las Meninas* is a representation of classical representation. Lacan thinks *Las Meninas* is representing representation.

29 Sarduy, *Barroco*, pp. 81–2. "El que se va, dice Lacan, es el que se y el que se ha visto; el que se queda – Velázquez – el otro punto de fuga: es la mirada que vendrá a pintar en nuestro lugar, el lugar de la vista, pero en la medida en que ésa no contiene la mirada; el maestro la deja sobre la tela." [The translation is mine.]

30 John Searle, "*Las Meninas* and the Paradoxes of Pictorial Representation," *Critical Inquiry* 6 (Spring 1980), pp. 477–87.

31 Ibid., p. 485.

32 Joel Snyder and Ted Cohen, "Critical Response: Reflexions on *Las Meninas*: Paradox Lost," *Critical Inquiry* 7 (Winter 1980), pp. 429–47

33 Ibid., p. 447.

34 Svetlana Alpers, "Interpretation without Representation, or, The Viewing of Las Meninas," *Representations* 1, (February, 1983), pp. 31–42.

35 Leo Steinberg, "Velázquez' *Las Meninas*," *October* 19 (Winter 1981), pp. 45–54.

36 Alpers, "Interpretation without Representation," p. 36.

37 Steinberg, "Velázquez' *Las Meninas*," p. 46.

38 Alpers, "Interpretation without Representation," pp. 36–7.

39 Ibid., p. 37.

40 Leo Steinberg, "Velázquez' *Las Meninas*" p. 54.

41 One of the earliest books on Freak Theory is *Freakery: Cultural Spectacles and the Extraordinary Body*, ed. Rosemarie Garland Thomson (New York, 1996), although *Las Meninas* is not discussed in depth in any of the essays.

42 For a basic approach to this specific problem, see Estrella de Diego, "Pintar al Otro: retratos de lo diferente," in *El retrato en el Museo del Prado* (Madrid, 1994). For a brilliant discussion of physical "Otherness" during Velázquez's time, see Fernando Bouza, *Locos, enanos y gentes de placer en la Corte de los Austrias* (Madrid 1991).

43 Jonathan Brown, "On the Meaning of *Las Meninas*," p. 88.

LAS MENINAS IN
TWENTIETH-CENTURY ART

When American painter Max Weber, the future modernist, submitted his canvas *Las Meninas after Velázquez* at an exhibition of Old Master copies at the Copley Society in Boston in 1906, no less than one-third of the exhibited paintings were copies of works by Velázquez.[1] This, however, was followed by a hiatus of nearly fifty years in the seventeenth-century master's influence on artistic creation.

The decline in the appreciation of realism in art at the end of the nineteenth century brought about a neglect of the painter of *Las Meninas* in favor of a growing admiration for the work of Goya and El Greco.[2] Velázquez's realism, once the source of his reputation, was now seen as a shortcoming offering little of interest for critics and artists.[3] Cézanne's famous epitaph about Monet – "only an eye, but what an eye!" – might as well summarize the prevalent opinion about Velázquez in the years of the budding avant-garde movement. Only when the content of Velázquez's library – 156 books on art history, art theory, mathematics, perspective, architecture, anatomy, astronomy, travel accounts, and atlases – came to be known in 1925 was this assessment of Velázquez as a solely visual artist somewhat amended.[4] Yet it would not be until the latter half of the twentieth century that the fascination for his art would revive a new flowering of artistic homages to *Las Meninas*, in an unprecedented variety of forms and media.

The rise of modernism in the late nineteenth century had also brought about radical changes in the theory and practice of copying. Although the act of copying was traditionally seen as an act of

homage and even surrender, the copy now came to be valued on its own merits as an integral and autonomous part of the copyist's oeuvre. As a work of art, it came to be seen as equal to the original precisely for its polemic dialog with and its departure from the model in the activity of interpretation.[5] In the work of Marcel Duchamps, in which the cited art work took on the role of an alterable "ready-made" (as in his "*L.H.O.O.Q.*," a postcard of the Mona Lisa to which he had added a moustache), the ironic function of the copy came fully into play.

In the second part of the twentieth-century, the quoted art work would increasingly be used as a template for the modern artist's inquiry into areas of his own artistic, philosophic, social, or political concerns, and even as a tool for the artist's critique of contemporary sociopolitical or artistic conventions.[6] As Benjamin Buchloh notes: "In esthetic practice appropriation can result from an authentic desire to question the historical validity of a local, contemporary code by referencing it to a different set of codes such as previous styles, heterogeneous iconic sources, or to different modes of production and reception."[7]

Similarly, references to *Las Meninas* in the work of twentieth-century artists could provide a mere pretext for the engagement with and elaboration of their own artistic preoccupations, and would frequently serve as a foil for the expression of issues that transcended purely aesthetic considerations. Although the older among modern masters such as Picasso and Dalí still responded to the painting as a masterwork of world art against which to gauge their own artistic authority, most of the younger artists were more interested in how a reference to the painting could be used for their own comments on contemporary artistic, social, and political conditions, or for the exploration of the validity of philosophic and psychological theories of art.

In fact, in discussing the following twentieth-century artists' quotations of Velázquez's *Las Meninas*, we can assign them to one of the three following trends; artists who referred to the painting as (1) an icon of world art to which homage was paid on artistic grounds; (2) as a work to be adapted and transformed to serve and validate the artist's own artistic, personal, social, or political agenda; or (3) as a testing ground for the application of theoretical concepts of perception and of the interaction among artist, viewer, and subject.

HOMAGE PAID ON ARTISTIC GROUNDS

It should not be surprising that many of the artists we can place in this first category are of Spanish or South American origin, artists for whom Velázquez represented above all the legacy of their cultural identity. In fact, *Las Meninas* reentered the stage of artistic consciousness in 1957 in a spectacular series of variations on Velázquez's canvas by Pablo Picasso. With his series of forty-five paintings on the subject of *Las Meninas* and of thirteen related works, Picasso engaged in what Hélène Parmelin recalled as "La bataille des Ménines." Between 17 August and 30 December 1957, working in near isolation in a studio on the top floor of his villa "La Californie," Picasso measured himself against Spain's premier Old Master painter.

Picasso first saw *Las Meninas* in 1895, when visiting the Prado with his father. The painting must have made a deep impression on the fourteen-year-old boy, not only because it was, as its label stated, "the foremost oeuvre of universal painting" ("Obra culminante de la pintura universal"), but also because it was a time of great tragedy and change in his young life.[8]

Although Velázquez never occupied the same role for Picasso as Goya and El Greco, Picasso had nonetheless alluded to *Las Meninas* in several earlier instances. His *Self-Portrait with Palette*, a drawing of autumn 1906, shows him in the position of Velázquez, whereas according to Susan Galassi, in her sensitive study of the artist's variations, his canvas *Les Demoiselles d'Avignon* (1907) and related drawings also reflect Picasso's fascination with the painting and its author. Even *Guernica* (1937) has been recognized to reveal similarities with *Las Meninas*.[9]

What attracted Picasso to *Las Meninas* were the ambiguities and complexities of its composition. This typically Spanish digression from the classical codes of representation had always been one of the principal points of fascination for Picasso in the work of his Spanish predecessors.[10] His dialog with *Las Meninas* provided Picasso with the opportunity, even the challenge, to further amplify this inherited counterclassicism.

Years earlier, before engaging in the series, he had already confessed to Sabartés and Roland Penrose that he wanted to appropriate Velázquez's masterpiece, produce variations that would be abhorrent to the specialist in the copying of Old Masters, and create his own

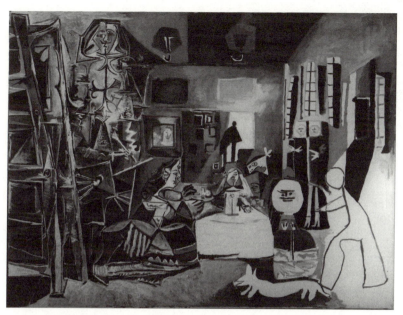

FIGURE 16. Pablo Picasso, *Las Meninas, after Velázquez I*, 17 August 1957. Oil on canvas, 194 × 260 cm. Barcelona, Museu Picasso. © 2002 Estate of Pablo Picasso/Artists Rights Society (ARS), New York.

Meninas.[11] There is no doubt that Picasso achieved his goal in the series, in which he manipulated his predecessor's use of light, space, perspective, and color into a dazzling summary of his own repertoire of styles.

The first painting of the series (Fig. 16), a large canvas in the monochrome black, white, and grays that recall *Guernica*, is the most faithful to Velázquez's composition. The figure of Velázquez himself has been enlarged to monumental proportions; towering over the other figures, he is restrained only by the claustrophobic space. Yet at the same time, rendered in cubistic faceting, he appears immaterial, quasi-ghostlike.

Already in this first version Picasso supplanted Velázquez, as he had intended to do, not only stylistically but also by insinuating his own life by introducing his dachshund, Lump, in lieu of the original's royal mastiff. Picasso would eliminate Velázquez's persona entirely in all but three of the subsequent paintings. Center stage is given to the Infanta, who appears alone in fourteen of the variations. In one instance, in

a further conflagration of biography and artistic homage, Picasso endowed the little blond princess with the round-faced, dark-eyed beauty of his daughter, Paloma.[12]

Although from his student days Picasso rebelled against the limitations of the practice of copying Old Master paintings, he engaged throughout his life in dialogs with the painters of the past he most admired, while assuming a great autonomy from his model.[13] According to Galassi: "Picasso invested variations with a vitality that brought it to the center of his artistic endeavor, where the creative and the critical overlap."[14] Indeed, one is reminded of Delacroix's words about Raphael: "His originality never seems more vivid than in the ideas he borrows. All that he finds, he exalts and regenerates with new life."[15]

Following World War II, Picasso intensified his dialog with a variety of Old Masters from the German Renaissance, the Spanish Golden Age, and seventeenth- and nineteenth-century France, all of whom belong to the realist tradition, a lineage in which Picasso proudly claimed his place. In the 1940s and 1950s in France, in an artistic climate of intense, and highly politicized debate between the young modernist champions of abstraction and the realists, many of them Socialist Realists under the sway of the Communist Party, Picasso may have wanted to assess and assert his own position within that polemic.[16]

As a new member of the French Communist Party, and at the same time as a creator of Cubism, which, although never totally abstract in his work, became the inspiration for much of abstract art, Picasso was the focal point of the debate. Picasso always held on to his dedication to depicting visible reality. Realism in itself, however, was for Picasso a concept to be called into question. He claimed that his art was devoted to the representation of truth, rather than to realism.

When Picasso turned to Velázquez in 1957, he saw in him not only a master of realism who, like himself, understood the ambivalence of that concept, but also looked to his compatriot for the roots of his own tradition. The 1950s have been called Picasso's Spanish decade, ushered in by his 1950 variation on El Greco's portrait of a painter. With the official United States recognition of the Franco government in Spain in December 1950, Picasso, who had vowed not to set foot in Spain as long as Franco was in power, experienced his exile with increased poignancy. His hopes for an end to his exile shattered, he sought to assert his cultural connections to his homeland. This was

particularly pertinent as an intense climate of nationalism in post-war France denied him his place within the French artistic tradition, and forced him to confront issues of national identity and cultural lineage.[17]

Picasso's nostalgia for his homeland was exacerbated by the loss of a number of close companions, a fact that according to Mary Mathews Gedo is reflected in his variations of the later years, and can certainly be traced in his *Las Meninas* series.[18] He was deeply affected by Matisse's death in 1954, and it was certainly as a tribute to his old friend and rival that, in the midst of his work on *Las Meninas*, he interrupted the series with a group of nine paintings of pigeons in a style clearly derived from Matisse. It is also likely that the death in 1955 of his first wife, Olga Kokhlova, to whom he was still legally married despite their almost twenty-year separation, brought back old memories.[19] Having seen Olga dance the role of one of the Meninas in Léonide Massine's ballet *Las Meninas* in Barcelona and Madrid in 1917 must have stimulated his interest in the painting.[20] Most importantly, when Jaime Sabartés, one of his oldest friends and his factotum of many years, died in 1968, Picasso donated the entire series plus the nine paintings of pigeons and three landscapes to the Picasso Museum in Barcelona in commemoration of their deep friendship.

Probably the first artist to follow Picasso's variation on *Las Meninas* with his own was his fellow Spaniard Salvador Dalí. Forever in competition with his contemporary compatriot, Dalí took up the challenge with his canvas *Velázquez Painting the Infanta Margarita with the Lights and Shadows of His Own Glory* in 1958, only one year after Picasso's homage (Fig. 17).[21]

Dalí's painting refers to *Las Meninas* as well as to Velázquez's portrait of the Infanta Margarita of Austria, although its background is taken directly from the background of Jan Brueghel the elder's and Peter Paul Rubens's *Allegory of the Senses: Vision and Smell*, which is in the Prado Museum in Madrid. Dalí had admired Picasso's "intuition of a genius" for giving Velázquez the stature of a Gulliver among Lilliputians in the first painting of his series of variations. Yet in his own painting he inverts the relationship of sizes.[22] Dalí's Velázquez, a tiny figure in a vast space flooded by light streaming through high windows, is working on his painting of the Infanta. He is further dwarfed by the monumental but ethereal apparition of the Infanta, who is sparkling in a diamond-like burst of colors – Dalí's homage to Velázquez's technique. As he wrote

FIGURE 17. Salvador Dalí, *Velázquez Painting the Infanta Margarita with the Lights and Shadows of His Own Glory*. 1958. Oil on canvas. 60½ × 36¼ inches. Collection of the Salvador Dali Museum, St. Petersburg, Florida. Copyright 2001 Salvador Dali Museum, Inc. © 2002 Salvador Dali, Gala-Salvador Dali Foundation/Artists Rights Society (ARS), New York.

admiringly about Velázquez: "his genre paintings, such as *Las Meninas* and *The Spinners*, sparkle because of his admirable technique that has never been surpassed."[23] Dalí's combination of pointillist dots and loose calligraphic lines also relates to his more recent admiration for Art Informel and the work of Yves Klein, Georges Mathieu, and Antoni Tápies, and to his pseudo-scientific ideas about what he called *nuclear mysticism*, an idiosyncratic concoction of his rather vague appreciation of quantum theory, metaphysics, and religion.[24]

Dalí's admiration of Velázquez took on increasingly nationalistic overtones, in line with his enthusiastic support of Franco. Writing in 1960, he declared, in an unmistakable jab at Picasso, all expressionistic deformation as anti-Spanish, meanwhile praising Velázquez as "*imperialista realista i eucuménico.*"[25]

Also in 1960 Dalí referred again to *Las Meninas* in two small paintings, one of which replaces all the familiar protagonists of Velázquez's painting with numbers from 1 to 9.[26] In 1972, he painted Gala seen from the back in front of a mirror that also reflects Dali peering from behind a large canvas, in clear emulation of Velázquez's self-portrait in *Las Meninas*. The Infanta recurs in Dalí's oeuvre in a Hologram, a three-dimensional collage,[27] and in 1981 in his canvas *The Pearl*.[28] It shows the Infanta standing next to the familiar diagonal of Velázquez's canvas and in front of a starry sky with an enormous luminous pearl hiding her face. One year later, in 1982, Dalí returned to the subject in two paintings: *The Infanta Margarita of Velázquez Appearing in the Silhouette of Horsemen in the Courtyard of the Escorial*,[29] and *Don José Nieto Velázquez, from Las Meninas by Velázquez, Museo del Prado Madrid*.[30]

From earliest youth, Dalí was much more fervent in his admiration of Velázquez than Picasso ever was. By age fifteen he had praised the artist as "perhaps the greatest of all Spanish artists and one of the best in the world." He saw in Velázquez's realism, composition, and distribution of colors antecedents to the Impressionists.[31] In later years, in an article in *Art News* in 1961, he expanded the list of intellectual and artistic strains that he saw as foreshadowed in the art of Velázquez, to include Action painting and modern physics – citing in particular Willem de Kooning, Max Planck, and "theories on relativity."[32]

Imbued with such qualities, Velázquez's example stimulated Dalí's own aspiration to integrate the experiments of modern art – in

particular, those of Klein, Mathieu, and Tápies – with the greater classical tradition. As Robert Lubar states:

> Collapsing the historical past with present-day developments in art and science – the gestural abstraction of de Kooning, the calligraphy of Mathieu and l'Art informel, and nuclear physics – Dalí locates Velázquez in a continuum that spans the entire history of Spanish painting, from the golden to the Atomic Age.[33]

Even Dalí's famous handlebar moustache seems to point to his identification with Velázquez, whose greatness he felt himself appointed to perpetuate in his own work.[34]

Picasso's death in 1973 prompted English artist Richard Hamilton's double homage to the two artists he most admired: Velázquez and Picasso, to Velázquez's *Las Meninas* and Picasso's series of variations after that painting. Having seen *Las Meninas* at the Prado in 1972 for the first time, he created his etching *Picasso's Meninas* of 1973 and its various preparatory sketches as part of *Hommage à Pablo Picasso*, an edition of some sixty prints by various artists (Fig. 18).[35]

As is usual in Hamilton's citations – and much of his work is dedicated to quotations of earlier masters – the origin of the imagery is clearly apparent in the print *Picasso's Meninas*. Yet although Hamilton stayed faithful to the composition of Velázquez's painting, he replaced the cast of characters with figures appropriated from the various stylistic periods of Picasso's oeuvre. Behind the canvas, Picasso himself fills the position of his seventeenth-century predecessor, wearing – as an added comment on his politics – the communist symbol of hammer and sickle instead of the decoration worn by the court painter Velázquez.

Hamilton's homage to Picasso was conceived to celebrate the qualities he most valued in Picasso's art; his stylistic variety and the "masterly craftsmanship and love of the medium that Picasso demonstrated in his own etchings." Therefore, in order to assure the quality of his print, Hamilton secured the collaboration of Picasso's own master printer, Aldo Crommelynck.

Hamilton claimed that he felt in constant competition with Rembrandt, Velázquez, and Poussin: "That's the kind of time span that art is all about."[36] Velázquez's example, and in particular his *Las Meninas*, remained central to Hamilton's concern with issues of vision,

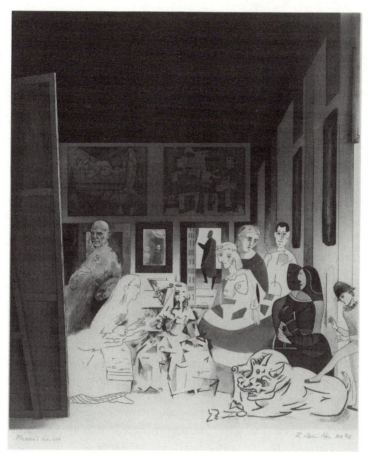

FIGURE 18. Richard Hamilton, *Picasso's Meninas*. 1973. Etching on paper. 570 × 490 mm. Tate Gallery, London. Credit: Tate Gallery, London/Art Resource, New York. © Artists Rights Society (ARS), New York.

perspective, and the role of the viewer, and can be recognized in the play of ambiguities in *Interior I* and *Interior II* of 1964, as well as in such works as *Northend I* of 1990.[37]

Although it would be an exaggeration to assess Hamilton's oeuvre solely with regard to Pop Art, he does share some essential aspects of that trend that he helped to popularize in Europe. Just as other artists of the incipient Pop Art movement in the late 1950s and early 1960s – artists such as Robert Rauschenberg, Andy Warhol, and Roy Lichtenstein – Hamilton integrated mechanically reproduced images

of high art with those of mass-produced commodity objects in his work. This demystification of the sanctity of the appropriated image was part of the movement's reaction to Abstract Expressionism, with its cult of individual expression and creative authorship.

Yet Hamilton does not entirely intend to subvert the goals of high art in his citations. Instead, he strives to recover them in terms of contemporary experience. His aim is to stimulate the viewer's response to the earlier representation of the image.[38] His interest also is directed mainly at art that displays the operation of the mind and that integrates the viewer into that operation.[39] Marcel Duchamp's influence was crucial to Hamilton's fascination with concept-based art, with the exposure of the artistic process in the finished work of art, as well as with the use of appropriation and simulation.[40]

With the development of New Realism in painting in the 1970s, the number of variations after earlier art increased considerably, used by many painters as critical confrontations with the art and the values of the past.[41] The art of Chilean-born Claudio Bravo (b. 1936) is frequently assessed in the context of these so-called New Realists.[42] His painting *La Vista (Sight)* of 1998, one of a series of canvases dedicated to the senses, is a discreet homage to Velázquez's *Las Meninas* and its mysteries of perception, reflection, and perspective (Fig. 19). In its representation of the seated figure of the artist, cloaked in a monkish robe, working on his canvas with his back turned toward the viewer, Bravo's work also brings to mind another masterpiece of art about art, Johannes Vermeer's *The Art of Painting* of 1667.[43] Here, as so frequently in his oeuvre, Bravo's meticulously realistic "Old Master" style is tinged with the surreal. What Bravo admired in Velázquez and in seventeenth-century masters in general was their conceptual approach to nature and their intellectual realism. These provided the roots of his own realism.

French painter Louis Cane's (b. 1943) interest in *Las Meninas* resided principally in Velázquez's use of color and space.[44] Between 1981 and 1983 he engaged in a series of paintings after *Las Meninas*. The first canvas of the series duplicates the exact dimensions of Velázquez's original. Beyond that similarity, however, the paintings are free adaptations with only vague references to their model. Only occasionally can we recognize one of Velázquez's figures among the caricatures that people Cane's canvases. Here and there we recognize pointers to Picasso's oeuvre in Cane's variations, such as the lamp from *Guernica*.

FIGURE 19. Claudio Bravo, *La Vista*. 1997. Oil on canvas. 78 × 59 inches (198.1 × 149.9 cm.). © Claudio Bravo, courtesy Marlborough Gallery, New York.

Cane, who had abandoned his earlier dedication to a rational approach to art making as a member of the group *Support-Surface*, distanced himself increasingly from their aims and their Marxist orientation in the late 1970s and turned to the investigation of strictly pictorial modes.[45] His own emphatic use of color and paint aims to capture what

he sees as essential to his art and what he calls the *sexualité chromatisé* of his paintings.[46]

For English painter Anthony Whishaw, it is primarily the drama of light and dark, and "the power of light to reveal or conceal form" in Velázquez's painting that inspired his own reflections after *Las Meninas* of the early and mid-1980s.[47] In their use of somber tones of black, gray, brown, and red, the paintings seem to comment on Whishaw's feelings about the darker aspects of Spanish culture.[48] Open doors and mirrors allude to the ambiguities and multiplicity of realities of *Las Meninas*. And in one painting of the series, Whishaw also includes an homage to Picasso by dressing Velázquez in Picasso's clothing.

There is little in Spanish artist Soledad Sevilla's *Las Meninas*, an ethereal and lyrical abstract work, that calls forth the Baroque original. Sevilla's paintings and installations are like scrims or webs in which memory images barely emerge before dissolving into oblivion. Her work is about nostalgia and the perception of transience.[49]

American sculptor Ned Devine seems similarly preoccupied with forms and spaces of recollection and the attention to memory and its imprint. His sculpture *The Secret of Las Meninas*, which is the result of a public commission for the park of MetroTech Center in Brooklyn, is made of poured and pigmented concrete in shades of pale yellow and rose. His sculptures are cast from large molds he creates from discarded consumer goods such as car parts, toys, computer keyboards, or in this case, stacked tires. The pieces produce the effect of fossilized reminders of our own era, all the while – user friendly – they serve as seats for the weary of the neighborhood.[50]

In a number of cases, Velázquez's model is invoked for seemingly nothing more than a pretext for the expression of the artist's own pictorial concerns. Fernando Botero's *Margarita after Velázquez* (1977) depicts the Spanish Infanta in the deadpan pneumatic appearance of any of his trademark paintings. John Clem Clarke's *Velázquez–Maids of Honor* (1972) painstakingly reproduces the central portion of Velázquez's canvas in his own stencil and airbrush technique. Catalan artist Joan Josep Tharrats weaves his version of *Las Meninas* into a carpet.[51] Artist Roy Schnackenberg was attracted to the theme of Velázquez's Infanta for formal reasons, and in particular by the form of her dress. Painter Fermín Aguayo admits that he uses Velázquez for his realistic copies as he would an apple in a still life.[52]

FIGURE 20. Jorge de Oteiza, *Las Meninas (Lo convexo y lo cóncavo, el Perro y el Espejo)*. 1958. Stone. 41 × 38 × 33 cm. Collection Fundación Juan March, Madrid. © Artists Rights Society (ARS), New York/VEGAP, Madrid.

The *Las Meninas* variations by the Basque sculptor Jorge de Oteiza Embil (1908) occupy the border between homage on artistic grounds and homage for political aims. Oteiza's abstract sculptures entitled *Las Meninas* (1958) and their reworking in 1974 (Fig. 20) were conceived

as an homage to Velázquez, in whose painting Oteiza perceives the presence of the delicate balance between spiritual and material values, that sense of emptiness and silence, he so values. The cubelike sculptures stem from Oteiza's belief that it was the basic abstract form most likely to communicate the essential structure of the cosmic experience. The cut-away corners would create voids that, however, were not to be seen as absence of mass, but as presence of empty space, a presence that for him was as important as the sculptural mass. According to his beliefs, the greater the noncommunication of a work of art, the greater was its capacity to produce preeminent content in the viewer.

For Oteiza, the arts of the world contained two major strains on either side of what he called the *frontera metafísica* (metaphysical border). One strain is convex, material, devoted to expression; the other is concave, spiritual, and devoted to the emptying out of expression (to silence). It was the latter, which he found in the Parthenon, the gardens of Kyoto, the Gothic cathedral, and in the artistic tradition of his native Basque culture, that was the focus of his own artistic oeuvre.[53]

Oteiza always conceived of art as a socially relevant occupation, in particular after his contacts with Communist circles during his studies in Madrid. He was dedicated to the formation of a national Basque consciousness based on the political and cultural tradition of the region. On a wider, universal level, he saw art as the medium through which the essential balance between humans and the universe could be reestablished and by which humans could achieve transcendence on earth, "a cure for death," as he would call it. Oteiza's gradual move away from exterior expression in his sculptures would lead in the 1960s to his nearly total retreat from practicing art in order to concentrate full-time on theoretical studies of linguistics, aesthetics, and anthropology. [54]

THE CONFISCATION OF *LAS MENINAS* FOR POLITICAL EXPRESSION

The adaptation of Velázquez's painting for the expression of political and social protest among young Spanish artists grew mainly out of the climate of increasing opposition to Franco's dictatorship in the early 1960s.

The tercentennial of Velázquez death, 1960, among other commemorations in Spain, was celebrated with a major exhibition of his

work at the Prado.[55] The government-sponsored events were seen by artists who opposed the regime as the confiscation of Velázquez's image for propagandistic aims benefiting tourism and the prestige of Franco's Spain. This triggered new trends in the appropriation of Velázquez, which in both the visual arts and literature became increasingly tinged with political protest. A sense of social responsibility motivated many of the variations after *Las Meninas*, now perceived as a stage for political commentary. Antonio Buero Vallejo's play entitled *Las Meninas* was particularly influential. Buero Vallejo was a well-known opponent of Franco who had served in the Republican army in the Spanish Civil War. Condemned to death but incarcerated instead, he spent many years in prison. His play, which premiered in the Teatro Español in Madrid in December 1960, presents Velázquez as a stalwart champion of humanity, honor, and integrity in the corrupt court of Philip IV. The play was a barely veiled attack on conditions in Spain under Franco, and was widely celebrated as such in underground circles. [56]

Among the artists who were actively engaged in the artistic underground in opposition to Franco's dictatorship was Antonio Saura (b. 1930). The cofounder of the Spanish Informel movement *El Paso* (Madrid, 1955) – the first post-war movement in Spain belonging to the international avant-garde – Saura acknowledges a strong political component to his work. His Infantas, which he started to create not coincidentally in 1960, belong to what he calls his *denunciation paintings*. Like much of his production of those years, they were motivated by his protest against the sociopolitical conditions in Franco's Spain.[57] They also belong to the artist's intense but complex engagement with the national artistic legacy, which he simultaneously embraces and rejects. The paintings he refers to can barely be recognized. Just as his portraits, which are not really portraits in the conventional sense of the word but what he calls *approximations*, his *Infantas* of 1960 and *Meninas* of 1973 are only a step removed from abstraction. Never interested in conceiving of a canvas as the mirror of an objective reality, he refers to the magic of fun-house mirrors.[58] There is an element of parody in his art, which turns his variations into graffiti rather than homage. In proceeding without any preconceived esthetic idea, Saura claims to unleash the monsters that lay hidden beneath the aesthetic codes of his models.[59] By thus liberating the original, he awakens it to a new dynamic existence.[60]

In 1973, not coincidentally the year of Picasso's death, Saura took up the theme of *Las Meninas* again with his *Menina de muerte*, a work on paper among his series of *Superposiciones*. Those drawings, executed directly onto Skira reproductions of art, all but obliterate the original, which appears as a memory image beneath its artistic metamorphosis. Much like Saura's violently gestural oil paintings, those drawings in black and white appear as icons of the essential polarity of Spain of *sombra y sol*, shade and light, death and life, protest and love.[61]

More militant is the work of the two young artists who collaborated under the name Equipo Crónica: Manolo Valdés (b. 1942) and Rafael Solbes (1939–1981). (A third member of the group, Joan Antonio Toledo, left the group a year after it was formed in 1965.) Natives of Valencia, where they had studied at the Fine Arts Academy of San Carlos, the two artists belonged in the early 1960s to the local branch of *Estampa Popular*, a radical underground movement of young graphic artists with a strong political pro-Democratic agenda in protest against the conditions of cultural and political repression under Franco.[62] Many of their variations on *Las Meninas* are sharply didactic accusations of injustice and brutality in a fascist society. The painting *El recinte*, for example, in their series "policía y cultura," illustrates their critique of the plight of art in Franco's Spain (Fig. 21). Velázquez's cast of characters has been replaced by modern works of art by Saura, Miró, Dalí, and Picasso. From behind the canvas emerges Picasso's woman with a lamp from *Guernica*, raising her fist instead of the lamp; Dalí's *Premonition of the Spanish Civil War* is reflected in the mirror; and the Infanta is replaced by Saura's portrait of her, while sinister secret police in overcoats and hats patrol the space. In the background, through the open door, we see a group of people, hands raised, lined up against a wall as though for execution.

In other works, Equipo Crónica parody what they see as the misuse of art as a prestigious political emblem, the way Velázquez had been appropriated by the government as a product for tourist consumption. In their sculpture *El Huevo de Pascua* (1968), for example, Queen Mariana is represented as a tourist bibelot in the form of an Easter egg, decorated with the American flag. Much of their art is devoted to depicting the strong connection between art and life, combining elements of high culture as well as popular culture, the mass media, and advertising.

FIGURE 21. Equip Cròvica (Manolo Valdés, Rafael Solbes). *El recinte.* 1971. Oil on canvas. 200 × 200 cm. Banyolles, private collection. © 2002 Artists Rights Society (ARS), New York/VEGAP, Madrid.

Strongly influenced by David Hamilton and Kitaj, Equipo Crónica were among the first Spanish artists of their generation to show an interest in Pop-style figuration.[63] They embraced Pop Art's critique of Informalismo and Abstract Expressionism, and in particular of their celebration of the artist's creative subjectivity.[64] Impressed by the Brechtian concept of distancing, they adopted instead the anonymity of collaboration behind what amounted to a brand name.[65]

In 1976, a year after Franco's death, the painters of Equipo Crónica, together with Arroyo and other previously dissident artists, were featured at the Venice Biennale. After Solbes' death at age 42 in 1981, Manolo Valdés continued to borrow from the history of art; however, less for its polemic content than as a starting point for his own artistic exploration. In his recent work, he shows more interest in the sensuality of seeing and painting than in the motif. This gives his numerous

representations of the Infanta the same consequence in his oeuvre as his paintings of Mickey Mouse or the Metropolitan Museum gift shop's shopping bag.[66] He has abandoned the anonymous style of his earlier collaboration and prefers a very tactile, painterly style that borrows from the Informalismo he previously criticized in his art. Much of his work is in oil on partly sewn, partly glued fragments of burlap, which endows it with a sensual, material quality that he treasures.[67]

Not quite as overtly political as the work of Equipo Crónica, the art of Mexican Alberto Gironella (b. 1929, Mexico City) shares nonetheless the cruel mix of irony and homage of their art, as well as the irrational, antibourgeois and anticlerical content he so admired in Luis Buñuel.[68] Gironella's first work to relate to *Las Meninas*, *Festín in Palacio* (*Banquet in the Palace*, 1958), is an assemblage of painted, sculpted, and ready-made elements combined into a structure that resembles an altarpiece (Fig. 22). The work in the shape of a box is divided in three horizontal sections, each of which is subdivided again. Center stage is occupied by a three-dimensional naturalistic representation of a large dog, while Velázquez's self-portrait appears twice in the upper register, next to a painting of a dog's head. Pride of place, however, is given to the dwarf Francisco de Lezcano (also known as Niño de Vallecas), whose portrait Velázquez had painted earlier and whose enormous head here occupies the two largest panels in the lower part of the box. The dwarf proudly wears Velázquez's decoration, the cross of the order of Santiago. Clearly rooted in the reliquaries, tabernacles, and altars of Gironella's Catholic upbringing, this assemblage comments on the powers of the church as well as the state.[69] Like much of Gironella's art, it is an amalgam of his admiration for Spanish Baroque art and Surrealism, in which his homage to Velázquez is translated through a vision formed by Buñuel.[70] This work launched Gironella's thirty-year engagement with the painter of *Las Meninas*, which produced, among others, a series of works (oil paintings, boxes, and etchings) over the decades that he called *The Studio of Francisco Lezcano*. Here too, dogs control the scene and the dwarf Lezcano has commandeered Velázquez's position. Gironella's 1961–1963 series *Muerte y Transfiguración de la Reina Mariana* combines court portraiture and allegorical images of decay and death in a typically Mexican equation of the cult of death with the cult of life, of death and resurrection.[71] In 1968, Gironella revisits *Las Meninas* in a series with the title *Camera obscura*.

FIGURE 22. Alberto Gironella, *Festín en Palacio.* 1958. Oil on wood. 251 × 174 × 60.5 cm. Collection María and Manuel Reyero, Mexico.

In a clear reference to the central issues of the celebrated painting that turn on the mystery of creation, vision, and focus, Gironella provides Velázquez with a camera.[72] Gironella professes that his motivation for his repeated citations of *Las Meninas* stems from his enthusiasm for the work. By recreating the painting in his own language, he strives for a better understanding of the original. Attracted to what he calls *ambiguity* in art, he suspects mysterious hidden powers operating beneath the seemingly quiet, ordered world of Velázquez's court. [73] At the same time, Gironella's dark visions address issues of national identity, of Mexico's past under Spanish rule.

Politics of a different time and place inspire Israeli artist Igael Tumarkin's oeuvre. The reference to the art of the past provides the context for his political works, which engage with the political turmoil of the Middle East. This is also the context into which Tumarkin places the series of prints entitled *Las Meninas* he produced in 1988.[74] The basic composition of Velázquez's painting appears side reversed in Tumarkin's prints. Next to the back of the canvas, now jutting into the picture plane from the right, and in lieu of the painter, stands a soldier in uniform holding a machine gun. Is it the artist himself? That interpretation is suggested by the lettering on the lower part of the canvas, again side reversed, reading "Intifadas" and "The artist in reserve service with Velázquez and Picasso." He may be either protecting or attacking the group of Arab women who occupy the place of the little princess and her court. Their figures are framed by the shape of a tent, recalling the pyramidal composition of *Guernica*. Across the entire width of the print, "*Las Meninas*" is written in large letters.

Tumarkin started the *Las Meninas* prints, as well as a large relief equally entitled *Las Meninas*,[75] in May 1988 as direct response to the Palestinian Intifada against Israel happening nearby. Earlier in the month, he had already given expression to his feelings about the events in his country in several prints after Goya's *The Third of May 1808*, on which he wrote in red "May 88."[76] The connection of the *Las Meninas* series with the Goya citations clearly speaks of Tumarkin's feeling for the plight of the Palestinians. Tumarkin, born in Germany in the early 1930s to an Israeli mother and a German father, who left the family under Nazi race legislation, had great empathy for the victims of political oppression. His art as well as his strong political commitment were furthered by his admiration for Bertolt Brecht, for whom he worked

as a set designer at the Berliner Ensemble in the mid-1950s. Brecht intensified Tumarkin's conviction of the responsibility of the artist in society, and of the role of art to bring about social and political change. Through his references to the work of Goya, Velázquez, Grünewald, and Géricault, he uses art history as a way to inform the present with the lessons of the past.[77]

LAS MENINAS VARIATIONS UNDER THE INSPIRATION OF MICHEL FOUCAULT

With the rise of conceptual art in the 1960s and 1970s, a growing number of artists turned their focus of interest in *Las Meninas* on what was now recognized as Velázquez's conceptual approach to the mechanics of perception and artistic production. Center stage of artistic concerns belonged to the idea rather than to the quality of execution, which became a mechanical action in the service of the underlying concept. Seminal in this was Michel Foucault's article on *Las Meninas*, the opening chapter in *Les Mots et les choses* (in English, *The Order of Things*), which defines Velázquez's painting as "representation of representation" and investigates the painting's complexities of representation, ambiguities of perspective, the role and position of the viewer, as well as the role and position (not least the social position) of the artist. Foucault's article now became as influential for many artists as the painting itself was for previous generations.

One artist whose engagement with *Las Meninas* was strongly influenced by Foucault's ideas was Italian Giulio Paolini (b. 1940). His citation of *Las Meninas*, in *L'ultimo quadro di Diego Velázquez* (1968), is the representation of the reflection of the king and queen in the mirror, but reversed, as they would have appeared to Velázquez as he painted their portrait.[78] As a sign of his indebtedness to the French philosopher, Paolini exhibited his painting with a quotation from Foucault's famous essay:

> The invisibility which this picture vanquishes is not the invisibility of things that are hidden: the picture does not overcome any obstacle, does not turn any corners so as to open up a new perspective, but attempts to deal with what has been rendered invisible both by the structure of the picture and by its very existence as a painting.[79]

The work is part of Paolini's investigations into and comments on the nature of art, which he has pursued since the early 1960s through manipulated variations on earlier works of art. Although his tampering with the original seems at times negligible, he insists on the importance of transforming the original artwork into something new.[80] One of the earliest practitioners of Minimal Art, Arte Povera, and Conceptual Art, Paolini has since the early 1960s practically abandoned painting (easel painting) in favor of the idea of art as a linguistic play. The surface of the canvas as stage of creativity is replaced by the engagement with the individual ingredients of art, such as perspective, space, and light, as well as with the materials of the artistic process, such as the canvas and easel for their own sake. No longer at issue is the representation of reality, but rather the representation of art as artwork, of the visual codes of artistic production. Representation is being replaced by the self-reference of art to itself and to the mechanisms of perception.[81] As part of that process, and obsessed with the dialectic of the gaze, Paolini increasingly disenfranchised the author in favor of the role and position of the viewer.[82]

Las Meninas, which Paolini considers to be "certainly the most beautiful painting in the history of art of all times," continued to fascinate him and was instrumental in his quest to render the inner workings of art visible.[83] We can see its impact clearly in such works as his *Contemplator enim* series (1991; Fig. 23). The lithographs are based on photos of the entrance hall to Paolini's apartment in Turin. The perspective through an open door, the complex use of mirror images of the artist at work and of the viewer, and, in one work, *Fuori l'autore*, the back of a canvas projecting into the foreground space, all reflect the influence of *Las Meninas* on the artist's mind.

Very similar concerns impel the art of French artist and professor of aesthetics at the École des Beaux-Arts in Paris Philippe Comar (b. 1955). A theoretician on perspective and author of a treatise on that subject, *La Perspective en jeu* (1992), Comar is captivated by the ambiguities of the dynamic relationships of viewer versus author, and the subtleties and idiosyncrasies of space and perspective in Velázquez's painting. His homage to *Las Meninas* is a physical three-dimensional installation and reconstruction of the spatial perspective of the painting (Fig. 24).[84] He constructed the space in the form of an optical pyramid whose apex would occupy the vanishing point, and whose base would

FIGURE 23. Giulio Paolini. *Contemplator Enim VI.* 1991. Lithographic print. Credit and copyright © Hopeful Monster, Turin and Christian Stein Gallery, Milan.

be the surface of the canvas. Viewed from a peephole, the effect of the *perspective accelerée* restores the exact spatial perspective of the painting. However, instead of one, it reveals two divergent perspectives; on the one hand the distorted space of the "accelerated perspective" that gives the viewer the theoretical perspective vision, and on the other hand the right-angled space of the model that places us right in front of

FIGURE 24. Philippe Comar. *Les Ménines.* 1978. Wood construction. Collection Musée National d'Art Moderne, Centre Georges Pompidou, Paris. © CNAC/MNAM/Dist Réunion des Musées Nationaux/Art Resource, New York. Photo © CSI/Michel Viard.

the mirror, which in turn translates the fictitious impression that the painting produces. In the first case, we are situated facing the door, and the image we see on the mirror is the image of the king and queen as reflected from the canvas. In the second case, we are facing the mirror, and we occupy the place of the subject of the painting.

Comar calls his installation "A theater of representation in the classical period with its scene, its stage sets, its mechanisms and its actors." He also states: "The spectator is not left out, he too has his place." Based on traditional stage design and its disposition towards the *point de vue idéal* – the position of a privileged spectator (in theaters, the royal loge) – Comar designates the exact position of the spectator. Although the model can be perceived from all sides, it is only from this one viewpoint that the painting recomposes itself to the eye.

In his explanation of his model, Comar too refers to Foucault's essay when he elaborates on the three positions that we occupy in front of

Las Meninas; the place of the painter when he painted the canvas, of the presumed model, and of the spectator.[85] The intent of his installation is the spatial organization of the play of gazes that are exchanged and cross each other around the invisible center that we occupy.

Chilean-born multimedia artist Juan Downey (1940–1993) also refers to Foucault's writing in his homage to *Las Meninas*, a color video of slightly over twenty minutes (1975). His pioneering work in video art is considered groundbreaking in gaining the medium acceptance as high art. The relationship among artist, subject, and viewer and between cognitive and subjective vision are at the core of his art and explain his fascination with Velázquez's masterpiece. Downey's video devoted to *Las Meninas* is a multilayered, evocative study in which actors impersonate various personages of the Velázquez painting in interaction with dancers who, rather than enacting the scene, give movement to meditations on the physiology and psychology of reflection, representation, and perception.[86] In this play with mirror images and illusion, cultural codes and subjective response are made to intermingle, as is the case in much of his art. In the text that mixes the artist's own words with quotations from Michel Foucault and George Kubler, Downey tells of his near orgiastic experience when first confronting the *Las Meninas* at the Prado in 1962 at the age of twenty-two. Through comments on colonialism and artistic, economic and political conditions in seventeenth-century Spain, he delivers a sharp critique of the ills of his own time: anti-humanism, fascism, depression, and alcoholism among them. Like much of his art, the video reflects his interests in linguistics, semiotics, psychoanalysis, and anthropology, all tools in his quest for self-discovery and in search of cultural identity.

Filmmaker Hisham Bizri adds a further dimension to the role and empowerment of the viewer. His reconstruction of *Las Meninas* (1997) with computer-generated moving images in a virtual reality environment lets us choose our position within the composition by permitting us to circulate freely within the space of the painting and view the scene from any perspective we wish, be it from the viewpoint of the artist, for example, or from that of José Nieto. His aim is to encourage "realistic spatial, temporal and phenomenological reactions to the narrative environment" in the viewer.[87] His animated explanation of the project on the web is part of the project. He qualifies his work not as art, but as "intellectual, political and historical explorations of the past using

FIGURE 25. Joel-Peter Witkin, *Las Meninas, New Mexico.* 1987. Toned gelatine silver print on paper. 20 × 16 inches. Edition of 15. © Joel-Peter Witkin. Courtesy Pace/MacGill Gallery, New York; Fraenkel Gallery, San Francisco; and Galerie Baudoin Lebon, Paris.

the new media." However, he allows that his project could "perhaps" be seen as part of Appropriation Art.

American photographer Joel-Peter Witkin (b. 1939) dedicated his work *Las Meninas, New Mexico* (1987) to the genius of Velázquez, Picasso, and Miró (Fig. 25).[88] On a preparatory drawing for this work, he also stipulates that the work is dedicated to Spain and Foucault. Created at the suggestion of the Spanish Ministry of Culture, the work includes many of Witkin's usual themes and figures, from his self-portrait in the place of Velázquez to the figure of Christ in the open doorway in the place of Nieto and to the maimed and disabled, who form his usual cast of characters. The Infanta is replaced by a woman

who holds a sleeping dog on a leash. She has stumps instead of legs and is lifted off the ground by a structure on wheels, which echoes the wide shape of the Infanta's skirt. In an extra touch of cruelty, characteristic of Witkin's art, the bottom of the structure is covered with vertical nails. Instead of the ladies-in-waiting, she is assisted by the reclining torso of a youth on the left and a large ghostlike form derived from Miró on the right. His *Las Meninas, New Mexico* belongs to Witkin's frequent appropriation of traditional art, which he infuses with his own grotesque and morbid vision. His proclivity for using freaks and sadomasochistic images of tortured and mutilated bodies in his art, for which he finds his material in a morgue in Mexico, is apparently motivated by his interest for "Any living myth. Anyone bearing the wounds of Christ," as he said.[89] "I consider myself a portraitist not of people, but of conditions of being . . . [My] hope is not only to show the insanity of our lives, but also that this work will be seen as part of the history of diverse and desperate times." Witkin views his works as *mementi mori* for which he claims a sacred vocation. According to Germano Celant, Witkin's photographic representation is the incarnation or revelation of a transition between the material and immaterial, between flesh and spirit, good and evil, life and death, sacred and pagan.[90] His art typifies what Hal Foster labeled the "postmodernist impulse toward theatricality or perversity."[91]

Throughout the twentieth century, *Las Meninas* continued to captivate the interest of artists. Just as the natural environment would serve the nineteenth-century painter as model and inspiration for his art, so has the art of earlier masters – an increasingly pervasive element in twentieth-century aesthetic as well as commercial experience – become a model and inspiration for the art of the twentieth-century artist. Increasingly, however, it was the distance from the model that would define the new art work. Although for some Velázquez's *Las Meninas* served no greater purpose than the apples did for Cézanne, others looked to the painting as a model of artistic excellence, as a national cultural icon, as an artistic ready-made imbued with culturally accessible referents, as a stage for political comment, or as a template for philosophical reflections on creation and perception. There is every reason to believe that new generations of artists will continue to find in Velázquez's *Las Meninas* a stage on which to express evolving artistic, intellectual, social, and political concerns.

NOTES

1 1906, oil on canvas, 10¹/₄ × 9 inches, collection Joy S. Weber. See Mary Anne Goley, *The Influence of Velázquez on Modern Painting: The American Experience*, exh. cat. (Washington, Federal Reserve Board, 2000), p. 7. I thank Mary Anne Goley for her catalog, and I am greatly indebted for the generous help I received during my research from many of my friends and colleagues: Egbert Haverkamp Begemann, Bettina Della Casa, Susan Grace Galassi, Janet Hicks, Robert Lubar, Caitlin Miller, Kristin Murray, Maria-Theresa Ocaña, Manuel Reyero, Nita Roberts, and Marie-Luce Staib-Mâche. My special thanks go to Suzanne Stratton-Pruitt for her astute editorial help and sound advice at every step of the project.

2 Goley, *The Influence of Velázquez, passim.*

3 Caroline Kesser, *Las Meninas von Velázquez: Eine Wirkungs-und Rezeptionsgeschichte* (Berlin, 1994), pp. 165–8.

4 Kesser, "Der Geist in *Las Meninas* oder der Versuch, das Bild in seiner Zeit zu situieren," in Kesser, 107.

5 Roger Benjamin, "Recovering authors: The modern copy, copy exhibitions and Matisse," *Art History* 12, no. 2 (June 1989), pp. 176–201. Benjamin Buchloh, "Allegorical Procedures: Appropriation and Montage in Contemporary Art," *Artforum* 21, no.1 (September 1982), p. 53. Gerhard Ahrens in Gerhard Ahrens and Katrin Sello, *Nachbilder: Vom Nutzen und Nachteil des Zitierens für die Kunst*, exh. cat. (Hannover: Kunstverein Hannover, 10 June–29 July 1979), p. 169. Francine-Claire Legrand, "Leihen und Wiedergeben," in Ahrens and Sello, *Nachbilder*, p. 218. See also Paris, Musée du Louvre, *Copier Créer: De Turner à Picasso: 300 Oeuvres Inspirées par les Maîtres du Louvre*, exh. cat. (Paris: Réunion des musées nationaux, 1993); Werner Schmidt, *Dialoge, Kopie, Variation und Metamorphose alter Kunst in Graphik und Zeichnung vom 15 Jahrhundert bis zur Gegenwart*, exh. cat. (Dresden: Staatliche Kunstsammlungen, Kupferstich-Kabinett, 1970); Victor I. Carlson, *The Inspired Copy: Artists Looking at Art*, exh. cat. (Baltimore: Baltimore Museum of Art, 1975); Craig Owens, "Representation, Appropriation and Power," *Art in America* 70, no. 5 (May 1982), pp. 9–21. Richard Morphet, *Encounters: New Art from Old*, exh. cat. (London: National Galery Company, Ltd., 2000).

6 Buchloh, "Allegorical Procedures," p. 53. Benjamin Buchloh, "Parody and Appropriation in Francis Picabia, Pop and Sigmar Polke," *Artforum* 20, no. 7 (March 1982), p. 28.

7 Buchloh, "Parody and Appropriation," p. 28.

8 Picasso's young sister Conchita had died earlier that year of diphtheria and the family moved once again, this time from La Coruña to Barcelona. See Susan Grace Galassi, "Picasso in the Studio of Velázquez," in Jonathan Brown, ed., *Picasso and the Spanish Tradition* (New Haven and London, 1996), p. 119. For Picasso's early years, see in particular John Richardson, *A Life of Picasso, Volume I, 1881–1906* (New York, 1991) and Marilyn McCully, ed., *Picasso, the Early Years, 1892–1906*, exh. cat. (Washington D.C., 1997).

9 Juan Marin, *Guernica, ou, Le rapt des Ménines* (Paris, 1994), in particular pp. 32–43. See also Werner Spies, "Picasso: L'Histoire dans l'Atelier," *Cahiers du Musée National d'Art Modern*, no. 9 (1982), pp. 60–7. See Susan Grace Galassi, *Picasso's Variations on the Masters: Confrontations with the Past* (New York, 1996), p. 152.

10 Jonathan Brown, "Picasso and the Spanish Tradition of Painting," in his *Picasso and the Spanish Tradition* (New Haven and London, 1996), p. 3. Galassi, "Picasso in the Studio of Velázquez," p. 157.

11 Jaime Sabartés, *Picasso, Les Ménines et la vie* (Paris, 1958), p. 5; cited in Galassi, *Picasso's Variations*, p. 9 and p. 154.

12 Galassi, *Picasso in the Studio of Velázquez*, p. 140.

13 Galassi, *Picasso's Variations on the Masters*, p. 126.

14 Ibid., p. 8.

15 Delacroix is quoted in Jonathan Mayne, ed. and trans., *Charles Beaudelaire, Art in Paris, 1845–1862, Salons and Other Exhibitions* (Oxford, 1965), introduction, p. xii.

16 Gertje Utley, *Picasso the Communist Years* (New Haven and London, 2000), in particular the chapter "Socialist Realism: A Realist *à sa façon.*"

17 Ibid., pp. 85–96.

18 Mary Mathews Gedo, *Picasso: Art as Autobiography* (Chicago and London, 1980), p. 235, cited in Galassi, *Picasso's Variations on the Masters*, p. 19.

19 Josep Palau I Fabre, *El Secret de Les Menines de Picasso* (Barcelona, 1981), p. 10.

20 The ballet was premiered in August 1916 with music by Gabriel Fauré, choreography by Léonide Massine, and costumes by José-Maria Sert, in the Teatro Eugenia Victoria in San Sebastián, Spain. Olga Kokhlova, Lydia Sokolova, and Léonide Massine were the dancers. Josep Palau I Fabre, *El secreto de Las Meninas de Picasso* (Barcelona, 1982), pp. 7–10; cited in Galassi, *Picasso in the Studio of Velázquez*, p. 125.

21 Oil on canvas, 60½" × 36¼", collection Mr. and Mrs. A. Reynolds Morse, on loan to the Salvador Dali Museum, St. Petersburg, Florida; Fig. 87, pp. 144–5 in Robert S. Lubar, *Dali: The Salvador Dali Museum Collection* (Boston, Bulfinch Press, 2000). See also *The Salvador Dali Museum Collection* (Boston, Little Brown, 1991), foreword, A. Reynolds Morse, introduction, Robert Lubar, museum in St. Petersburg, Florida. See also Robert Descharnes/Gilles Néret, *Salvador Dalí 1904–1989: The Paintings, Vol. II, 1946–1989* (Cologne, 1994), and A. Reynolds Morse, *Salvador Dali: A Panorama of His Art* (Cleveland, Ohio, 1974).

22 Salvador Dali, "Ecumenical 'chafarrinda' of Velázquez," *Art News* 61, no. 2 (February 1961), p. 30.

23 Salvador Dalí, "Velázquez" in *Studium* (Figueres) 5 (June 1919); quoted in Robert Lubar, *Dalí: The Salvador Dali Museum Collection* (Boston, Toronto, London, 2000), p. 12.

24 Lubar, *Dali,* 2000, pp. 136, 145, 148.

25 Lubar, *Dali,* 2000, Fig. 91, "The Ecumenical Council," 1960.

26 Descharnes and Néret, *Salvador Dalí 1904–1989,* p. 526; Fig. 1174, "The Maids in Waiting, A," 1960; Fig. 1175, "The Maids in Waiting, B," 1960.

27 "Holos! Holos! Velázquez! Gabor!" 16½" × 22½". Fundacíon Gala-Salvador-Dalí, Figueres, Spain.

28 "The Pearl," 1981, oil on canvas (140 × 100 cm). Figueres, Fundacíon Gala-Salvador-Dalí, reproduced in Descharnes and Néret, *Salvador Dalí 1904–1989,* p. 692, no. 1554.

29 Descharnes and Néret, p. 432, oil on canvas (28¾ × 23⅜). Private collection.

30 Figueres, Fundacíon Gala-Salvador-Dalí, reproduced in Descharnes and Néret, p. 695, Fig. 1560.

31 Dalí, "Velázquez," in Lubar, *Dalí*, 2000, p. 145.

32 The subtitle in *Art News* was "A theological–philologic hommage to the grandfather of Action Painting by the father of painted dream photographs Salvador Dalí." See Dalí, "Ecumenical 'chafarrinada,'" p. 30.

33 Lubar, *Dalí*, 2000, p. 145.

34 Descharnes and Néret, *Salvador Dalí, 1904–1989*, p. 512.

35 Propyläen Verlag in Berlin 1973; Kesser, *Las Meninas von Velázquez*, p. 188.

36 "The Distant Involvement of Richard Hamilton. An Interview," in *Vanguard*, Journal of Vancouver Art Gallery (September 1978): pp. 12–14; cited in Richard Morphet, "Richard Hamilton: The Longer View," in *Richard Hamilton*, exh. cat. (London: National Gallery, 1992), p. 18.

37 Richard Morphet with introduction by Robert Rosenblum, *Encounters: New Art from Old*, exh. cat. (London: National Gallery, 2000), p. 149.

38 Morphet, "Richard Hamilton: The Longer View," p. 14. Buchloh, "Allegorical Procedures," p. 46. See also Buchloh, "Parody and Appropriation," p. 28.

39 Morphet, "Richard Hamilton: The Longer View," p. 21.

40 Hamilton curated the largest retrospective of Duchamps in Duchamps' lifetime, and also reconstructed in 1966 Duchamps' damaged *Large Glass* of 1915–1923.

41 Sello in Ahrens and Sello, p. 14; Kesser, *Las Meninas von Velázquez*, p. 188.

42 Edward Lucie-Smith, *Super Realism* (New York, 1979); cited in Edward J. Sullivan, *Claudio Bravo: Painter and Draftsman*, exh. cat. (Madison, Wisconsin: Elvehjem Museum of Art, 1987), p. 5, who does not agree with that assessment.

43 Johannes Vermeer "The Art of Painting," 1666–1667, oil on canvas, Kunsthistorisches Museum, Vienna; reproduced in Arthur K. Wheelock, Jr., *Vermeer and the Art of Painting* (New Haven, 1995), p. 128, Fig. 90.

44 Kesser, *Las Meninas von Velázquez*, p. 189.

45 Louis Cane, *Les Ménines, les annonciations, les femmes debout, les toilettes, les Accouchements, les déjeuners sur l'herbe . . . et le déluge*, exh. cat. (Saint-Paul: Fondation Maeght, 7 May–20 June 1983), pp. 7, 16.

46 Cane, *Les Ménines, les annonciations, les femmes debout*, pp. 5–7.

47 Anthony Whishaw, "A few notes on the series that derived from *Las Meninas*," in *Anthony Whishaw: Reflections after* Las Meninas, exh. cat. (London: Royal Academy of Arts/ John Hansard Gallery, 1988), p. 4.

48 Michael Phillipson, introduction to, *Anthony Whishaw: Reflections after* Las Meninas, exh. cat. (London: Royal Academy of Arts/ John Hansard Gallery, 1988), p. 2.

49 Soledad Lorenzo, *Soledad Sevilla*, exh. cat. (Madrid: Galeria de Arte Soledad Lorenzo, 1989), n.p.

50 Terry A. Winters, "Dan Devine," *The New Art Examiner* 21, no.7 (March 1994), pp. 41–2.

51 Palau Robert, *Joan Josep Tharrats, Setanta-cinc anys* (Barcelona, 1993), p. 111.

52 Claude Esteban, interview with the artist, Fermín Aguayo, in Charles Etienne, *Procès pour Aguayo*, exh. cat. (Paris: Galerie Jeanne Bucher, 1982), n.p.

53 According to Oteiza, those qualities were lacking in Spanish art and most Western art in general, yet could be found in the culture of the Basque tradition. Margit Rowell, "A Timeless Modernism," in Jorge Oteiza, *Oteiza, propósito experimental – An Experimental Proposition*, exh. cat., Madrid, Fundación Caja de Pensiones;

Bilbao, Museo de Bellos Artes; Barcelona, Fundació Caixa de Pensiones, 1988. p. 57; Kesser, *Las Meninas von Velázquez*, p. 175.

54 Rowell, "A Timeless Modernism," p. 57; Kesser, *Las Meninas von Velázquez*, p. 174.

55 Kesser, *Las Meninas von Velázquez*, p. 179.

56 Antonio Buero Vallejo, foremost Spanish dramatist of the second half of the twentieth century, was born 1916 in Guadalajara, Spain. See Antonio Buero Vallejo, *Las Meninas: A Fantasia in Two Parts*, transl. Marion Peter Holt (San Antonio, Texas, 1987). See also Kesser, *Las Meninas von Velázquez*, pp. 177–9.

57 Paule Gauthier, "Saura," *Cimaise* 24, no. 131–2, (July–October 1977) p. 38.

58 Severo Sarduy, "Galeries (portraits imaginaires)" in Gérard de Cortanze, ed., *Antonio Saura* (Paris, 1994), pp. 221–8.

59 Antonio Saura, "Neuf reponses à Angel S. Harguinday," typed manuscript in the library of the Museum of Modern Art, n.d., n.p.

60 Sarduy, "Galeries (portraits imaginaires)," p. 226.

61 Gauthier, *Saura*, pp. 40, 42.

62 Dan Cameron, "Contents under Pressure: Equipo Crónica," *Artforum* 89 (November 1989), p. 126. Carla Stellweg, "New Mirrors for a New Society: Seven Artists in Post-Franco Spain," *Art News* 79, no. 3 (March 1980), p. 63.

63 Cameron, "Contents under Pressure: Equipo Crónica," p. 126.

64 Manolo Valdés with an introduction by Tomàs Llorens, *Manolo Valdés: The Timelessness of Art* (Bogotá, 1999), p. 11.

65 Kesser, *Las Meninas von Velázquez*, p. 186.

66 Valeriano Bozal, "Manolo Valdés, ways of looking at worlds," in *Manolo Valdés*, exh. cat. (São Paulo, Brazil: Pinacoteca do Estado, 15 December 1998–5 January 1999), p. 173. See also Josep Palau I Fabre, *Dancing Notes on Las Meninas*, with monotypes by Manolo Valdés (Paris, 2000).

67 Dan Cameron, "Contents under Pressure: Equipo Crónica," p. 128.

68 Margarita María de Guadalupe Martínez Lámbarry, *Tradición y ruptura en la pintura de Alberto Gironella*, exh. cat. (Mexico: Centro de Arte Mexicano, 1988), n.p.

69 Valerie Fraser, "Surrealising the Baroque: Mexico's Spanish Heritage and the Work of Alberto Gironella," *Oxford Art Journal*, 14, no. 1 (1991), p. 39.

70 Fraser, "Surrealising the Baroque," pp. 34–43.

71 Fraser, "Surrealising the Baroque," p. 41.

72 Salvador Elizondo, "Camera Obscura" in: *Antonio Gironella Camera Obscura*, exh. cat., (Mexico City, Galería Juan Martín 1968)

73 Martínez Lámbarry, *Tradición y Ruptura*, n.p.; Kesser, *Las Meninas von Velázquez*, p. 80. Fraser, "Surrealising the Baroque," pp. 34–43.

74 Igael Tumarkin, "*Las Meninas*" (76 × 57 cm), two-color lithography on Arche paper, collection Muze'on Tel Aviv le-omanut, Tel-Aviv; reproduced in Avigdor W. Posèq, "On Creative Interpretation: Igael Tumarkin's Homage to Velázquez's *Las Meninas*," *Konsthistorisk Tidskrift* 69, no.1 (2000), p. 36.

75 Igael Tumarkin, "*Las Meninas*" (205 × 154 × 15 cm), relief of wood, steel, cloth, and acrycolor on wood; collection Israel Phoenix Assurance Company, Tel-Aviv.

76 Edna Moshenson, *Tumarkin: Prints, 1962–1991*, exh. cat. (Tel Aviv : Muze'on Tel Aviv le-omanut, 1992), p. 6. See also Avigdor W. Poseq, "On Creative Interpretation: Igael Tumarkin's Homage to Velázquez's *Las Meninas*," *Konsthistorisk Tidskrift* 69, no. 1 (2000), pp. 33–40.

77 Moshenson, *Tumarkin: Prints*, pp. 8, 9.

78 *L'Ultimo quadro di Diego Velázquez* 1968, collection Cavellini, Brescia (93 × 62 cm/36.5 × 24.3 inches) in Germano Celant, *Giulio Paolini*, exh. cat. (New York: Sonnabend Gallery, 1972), p. 76, Fig. 67.

79 See Celant, *Giulio Paolini*, pp. 74, 75.

80 Kesser, *Las Meninas von Velázquez*, p. 146. Peter Weibel, "Giulio Paolini's Werk: Vom Rahmen des Bildes zu den Rahmenbedingungen der Kunst," *Giulio Paolini von Heute bis Gestern*, exh. cat. (Graz: Neue Galerie im Landesmuseum Joanneum, 4 April–31 May 1998), p. 18.

81 Weibel, "Giulio Paolini's Werk," p. 18.

82 Weibel, "Giulio Paolini's Werk," pp. 14, 16.

83 Giulio Paolini, *Contemplator Enim* (Milan, 1991), p. 35, English translation, Paul Blanchard.

84 The model, which belongs to the Centre Pompidou, is now housed in the exhibition devoted to space in the Cité des Sciences et de l'Industrie in Paris. I thank Marie-Luce Staib-Mâche for her efforts in obtaining information and photographs of the work.

85 Philippe Comar, "Les Ménines," *Opus International*, no. 83 (December 1981–January 1982), pp. 33–9.

86 I thank Electronic Arts Intermix for allowing me to view the video in their premises.

87 Hisham Bizri, "Story Telling in Virtual Reality," *Leonardo* 33, no. 1 (2000), p. 18. See also Lillian F. Schwartz, "Computers and Appropriation Art: The Transformation of a Work or Idea for a New Creation," *Leonardo* 29, no.1 (1996), pp. 43–9.

88 Joel-Peter Witkin, in *Joel-Peter Witkin: Centro de Arte Reina Sofía*, exh. cat., (Madrid: Centro de Arte Reina Sofía, 1988), pp. 25, 26.

89 Joel-Peter Witkin, "afterword" in *Joel-Peter Witkin*, exh. cat. (Pasadena, California: Twelvetrees Press, 1985), n.p.

90 Germano Celant, *Joel-Peter Witkin*, exh. cat., Rivoli, Italy, Museum of Contemporary Art, Castello di Rivoli, and New York, Solomon R. Guggenheim Museum, (1995), p. 10.

91 Hal Foster quoted in Howard Singerman, "In the Text," in Catherine Gudis, ed., *A Forest of Signs: Art in the Crisis of Representation*, exh. cat. (Los Angeles, Cambridge, MA: Museum of Contemporary Art, 1989), p. 159.

BIBLIOGRAPHY

Ackerman, Gerald. "Thomas Eakins and His Parisian Masters." *Gazette des Beaux-Arts*, ser. 6, 73 (April 1969): 235–56.

Ahlstrom, Sidney. *A Religious History of the American People*. New Haven, 1972.

Ahrens, Gerhard and Katrin Sello. *Nachbilder: Vom Nutzen und Nachteil des Zitierens für die Kunst*, exh. cat., Hannover, Kunstverein Hannover, 1979.

Alpatow, Michail W. "Menn'i Velaskera." *Iskusstvo*, 1 (1935): 123–36; [in Spanish] "*Las Meninas* de Velázquez." *Revista de Occidente* (April 1953): 35–68; [in German] "*Las Meninas* von Velázquez," in: *Studien zur Geschichte der Westeuropäischen Kunst*, ed. Werner Hofmann. Cologne, 1974: 204–28.

Alpers, Svetlana. "Interpretation without Representation, or, The Viewing of *Las Meninas*." *Representations* 1 (February 1983): 31–42.

Alpers, Svetlana. *The Decoration of the Torre de la Parada*, Corpus Rubenianum Ludwig Burchard, pt. 9 (London, 1971), pp. 237–39.

Anderson, Roland and Anne Koval. *James McNeill Whistler: Beyond the Myth*. New York, 1994.

Anonymous. "Galería de pinturas: Escuela española." *Semanario Pintoresco Español* 8 (18 June 1843): 193–94.

Anonymous. "Art Items." *Philadelphia Evening Bulletin* (20 September 1870).

Anonymous. "En el Museo del Prado: La sala de Velázquez." *El Liberal* 21 (6 June 1899).

Anonymous. "Noticias Generales." *La Epoca* 27 (27 December 1899).

Anonymous. "What the Artists Think of Sargent's 'Beatrice,'" *Harper's Weekly* 35 (9 May 1891): 346–7.

Anonymous. "Reviews: Velazquez and His Works. By William Stirling." *The Crayon* 1 (2 May 1855): 279–80.

Anonymous. "From a Talk by William M. Chase with Benjamin Northrup, of the Mail and Express." *The Art Amateur* (February 1894): 77.

Anonymous. "El Centenario de Velázquez: La sala del museo." *El Imparcial* (6 June 1899).

Anonymous. Exhibition review in *The Athenaeum* no. 1911 (11 June 1864): 811.

Anthony Whishaw: Reflections after Las Meninas. Exh. cat., London, Royal Academy of Arts/John Hansard Gallery, 1988.

Arana, Luis I. de. "*Las Meninas.* Punto final." *Arquitectura* 3 (May 1961): 27.

Araujo Sánchez, Ceferino [attrib.]. *Biblioteca Popular de Arte. Los grandes artistas: Pintores españoles II.* Madrid [ca. 1897].

Araujo Sánchez, Ceferino. *Los museos de España.* Madrid, 1875.

Arendt, Hannah, ed. and Harry Zohn, trans. *Illuminations.* New York, 1969.

Atkinson, D. Scott Atkinson and Nicolas Cikovsky, Jr. *William Merritt Chase: Summers at Shinnecock.* Exh. cat., National Gallery of Art, Washington, D.C., 1987.

Baignières, Arthur. "Première Exposition de la Société Internationale de Peintres et Sculpteurs." *Gazette des Beaux-Arts* 27 (February 1883): 187–92.

Bal, Mieke. *Reading "Rembrandt": Beyond the Word–Image Opposition.* Cambridge, 1991.

Balsa de la Vega, Ramón. "Velázquez: *Las Meninas.*" *La Ilustración Artística* 15 (19 June 1896): 451.

Balsa de la Vega, R. "Velázquez *animalista.*" *La Vida Literaria* 22 (8 June 1899): 364.

Bareau, Julie Wilson. *Edouard Manet: Voyage en Espagne.* Paris, 1988.

Barlow, Paul and Colin Trodd, eds. *Governing Culures: Art Institutions in Victorian London.* Aldershot, 2000.

Barolsky, Paul. "A Source for *Las Meninas,*" *Source* 10 (1991), 22–4.

Barthes, Roland. *Camera Lucida. Reflections on Photography.* New York, 1981.

Baticle, Jeannine and Cristina Marinas. *La Galerie Espagnole de Louis-Philippe au Louvre, 1838–1848.* Paris, 1981.

Battersby, Christine. *Gender and Genius: Towards a Feminist Aesthetics.* London, 1989.

Bauer, George and Linda. "Portrait Practice in *Las Meninas.*" *Source* 19 (Spring 2000): 38–42.

Bean, Thomas. "Richard Ford as Picture Collector and Patron in Spain. Documents for the History of Collecting 19." *Burlington Magazine* 137 (February 1995): 96–107.

Beauvoir, Roger de. *La Porte du Soleil.* 4 vols. Paris, 1844.

Bedaux, Jan Baptist. "Velázquez's *Fable of Arachne (Las Hilanderas)*: A Continuing Story." *Simiolus* 21 (1992): 296–305.

Bell-Villada, Gene H. *Art for Art's Sake & Literary Life.* Lincoln, NB and London, 1996.

Benjamin, Roger. "Recovering Authors: The Modern Copy, Copy Exhibitions and Matisse." *Art History* 12 (June 1989): 176–201.

Berger, Martin A. *Man Made: Thomas Eakins and the Construction of Gilded Age Manhood.* Berkeley, CA, 2000.

Berkowitz, Julie S. *"Adorn the Halls": History of the Art Collection at Thomas Jefferson University.* Philadelphia, 1999.

Bermejo, Luis. "Estatuas á Velázquez." *Blanco y Negro* (Madrid) (10 June 1899).

Beruete, Aureliano de. *Vélazquez.* Paris, 1898.

Beruete, Aureliano de. *Vélazquez.* Preface by Léon Bonnat. London, 1906.

Beulé, [Charles-]E[rnest]. "Velázquez au musée de Madrid." *Revue des Deux Mondes* 31 (1 July 1861): 167–192.

Beulé, E. *Causeries sur l'art.* 2nd ed. Paris, 1867.

Bizri, Hisham. "Story Telling in Virtual Reality." *Leonardo* 33, no. 1 (2000): 17–19.

Blanc, Charles. "Vélasquez à Madrid." *Gazette des Beaux-Arts* (1 July 1863): 65–74.

Blanc, Charles, et. al. *Histoire des peintres de toutes les écoles: ecole espagnole.* Paris, 1869.

Bledstein, Burton J. *The Culture of Professionalism: The Middle Class and the Development of Higher Education in America.* New York, 1978.

Bonnat, Agustín. "Retrato de Doña Juana de Pacheco, mujer de Velázquez." *Semanario Pintoresco Español* (24 August 1856): 265–7.

Boone, M. Elizabeth. "Sol y Sombra: American Artists Explore the Sunlight and Shadows of Spain," in *España: American Artists and the Spanish Experience.* Exh. cat., Hollis Taggart Galleries, New York and New Britain Museum of American Art, 1998.

Bouza, Fernando. *Locos, enanos y gentes de placer en la Corte de los Austrias.* Madrid, 1991.

Braham, Alan. *El Greco to Goya: The Taste for Spanish Paintings in Britain and Ireland.* Exh. cat., London, National Gallery, 1981.

Braidotti, Rosi. "Un-Cartesian Routes," in *Patterns of Dissonance.* Cambridge, 1991.

Brilliant, Richard. *My Laocoön: Alternative Claims in the Interpretation of Artworks.* Berkeley, CA, 2000.

Broun, Elizabeth. "Thoughts that Began with the Gods: The Content of Whistler's Art." *Arts Magazine* 62 (October 1987): 36–43.

Brown, Jonathan. *Images and Ideas in Seventeenth-Century Spanish Painting.* Princeton, 1978.

Brown, Jonathan. *Velázquez: Painter and Courtier.* New Haven and London, 1986.

Brown, Jonathan. *"Las Meninas' como obra maestra," in *Velázquez.* Barcelona, 1999, pp. 85–109.

Brown, Jonathan, ed. *Picasso and the Spanish Tradition*. New Haven and London, 1996.

Brown, Jonathan and Carmen Garrido. *Velázquez: The Technique of Genius*. New Haven and London, 1998.

Brownell, William Crary. "Whistler in Painting and Etching." *Scribner's Monthly Magazine* 18 (August 1879): 481–95.

Brownell, William Crary. "The Younger Painters of America." *Scribner's Monthly* 20 (May 1880): 1–16.

Brownell, William Crary. "American Pictures at the Salon." *The Magazine of Art* 6 (1883): 492–501.

Buchloh, Benjamin. "Parody and Appropriation in Francis Picabia, Pop and Sigmar Polke." *Artforum* 20 (March 1982): 28–34.

Buchloh, Benjamin. "Allegorical Procedures: Appropriation and Montage in Contemporary Art." *Artforum* 21 (September 1982): 43–56.

Buero Vallejo, Antonio. *Las Meninas: A Fantasia in Two Parts*. Marion Peter Holt, trans. San Antonio, TX, 1987.

Bürger, William. *Trésors d'art exposés à Manchester*. Paris, 1857.

Bürger, William [Théophile Thoré], et al. *Les Dieux et les demi-dieux de la peinture*. Paris, 1864.

Burns, Sarah. "Old Maverick to Old Master: Whistler in the Public Eye in the Turn-of-the-Century America." *American Art Journal* 22 (1990): 29–49.

Burns, Sarah. *Inventing the Modern Artist: Art and Culture in Gilded Age America*. New Haven and London, 1996.

Cabanis, José. *Le Musée espagnol de Louis-Philippe: Goya*. Paris, 1985.

Calvo Serraller, Francisco. *Las Meninas de Velázquez*. Madrid, 1995.

Cameron, Dan. "Contents under Pressure: Equipo Crónica." *Artforum* 89 (November 1989): 125–30.

Campo y Francés, Angel del. "El Alcázar de *Las Meninas*." *Villa de Madrid* 12 (1974): 55–61.

Campo y Francés, Angel del. *La magía de Las Meninas: Una iconología velaz-queña*. Madrid, 1978. 4th ed. 1989.

Campo y Francés, Angel del. "La invención de *Las Meninas*," in: *V Jornadas de Arte: Velázquez y el arte de su tiempo*. Madrid, 1991, pp. 151–60.

Campo y Francés, Angel del. "Especularia geométrica en *Las Meninas*," in: *Reflexiones sobre Velázquez*. Madrid, 1992, pp. 133–50.

Cane, Louis. *Les Ménines, les annonciations, les femmes debout, les toilettes, les accouchements, les déjeurners sur l'herbe . . . et le déluge*. Exh. cat., Saint-Paul, Fondation Maeght, 1983.

Carey, John. *The Intellectuals and the Masses: Pride and Prejudice among the Literary Intelligentsia, 1880–1939*. London, 1992.

Carlson, Victor I. *The Inspired Copy: Artists Looking at Art*. Exh. cat., Baltimore Museum of Art, 1975.

Casellas, Ramón. "El Impresionismo de Velázquez." *Hispania* 7 (30 May 1899): 51–54.

Casellas, Ramón. "L'Espanya de Velázquez." *La Veu de Catalunya* 1; 161 (11 June 1899): n.p.

Catálogo de los cuadros que existen colocados en el real museo de pinturas del Prado. Madrid, 1824.

Catálogo de los cuadros que existen colocados en el real museo del Prado. Madrid, 1821.

Catálogo de los cuadros de escuela española que existen en el real museo del Prado. Madrid, 1819.

Catalogue of Paintings, Studio Appointments, Curios, Bric-a-Brac . . . Belonging to William Merritt Chase, N.A. Exh. cat., American Art Association, New York, 7–11 January 1896.

Ceán Bermúdez, Juan Agustín. *Diccionario histórico de los más ilustres profesores de las bellas artes en España.* 6 vols. Madrid, 1800.

Ceán Bermúdez, Juan Agustín. *Diálogo sobre el arte de la pintura.* Seville, 1819.

Celant, Germano. *Giulio Paolini.* Exh. cat., New York, Sonnabend Gallery, 1972.

Celant, Germano. *Joel-Peter Witkin.* Exh. cat., Rivoli, Italy, Museum of Contemporary Art, Castello di Rivoli and New York, Solomon R. Guggenheim Museum, 1995.

Célestin, Roger. *From Cannibals to Radicals. Figures and Limits of Exoticism.* Minneapolis, 1996.

Champfleury. *Grandes figures d'hier et d'aujourd'hui.* Paris, 1861. Geneva, Slatkin Reprints, 1968.

Charteris, Evan. *John Sargent.* New York, 1927.

Chase, William M. "Velázquez: Extract from an address made by Mr. Chase before the American Art Association of Paris." *Quartier Latin* 1 (July 1896): 4–5.

Chronique des arts et de la curiosité 24 (1 July 1899): 218.

Clément, Charles. "Variétés: Le Musée européen." *Journal des Débats* 25 (April 1873).

Clément de Ris, Compte L. *Le Musée Royal de Madrid.* Paris, 1859.

Clifford, James. *The Predicament of Culture. Twentieth-Century Ethnography, Literature, and Art.* Cambridge, MA, 1988.

Comar, Philippe. "Les Ménines." *Opus International,* no. 83 (December 1981– January 1982): 33–9.

Cook, Clarence. "Why Drag in Velázquez?" *The Studio,* n.s. 6 (16 May 1891): 233–4.

Cooper, Colin Campbell. "A Spanish Painter." *Lippincott's Magazine* 51 (January 1893): 75–82.

Copier créer: de Turner à Picasso: 300 oeuvres inspirées par les maîtres du Louvre. Exh. cat. Paris, Musée du Louvre, 1993.

Cortanze, Gérard de, ed. *Antonio Saura*. Paris, 1994.

Costa, Felix da. *The Antiquity of the Art of Painting by Felix da Costa.* Trans. and notes by George Kubler and others. New Haven, 1967.

Crary, Jonathan. *Techniques of the Observer: On Vision and Modernity in the Nineteenth Century.* Cambridge, MA, 1990.

Crimp, Douglas. "The End of Painting." *October* 16 (Spring 1981): 69–86.

Crimp, Douglas. *On the Museum Ruins.* Cambridge, MA, 1993.

Cruz y Bahamonde, Nicolás de la. *Viage de España, Francia é Italia.* 14 vols. (Cadiz, 1812–13).

Cruzada Villaamil, Gregorio. [G.C.V.] "Variedades." *El Arte in España, Boletín* 3 (20 April 1862): 9.

Cruzada Villaamil, Gregorio. *Velázquez: Anales de su vida y obras.* Madrid, 1885.

Cuendias, Manuel de and V. de Féréal. *L'Espagne pittoresque, artistique et monumentale. Moeurs, usages et costumes.* Paris, 1848.

Cunningham, Allan. *Life of Wilkie.* 2 vols. London, 1843.

Dalí, Salvador. "Ecumenical 'chafarrinda' of Velázquez." *Art News* 61 (February 1961): 30, 55.

Damisch, Hubert. *The Origins of Perspective.* Trans. John Goodman. Cambridge, MA, 1994. [First published as *L'Origine de la perspective*, Paris, 1987.]

Darío, Rubén. "La fiesta de Velázquez." *España Contemporánea* (Paris, 1901): 172–3.

Délécluze, Etienne-Jean. "Galerie Espagnole du Louvre." *Journal des Débats* (24 February 1828).

Denker, Eric. *In Pursuit of the Butterfly: Portraits of James McNeill Whistler.* Exh. cat., Washington, D.C., National Portrait Gallery, 1995.

Descharnes, Robert and Gilles Néret. *Salvador Dali, 1904–1989: The Paintings 1904–1946.* Cologne and New York, 1997.

Diego, Estrella de. "Pintar al Otro: Retratos de lo diferente," in *El retrato en el Museo del Prado.* Madrid, 1994.

Domenech, Rafael. *"Velázquez." Discurso leído en el Círculo de Bellas Artes de Valencia* (6 June 1899). In *Revista Contemporánea* 115 (30 June 1899): 186–200.

Dubreuil-Blondin, Nicole. "Le philosophe chez Vélasquez: L'intrusion de Michel Foucault dans la fortune critique des *Ménines*." *Revue d'Art Canadienne/Canadian Art Revue* 22 (1993): 116–29.

Duro, Paul. "Le Musée des copies de Charles Blanc à l'aube de la IIIe République." *Bulletin de la Société de l'Histoire de l'Art Français* (1985): 283–313.

E.O. [Eugenio de Ochoa], "Don Diego de Velázquez." *Semanario Pintoresco Española* (26 February 1837): 70 [extract from *El Artista* 1 (1835)].

El Real Museo de Madrid: Las joyas de la pintura en España. Madrid, 1859.

Elias, Norbert. *Involvement and Detachment.* Michael Schröter, ed. Edmund Jephcott, trans. Oxford and New York, 1987. [First published in German as *Engagement und Distanzierung.* (Frankfurt am Main, 1983).]

Elizondo, Salvador. "Camera Obscura," in: *Antonio Gironella Camera Obscura.* Exh. cat., Mexico City, Galería Juan Martín, 1968.

Emmens, J.A. "Les Ménines de Vélasquez: Miroir des Princes pour Philippe IV." *Nederlands Kunsthistorisch Jaarboek* 12 (1961): 51–79.

Etienne, Charles. *Procès pour Aguayo.* Exh. cat., Paris, Galerie Jeanne Bucher, 1982.

Fairbrother, Trevor. "A Private Album: John Singer Sargent's Drawings of Nude Male Models." *Arts Magazine* 56 (December 1981): 70–80.

Fairbrother, Trevor. "Sargent's Paintings and the Issues of Suppression and Privacy." *Studies in the History of American Art around 1900, 37: Lectures in Memory of Daniel Fraad*, 37. Washington, D.C., National Gallery of Art, 1990.

Fernández Villabrille, F. "Glorias de España: Don Diego de Velázquez de Silva." *Museo de las Familias* (1847): 220–2.

Fine, Ruth E., ed. *Studies in the History of Art 19. James McNeill Whistler: A Reexamination.* Washington, D.C., National Gallery of Art, 1987.

Foster, Kathleen A. and Cheryl Leibold. *Writing about Eakins: The Manuscripts in Charles Bregler's Thomas Eakins Collection.* Philadelphia, 1989.

Foucault, Michel. *The Order of Things: An Archaeology of Human Sciences.* London, 1970.

Fouquier, Henri. *Etudes artistiques.* Marseilles, 1859. [Extract of his "Vélasquez au Musée de Madrid." *Tribune Artistique et Littéraire du Midi* 3 (1859).]

Fraser, Valerie. "Surrealising the Baroque: Mexico's Spanish Heritage and the Work of Alberto Gironella." *Oxford Art Journal* 14, no. 1 (1991): 34–43.

Fried, Michael. *Realism, Writing, and Disfiguration in Thomas Eakins and Stephen Crane.* Chicago, 1987.

From Reynolds to Lawrence: The First Sixty Years of the Royal Academy of Arts and Its Collections. Exh. cat., Royal Academy, London, 1991.

Galassi, Susan Grace. *Picasso's Variations on the Masters: Confrontations with the Past.* New York, 1996.

Gállego, Julián. *El pintor, de artesano a artista.* Granada, 1976.

García Felguera, María de los Santos. *Viajeros, eruditos y artistas: Los europeos ante la pintura española del Siglo de Oro.* Madrid, 1991.

Garrido Pérez, Carmen. *Velázquez: Técnica y evolución.* Madrid, 1992.

Gasparin, condesa de. *Paseo por España.* Valencia, 1875.

Gauthier, Paule. "Saura." *Cimaise* 24, no. 131/132 (July–October 1977): 38.

Gautier, Théophile. "Voyage en Espagne." *Musée des Familles* 14 (January 1847): 97–108.

Gautier, Théophile. "Musée Espagnol." *La Presse* (17 August 1850).

Gautier, Théophile. "Une Esquisse de Vélasquez." *Le Moniteur* (2 January 1862). Reprinted in *Notice de Velázquez première pensée du célèbre tableau la Rendition de Bréda*. Paris, 1872.

Gautier, Théophile. "De Paris à Madrid." *Le Moniteur Universel* 268 (24 September 1864).

Gaya Nuño, Juan Antonio. *Bibliografía crítica y antológica de Velázquez*. Madrid, 1963.

Gedo, Mary Mathews. *Picasso: Art as Autobiography*. Chicago and London, 1980.

Gerdts, William. H. "The Square Format and Proto-Modernism in American Painting." *Arts Magazine* 50 (June 1976): 70–5.

Gerstenberg, Kurt. *Diego Velázquez*. Munich, 1957.

Giulio Paolini von Heute bis Gestern. Exh. cat., Graz, Neue Galerie im Landesmuseum Joanneum, 1998.

Glen, Thomas L. "Should Sleeping Dogs Lie? Once Again, *Las Meninas* and the Mise-en-Scène." *Source* 12 (1993): 30–6.

Glendinning, Nigel. "Goya and England in the Nineteenth Century." *Burlington Magazine* 106 (January 1964): 4–14.

Glendinning, Nigel. "Nineteenth-Century British Envoys in Spain: Documents for the History of Collecting 7." *Burlington Magazine* 131 (1989): 117–26.

Glendinning, Nigel, Enriqueta Harris and Francis Russell. "Lord Grantham & the Taste for Velázquez: 'The Electrical Eel of the day.'" *Burlington Magazine* 141 (October 1999): 598–605.

Goley, Mary Anne. *The Influence of Velázquez on Modern Painting: The American Experience*. Exh. cat., Washington, D.C., Federal Reserve Board, 2000.

Gonse, Louis. "Velázquez." *Le Monde Moderne* 3 (June 1896): 865–83.

Goodrich, Lloyd. *Thomas Eakins*. 2 vols. Cambridge, MA, 1982.

Greub, Thierry, ed. *Las Meninas im Spiegel der Deutungen. Eim Einfürung in die Methoden der Kunstgeschichte*. Berlin, 2001.

Gudiol, José. *Velázquez: Historia de su vida, catálogo de su obra, estudio de la evolución de su técnica*. Barcelona, 1973. [English translation by Kenneth Lyons, New York, 1974.]

Gudis, Catherine, ed. *A Forest of Signs: Art in the Crisis of Representation*. Exh. cat., Cambridge, MA, Museum of Contemporary Art, 1989.

Guellette, Charles. *Les Peintres espagnols*. Paris, 1863.

Hale, Philip L. "Velázquez and All the Little Velázquez's." *Criterion* 1 (November 1900): 15–16.

Harlizius-Klück, Ellen. *Der Platz des Königs: Las Meniñas als Tableau des klassischen Wissens bei Michel Foucault*. Vienna, 1995.

Harris, Enriqueta. "Sir William Stirling Maxwell and the History of Spanish Art." *Apollo* 79 (January 1964): 73–7.

Harris, Enriqueta. *Velázquez*. Oxford, 1982.

Harris, Enriqueta. "*Las Meninas* at Kingston Lacy." *Burlington Magazine* 132 (February 1990): 125–30.

Harris, Enriqueta and Herbert Lank. "The Cleaning of Velázquez's Portrait of Camillo Massimi." *Burlington Magazine* 125 (July 1983): 410–15.

Harrison, Gabriel. "The Two Artists." *The Aldine* 7 (March 1874): 52–3.

Hastings, Mary Kay. *The Impact of Velázquez on Nineteenth Century American Artists: Thomas Eakins and William Merritt Chase*. M.A. Thesis, George Washington University, 1986.

Head, Edmund. *Handbook of the History of the Spanish and French Schools of Painting*. London, 1848.

Hennessy, Richard. "What's All This about Photography?" *Artforum* 17 (May 1979), 22–5.

Herrmann, Frank. *The English as Collectors: A Documentary Chrestomathy*. London, 1972.

Homenaje a Menéndez Pidal. 3 vols. Madrid, 1924.

Howarth, David. "Mr. Morritt's Venus: Richard Ford, Sir William Stirling Maxwell and the 'cosas de España.'" *Apollo* 159 (October 1999): 37–44.

Illustrated Catalogue: A Lone [sic.] Exhibition of the Masters of Modern Caricature and Others. Exh. cat., The Copley Society, Boston, 1906.

Imbert, P.L. *L'Espagne: Splendeurs et misères, voyage artistique et pittoresque*. Paris, 1875.

Inza, Carlos de. "Prosiguen las pesquisas (sobre *Las Meninas*)." *Arquitectura* 3 (April 1961): 44–8.

Ivins, Jr., William M. *Prints and Visual Communication*. Cambridge, MA, 1953.

J.M.A. [José María Asensio], "Velázquez y Murillo: Un monumento en proyecto." *La Ilustración Española y Americana* 16 (8 November 1872): 662–3.

James, Henry. "John S. Sargent." *Harper's New Monthly Magazine* 75 (October 1887): 683–91.

James McNeill Whistler. Exh. cat., The Tate Gallery, London, 1994.

Joel-Peter Witkin. Exh. cat., Madrid, Centro de Arte Reina Sofia, 1988.

Joel-Peter Witkin. Pasadena, CA, 1985.

Johns, Elizabeth. *Thomas Eakins: The Heroism of Modern Life*. Princeton, 1983.

Jovellanos, Gaspar Melchor de. *Obras de Gaspar Melchor de Jovellanos: Diarios (Memorias íntimas), 1790–1801*. Madrid, 1915.

Jovellanos, Gaspar Melchor de. *Jovellanos: Obras en prosa.* José Caso González, ed. Madrid, 1969.

Justi, Carl. *Diego Velazquez and His Times.* A.H. Keane, trans. ed. rev. by the author. London, 1889.

Kahr, Madlyn Millner. "Velázquez and *Las Meninas.*" *Art Bulletin* 57 (June 1975): 225–46.

Kahr, Madlyn Millner. *Velázquez: The Art of Painting.* New York, 1976.

Kemp, Martin. *The Science of Art: Optical Themes in Western Art from Brunelleschi to Seurat.* New Haven and London, 1990.

Kenyon, Cox. "Justi's Velázquez." *The Nation* 49 (18 July 1889): 57–8.

Kesser, Caroline. *Las Meninas von Velázquez: Eine Wirkungs- und Rezeptionsgeschichte.* Berlin, 1994.

Kidson, Alex. *Earlier British Paintings in the Lady Lever Art Gallery.* National Museums & Galleries on Merseyside, 1999.

Kraus, Rosalind. *The Originality of the Avant-Garde and Other Modernist Myths.* Cambridge, MA, 1985.

Kubler, George. "Three Remarks on the *Meninas.*" *Art Bulletin* 48 (June 1966): 212–14.

Kubler, George. "The 'Mirror' in *Las Meninas.*" *Art Bulletin* 67 (June 1985): 316.

Künstler, Gustav. "Uber 'Las Meninas' und Velázquez," in: *Festschrift Karl M. Swoboda zum 28. Januar 1959.* Vienna-Wiesbaden, 1959, pp. 141–58.

Lacan, Jacques. *Ecrits.* Alan Sheridan, trans. Paris, 1966.

Lacan, Jacques. *Les Quatre concepts fondamentaux de la psychanalise.* Vol. 11. Paris, 1973.

Lacan, Jacques. *Encore, Le Séminaire.* Vol. 20. Paris, 1975.

Laforge, Edouard. *Des Arts et des artistes en Espagne jusqu'à la fin du dix-huitième siècle.* Lyon, 1859.

Laing, Alastair. *Kingston Lacy Guide.* London, 1988, 2nd ed. London, 1994.

Lambert, Susan. *The Image Multiplied: Five Centuries of Printed Reproductions of Paintings and Drawings.* London, 1987.

Laurent, J. *Catalogue des principaux tableaux des musées d'Espagne.* Madrid, 1867.

Lavery, John. *Life of a Painter.* London, 1940.

Lavice, A. *Revue des Musées d'Espagne: Catalogue Raisonné.* Paris, 1864.

Lawrence, Sir Thomas. *Letters Addressed to the Late Thomas Penrice, Esq. while Engaged in Forming His Collection of Pictures, 1808–1814.* Yarmouth, n.d.

Lears, T.J. Jackson. *No Place of Grace: Antimodernism and the Transformation of American Culture, 1880–1920.* Chicago and London, 1981.

Lefort, Paul. "Le Musée du Prado: L'Ecole espagnole: 2e article." *Gazette des Beaux-Arts* (1 November 1894): 405–22.

Leighton, Frederic. *Discourse on Spanish Art.* London, 1889.

Les peintres français et l'Espagne: de Delacroix à Manet. Exh. cat., Castres, Musée Goya, 1997.

Licht, Fred. *Goya: The Origins of the Modern Temper in Art.* New York, 1979.

Lipschutz, Ilse Hempel. *Spanish Painting and the French Romantics.* Cambridge, MA, 1972.

López Rey, José. *Velázquez. Catalogue Raisonne.* 2 vols. Cologne, 1999.

Lorenzo, Soledad. *Soledad Sevilla.* Exh. cat., Galería de Arte Soledad Lorenzo, 1989.

Lubar, Robert S. *Dali: The Salvador Dali Museum Collection.* Boston, 2000.

Lubin, Michael. *Act of Portrayal: Eakins, Sargent, James.* New Haven, 1985.

Luna, Juan J. "John Singer Sargent y el Museo del Prado." *Historia 16* 13 (June 1988): 100–7.

Luna, Juan J. *Las pinturas y esculturas del Palacio Real de Madrid en 1811.* Madrid, 1993.

Luxenberg, Alisa. "Regenerating Velázquez in Spain and France in the 1890s." *Boletín del Museo del Prado* 17 (1999): 125–49.

Macartney, Hilary. "Sir William Stirling Maxwell: Scholar of Spanish Art." *Espacio, Tiempo y Forma,* Series 7 *Historia del Arte,* vol. 12 (1999): 287–316.

Macartney, Hilary. Review of 1999 edition of Stirling Maxwell's *Vélazquez and His Works,* in *Bulletin of Hispanic Studies* 78 (October 2001): 524–5.

MacCannell, Dean. *The Tourist: A New Theory of the Leisure Class.* Berkeley, CA, 1999.

MacDonald, Margaret F. *James McNeill Whistler: Drawings, Pastels and Watercolours.* New Haven and London, 1995.

Madrazo, Federico de. *Epistolario.* 2 vols. Madrid, 1994.

Madrazo, José de. *Epistolario.* Santander, 1998.

Madrazo, Pedro de. *Catálogo de los cuadros del real museo de pintura y escultura.* Madrid, 1843.

Madrazo, Pedro de. "Velázquez y sus obras." *El Siglo Pintoresco* 1 (May 1845): 25–31.

Madrazo, Pedro de. *El Real Museo de Madrid: Las joyas de la pintura en España.* Madrid, 1859.

Madrazo, Pedro de. *Joyas del arte en España: Cuadros antiguas del museo de Madrid.* Madrid, 1878.

Mainardi, Patricia. "Copies, Variations, Replicas: Nineteenth-Century Studio Practice." *Visual Resources* 16 (1999): 123–47.

Manolo Valdés. Exh. cat., São Paolo, Pinacoteca do Estado, 1998.

Marías, Fernando. "Las Meninas de Velázquez, del despacho de Felipe IV al cenador de Carlos III, pp. 157–77, in: *Velázquez y Calderón: dos genios de Europa (IV Centenario, 1599–1600, 1999–2000).* Madrid, 2000.

Marías, Fernando. *Velázquez: Pintor y Criado del Rey*. Madrid, 1999.

Marías, Fernando, ed. *Otras Meninas*. Madrid, 1995.

Marías Franco, Fernando. *Las Meninas*. Madrid, 1999.

Marin, Juan. *Guernica, ou, Le rapt des Ménines*. Paris, 1994.

Martínez Lámbarry, Margarita María de Guadalupe. *Tradición y ruptura en la pintura de Alberto Gironella*. Exh. cat., Mexico City, Centro de Arte Mexicano, 1988.

Mayne, Jonathan, ed. and trans. *Charles Baudelaire, Art in Paris, 1845–1862, Salons and Other Exhibitions*. Oxford, 1965.

McConkey, Kenneth. *Sir John Lavery*. Edinburgh, 1993.

McCully, Marilyn, ed. *Picasso, the Early Years*, exh. cat. Washington, D.C., National Gallery, 1997.

McKim-Smith, Gridley; Greta Andersson-Bergdoll and Richard Newman. *Examining Velázquez*. New Haven, 1988.

McKim-Smith, Gridley and Richard Newman. *Ciencia e historia del arte. Velázquez en el Prado*. Madrid, 1992.

Mélida, J. R. "El cuadro de *Las Meninas*." *Hispania* 9 (30 June 1899): 87–90.

Mélida, José Ramón. "El arte de Velázquez." *Album-Sálon* (1899): 132–5.

Mélida, José Ramón. "Notas bibliográficas." *Revista de Archivos, Bibliotecas y Museos* 3; 1 (January 1899): 50–3.

Mélida, José Ramón. "Bibliografía de Velázquez." *Revista de Archivos, Bibliotecas y Museos* 3; 5 (May 1899): 278–90; 6 (June 1899): 335–50; 8/9 (August–September 1899): 489–508; and 3, 11/12 (November–December 1899): 679–83.

Mena Marqués, Manuela. "La restauración de Las Meninas de Velázquez." *Boletín del Museo del Prado* 5 (1984): 87–107.

Mena Marqués, Manuela. "El encaje de la manga de la enana Maribárbola en *Las Meninas* de Velázquez," in *El Museo del Prado: Fragmentos y detalles*. Madrid, 1997, pp. 135–61.

Mérimée, Prosper. "Beaux-Arts: Musée de Madrid." *L'Artiste* 1; 6 (March 1831): 73–5.

Mérimée, Prosper. "Annals of the Artists in Spain." *Revue des Deux Mondes* (15 November 1848): 639–45.

Michel, Emile. *Etudes sur l'histoire de l'art*. Paris, 1894.

Millais, Geoffroy. *Sir John Everett Millais*. London, 1979.

Millais: Portraits. Exh. cat., National Portrait Gallery, London, 1999.

Minchin, Hamilton. "Some Early Recollections of Sargent." *The Contemporary Review* 127 (June 1925): 735–43.

Mitchell, W.J.T. *Picture Theory*. Chicago and London, 1994.

Moffitt, John F. "Velázquez in the Alcázar Palace in 1656: The Meaning of the *Mise-en-scène* of *Las Meninas*." *Art History* 6 (September 1983): 271–300.

Moleón Gavilanes, Pedro. *Proyectos y obras para el Museo del Prado: Fuentes documentales para su historia*. Madrid, 1996.

Molfino, Alessandra Mottola. Review of Francis Haskell, *The Ephemeral Museum, 2000. The Art Newspaper* (February 2001): 52.

Morphet, Richard. "Richard Hamilton: The Longer View," in: *Richard Hamilton*, exh. cat., London, National Gallery, 1992.

Morphet, Richard. *Encounters: New Art from Old*, exh. cat., London, National Gallery, 2000.

Morse, A. Reynolds. *Salvador Dali: A Panorama of His Art*. Cleveland, OH, 1974.

Moshenson, Edna. *Tumarkin: Prints, 1962–1991*. Exh. cat., Tel Aviv, Muze'on Tel Aviv, leomanut, 1992.

Moya, Ramiro de. "El trazado regulador y la perspectiva en Las Meninas." *Arquitectura* 3 (January 1961): 3–12.

Nahum, Katherine Coburn Harding. *The Importance of Velázquez to Goya, Manet and Sargent*. Ph.D. Dissertation, Boston University, 1993.

Notice des tableaux exposés jusqu'à présent dans la galerie du Musée du Roi. Madrid, 1828.

Orso, Steven N. *Philip IV and the Decoration of the Alcázar of Madrid*. Princeton, 1986.

Ortega y Gasset, José. *Velázquez, Goya and the Dehumanization of Art*. Trans. by Alexis Brown with introduction by Philip Troutman. New York, 1972.

Orvell, Miles. *The Real Thing: Imitation and Authenticity in American Culture, 1880–1940*. Chapel Hill and London, 1989.

Oteiza, Jorge. *Jorge Oteiza. Propósito experimental (An Experimental Proposition)*. Exh. cat., Madrid, Fundación Caja de Pensiones; Bilbao, Museo de Bellas Artes; Barcelona, Fundació Caixa de Pensiones, 1988.

Owens, Craig. "Representation, Appropriation and Power." *Art in America* 70 (May 1982): 9–21.

Painting in Spain in the Age of Enlightenment: Goya and His Contemporaries. Exh. cat., Indianapolis Museum of Art and The Spanish Institute, New York, 1997.

Palau I Fabre, Josep. *El secret de les menines de Picasso*. Barcelona 1981. In Spanish: *El secreto de las Meninas de Picasso*. Barcelona, 1982.

Palau I Fabre, Josep, *Dancing notes on Las Meninas*. With monotypes by Manolo Valdés. Paris, 2000.

Palomino, Antonio. *Lives of the Eminent Spanish Painters and Sculptors by Antonio Palomino*. Nina Ayala Mallory, trans. and ed. Cambridge, 1987.

Paolini, Giulio. *Contemplator Enim*. Milan, 1991.

Pardo, Arcadio. *La visión del arte español en los viajeros franceses del siglo XIX*. Valladolid, 1989.

Pardo Bazán, E. "De Europa." *La Ilustración Artística* 18 (3 July 1899): 394.

Pardo Bazán, Emilia. "La vida contemporánea: Velázquez." *La Ilustración Artística* 18 (19 June 1899): 426.

Penny Cyclopedia of the Society for the Diffusion of Useful Knowledge. 30 vols. London, 1833–58.

Petit, Fernand. *Notes sur l'Espagne artistique.* Lyon, 1877.

Phillipson, Michael. Introduction, *Anthony Wishaw: Reflexions after Las Meninas.* Exh. cat., London, Royal Academy of Arts/John Hansard Gallery, 1988.

Picón, Jacinto Octavio. "Plutarco del Pueblo: Velázquez." *El Liberal* 16 (7 May 1894).

Pita Andrade, José Manuel, and Angel Aterido Fernández, eds. *Corpus Velazqueño: Documentos y textos.* 2 vols. Madrid, 2000.

Ponz, Antonio. *Viage de España.* 18 vols. 1772–1794.

Portús Pérez, Javier. *Entre dos centenarios. Bibliografía crítica y antológica de Velázquez (1962–1999).* Seville, 2000.

Posèq, Avigdor W. "On Creative Interpretation: Igael Tumarkin's Homage to Velázquez's Las Meninas." *Konsthistorisk Tidskrift* 69, no. 1 (2000): 33–40.

Poutou, Eugène. *Voyage en Espagne.* Tours, 1869.

Quilliet, Frédéric. *Dictionnaire des peintres espagnols.* Paris, 1816.

R.B. [Ramón Balsa?]. "Tercer Centenario de Velázquez." *La Correspondencia de España* 50 (7 June 1899).

Ramazanoglu, C., ed. *Up Against Foucault. Explorations of Some Tensions between Foucault and Feminism.* New York, 1993.

René. "Peintres espagnols: Don Diego Velazquez de Silva." *L'Artiste* 9 (1835): 229–33.

Réveil, [Etienne] Achille, and Jean Duchesne. *Musée de peinture et sculpture.* 16 vols. Paris, 1832–1834.

Reymond, Rhonda Laseman. *James McNeill Whistler's* The Artist in His Studio: *A Study in the Concealment and Revelation of an Arist.* M.A. Thesis, University of Georgia, 1997.

Richard Hamilton. Exh. cat., London, National Gallery, 1992.

Richardson, John. *A Life of Picasso,* vol. 1, 1881–1906. New York, 1991.

Robert, Palau. *Joan Josep Tharrats: Setanta-cinc anys.* Barcelona, 1993.

Robins, Elizabeth and Joseph Pennell. *The Life of James McNeill Whistler.* New and rev. ed., Philadelphia, 1920.

Roof, Katharine Metcalf. *The Art and Life of William Merritt Chase.* New York, 1917.

Rosenblum, Robert, intro. *Encounters: New Art from Old,* exh. cat., London National Gallery, 2000.

Rosenthal, Léon. "Manet et l'Espagne." *Gazette des Beaux-Arts.* (September–October 1925): 203–14.

Ruskin, John. *The Works of John Ruskin*. Edward Tyas Cook and Alexander Wedderburn, eds. 39 vols. London, 1903–1912.

Sánchez Cantón, Francisco Javier. *Las Meninas y sus personajes*. Barcelona, 1952.

Sarduy, Severo. *Barroco*. Buenos Aires, 1974.

Sarup, Madan. *An Introductory Guide to Post-Structuralism and Post-Modernism*. Athens, GA, 1989.

Schmidt, Werner. *Dialoge, Kopie, Variation und Metamorphose alter Kunst in Graphik und Zeichnung vom 15 Jahrhundert bis zur Gegenwart*. Exh. cat., Dresden, Staatliche Kunstsammlungen, Kupferstich-Kabinett, 1970.

Schmitter, Amy M. "Picturing Power: Representation and *Las Meninas*." *Journal of Aesthetics and Art Criticism* 54 (Summer 1996): 225–68.

Schwartz, Lillian. F. "Computers and Appropriations Art: The Transformatin of a Work of Idea for a New Creation." *Leonardo* 29 (1966): 43–9.

Searle, John R. "*Las Meninas* and the Paradoxes of Pictorial Representation." *Critical Inquiry* 6 (Spring 1980): 477–88.

Sebastián, Santiago. *Emblemática e Historia del Arte*. Madrid, 1995.

Sentenach, Narciso. "La nueva sala de Velázquez en el museo del Prado." *La Ilustración Española y Americana* 43 (30 July 1899): 59–62.

Serrera, Juan Miguel. "El palacio como taller y el taller como palacio. Una reflexión más sobre *Las Meninas*," in: *Madrid en el contexto de lo hispánico desde la época de los descubrimientos*. 2 vols. Madrid, 1994, pp. 585–601.

Shaw-Sparrow, Walter. *John Lavery and His Work*. London, 1911.

Sherman, Daniel. *Worthy Monuments: Art Museums and the Politics of Culture in Nineteenth-Century France*. Cambridge, MA, 1989.

Sidlauskas, Susan. *Body, Place, and Self in Nineteenth-Century Painting*. Cambridge, 2000.

Simpson, Marc. "Sargent, Velázquez, and the Critics: Velázquez Come to Life Again." *Apollo* 148 (September 1998): 3–12.

Smith, Gerard W. *Painting Spanish and French*. London, 1884.

Snyder, Joel. "*Las Meninas* and the Mirror of the Prince." *Critical Inquiry* 11 (1985), 539–72.

Snyder, Joel and Ted Cohen, "Critical Response, Reflexions on *Las Meninas*: Paradise Lost." *Critical Inquiry* 7 (Winter 1980): 429–47.

Soriano, Rodrigo. "El Centenario: Esperando Sentado (carta refundida de Velázquez)." *Los Lunes del Imparcial* (5 June 1899).

Spielmann, Marion Harry. *Millais and His Works*. Edinburgh, 1898.

Spies, Werner. "Picasso: L'Histoire dans l'Atelier." *Cahiers du Musée National d'Art Modern* 9 (1982): 60–7.

Squires, Carol, ed. *The Critical Image. Essays on Contemporary Photography*. Seattle, 1990.

Staley, Allen, ed. *The Royal Academy Revisited: Victorian Painting from the Forbes Collection*. New York, 1975.

Steinberg, Leo. "Velázquez' *Las Meninas*." *October* 19 (Winter 1981): 45–54.

Stellweg, Carla. "New Mirrors for a New Society: Seven Artists in Post-Franco Spain." *Art News* 79 (March 1980): 58, 63.

Stern, Raphael, Philip Rodman and Joseph Cobitz, eds. *Creation and Interpretation*. New York, 1985.

Stevenson, R.A.M. [Robert Alan Mowbray]. "Sir John Everett Millais P.R.A." *Art Journal* 60 (January 1898): 1–5.

Stevenson, R.A.M. *Velázquez*, ed. Denys Sutton. London, 1962.

Stirling, William. "The Church and the Artist in Spain." *The Crayon* 1 (21 June 1855): 392.

Stirling, William. "Philip IV of Spain." *The Crayon* 2 (11 July 1855): 21–2.

Stirling, William. *Velazquez et ses oeuvres*, trans. and annoted by Gustave Brunet and William Bürger [Théophile Thoré]. Paris, 1865.

Stirling, William. *Annals of the Artists of Spain*. 4 vols. London, 2nd ed., rev., 1891.

Stirling, William. *Velázquez and His Works*. Bilingual English/Spanish edition, trans. by Joaquín Maldonado y Macanaz with introduction by Enriqueta Harris. Madrid, 1999.

Stirling Maxwell, William. *Velazquez and His Works*. London, 1855.

Stoichita, Victor I. "Imago Regis: Kunsttheorie und königliches Porträt in den Meninas von Velázquez." *Zeitschrift für Kunstgeschichte* 49 (1986): 165–89.

Stoichita, Victor I. *The Self-Aware Image: An Insight into Early Modern Meta-Painting*. Cambridge, 1997.

Stratton, Suzanne L., ed. *Spain, Espagne, Spanien: Foreign Artists Discover Spain, 1800–1900*. Exh. cat., New York, The Spanish Institute and The Equitable Gallery, 1993.

Stratton-Pruitt, Suzanne L., ed. *Cambridge Companion to Velázquez*. Cambridge, 2002.

Sullivan, Edward J. *Claudio Bravo: Painter and Draftsman*. Exh. cat., Madison, WI, Elvehjem Museum of Art, 1987.

Taylor, Baron Isidore. *Voyage pittoresque en Espagne, en Portugal et sur la côte d'Afrique*. vol. 1 text. Paris 1826 [sic, 1856].

The Salvador Dali Museum Collection. A. Reynold Morse, Robert Lubar, intro. Boston, Toronto, London, 1991.

Thomson, Rosemarie Garland, ed. *Freakery. Cultural Spectacles and the Extraordinary Body*. New York, 1996.

Thoré, Théophile. "Etudes sur la peinture espagnole: Galerie du Maréchal Soult." *Revue de Paris* 21 (September 1835): 201–20; "Deuxième partie." (October 1835): 44–64.

Tolnay, Charles de. "Velazquez's *Las Hilanderas* and *Las Meninas* (An Interpretation)." *Gazette des Beaux-Arts*, 6th series, 35 (1949): 21–38.

Tubino, Francisco María. "Luis Morales, llamado el divino y Diego Velázquez de Silva: el idealismo y el naturalismo en el arte pictórico español." *Museo Español de Antigüedades* 7 (1876): 71–108.

Uhagón, Francisco R. de. "Diego Velázquez en la orden de Santiago." *Revista de Archivos Bibliotecas y Museos* 3; 5 (May 1899): 257–71.

Umberger, Emily. "Velázquez and naturalism II: Interpreting *Las Meninas*." *Res* 28 (Autumn 1995): 94–117.

Utley, Gertje. *Picasso the Communist Years*. New Haven and London, 2000.

Valdés, Manolo. *Manolo Valdés: The Timelessness of Art*. With introduction by Tomàs Llorens. Bogotá, 1999.

Valera, Juan. "Velázquez y su tercer Centenario." *La Ilustración Española y Americana* 43 (6 June 1899): 330–60.

Valne, Bo. "Velázquez' *Las Meninas*: Remarks on the Staging of a Royal Portrait." *Konsthistorisk Tidskrift* 51 (1982): 20–8.

Varia Velazqueña. 2 vols. Madrid, 1960.

Vega, Jesusa. "Goya's Etchings after Velázquez." *Print Quarterly* 12 (1995): 145–63.

Velázquez en blanco y negro. Museo del Prado, Madrid, 2000.

Velázquez et la France: La découverte de Velázquez par les peintres français. Exh. cat., Musée Goya, Castres, 1999.

Velázquez, son temps, son influence. Casa de Velázquez, Actes de Colloque, 1960. Paris, 1963.

Viardot, Louis. *Galerie Aguado: choix des principaux tableaux*. Paris, 1839.

Viardot, Louis. *Musées de l'Espagne*. 1843.

Volk, Mary Crawford. "On Velázquez and the Liberal Arts." *Art Bulletin* 58 (March 1978): 69–86.

Waagen, Gustave. *Galleries and Cabinets of Art in Great Britain*. [Supplement to *Treasures of Art in Great Britain*, 3 vols.] London, 1857.

Wedd, Kit, Lucy Peltz and Cathy Ross. *Creative Quarters: The Art World in London, 1700–2000*. Exh. cat., Museum of London, 2001.

Weibel, Peter. "Giulio Paolini's Werk: Vom Rahmen des Bildes zu den Rahmenbedingungen der Kunst," in: *Giulio Paolini von heute bis gestern*. Exh. cat., Graz, Neue Galerie im Landesmuseum Joanneum, 1998.

Wilmerding, John, ed. *Thomas Eakins*. Exh. cat. National Portrait Gallery. London 1993.

Winner, Matthias. "Gemälte Kunstheorie. Zu Gustave Courbet's 'Alégorie réelle' und der Tradition." *Jahrbuch der Berliner Museen* N.F. 4 (1962): 151–85.

Winters, Terry A. "Dan Devine." *The New Art Examiner* 21 (March 1994): 41–2.

Witkin, Joel-Peter. *Joel-Peter Witkin: Centro de Arte Reina Sofía.* Exh. cat., Madrid, Centro de Arte Reina Sofia, 1988.

Wohl, Alice Sedgwick. "Velázquez: *Las Meninas.*" *News from RILA (International Repertory of the Literature of Art), The Getty Art History Information Program,* no. 5 (Februry 1987): 5–10.

Wyzewa, Téodor de, and X. Perreau. *Les Grands peintres de l'Allemagne, de la France, de l'Espagne et de l'Angleterre,* vol. 6, Paris, 1891.

Young, Andrew McLaren, et al. *The Paintings of James McNeill Whistler.* New Haven and London, Yale University Press, 1980.

INDEX